AMERICAN WITNESS

AMERICAN WITNESS

THE ART AND LIFE OF
ROBERT FRANK

RJ SMITH

DA CAPO PRESS

Da Capo Press
Hachette Book Group
1290 Avenue of the Americas, New York, NY 10104
www.dacapopress.com
@DaCapoPress; @DaCapoPR

Printed in the United States of America

First Edition: November 2017

Published by Da Capo Press, an imprint of Perseus Books, LLC, a subsidiary of Hachette Book Group, Inc.

The Hachette Speakers Bureau provides a wide range of authors for speaking events. To find out more, go to www.hachettespeakersbureau.com or call (866) 376-6591.

The publisher is not responsible for websites (or their content) that are not owned by the publisher.

Editorial production by Christine Marra, *Marra*thon Production Services.
www.marrathoneditorial.org
Book design by Jane Raese
Set in 11.5-point Berthold Baskerville

Library of Congress Cataloging-in-Publication Data has been applied for.

ISBN 978-0-306-82336-7 (hardcover)
ISBN 978-0-306-82337-4 (ebook)

LSC-C

10 9 8 7 6 5 4 3 2 1

TO MADELEINE ECHO,

BADGER

BOO

CONTENTS

INTRODUCTION

ROBERT FRANK'S FAVORITE IMAGE from his most famous work, the photo book *The Americans*, is a photograph titled *San Francisco* from 1956. It's like a punch in the nose. He was shooting in a park above San Francisco and was sneaking up on an African American couple enjoying the view, and their privacy, when a stranger approaches from behind.

The thing is that Frank wasn't surprised they turned around; you can pretty much assume he was hoping—even counting—on them turning around. Confrontations got his juices flowing. So maybe he made some noise, maybe not, but when they turned around, the African American man crouched down in a protective stance, eyes flashing hostility, the woman's face warily asking *What are you doing?*, Frank was prepared to pounce. This white guy has entered their space and is taking something they were not offering. A moment of submerged feeling dragged into the daylight.

As the contact sheet shows, Frank very quickly made a gesture of photographing whatever was next to them, pretending he wasn't really taking their picture. Then he walked away, and nobody got punched.[1]

Frank has always said that he liked this photograph because of the candor on the couple's faces and the intensity of their unguarded reaction to a stranger's approach. He liked it because it is honest, and it is honest because it reveals human feeling, and anger was a feeling that explained the country in which he was traveling in 1956 about as well as any single emotion could. On both sides quiet reflection had become impossible.

Like that couple on the overlook, Robert Frank has pretty much always wished to go unobserved. There is little he appreciates less than people taking his picture, putting a microphone in his face,

asking him questions. When approached, he has responded in a manner similar to the couple in his *San Francisco* photograph—or worse.

It's a fall day in 2015, and I am running down a long row of stairs while a crowd is walking up. A documentary of Frank's life had just premiered at the New York Film Festival in Lincoln Center, and the subject was making a rare public appearance. At the end of the movie Frank stood and waved to the sold-out room, and everybody else stood too, clapping for the man whose work they loved and whose life they knew more about than they had ninety minutes before. The documentary's maker answered a few questions, then everyone headed out.

I was sitting in a back row, the farthest corner from Frank and his wife, June Leaf. I had been working on this book for several years, and he had not responded to various appeals to meet. Neither letters nor the interventions of friends over the previous years had stirred his interest—or disinterest. What he extended was a shrug, a neutral acknowledgment that declared any exchange was beyond reach. I came to New York in hopes of at least looking him in the eye and telling him what I was about.

The room lights went on, and I had to move quickly because he was heading toward a side door that had just opened at the far corner. I raced toward him. A man was coming up the stairs, leaning on a cane, and suddenly I could see tomorrow's headlines about the legendary filmmaker Jonas Mekas being trampled at Lincoln Center. I stopped running and walked down to where Frank was a moment before—just in time to see him, Leaf, and several others enter an elevator and disappear behind the closing door.

By the time I made it upstairs they were gone.

Some people's art initiates a conversation with other art; Robert Frank's work has been engaged in a dialogue with his first important subject—America—for over fifty years. It eventually became the most influential American photo book and a signal American art work of the last hundred years. *The Americans* has inspired plenty of people beyond the art world as well, far more than museum art usually does. Plenty of artists have described how his work

impacted their own, but maybe more telling is that Frank's work has been so inspiring as to lead some—including Chris Marker and Ed Ruscha—to abandon a career in photography.[2] Others return to *The Americans* again and again. "I was twenty-four when I first saw the book," Bruce Springsteen told an interviewer in 1995. "I think a friend had given me a copy—and the tone of the pictures, how he gave us a look at different kinds of people, got to me in some way. I've always wished I could write songs the way he takes pictures. I think I've got half a dozen copies of that book stashed around the house."[3]

On the verge of abandoning his own photographic career, Frank made his first film, *Pull My Daisy*, with Alfred Leslie in 1959, embodying a countercultural sensibility long before anybody understood what counterculture was. *Pull My Daisy* was a key film that helped launch a new American independent cinema, and by the time it had, Frank had turned to other styles of filmmaking. He was on his way to becoming, in the words of *New York Times* critic Manohla Dargis, "One of the most important and influential American independent filmmakers of the last half-century."[4]

He has influenced MTV videos and generations of photographers who weren't even born when *The Americans* was published. And he has, more distantly, helped launch generations of Americans who have set out from home to see their country for themselves. There's not another living American artist who has inspired so many different kinds of people—writers, political activists, musicians, sleepers on the beach—to do what they believe in. His example shows where following your own path can lead, how honest you need to be, and the cost it will inevitably exact. He's a pill and selfish and sometimes incredibly sad and one of the freest individuals I can think of. He does not give a fuck about protocol and proprieties, and he has lived long enough to show that he has been right more often than he was wrong. As his friend Miles Forst once said, "There is no peace in him."[5]

FRANK PUSHES PEOPLE HARD, testing their loyalty and weakness. In the middle of the National Gallery's assemblage of a major exhibition on Frank's career, its curators sent him a catalog showing everything they wanted to use. He cut out all but two or three images from *The Americans* and then sent it back. He didn't want that work included, curator Sarah Greenough told a Washington audience, "because he was bored with it."[6] The stubbornness was no fluke. In the middle of editing a book-length overview of Frank's film and video work, that project's coeditor was told Frank wouldn't give her an interview, wouldn't come to her retrospective of his work, and didn't have copies of his work to share with her. Then he retracted permission to show his films in the retrospective and ordered her not to publish any of his photographs or film stills in the book. This was tough love—or just tough.[7] Such actions, the editor decided, "wiped away his fear of repeating himself and guaranteed uniqueness. . . . Without realizing it at first, we would be actors under Robert Frank's direction." It is through such difficulties, by the things that keep you from taking the established route and force one to improvise, that something new comes into being. That has been his experience, and he offers this understanding to others when he can. Make plans with him at your peril. Events change on the ground.

Early in 2016 a New York University art gallery presented a career overview, and it was announced that the ninety-one-year-old himself would attend the opening and take questions from an audience. It seemed like another chance to make my case. So I went, and after a short question-and-answer session a side door in the room opened onto Mercer Street. He walked past a cloud of photographers and video cameras and headed into Greenwich Village. Frank was walking down the block by himself, cane in hand, motoring along.

I introduced myself, and he smiled. "I'm writing a book about you," I said.

"You are writing a book?" he said in his Swiss-German accent. He looked amused. "Good luck!"

I explained I was pretty far along, that I had been to Zurich and seen the building he grew up in, the schools he'd attended.

"Say hello to the mountains!" he said heartily.

We talked a little, the smile stayed on his face, and his step picked up as he headed for the van at the end of the block that would drive him back to his building on Bleecker Street. Friends of his have said he sometimes gets confused, and his body is wearing out. But Frank was charging down the street now, his shoulders powerful, his thoughts all in order. He arrived at the van, and I shook his hand.

"You caught him on a good day," Frank's friend Jim Jarmusch would say later.

AT A PARTY around this time a few bros in their twenties listen as I ramble on about Frank, how he has altered the direction of his life in order to not repeat himself, how much that's cost him. I describe his mistrust of money and explain that he has wriggled out of every definition people like myself have laid on him. The word integrity was used two or three times. And when I catch my breath, one of my friends, with a confused look on his face, earnestly says, "Wow. You know, people my age don't understand that at all. There's nothing about those kinds of values that makes sense to us." Perhaps I flashed the indignation of an aging baby boomer who can't believe the convictions his era honored are anything but eternal. And yet I don't believe that Frank or his ideals are an anathema to this time, and if that were true, I still could not accept it, and one other reason for writing this book is the possibility of sharing his story, his values, and, most of all his work with people to whom they are unfamiliar.

A photographer friend of Frank's, who didn't want her name used and risk falling out of his affection, says, "I come out of this community of people who just really worship him. Worship isn't strong enough of a word. And it's all about the pictures. Because nobody knows Robert." People have had little information, which

is how he likes it. And the information they do have is sometimes wrong, contradictory, and gleefully made up by an artist who would be happy if the story got out wrong. "Look," says Frank's buddy, journalist Charlie LeDuff, "people don't fucking know the guy. They just *think* they know the guy."[8]

What they have known, for the last fifty-plus years, is the myth of Robert Frank. It can be broken down into pieces.

Part of it is that Frank turned his back on success and found a harder way forward, taking a spider web of backroads to get as far away from a sure thing, the certain life, as he could get. He has disliked the smell of success and fought its material rewards. "If you looked into Lee Friedlander's home in Upstate New York, you'd probably see assistants and neatly stacked prints and a dark room. It's a *business*," says the photographer friend. "You look at Robert's home, and there's piles of photos and cans of film stacked all around with potted plants on top, no couch. He fucking hates capitalism."

In the piles and canisters and drawers, presumably, are clues to a lifetime's worth of art. Evidence relating to the photographs that came after *The Americans*: an indelible series shot from New York City buses. And then the secretive years of the seventies, eighties, and nineties, when he remade his photography into something damaged, personal. Clues as well to the filmmaker: Frank has produced a string of unique and meandering films and videos that chase down truth and time and what it means to be an artist in the late twentieth century. And then *Cocksucker Blues*, the legendary, essentially unseen feature he made on tour with the Rolling Stones in 1972. The film itself was a masterful head-into-the-void essay on celebrity and isolation and the color blue. The fate of the film, criticized and forbidden, introduced Frank to a new audience, as someone unwilling to disfigure a work just to gain viewers.

But the legend is built, of course, on the foundation of *The Americans*. The photo book, which was published in Paris in 1958 and in the United States in 1959, is the Marcellus Shale of Frank's reputation: bedrock both enormous and hard to see, singular and underground. The straight trail forward from there looked impossible to

Frank. And so he found other ways to be, discovered an impulse to stay creative, work in the dark, remain alive. "The irony is that more than anybody ever, he is branded with the curse of the early work," says photographer Ralph Gibson. "You're nobody with it, and nobody without it. He will always be compared to *The Americans*."[9]

It was "his failed book," the photographer Danny Lyon gushes, that made the legend. "He had integrity, and that is what was totally lacking in the world of photography. Robert, who was rejected by the Magnum Agency, he said, because he had egg on his shirt—he had integrity. He sucked it up, he lived in poverty, and he didn't do commercial jobs. He was a beacon on the hill of what you could do in America. Who cared if you failed?"[10] An artist in America, calling into question what being a winner meant in this place. Who gets to define what a life is worth? He had an answer.

One final aspect of the myth: the person created by the work. It has been said that he stopped doing interviews, pulled back from public scrutiny, and went into hiding after *The Americans* began to get attention. Frank wants his work to speak for him, and it does—with shrieks and muffled voices. And as much as he has lowered his own voice, his iconic image as an unplugged oracle has grown. "I think it's easier to talk to Bob Dylan today than to Robert Frank," says the photographer John Cohen. "Isn't that strange?"[11]

TODAY A CULT OF FANS who personally know him envelope Frank in a way that is rare for an art world figure. They get emotional about the man: "He is my friend, my teacher, my roshi," one follower explained (he didn't want to run the risk of offending Frank by using his name). And then there is a professional contingent, a protectorate of dealers, academics, museum figures, and others who have benefited from managing his image and following Frank's personal wishes.

These folks' devotion has been instructive and inspiring to me as I have conducted interviews and research, even as much as

their protectiveness has been a challenge. Robert Frank and his wife, June Leaf, have not expressed interest in being involved with this project. Nor have they stood in its path. This is a book written from outside Frank's orbit by someone who thinks his story speaks to others outside that circle. I have thought more than once of a passage in a letter he wrote to Sarah Greenough, senior curator and head of the department of photographs at the National Gallery of Art. I would quote his words to you if I could, but Frank has declined permission.[12] He thinks all the time about the people who want to tell his story, and in the letter he wonders who will succeed. He says that he almost always wonders if it will be somebody he doesn't know, a stranger outside the vetted and obedient group, who will eventually do the best job of describing him.

"He's really a very pure, beautiful person, and he is not about planning," the filmmaker Jonas Mekas explains. "There are no machinations. He is not trying to make himself bigger or more important. He's just there, himself, doing his work."[13] His longtime film editor Laura Israel told me how she and Frank were heading out on a field trip once when she asked him to wait—she needed to grab a map. He had other ideas. "Don't bring a map," he said. "We're gonna get lost. That's part of the plan."[14] That was part of my plan too, working from one interview, one image to the next. I set out in random order, working from the outside in, from sources most distant to ones closer. At times the work led me to a person who knew him, say, in the 1950s, and they would mention a photographer of today I should speak to. A man in Zurich would mention a contemporary exhibition exploring the work of Frank and the Swiss writer Robert Walser in tandem, and suddenly a profound connection was exposed. Maps have limits.

Frank has made the most of his time. He has laid in the cut, hidden among the abstract expressionists, the street photographers, the Beat generation, the founders of American independent cinema, the Rolling Stones. In his own work, as in his life, he has been a master of the all-seeing hang. In one of the great images from *The Americans* he photographs cowboys at a rugged bar in Gallup, New Mexico. The view is from an exceedingly low angle—almost

the floor. It's pretty clear he was holding the camera beneath his table to photograph without notice. "Robert has a great expression: he says, 'I'm like a crow. I visit the piles of garbage, and I pull out the best pieces!'" says the photographer Jerry de Wilde, who knew him in the 1960s and 1970s. "He's the master of being unobtrusive. He can be there and nobody knows he's there. He allows what's happening to happen, and as a result he's a witness to everything."[15]

This book is the story of the crow, the witness, the pile of stones, the man in the window. In his early nineties at the time of this writing, Frank is still getting around the Village and still traveling outside it too. Associates say that he is prone to long silences, that he picks his moment to engage, and that when he wants to be he is very much present. "He's gotten a lot nicer," his close friend Peter Kasovitz, the owner of K&M Camera in New York, says. "These days his thoughts are on tranquility, serenity."[16]

A few days after I talked to Frank on the street I entered a coffeehouse in New York's East Village. It was the middle of the afternoon, and as I sat down to write, who should be by the window but Frank and Leaf, sitting at a small café table.

I looked up, and he met my gaze. And then, he did what he did in San Francisco half a century before and many times since: he turned his head quickly and acted like he was looking at something else.

I couldn't tell if he held a camera under the table.

CHAPTER ONE

"BRUSH"

THERE IS A SHOP in Zurich's medieval Old Town with a precisely calibrated display of oddity. From a distance it looks unassuming. The incline is steep leading to the door, and the roads bend like rockers; two blocks away is the Cabaret Voltaire, a bar where a century ago the art movement known as Dada began. In the small storefront a bit of its spirit lives on.

The place is long famous in Zurich for its poetic arrangements of stuff, lovingly tended by the owner. Inside is a stylish, handmade wooden armoire, its door open to reveal a brassiere dangling daintily; an antique bar cart with a stack of plates on it, each one emblazoned with the face of an old-school Hassidic scholar; an old typewriter: and a mask that looks like Heidi, the Swiss Alpine orphan, having a bad hair day. The shop is owned by an elderly woodworker and paradox lover named Massimo Biondi.

Robert Frank was born and grew up in Zurich, and Biondi is one of his oldest friends in town. On a cold December afternoon Biondi is at a worktable in a back room, leaning over a restoration project. The overpowering smell of glue fills the air, enough to make a visitor dizzy. We talk a bit about the city. Having built and sold things in Zurich for decades, Biondi offers his thoughts on the place that is his home. "What do I like about Zurich?" he repeats. "Here I am very free. There is no violence, and the tax is not too high. It is efficient. When you go to the hospital it is—" and here he makes a sound that could be the universal signal for *lickety-split.* "If you want a train—" a different *lickety-split* noise. "And if you need a bus—" again. "Here everything is clean and efficient. It is a very good kind of life," he says, brushing his hands on his apron.[1]

Biondi is a craftsman who found his place within the comfort and security of the Swiss way. Robert Frank was different. The question Frank has been asked most often over the years is: *Why did you leave photography behind?* It's an inquiry likely to trigger a sharp rebuke. The second-most asked question, *Why did you leave Switzerland?*, gets a different answer. He had to, he eagerly explains to audiences. That safety, orderliness, the rigid hewing to business and decorum, the methodical predictability, the neatness of the sidewalks, and the knowledge that your block was watched—all are familiar to those who live there. Those qualities, Frank would explain later, sucked the air out of him. Robert Frank has been back to Switzerland many times over the years since he moved away, and perhaps every one of those times he has answered the question on home ground by saying that he had to leave if he was to become an artist. Really, he indicates, if he was to *breathe.*

When he comes back to Zurich now Frank is a creature of small habits. He still rides the tram running through the Enge District he grew up in. He still buys a sausage from a guy near the main train station, the best in town, he declares. Though he has escaped it, Frank acknowledges he is a product of what he's called "the Swiss mentality." Growing up in Zurich and living in Switzerland until he was twenty-two, Frank was raised in a household that thrived on the illusion of order. His street offered a privileged view of Swiss order, visible from multiple angles.

The street called Schulhausstrasse starts a few blocks from the western shore of Lake Zurich, at the intersection of Lavaterstrasse, named for the Lavater School, a local landmark built in 1897 and the elementary school Frank attended. The closer one lived to the lake, the more formidable were the buildings and the families. Schulhausstrasse runs up and down several hills before ending at the Sihl River. Going up the first hill, with a premium view of the mountain on the other side of Lake Zurich, were the fanciest homes, three and four stories. Going up the next, one sees well-to-do houses and Schule Gabler, Frank's secondary school. Frank grew up in a substantial four-story building at the Sihl end, the more frugal point of a prosperous street in one of the main Jewish

neighborhoods of Zurich. Where the Franks lived, as Schulhauss-
trasse sloped down to the local business district, was an easy walk
to the Enge train station and neighborhood shops.[2]

Robert Louis Frank was born on November 9, 1924. A photo-
graph taken by his father shows a toddler with coarse, wild drifts
of curly hair, surrounded by toys, one arm reaching out of the
picture.[3] Growing up in that house and in the surrounding neigh-
borhood of Enge made possible a secure and comfortable exis-
tence. There were plenty of toys and books for Robert and his
brother, Manfred, who was two years older. Robert particularly
enjoyed German translations of Edgar Rice Burroughs's Tarzan
series as well as the westerns of Karl May. The Franks had a maid;
took family excursions to the mountains, France, and Italy; and
Dad liked big American cars. Hermann, their father, was an ama-
teur photographer with a stereo camera and a Leica in the house.
He painted and collected art, including landscapes, drawings, and
portrait miniatures painted on ivory.[4]

Hermann came from a Jewish family in Frankfurt-am-Main,
Germany, where he had worked as an interior designer. He fought
in World War I and had taken a bullet in the leg. The injury caused
him troubles, but not enough to impair the walking he liked to do.[5]
After the war Hermann traveled to Switzerland, and in Basel he
met Regina Zucker, the daughter of a wealthy Russian immigrant
who owned a bicycle factory. "He was a very smart guy but my fa-
ther didn't get along with him," said Robert. "He didn't talk much
and he was different."[6]

They moved to Zurich, where Hermann started a business im-
porting Swedish Luxor radios and record players and selling them
from a shop in the Enge. "He also designed horrible furniture—it
was all over Zurich-Enge," Robert said.[7]

After he closed his shop and came home at 6 p.m. Hermann
would write letters, dictating correspondence addressed to various
newspaper editors through an assistant—and god forbid the secre-
tary made a punctuation mistake, for Hermann did not hold back
his anger. After that the house had better be silent—no news, no

noise. Time to smoke a cigar. And then, if he could, he would get out of the house and see what was going on in town.

"My father also slept, every day on the couch. He would smoke a cigar and then he would fall asleep," remembered Frank. "Then he went to a café. In a way, he was a bon vivant but he had a business. All the conversation at the dinner table was about money."[8] Beyond the dinner table, however, Hermann was a charmer, a very good conversationalist who "could tell jokes like nobody else," says Claude Brunschwig, a cousin who grew up in Zurich with Robert Frank. Hermann had affairs, an open secret in the household. "He wanted to have a good life, but I think he paid too much,"[9] said Robert. The children were left with a feeling that Hermann was not particularly interested in them.

Regina's eyesight was failing when Robert was young, and by the time she was fifty she was blind. "My mother was a sad woman. She had a hard life but she was a brave woman," he has said. Like Hermann, Rosa had artistic skills and drew well. According to cousin Claude, Hermann left her at home when he went out on the town, but the onset of Regina's blindness softened him. "Her husband, who was usually not so nice—he went with other women and so on and so forth—when she went blind he was *so nice* to her, explaining the whole picture to her, describing what was before her. He was unbelievable."[10]

Regina had a temper she sometimes turned on others in the house. Robert has somewhat angrily described his mother as an "invalid" and an "unhappy woman" who, after she lost her eyesight, "became afraid of everything." He likes to say Regina raised him to be "a good Swiss boy," by which he means "Mama tried."

FRANK SPEAKS REGULARLY—if not expansively—regarding his mixed feelings for Swiss culture. He is comfortable framing a subject when it is one he can define himself against. But he has spoken far less, and almost not at all to outsiders, about the first community to shape him, the Jewish world of the Enge. The formation

of this Zurich neighborhood itself is a Swiss story of diplomacy and paperwork. Jews did not have the freedom of movement accorded other Swiss citizens, and thus an act of self-definition, a group move to a new area, began as an administrative act. Around 1862 several hundred Jewish citizens from the Swiss towns of Endingen and Lengnau received permission from the canton of Zurich to move into the district. Some of them formed Israelitische Cultusgemeinde Zürich (ICZ, Jewish Community Zurich) in 1880, and today the ICZ is an important community center and archive for Swiss Jewry. The word *enge* in German refers to a "narrowness" or a "strait," and Zurich's Enge District was named after a group of medieval houses set on a hillside facing Lake Zurich that were clustered together on a strip of land. From that narrowness a prominent German-Jewish community outside of Zurich proper flourished. A familiar local joke plays off a paraphrase of an Old Testament line, "Und Gott trieb die Juden in die Enge," which translates as "And God drove the Jews into a corner." In Switzerland he drove them into Enge.

In the first decades of the twentieth century, as the city absorbed the Enge, the district grew from a detached suburb to an island in the city. And its people mastered a relationship that grew from acknowledgment to, perhaps, acceptance. The nature of that progression within Swiss society is suggested in Rose Choron's poem "Swiss Transit":

Ice-capped in the beginning, like their mountains,
The Swiss warmed up to us
After we paid our bills and kept to ourselves.[11]

"The Jewish community is small in Zurich," says Brunschwig, "and the families were tight at that time." As the quarter flourished in the early twentieth century certain tensions came into the open. Switzerland experienced an influx of Russian and Eastern European Jews, and at the same time that the country at large was expressing mistrust of the newcomers, longtime Jewish citizens saw

their hard-earned community status endangered. The Russian and Eastern European newcomers were seen as blatant strivers and countryfolk, living next to folks who'd spent years fitting in. Tensions increased during and after World War I. "If you were coming to the quarter as a Jew from Germany, it was no problem," explains Charles Lewinsky, a Zurich-born screenwriter and novelist. "We're talking mostly about the Jewish community, no problem there. If you were from the East, however, *nobody* was too happy to have you." The citizens of Enge "were Swiss Jews who had enjoyed their emancipation act for a very long time and were blending in. Suddenly these strange characters talking strange dialects arrive, and Swiss Jews didn't really like them."[12] Who belonged—to the neighborhood, to the nation—was a delicate matter and not clear from within. At the same time, in the 1930s, a system of judgments regarding who belonged where was coming down from high up, and the situation became far more complicated.[13]

Hermann Frank was one resident who could feel a measure of contempt for the arrivals. He made a show of enjoying his urbane life, and in his enjoyment defined himself as anything but a striver—an *arriver* was he. His contempt in other ways was no secret in the house either. Hermann spoke English and French fluently, but he had made a personal decision that defined him in the community: he refused to speak Swiss German. German was one of the three official Swiss languages and was taught in school. When you wrote, you used the German of Kleist and Schiller. But when you spoke, you employed a regional version with its own grammar, distinct pronunciations, and words that distinguished it from German. Swiss German was almost another language (and then there was Züridüütsch, the Swiss German dialect spoken on Zurich's streets). Hermann Frank was a proud German who could recite long passages of Goethe from memory, and what the Swiss spoke was to him the tongue of the rabble, unserious, and low class.

His children, meanwhile, took avidly to Swiss German, as had his Swiss wife. In the cafés and in his radio shop the language poured forth. Hermann was unbending. "My father . . . considered

it an inhuman language," Robert said. "I was very embarrassed at my father; he couldn't speak the way we did. He said he didn't want to listen to us speak like this, that we were primitive almost, to speak that language. And they made fun of him, because he couldn't learn it. And I thought a lot about that."[14]

It marked him as an outsider. A successful, educated German, perhaps he resented the terms of assimilation, the insistence that he trade down for a tongue even his son has called "very primitive"—though that primitivism was probably what appealed to the son. Hermann was no joiner and in no mood to plead his case to customers. If he felt an impact of this decision into the mid-1930s, he masked it behind the stubborn belief in his rightness, which his family knew all too well. The refusal to learn Swiss German also implied a judgment of his children: they were inferior, not sufficiently high minded. Worse, they had rejected their inheritance—Hölderlin! Kant!—with a slack-minded acceptance of present realities. You can assume he did not hold back on his opinions in the house: "There are hints from Robert that his father ran the type of rigid, authoritarian household not uncommon to that generation," William S. Johnson described. "Robert was a sensitive child."[15] The sons had embraced their Switzerland and, thus, failed a test. No wonder, as Robert said, he thought a lot about it.

He would have thought about it into the mid-1930s and noticed when people made fun of his father. He would have thought about it into the early 1940s, when to insist on speaking strict German would have marked you *as* a German, which was one complexity in neutral Switzerland and a further one in Jewish Enge. As time went on, there was only more to think about.

THE SWISS BORDER with Germany was 225 miles long, and Zurich itself was but 15 miles from the border. Hitler had a plan for invading the neutral country, but for various reasons, not all of them clear, he never did. Indisputably the country was valuable to the Nazi regime and not always so neutral in regard to Nazi goals. In the 1930s Switzerland was still mired in an economic de-

pression, while Germany, engaged in a military buildup, became an economic powerhouse. This made things complicated for Switzerland because Germany was the country's leading trade partner. With its secretive banking system, the nation had become a financial pinion of Europe between the wars, a tax-exempt resting spot for imported capital, a welcome nest for holding companies. By the late 1930s Switzerland was invested in all sides of the European crisis, laundering money, feeding underground economies, and storing gold bars stamped with the swastika. The cooperation of Swiss bankers lowered the risk of attack, though some of what the banks were doing hardly seemed neutral.[16]

Maintaining a relationship with those on your border was expedient and helpful, and it held out the possibility of preserving Switzerland's doctrine of neutrality. Impartiality had protected the democratic federation from getting pulled in multiple directions, a very real problem when border partners France, Germany, and Italy were fighting. But that doctrine was fraying badly by the time of the Anschluss, in March 1938, when Germany invaded Austria. Third Reich calls to unite all German-speaking people were getting louder, and German soldiers were shouting provocations across the Swiss border. After the Anschluss a flood of Jewish refugees began pouring into Switzerland from Germany, Austria, and elsewhere in Europe. Their plight put neutrality in the balance because Germany demanded that asylum seekers be turned over and then delivered to the camps.

In a nation juggling German, French, and Italian regions, citizenship had long been a fraught concept; allowing Jewish refugees full rights, it was felt, could wreck the meticulous balance established for the historically decentralized state. Of course, there was another inspiration for Swiss fears of a growing Jewish community—a centuries-old tradition of anti-Semitism. Domestic anti-Semitism was merging at the border with the weaponized version that was spreading across Europe. By the time of World War II offering—or declining—entry, let alone citizenship, to those in flight had the clear impact of siding with the Allies or the Axis powers. What balance was possible?

A word crept into public conversation: *Verjüdung*, or Judaiza-
tion. It expressed a national fear that the state was becoming too
Jewish. Among a population of about 4 million, there were proba-
bly fewer than twenty thousand Swiss Jews, perhaps .5 percent of
the population. But Switzerland had a long history of restricting
and marginalizing this population, and upheaval across Europe
brought old impulses again to the surface.

The journalist and historian Simon Erlanger has observed, "the
special, bottom-up character of the Swiss body politic, with its
semiautonomous cantons and communities, has enabled medieval
stereotypes to survive into modernity."[17] The Helvetic Republic,
the first modern attempt at nationhood, was formed in 1798 but
collapsed in a few years, partly over the issue of giving Jews cit-
izenship. It would not be until the constitutional reforms of 1866
and 1874 that Swiss Jews were given the right to worship and equal-
ity under the law.

In a late-nineteenth-century effort to restrict the immigration of
Russian and Eastern European Jews, says Swiss historian Jacques
Picard, a moral panic swept the country, a call to ban *shechitah*,
the traditional kosher animal slaughter, on the grounds that it was
cruel to animals. In 1919 the Swiss government began putting a
Star of David stamp on the documents of Jews applying for nat-
uralization.[18] The country had denied James Joyce entry in 1940
purportedly because he was Jewish (as legend has it, authorities
confused him with Leopold Bloom).[19] In a republic built of tight,
semiautonomous cantons that struggled to achieve a national iden-
tity, says Erlanger, "The medieval image of the Jew as the reli-
gious Other has thus transformed into the image of the Jew as the
essential Other against which, for most to the 20th century, Swiss
identity was defined." If the country has wrestled with the concept
of who was Swiss, it could, over centuries, at least reach agreement
on who was not.

All of which shaped Robert Frank, who grew up balanced be-
tween a professed political "inclusiveness" that excluded him and
a father's stubborn protest that made Hermann an outsider at the
worst possible moment. Layers of banishment and self-definition

lay flat on top of one another, and an alert son watching everything around him received a nuanced education in exile.

By 1939, when the Swiss government either (a) helpfully suggested to Germany that Swiss border guards could stamp a *J* on passports of all Jewish refugees entering the nation or (b) made the best of a bad situation and complied with Germany's insistence on the stamp (there is evidence for both; postwar Switzerland destroyed many records that might have been instructive), the nation looked with fear and concern at its Jewish population and wondered what could be done about it. The borders tightened, and Swiss authorities turned away more than twenty thousand Jewish refugees between 1933 and 1945. During this same period twenty-nine thousand Jewish refugees entered and were kept in internment camps. But while it paid for the welfare of other refugees, Switzerland refused to help Jews, instead striking up a private arrangement with domestic and foreign aid groups to provide help.[20]

"Historically it was not a time for the government to be heroic," says Lewinsky. "It was better to lick a brown arse than to have bombs in Zurich. If Germany had invaded, they would have been in control in a few days. But Switzerland was useful."[21]

Hermann Frank had no burning desire for citizenship, but Germany presented a compelling argument. Hitler had passed the Reich Citizenship Law of November 25, 1941, which stripped Jews living abroad of their German citizenship. It was a tool for taking the property of those who had been forcibly deported, and had the effect of denying many others of citizenship and property rights.[22] Suddenly Hermann and his sons were stateless. In December of 1941 Hitler began exterminating European Jewry. In order to maintain his Zurich residence and business, Frank deposited 10,000 Swiss francs as a bond with the Swiss government. He applied for citizenship for himself, Robert, and Manfred on December 24, 1941. In the paperwork he filed with the Fremdenpolizei, the Swiss immigration police, the requirements of the state are spelled out. It must be proved that "the two upright youths were well able to cope with life," "fully assimilated," and demonstrably had "absolutely nothing Jewish about them anymore."[23] The

immigration police were widely viewed as tasked with keeping as few Jews as possible from becoming Swiss nationals. Frank always assumed that's why his father was turned down by the Fremden-polizei; Heinrich Rothmund, the police chief, was the official who authorized the mandatory *J* on Swiss passports. It didn't help that, unlike his sons, Hermann was too old for military service. The Fremdenpolizei did not grant Manfred or Robert citizenship until 1945, near the end of the war; it doesn't seem that Hermann ever gained citizenship. For the duration of World War II the family lived in fear of an attack and also of being ejected from their home by the Swiss government. The family tracked the progress of the German military and the resoluteness of the Swiss Federal Council from the temporal comfort of the Enge.

Hermann put a map of Europe on the dining room wall, moving pushpins around as news of each battle arrived. In May and June of 1941, fearing imminent attack after the invasion of Belgium and Holland, the Franks and the Brunschwigs moved for a period to the mountain village of Château-d'Œx, where they shared a chalet.[24] Through 1942 and 1943 Dutch, Belgian, and French Jewry were being deported while a large group of refugees attempted to enter Switzerland.

Families were torn apart. Soon after the invasion of Poland in September 1939 the daughter of one of Hermann's German siblings was sent to live with the Franks. She got into the country, but her parents were not allowed to enter. This relative of Frank's was alive in 2015, and though she did not want her name used, she was willing to speak briefly. "I can tell you only one thing: Robert is my cousin, and I came to Zurich in 1939 from Germany. They saved my life, and then my parents were deported from Germany to the concentration camp, and they died there. When I came to Switzerland they said I could stay with them. In a way they saved my life."

"The war was interesting—the fear that I saw in my parents," recalled Robert. "If Hitler invaded Switzerland—and there was very little to stop him—that would have been the end of them. It was an unforgettable situation. I watched the grown ups decide what to

do—when to change your name, whatever. It's on the radio every day. You hear that guy [Hitler] talking, threatening, cursing the Jews. It's forever in your mind, like a smell, the voice of that man, of Goering, of Goebbels—these were evil characters. Of course, you're impressed. It made me less afraid and better able to cope with difficult situations later because I lived through that fear."[25]

There were an infinite number of reasons to worry. Yet in Robert the war also unleashed a desire to take action and define himself against his parents. An adolescent when war broke out, Robert viewed his parents' dread as weakness and was flush with the feeling that he could do something to engage in the conflict. "I didn't fear for my life—when you're 16 you don't have that kind of fear—but my parents wanted to run away. When I saw my parents' inability to cope with Germany, their fear forced me to believe I could and should do something on my own because I couldn't count on them. They were just scared old people."[26]

Later, in New York, Frank would tell a friend (who asked to remain anonymous) a story about a family member who did business with Germany when Frank was growing up. "He said, 'I had an uncle who traded with the Nazis—can you imagine that?' That's all he said to me about it, but it was clear to me that as a teenager seeing this, he was absolutely disgusted."

Robert and his brother, Manfred, did not get along. Regina was physically abusive to her niece and also struck her maid.[27] From the outside the Franks formed the portrait of a prosperous and happy bourgeois family. But in the home on Schulhausstrasse fear and resentment circled while Hitler's voice bellowed from a tube radio.

ANTI-SEMITISM, FRANK TOLD A WRITER for an Israeli magazine, was "an organic part of life in Switzerland" and that he "had to fight if necessary." During the years of German aggression he took his own steps to symbolically defend home and manage his feelings of powerlessness. He participated in the Knabenschiessen, an annual shooting competition for boys between thirteen and

seventeen that dates back to the nineteenth century. Held on the Albisgütli fairgrounds on the edge of the city, the competition was open to boys in the Zurich public school system.

He joined the Swiss scouts while in secondary school; the boys nicknamed him "Brush" for his bushy hair.[28] The Swiss Guide and Scout movement was semimilitarized and akin to an ROTC program in which members built chalets in the mountains and went on arduous treks. Frank was also becoming an avid mountain climber, joining the Swiss Alpine Club and making several high climbs, including one above four thousand feet. "Mountain climbing was one of my base experiences. It was the way you travelled, starting at four or five o'clock, early in the morning," he has said. "You would go slow and every fifteen minutes you would stop . . . those were the best times I had in Switzerland. That was the best school."[29]

According to Guido Magnaguagno, critic, historian, and friend of Frank, to be a shooter and a scout and to have a bond with the Swiss mountains deeply resonated with Frank. "He felt a kind of thrill because he admired Switzerland at that time. Even though he was Jewish and even though they had problems in the family.

"It was a kind of manifestation I would say that you didn't have to be afraid of Germany but instead be proud. Swiss proud, to resist, with this neutral position, to resist danger." These acts gave him a way to fight.[30]

Another way to battle came in 1939, with the opening of an influential national festival. Landesausstellung was the full mouthful for this traditional exposition, but it was just called Landi. Switzerland had been holding these fairs about every twenty years since 1883. They featured displays of livestock, cheese, technology, and regional crafts. Some were better than others, but none matched the ambition or the wow of the Landi '39.

Organizers knew that with war out in the open, the national exhibition could be retooled to generate much-needed national unity. Switzerland's self-image was bound up in its identity as a confederation, a proudly bifurcated state that provided its twenty-six cantons with a good deal of autonomy. Its divisions, bridged by

public-forum direct democracy, were celebrated as the foundation of its nonaligned independence. But as nationalist tensions rose across Europe, Switzerland suddenly realized she needed to fabricate a new kind of unity, a unity that could defend that independence. And so Switzerland rebranded. Old symbols were brought into the sunlight. The Federal Charter of 1291, the founding document of the Confederacy, would get a museum of its own in 1934. Around this time a trail in the middle of the country, where national hero William Tell was said to have once killed a bullying bailiff, received landmark designation. The timing of these glorifications was no accident.[31] The national exhibition would be the most important effort to identify and venerate Swissness.

The 1939 event's theme was *Geistige Landesverteidigung,* or "spiritual defense of the nation," though what it meant was something more like *cultural* defense—and that was important because in a country with inadequate military defenses and a doctrine of neutrality, a social movement was needed to give hope and solidify resistance. The wish was that by identifying and rallying around an essential Swissness, solidarity and all the defense it could muster would follow. Unlike the ideology of the Third Reich, it was not a racial identity that made one Swiss; the Landi underscored how certain shared experiences and contact with national symbols defined Swiss identity. The exhibition launched a cultural movement that would have influence for years to come, making a big impact on both Switzerland and young Robert Frank.[32]

The Landi was designed as a symbolic journey, a pilgrimage from the farthest corner of the country to the national core. It signified a righteous wandering and literally offered a footpath that took viewers through a *dörfli,* an archetypal Swiss village. The path distilled the unifying spirit in images of the central mountain range, the alpine life, and the peasant. The trek culminated with a long wooden gangway, a walk of Swiss nationalism, displaying some three thousand communal flags fluttering overhead and twenty-five flags, representing each canton, along either side. It was stirring and inspiring to many, though some found its folk nationalism troubling. The writer Max Frisch rancorously recalled

his visit to the 1939 national exhibition:. "With no Utopia, immu-
nized against everything that is not truly Swiss. Self-confidence
through folklore. And something that didn't strike me at the time:
the subtle odour of Swiss blood and soil."[33]

The festival was built on both sides of Lake Zurich. Much of it,
including four photographic exhibitions, was within walking dis-
tance of Enge. Robert Frank made repeated visits to Landi '39 and
would later say he was "infatuated" with the presentation.

"It was a way to strengthen an interior power, resisting these in-
fluences that were infiltrating Switzerland," says photography his-
torian Martin Gasser. He points to the rise in National Front activ-
ity inside the country—Zurich was laced with supporters—and says
the movement was an important effort to push back. The Swiss
response "was not only politically and militarily active but it was
present culturally as a way to strengthen Swiss identity. It asked,
What is different for Germany? What is *Heimat* [homeland] and is
it worth defending? What is *degenerate*? What is our strength as a
Swiss nation? . . . And this exhibition was right in Robert's neigh-
borhood; he lived right next to it. And of course at the time he was
fifteen or sixteen and he was open to it—it was *alive.* Being already
if not critical he was certainly an intelligent person observing what
was going on around him, and he was taken by the movement."[34]

For the time being, abstract art, modernism, and political dis-
cord were all put in a Swiss vault while a cultural mass movement
conquered all. Portraits of Swiss workers and a reverence for cows
filled gallery walls. A folkish realism became government policy
for the next few years, and, as Gasser says, a *Landi* or *Heimat* style
prevailed across architecture, visual arts, literature, and film. "But
Robert was interested in that. It had something to do with the gen-
eral spirit of what was going on."[35]

Through the prism of the last seventy-five years Charles Lewin-
sky views the exhibition and the movement it fostered as something
like state-supported identity politics. He notes that around 1939 the
Swiss Federal Council made Romansch, a Swiss language spoken
in one particular region, one of the four national languages. "It was
meant to foster the feeling of 'We Swiss.' *Geistige Landesverteidigung*

came with a lot of politics." But, he adds, there were limits to inclu-sion. If you were a descendant of the fifteenth-century Roman sol-diers who conquered the area that was now the canton of Grisons and spoke Romansch, you were in. But "the message to the Jewish community was, 'You're different.' Not 'Become part of us,' but 'You had better behave,' I think, would have been the feeling."[36]

And yet it's easy to understand how a young man in 1939 would have been drawn to the National Exhibition. There were struggles at home, and outside the home there were questions of citizen-ship that fed into questions of survival. Here was something solid, something big. Robert Frank was a mountain climber, and now the state was celebrating both the mountain and the men who climbed it. For a teenager this was something to embrace.

CHAPTER TWO

FLAGS AND
MIRRORS

S HOOT THE BULL'S-EYE and win. First prize a photograph.
The family is on a holiday to Italy, at a carnival in Viareggio, and Hermann looks rugged in a suit and flat cap, squinting down the barrel of a rifle. The shot triggers a flash of light, a shutter clicks in a camera overhead. The souvenir picture from this sideshow attraction shows the stone-cold look on Hermann's face—and the deeply entranced, slightly sad look on twelve-year-old Robert's. The gun was a camera; the camera was a toy. Robert was gripped. "It was at that time that I grasped the value of a photograph," he says, looking back.[1]

Photography was part of family life. An energetic amateur who owned several cameras, Hermann treasured his expensive stereo camera with two lenses that exposed paired images onto glass plates. By looking at them through his tabletop viewer he could see a 3D picture. When Robert was a boy Hermann took photographs of the family on vacation—Regina and the kids, family trips, lots of stiff postures and uncomfortable expressions. Robert saw the investment in time and money his father made and how proud he was of his work.

Pictures captured his attention: soon after the Spanish Civil War broke out in 1936 Frank saw images of refugees—perhaps a famous series from the swashbuckling Swiss photojournalist Paul Senn—that left a lasting impression.[2] The photographic exhibitions of Landi '39 drew him in, and he visited them repeatedly. The

experience made a case for the power in a picture. The photographs showed to a boy struggling to feel powerful in a family under the gun that a camera gave one a claim on the world—it could let you connect with your country.

Making pictures presented a way to stand up for one's self. There was romance in photography and defiance, and it held his attention.

School did not. In 1940 he graduated from secondary school, and not long after that his formal education drew to a close. "I did not like school," he said.[3] After graduating his parents sent him to the Institut Jomini in the rural town of Payerne, a French-speaking part of the country; many Swiss parents at this time chose a college-level immersion in French for their children. But Payerne was a washout: "I had to wear a cap and a uniform," he explained. "My parents came to find me. I told them I was not going to stay."[4] Not long after Frank left the Institute a Jewish merchant who had come to Payerne to buy cattle was lured to a farm shed and beaten to death by a local gang of Nazis. They cut up his body, put the parts in milk cans, and sank them in Lake Neuchatel.[5] The war penetrated one's daily life in unknowable ways. The war wasn't out *there*; it brushed against you, and its presence helps explain Frank's mix of indolence and anger.

Back in Zurich he was unmoved by ambition. His chief motivation was what he did *not* want, which was to enter his father's business. Let brother Manfred—Freddie, who had a good head for figures—work in the store. Robert did not want more of Hermann in his life, but to explain this to his father, he knew he must be able to present him with some viable alternative. There was a man upstairs in the home on Schulhausstrasse, someone who lived in the attic and ran a photographic studio from there, and one day Frank asked him if he needed an assistant. The man, Hermann Segesser, spoke quietly and patiently, as his hearing wasn't very good. Frank started working for Segesser as an unsalaried apprentice, learning how to use a camera, mix chemicals, develop negatives, and retouch the postcard pictures that were Segesser's stock in trade. Segesser enjoyed modern art and shared this passion with

his neighbor and apprentice, though the word *apprentice* was problematic because, being less than a citizen, Frank was barred from taking a formal internship or accepting paid work. All he could do was volunteer his time as he moved on a path parallel to employment. Still, Segesser made the most of Frank's help, and he described to him how the artist was a hallowed figure, one who exists outside the matrix of business and obligations. Segesser talked about the painting of Paul Klee, for instance, and in his quiet way he transmitted his passion to the youth downstairs.[6]

When Frank completed his training Segesser presented him with a gift, a modest oil painting of cresting waves. Frank would later describe it in writing: "Just the water (the sea) it is peaceful it is alive & moving with the wind and currents from below. It seems to have a prophetic quality feeling—this man in the little attic room below the roof in the Schulhausstrasse 73 gives this boy—going away from home—his understanding or longing for freedom for space for mystery for nature. All this I would begin to understand much later . . . and try to express in my work."[7] To Frank "the sea" probably meant leaving home, a route out, but Segesser saw further. "This will remain a part of you," he told the young man.[8]

From 1942 to 1944 Frank next assisted Michael Wolgensinger, a photographer and filmmaker with a considerable reputation. Wolgensinger would be an important influence through his teaching of the modernist photographic tradition powerfully alive in Zurich. Wolgensinger had studied with and assisted the Swiss photographer Hans Finsler at Zurich's School of Arts and Crafts. The school was a key outpost for the Neue Sachlichkeit, or New Objectivity, a German-centered movement of the 1920s and 1930s. New Objectivity was a way of seeing the world more than it was a cogent visual language, but its contemporary photographic wing stressed crisply focused, brightly lit images, communicating in a dispassionate, almost deadpan tone. After the shrill subjective cry of Expressionism springing from World War I, here was a head-down art movement touching upon literature, architecture, painting, and design, championing seeing things as they were and building our world from the facts around us. Its conviction that critique sprung

from reportage, that there was truth in clarity, made for art with a knifelike social thrust. It was well suited to leave an impact on photography, which claimed a special relationship to truth.

Finsler's teaching retained aspects of New Objectivity's roots as a glum protest of human imperfection. But when introduced to the European mass media New Objectivity displayed a highly marketable versatility that would flourish in graphic design, print journalism, and advertising alike.[9] Wolgensinger, who made his living as an advertising photographer, carried the flag for this sensibility, and as an instructor he had an important influence on Swiss photography. "He didn't teach by saying 'do this, do that'—he talked with students much, and then they made their things," said René Perret, an art historian who has researched Wolgensinger's work. "They talked of philosophical things and music and other subjects beyond photography."[10] Wolgensinger took his assistants on his commercial assignments, showing them the mechanics of a professional career. Through him Frank learned how to light a subject and achieved a growing understanding of the fundamental geometries of a picture.

Luzzi Wolgensinger, the photographer's widow, has said that her husband felt Frank at first wasn't so serious about the work and initially declined to let him into his atelier. Once he got in, Frank was not regularly in attendance, and Wolgensinger had questions about his commitment to the profession. It may well have been Hermann, rather than Robert Frank, who set up Robert's introduction to Wolgensinger in the first place.

It took Hermann's intercession to persuade Wolgensinger to re-admit Robert after an absence. Frank studied with Wolgensinger on and off from August of 1942 to September of 1944 (he might also have worked with him in 1941). He was a restless apprentice on a somewhat random course. "I didn't know exactly what I wanted, but I sure knew what I didn't want," he later explained.[11] Frank followed this apprenticeship with two jobs, the first one later in 1944 with Victor Bouverat in Geneva. After Bouverat he worked for the Eidenbenz studio in Basel, running the darkroom and the apprenticeships for the largest graphic and photographic concern

in Switzerland. Two apprenticeships and two jobs in three cities
in just a handful of years is a unique course, suggesting a hunger
for mentors and a hunger to push past them. He did not want to
become attached to one teacher or place.

His independence comes through when he talks about May Day
demonstrations he photographed in Zurich and vaguely wanted to
be a part of. "I went to some political meetings but I didn't be-
come involved. I didn't want to give up anything for a group," he
told William S. Johnson. "I'm not the type to do that. I'm not very
generous that way. I'm suspicious of groups and rules and author-
ity. I'd like to not be bound by rules."[12]

IN A FEW SHORT YEARS he had gone from being an unpaid neo-
phyte to a professional getting commercial and photojournalism
assignments.

After he left Segesser Frank also worked on two Swiss motion
pictures, shooting production stills on movie sets. His first pic-
ture, *Landammann Stauffacher*, was a true Landi classic, drawing on
Schiller's William Tell for its story of a founder of the Swiss Repub-
lic and his heroic defeat of a more powerful opponent. (Hermann
Frank helped his son get the job.) It was followed by *Steibruch*, a
tale of redemption based on a prize-winning play from the 1939
national exhibition. The experience briefly led Frank to consider
a career making movies. Frank had a nascent love of film; he'd
seen Pagnol's Marseilles trilogy, *Zéro de conduite*, and assorted Jean
Gabin pictures. Hollywood was giving him a vision of the United
States; he liked *They Drive by Night* and took cues for how Ameri-
cans lived from the collected works of actor Wallace Beery.[13]

In the orderly, organized nation where careers were plotted on
a graph, Frank was conspicuously off road. Those who observed
him noticed his interest in photography and also his disinterest
in doing the things ambitious photographers did to launch their
careers. Maybe he was not serious; maybe he knew something.
Either way, he stood apart, even as a twenty-year-old.

There was a role model in Zurich for a young artist who was never going to fit into the system. An artist who had left commercial work largely behind him, a difficult and serious-minded photographer named Jakob Tuggener. Wolgensinger had first described him to Frank, and Frank would end up convinced that Tuggener, because of his devotion to the work itself, was the one true artist of his time and place, the "one Frank really did love, from among all Swiss photographers," as writer Guido Magnaguagno has said. Tuggener provided photographs for publications of the Oerlikon mechanics workshop foundry in Zurich. Some of these would be presented in *Fabrik* (Factory), a remarkable photo book published in 1943. *Fabrik*'s subtitle described his intention: "A Picture-Poem on Technology." The book takes you on a mystery path through mills, steam, and past a pretty girl named Berti. There is a cryptic wooden mask and a skull on a ring. These glimpses of an external reality trigger inner association. Some writers have come away believing *Fabrik* to be a darkly critical fable of technology, while others believe Tuggener was intuiting a postwar industrial rebirth. The meaning was found outside the image, in shifting contrasts and continuities between pictures. For somebody in Zurich interested in film, *Fabrik* would have been a revelation, a seemingly clear, matter-of-fact rendering of truth that unfolds like a Val Lewton film noir.[14]

He was the kind of established artist who inspired the fledgling. He called himself "the illustrious" Tuggener and Photographic Poet I; he lived like a hermit. In the 1940s Tuggener quit his factory job to devote himself to making photo books. That, too, might have caught Frank's attention. His goal was to follow *Fabrik* with a book dedicated to the *ballnächte*—the society balls that Tuggener liked to glide through. He was obsessed with high-society soirees, both romanticizing the sexy drunk luxe world and bitingly judging its affairs. He loved the sensuality of surfaces, the liquid seen through the glass and strong-backed women enjoying the dance. If *Fabrik* tanked—which it did, losing money, then remaindered, then pulped—it was a hit compared to the ballnächte pictures of

the 1960s, which met with such hostility from Swiss one-percenters that Tuggener could not get them published in his lifetime. Tuggener himself took a vow of poverty, living in a small basement room, constructing maquettes for dozens of photo books that never got made, and accruing an image over time as an artist's artist—someone who did the work because he had to.

Frank calls Tuggener "a monument as large as William Tell." He describes his "anti-sentimental point of view" as being inspirational and "like a lighthouse." He also has noted how Tuggener's photos were meant to be seen in a book format, in the order the photographer intended: "It is in these associations of images," says Frank, "that he is a great artist. He used the photo in a new way."[15]

The work was inspiring, as was the figure cut by the artist. He was the kind of figure Frank represented to another generation. Frank and Tuggener, says Magnaguagno, "are the only auteurs who in their day acted first and foremost as their own clients. Who relied on their own lives and their own creative potential." Had Tuggener not been so hard to get along with, he might be known today as one of the great photographers of the 1930s and 1940s. No wonder Magnaguagno compares him to D'Artagnan: he was a lover and a fighter—and flat broke.[16]

THE WAR IN EUROPE ended on May 8, 1945, but in Switzerland the celebration was muted. The Swiss government disbanded the local branch of the German Nazi Party and expelled its leader. Church bells tolled.

Only in the final days of the war did the Swiss immigration police approve citizenship for Robert and Manfred Frank (though not Hermann). The brothers were no longer stateless. Robert made immediate use of his long-delayed Swiss status by registering to perform his national service in the army. At the age of twenty-one he volunteered for the grenadiers, a special-forces company that was integrated into each infantry unit. Grenadiers were taught close-combat fighting and received training that was

more demanding than other infantrymen got. "Robert Frank was in the toughest part of the Swiss Army," said Claude Brunschwig. "That was the harshest possible section you could get into. He was a tough, tough guy."[17] He was stationed in the southern part of the country, in Ticino, near the Italian border.

A picture taken by a Ticino photographer shows skinny soldier Frank, strutting down a street in uniform, arms swinging, rifle on his back, looking elated, as women line the curb to watch the parade.[18] He had been denied citizenship, and now he was throwing in with the citizens, proving he was every bit as capable of defending the homeland as any of them. When he signed up for mandatory service, said Martin Gasser, "he went into the toughest group he could find. And he told me, 'I wanted to do that. I wanted to show that the Jew could be just as tough as the others.'"[19]

With the war over, European borders opened. Now that he knew he could get back into the country after leaving it, Frank took the opportunity to travel upon completion of his military training. In 1946 he went to Paris with his father and looked for commercial photography work, also traveling to Milan and Antwerp. Along the way he took pictures of a devastated Europe, though few survived. On that excursion to Paris a small moment occurred, something that seemed to have a larger influence on him as time went by.

His father collected art that he displayed around the house, primarily nineteenth- and twentieth-century realist landscapes. Hermann had gone to Paris to visit a friend who sold art and to view new paintings his friend was offering. Up to now Robert had been exposed to art, but he hadn't thought much about it. Photography was a way out of the family business and maybe out of Zurich. But art was another category entirely.

"On this trip the dealer came to our hotel room to show my father some work," Frank said. "He brought one small painting along with the others. It was a small painting of a clown by Rouault. He said that it would be valuable someday and he asked for a price." Georges Rouault was a French expressionist whose

reputation had grown internationally before the war broke out. Hermann was appalled. "Look at this terrible thing," he said to his son, "I wouldn't pay $10 for a painting like that!"

"I looked at that painting and I understood that my father didn't get it at all. . . . That was the first time I had an opinion about art."[20]

There was something about it Frank liked, and the feeling gave him an insight into his father. "This painting broke the rules of what was considered art in my house. It wasn't a decorative, well-painted farm scene. I probably began to think about it. I think that what I must have felt at that time was that art permitted you to be absolutely free."[21] Segesser had told him that the artist learned his own way, off the path others follow, and he'd been thinking about such things in a broad, private way. Suddenly modern art seemed interesting, one more way to declare what you were not.

There had been a circling around, a vagueness of purpose in Frank that his teachers had noticed. Four apprenticeships were a lot; throw in working on movie sets and commercial jobs nobody remembers today, and you had someone who was arguably over-trained and adrift. His teacher-boss Wolgensinger stressed to his students the need to make a formal presentation of their work, to the point of requiring that interns compile portfolios as part of their training. In 1946 Frank composed *40 Fotos* using the Rollei-flex camera he relied on at this time. *40 Fotos* was a book of diverse subject matter and approaches meant to show employers what he could do; there are even examples of the kind of photo retouching he had done back with Segesser. Yet the portfolio had untypical wit and force, starting with its cover image, an open camera lens with an eye collaged on. A book of photographs is looking at you, focusing your attention on the one eye responsible for this diverse vision. What he shows is what he sees—what *he* sees—for this is not simply a pile of images; it's a collection assembled with care that, lacking captions or dates, encourages one to focus on the work itself.

On the first page a Zurich phone book is opened down the middle, a mound of words across the page. At the portfolio's end is a young mountain climber (it is Frank himself) turning away

from the camera as he heads on. The message to the prospective employer might be: *To you I'm just another name, but by the end of this book you'll know a flesh-and-blood figure who rises above the rest.* There are crisply designed moments of New Objectivity and mountain shots that hit the Landi target. And, heralding the future, there are recurring motifs like flags and mirrors. *40 Fotos* had swagger.[22]

Wolgensinger wrote a positive recommendation of Frank when he left the atelier.[23] "He approaches every task assigned to him efficiently and with enthusiasm. In everything he undertakes he is aided by his intelligence, his good education, and his farsighted-ness even for things outside the purview of his jobs." Wolgensing-er's wife, Luzzi, said she could tell Frank wouldn't be around long because he liked to argue and his values were not those of main-stream Switzerland; he had little patience for the commercial de-mands of the photographic scene and was not hiding his disgust with the middle-class world he grew up in.

"The Swiss are very traditionalist and very conformist and very closed," explained Brunschwig. "He never liked that kind of per-son. As a photographer in Switzerland, he went all over the place taking pictures of people, and he didn't care about what they thought about him or what he wore—he never cared about anyone. And the Swiss are the opposite. They are very concerned. *You don't do that. You don't do this.*"

On another trip to Paris looking for work Frank was staying in a hotel with a cousin who had been a war hero. He was riding a motorcycle in the fourteenth arrondissement when he struck a pe-destrian, breaking the man's leg. The police locked Frank up in a Saint-Germain jail cell. He finally reached his cousin, who arrived and identified himself as a military man. With that Frank was re-leased, and the wine was poured in the jail.[24]

When the work dried up, Frank considered other places he might explore. The Brunschwig brothers had moved to New York and wrote to say he ought to come too. By 1947 Frank's feelings about Switzerland were thoroughly established. "It's sad when you know the only thing you want to do is to get away from what someone is offering you. Sad for them. But I knew right away

there was no compromise. . . . Everything not to do I learned from Switzerland," he explained. "The smallness of Switzerland had an effect on me. I realized what a small, threatened country it was, especially for a Jew. You were near disaster, so you wanted to get away."[25] To a French writer he would explain, "The bird is in the cage, the door is opened." If the bird is tired or too old, he wouldn't want to risk leaving. "But I did."[26] Leaving Switzerland had much to do with his work, with his parents, with rigid assumptions, with not wanting to feel trapped

But there's also an apparent irony. After years of effort he had won the paper that said he was Swiss. He set out to prove his worthiness, serving in the grenadiers. For him, in this place and time, all that was left was to leave. He had earned the right to defend his country; now he'd earned the right to leave it.

He bought a ticket to America. His cousins, Claude and Roger Brunschwig, had already sailed to America in November 1946. Sailing first to Rotterdam, then boarding the Liberty ship *James Bennett Moore* on February 20, 1947, Frank headed to New York City. It was cold and icy in Zurich. On the *Bennett Moore* he encountered a cast of characters worthy of Thornton Wilder. There was an American, "a wild fellow, a gangster hat perched rakishly on his head, unshaven, the sauerkraut he eats with his fingers," he wrote in a letter to his parents. "Next to him, the bishop, red sash, huge crucifix on his chest, some rosaries, prays before he begins to eat etc. the waiter places the full plates on the table; the bishop crosses himself and mumbles a prayer while that American flicks off his cigarette and exclaims, Oh damned I'm hungry! How I laughed about this guy today."[27]

Packing for the journey, some things Frank took: a box of his father's glass negatives, his portfolio *40 Fotos*, the sea painting Hermann Segesser had presented him five years before. Frank was twenty-two. Onboard he took pictures of the other passengers and the ocean before him.

"I should have photographed the departure from Zurich, but I do not think I did," he recalled. "Whatever that means."[28]

A STEP AWAY FROM THEM

CROSSING TOWN, walking alone, he would stop at a busy corner. A knot of people pushing each other in front of an appliance shop, men and boys with eyes riveted to a TV set in the display window. In the fall of 1947 that would have been the all–New York World Series, the Yankees versus the Dodgers. Some-body asked Frank what the score was, who was pitching, how was DiMaggio looking? "That guy next to me he says, 'What inning?' I look at the guy. I have no idea what he's talking about . . . these people would stand there and watch this guy hit the ball, and it meant nothing to me."[1] The game meant nothing, but the crowd? He planted himself in it, acting like he belonged. That meant something.

Frank arrived on March 14, 1947, wearing a long Swiss overcoat that reached down to his shoes. He quickly found a place to stay on 52nd Street. Though his English was not good, especially in contrast to the rapid-fire version spoken by locals, he gave it his all, asking a stranger if he knew the time. "Sure, I know what time it is," the wise guy said before walking away. Frank stuck to eating at Nedick's, where he knew how to order one thing, French fries. "My fantasy of America was based on Wallace Beery films—and I wasn't disappointed when I got here. I saw what a big country it is, that it just goes on and on, and I saw that the attitudes of Switzerland meant nothing here. The Swiss are very polite, so the rudeness and toughness of New York shocked me."[2] Right from

the start he was impressed by the tests New Yorkers dished out, the way they sized you up and educated you through the most ordinary of interactions. He was taken to Schrafft's on 34th Street. No cheerful "Gruetzi!" greeting him upon entry, no nothing, just a waiter throwing silverware and a napkin down and "asking" if he was ready to order. It made his head spin, the lack of formality, and he liked it—a lot. "Other countries have tremendous pasts that they carry on their shoulders, and that they pretend or actually do take care of," he said. "In America, people go forward and that's not a gentle sport."[3]

He noticed the racial hierarchy right away, both stark and re-freshing—unlike in Switzerland, where difference was officially trivialized, here it was more out in the open. He noticed something else too. Drop down into the subway, and you saw everybody jammed up, nobody better than anybody else. "You could see that the blacks were treated differently from the whites; it was imme-diately noticeable and tangible, but everybody was in the same subway. And everybody spoke the same language. And even if you only spoke English badly, it didn't matter." At the street level everybody was treated roughly equal and equally rough by other strangers. He saw that "you didn't have to worry about who was sitting next to you or whether you were wearing a tie or not." In this he found his welcome.[4]

Between Fifth and Sixth Avenues, 52nd was known as "Swing Street," and after the war it supported a flock of jazz clubs; Frank heard Billie Holiday sing. The 52nd Street clubs and the sidewalk outside them at night were packed with veterans and hustlers and showfolk, a ravenous parade making up for lost time, working fresh angles, spending money suddenly in their pockets as quickly as they could. Another cluster Frank was drawn to, another sub-culture of mystifying specifics.

The city itself was becoming a different place. Mayor Fiorello La Guardia resigned in 1945, leaving an unfillable void. The city's Puerto Rican population would triple by 1950, to almost 190,000, and the number of African Americans grew by more than 60 per-cent. Thousands of veterans returned to the city, and there were

shortages of housing and employment. Many soldiers arrived packing weaponry they brought from overseas, and after VJ Day the city was averaging almost a murder a day, twice the rate for 1944.[5] In an essay about New York written just after the war, E. B. White lamented, "The city has never been so uncomfortable, so crowded, so tense." Frank himself noticed how many of those he met had just left the Army and had no idea where they were headed.[6]

People stayed out later, and the city got louder. There were strangers, feeling the pressure of beginning again, raising their voices all over town. "It was loneliness that walked the streets of the Village and filled the bars, loneliness that made it seem such a lively place," Anatole Broyard wrote in a memoir of New York life. "Looking back at the late 1940s, it seems to me now that Americans were confronting their loneliness for the first time. Loneliness was like the morning after the war, like a great hangover. The war had broken the rhythm of American life, and when we tried to pick it up again, we couldn't find it—it wasn't there. It was as if a great bomb, an explosion of consciousness, had gone off in American life, shattering everything."[7]

When a temporary job was available in Queens Frank jumped at it—taking publicity photographs for the yammering comedy team the Three Stooges. He rode with them on a bus tour of high schools, where the Stooges would jump out, punch and claw and mug and spittle with their teenage fans while Frank shot the shtick. The photographer was struck by how friendly and warm the comics would be with their fans during each appearance and then how mocking and contemptuous they became once back on the bus. "Yeah, it was absolutely devastating. They didn't have a good remark about anybody. They were all sarcastic. I loved it," he said.[8] The Three Stooges taught him things you didn't learn from Wallace Beery pictures.

Within a few months of living in New York Frank visited Alexey Brodovitch, the art director at *Harper's Bazaar*, to inquire about a job. In Europe Frank felt he needed to have a diploma and letters of introduction to have any hope of finding employment. In New

York things were simpler: he showed Brodovitch *40 Fotos*. Then
Brodovitch handed him a shoe. The art director told him "photo-
graph this green shoe and then we'll see how it goes." It went well,
so well the fashion magazine hired Frank.[9]

Brodovitch was a smoking, drinking, brooding vortex of con-
trasting impulses. He was described as a supportive motivator by
some artists who encountered him and as witheringly direct by
others; Brodovitch was said to have crushed as many careers as he
launched—and he launched plenty. Born into an aristocratic family
in 1898 in what today is Belarus, he ran away from home to join
the czar's White Army during the Russian Civil War, then fled
to Paris, where he became a set painter for Diaghilev as well as a
poster designer and textile artist in the 1920s. In 1930 he founded
the Advertising Design Department at the Philadelphia Museum
School of Industrial Art and soon formed his first Design Labo-
ratory—a place where artists, designers, and photographers met
with the voluble master to discuss one another's work along with
everything from books to painting to technology. Before young
photographers he would decant the old call to "astonish me" and
then tell them how: by shooting what they had never seen before.
Or by coming back with something extreme and different from
what they'd brought in the week before. He'd argue for one artistic
value this week and its opposite the next, the underlying principle
being to never recline on established approaches. He was inspiring
and exhausting in equal measure.[10]

When, in 1941, Brodovitch was hired as art director of *Harper's
Bazaar*, William Randolph Hearst's leading fashion magazine, he
moved to New York and brought the Design Laboratory with him,
teaching from the New School for Social Research. He was now
instructing those who wanted to work for him, and the Laboratory
became a complicated minefield where photographers and others
were desperately competing to attract his attention.

Brodovitch had mastered an array of undertakings by the time
he reached New York, and in the mid-1940s one more appeared,
a project that few even in the Hearst office knew of. In 1945 he
published a radical book of his own photographs, *Ballet*. A decade

before, Brodovitch photographed the Ballets Russes on several US tours, taking intimate, unusual pictures from the wings of the stage. There was little context for these 104 photographs, his camera pressing in on the performers from the edges, the dancers seeming to move in a field of smudge pots, their movements captured as gritty hallucinations, off balance, not classically beautiful: they are anything but what most dance patrons thought the art did or should look like. They were run full bleed to the edge of the page, unbordered and uncaptioned, on paper that was uncoated, rough; it drank the ink instead of reflecting back at the viewer. Gradations of black and white were markedly reduced; opposing forces jammed right into one another the way they might be in memory or when only perceived for a moment.[11]

Brodovitch used slow film and no flash to distort the picture in expressive ways. In the darkroom he employed chemicals to burn out part of the picture and make the footlights look even brighter; he put cellophane on his enlarger to make the borders appear fuzzier.[12] He messed with the image to fix something or to make something that his eyes didn't see from the stage. Every step took him further from the idea of simply recording a performance and made the work more deeply a record of his own set of choices, his own feelings. Imprecision, mess, blur, and grain were used for their expressive qualities. Therefore, the randomness that produced them—a splash of bleach in the darkroom, for instance— became more than an accident. The viewer would read something meaningful into it. When a photographer accidentally dropped a negative for *Ballet* and then stepped on it, Brodovitch half-joked that the footprint should be left in. "Print it exactly as it is," he said. "It's part of the medium, things like that."[13] There could be surprise and a new kind of truth in accidents.

Ballet was like some basement experiment without context—it was both ahead and outside of time, and when it sold poorly—a few hundred copies, it is said—Brodovitch passed it out to his friends, who over time showed it to theirs. Word got out. *Ballet* made dance seem a personal, effervescent ritual. It pressed you into the movement, into a world the artist clearly knows and loves

and yet does not romanticize—he captures awkward, in-between moments. There must have been those who viewed it as disrespectful, and they are not wrong—it is both devout and rude. In the years to come the rule-smashing energy of *Ballet* would be a template for the work Brodovitch championed in *Harper's Bazaar* and would show up in the work of photographers he employed. But before this vision was expressed as mass media, it existed as a private rite of a gifted photographer.[14]

The photographer of *Ballet* used a 35mm Contax camera. The 35mm camera had only been commercially available for about a decade when Brodovitch began shooting the Ballets Russe in the mid-1930s, but in Europe it had already transformed the art and business of photography. World War II slowed its penetration further, but by the late 1940s the technology was upending American photography. Oskar Barnack, an engineer for a German lens company, had been trying to make the standard boxy, heavy still camera more portable, and by 1914 he succeeded by using new high-quality lenses that made the use of 35mm motion picture film possible with smaller frames. The weight and ease of the Leica, as Barnack named the camera, permitted greater spontaneity, for the instrument could be casually pulled out and a picture taken with little notice. The Leica's ability to hold thirty-six negatives on a film strip, when most rolls held eight or twelve, meant photographers didn't have to constantly stop and reload. The longer rolls made it easier to try something new, gamble on a shot, or just keep going without worrying that you'd miss the next picture. The tripod of earlier cameras, which steadied an image while limiting shooting off-the-cuff, was jettisoned. If the older technology was more like the eye, the 35mm camera was more like the mind—synthesizing perspectives, taking what the eye saw, and filtering it through the experience of the viewer.[15]

The Leica let photographers enter the crowd. Other 35mm cameras introduced around the same time were cheaper and some very popular, but the Leica's superior design and look, along with its prohibitive price, made it a status symbol at a time when the

market was right for one. The Leica became an instant object of lust—the iPhone of the Weimer era.

Brodovitch carried his vision forward at his Design Lab classes and in the pages of *Harper's Bazaar*, where he demanded break-throughs or at least mistakes, nothing in the rote middle. His hunger for the new sometimes lapsed into a lust for novelty. The public's appetite for images was voracious, and any fresh advance that could be codified as a look or style—whether starting from an avant-garde photographer's experiment or an accidental shot taken in haste on a battlefield—was likely to be copied within weeks and end up as advertising a few weeks after that. The speed with which inspiration became institutionalized as novelty was not lost on photographers. You came up with a radical way of captur-ing a dancer's body one day, and the next you were turning it into a photo essay depicting dresses on Park Avenue. And then you realized the latter paid a lot better than the former.

Still, when an untested talent came looking for work, Brodo-vitch had the freedom and vision to float an open-ended assign-ment like the one he gave to Ted Croner: "I'd like you to go out and photograph the city at night." No models, nothing shot neatly in the studio. Bring me the night![16] It was a wonderful and vexing time to be a photographer in New York City. Robert Frank could find a good amount of work, and there was a nascent creativity around every corner. Young photographers from around the world kept arriving in search of commercial work. At the same time the assignments were typically constraining, and you only ate if you'd sold something the previous month. The European masters Bro-dovitch admired weren't finding ennobling work beyond what he doled out; a magazine editor once browbeat André Kertész that his pictures were "saying too much."[17]

According to Wilson Hicks, the photo editor at *Life*, the pho-tographer had to understand his or her role. One "has got to tell the truth as nearly as he can. That's what you'll be hired to do. The word reporter knows this, but some young photographers have a hard time getting it through their thick heads—excuse the

expression. Let the editor worry about the opinions his publication expresses. He'll stand or fall on them. If you have a hankering to express opinions, work hard and maybe someday you'll be the editor."[18]

At *Harper's Bazaar* Frank's job was to shoot clothing and accessories against simple backgrounds. He also photographed for *Junior Bazaar*, a separate magazine that targeted teenage and collegiate audiences, and *Junior Bazaar*'s art director, Lillian Bassman, assigned him more imaginative work. Frank traveled to Kansas City, Boston, and St. Louis to make multipage picture essays of life on campus. But there were always clear limits on what a photographer could get into print. Bassman, herself a talented photographer, was once publicly berated by a *Harper's Bazaar* editor while on an assignment: "You are not here to make art, you are here to show the buttons and bows."[19]

Harper's Bazaar was a regal office where the "richest woman in the world," Doris Duke, worked as an assistant to the editor, a place where a job interview included the question "Who do you know?" It was a discriminating workplace too, as Richard Avedon said, "I felt anti-Semitism very strongly in that office." The magazine's star columnist, Diana Vreeland, assistant editor Mary Lee Settle once said, was "a Nazi, for God's sake."[20]

Avedon had appeared in the office over a dozen times to meet with Brodovitch and gotten turned down on each occasion. It's hard to imagine Frank returning after someone had rejected him; he would have stored up the memory and used it as motivation at his next assignment. But Avedon was limber in the office and able to squelch his frustrations and lobby for assignments in a way editors found charming—within months of getting his first assignment (he was hired in 1946) he had access to the office of editor Carmel Snow and was fielding plum assignments. Being able to do magic tricks with green shoes was important, but a multitude of skills were necessary if you wanted to thrive at *Harper's Bazaar.*

At Brodovitch's Design Laboratory classes photographers' work was laid out on a table and picked apart by the group. Frank went

to a few of these things, but he had never liked verbalizing what made an image—especially his own—succeed or fail. Avedon, however, thrived in the Laboratory. "I would do anything Brodovitch asked," he said.[21] By the end of the decade the Design Laboratory was meeting at Avedon's studio and Avedon was a star of the *Harper's* stable.

As for Frank, Brodovitch had gone the rare step of inviting him—usually you had to ask the master. And then Frank stopped going. "I like to bite the hand that feeds me. That was the end of our friendship," he remembered later.[22] He had hated school and had serious doubts about regular employment, and being around Brodovitch combined the worst of both. The hustle for magazine assignments was too much like other kinds of work, and the meddling of editors who hired you for your vision but would only pay you when you bent it toward theirs was impossible to swallow for long.

Six months after he was hired Frank departed *Harper's Bazaar* in October 1947. His relationship with Brodovitch couldn't have been that bad: on June 1, 1948, he won an Art Directors Club "Award for Distinctive Merit," and the certificate was signed by Brodovitch and Bassman.[23] He collected his prize, and then, before the month was over, he left the country. From June to December of 1948 Frank traveled through Cuba, Panama, Bolivia, Brazil, and, most of all, across Peru, a challenging place even for a tough traveler. "I realized that security didn't matter," he would say. "I could never have the security that I had in Switzerland, so there was no reason for me to attempt to get into the high-fashion world. I went to Peru to satisfy my own nature, to be free to work for myself."[24]

He went alone, but Brodovitch's influence came along. The art director had already suggested Frank move beyond his large-format four-by-five camera and encouraged him to use a Rolleiflex twin lens reflex mid-range camera for shooting outdoors in New York. As Frank was preparing for South America Brodovitch urged him to take a 35mm camera and explore what it could do.[25] Frank took his Rolleiflex and a Leica.

He traveled by plane, jeep, donkey, and bus; in Peru he launched from Lima, where he met Ramon Penadillo, a local figure who later introduced Allen Ginsberg to ayahuasca, the spiritual hallucinogen of the Amazon.[26] Then he headed into the mountains alone. "He was fearless," said cousin Claude Brunschwig. Frank climbed into small boats with unsavory characters on isolated waters and got sick from sleeping on the ground without warm clothes. "It was a really good time, the best trip I ever made," Frank exclaimed. "I didn't talk to anybody for maybe a month."[27]

Far from assigning editors, an "other" from multiple angles, Frank was free and unaccountable. He thought of the Leica in the way Brodovitch had suggested: as a tool for abandon, the sort of abandon that abstract expressionist painters were lighting up New York with. Paint slingers like Jackson Pollock and Willem de Kooning were making supremely physical art, their canvasses a record of performance. As Brodovitch had realized by using his Contax to photograph dance movement, the 35mm camera became part of the body. In Peru "I was very free with the camera," Frank told William S. Johnson. "I didn't think of what would be the correct thing to do; I did what I felt good doing. I was like an action painter."[28]

New York in the 1940s was stuffed with jittery photographers slamming office doors and wrestling with their Leicas, learning their craft and exchanging ideas while hustling for assignments. Frank had done that and now had also gone to countries where he didn't speak the language and couldn't find a fashion magazine and had worked out his craft on his own, free to make whatever mistakes he wished. The Peru pictures are the product of instinct and impulse—he might follow a person around because of something he liked about their hat or examine the possibilities suggested in the shape of a hill. He wasn't shooting for *National Geographic,* not engaging in anthropology. He did not have a viewer in mind and didn't care about providing information on indigenous cultures: his photographs are quick interjections into a shared reality. We are not viewing a "foreign" place but a place this one person with a camera has entered.

It's hard to come away with much sense of how he felt about the people he viewed in South America—Frank withheld any impulse to dramatize "dignity" or "humanity," the kind of content a photo editor at *Life* magazine would have expected. The dignity he gives the people is the dignity of their unknowableness. They are themselves. It's enough for the photographer to breach proximity with the people and landscapes and simply note that paths have crossed.

When he returned Frank put together a pair of books of the Peru photographs, one a birthday gift to his mother and the other for Brodovitch. (In 2008 Steidl published *Peru*, culled from this excursion.) He isn't fond of the South American work, declaring, "Peru was the end of exoticism."[29] The next time he photographed a foreign culture he would do it from inside, from a place of understanding those around him. Peru was the beginning of an extended period of travel, and Frank came back a different person, even more confident that chucking it would point him in the right direction. There was work that paid the bills and then work that mattered, and any overlap was unintentional.

NOT LONG AFTER he had first arrived in New York Frank said "an old German guy" took him on several visits to Times Square. This was his introduction to the place, "and when I saw that I said I would never go back to Switzerland." Times Square was like a giant tuning fork set to a brand-new pitch. "It was very strong, all the people and the traffic and everything. It was simple. You had the feeling that this was where it was happening."[30]

The Times Square of the late 1940s was a far different place from that of our own era. There were no throngs of tourists lining the sidewalks erecting makeshift forests of selfie sticks. No surveillance equipment, no "If You See Something Say Something" or costumed Cookie Monsters shoving superheroes off the curb. Times Square was a sea of light and noise where strangers met and transactions were broadly permitted.

After the war it had become a distinctly different place, much louder and low falutin', more diverse than it had been during the fighting and, most importantly, far brighter. During the war it was lights out: the great electric signage of the Square turned off as part of a city-wide dim-out meant to make it hard for attackers to target the metropolis. Now the electricity poured forth, laying a warm bath of light on a public space that was becoming less elegant and increasingly embracing the funk. Nightclubs and fancy restaurants were moving to Fifth Avenue and points east. In their place were cavernous night-owl cafeterias and pinball arcades and shops selling live turtles, pictures of girls in underwear, cigars, hamburgers, and Ouija boards.[31]

In the years after World War II Frank and other young photographers brandishing portable cameras discovered Times Square, passing among the Legionnaires and locals, firing off pictures on the fly, moving with the crowd. With 35mm instruments half hidden in the palm of their hands, they could capture a range of human activity without being noticed in a Square that was a free zone of kaleidoscopic proximity, not to mention a place where the soul of the city revealed itself in the glow of a movie marquee shouting, "GOONA GOONA LAND OF LOVE!"

The most famous photograph of the era, Alfred Eisenstaedt's 1945 image of a sailor and nurse spontaneously kissing in Times Square as World War II ends, was taken with a 35mm Leica. The *Life* magazine photojournalist spotted a lone sailor weaving along as if on a hunt, and Eisenstaedt joined in, taking pictures on the fly as he stalked the hunter. "I was running ahead of him with my Leica, looking back over my shoulder, but none of the pictures that were possible pleased me. Then suddenly, in a flash, I saw something white being grabbed. I turned around and clicked."[32]

At its birth photography was understood on the creative fringe as a new way of seeing. Certain painters and thinkers respected its technical limitations, finding possibilities in those flaws. In its failure to mirror the world, they felt, photography might usher in a new kind of art. In 1853 the painter Eugène Delacroix for one signed on, championing this new form "in which the imperfection

of the process itself . . . allows certain gaps, certain resting places for the eye."[33]

A century later the new technology spoke to a creative fringe whose art was rippling through the streets of New York City. One criticism of the Leica was that its small negatives led to blurry imprecision when enlarged; Leica users countered that capturing the moment was better than clarity. Blur and grain, part of what made *Ballet* so unfathomable, were showing up everywhere. They divided folks, not unlike the way photography itself once had, and those who trafficked in blur and grain were viewed as amateurs, outsiders rebuked by correct artists. The conflict would only have excited Frank.

One of the earliest photographers to free-dive into the Square was a high-strung Philadelphian named Louis Faurer. A child of Russian Jewish immigrants, Faurer was commuting from Philadelphia to do magazine jobs in the city. He had already masterfully photographed Times Square before Frank arrived in town and was working for fashion magazines when he encountered Frank at the *Junior Bazaar* office in 1947. Upon meeting, their intensities entangled, and friendship was inevitable. Frank invited him to crash at his Manhattan loft with him and his nine cats. Photography was what both believed in, but what they shared was 42nd Street. "I photographed almost daily, and the hypnotic dusk led me to Times Square," Faurer wrote. "Nights of photographing in that area and developing and printing in Robert Frank's dark room became a way of life."[34] They shot and developed pictures together, and when they found one that they especially liked, both would spontaneously crack up.

Faurer would soon be living with Susan Hoffman, a fashion model who, using the name Viva, would become a star of Andy Warhol's films. In a thinly veiled autobiographical novel, *Superstar*, Viva talks of her romance with "Louis Faber," a controlling but weirdly charismatic personality. Faber is friends with "Robert Drake," a stand-in for Frank. "Robert Drake wasn't so bad, but he was pretty depressive," a character says. "Yeah, PRETTY DEPRESSIVE!" Viva agrees.[35]

Back then Frank was open and vulnerable, Faurer recalled; he was somebody who people wanted to give stuff to, such as clothing. Frank was drawn to Faurer's intensity, to a guy "so intelligent and so angry, and having such passion for the world."[36] He introduced Faurer to the Leica after Faurer found one in a phone booth. The pair shared the same general contempt for the idea of success in the magazine world, and whether they would use the word or not (they would not), they felt that they were artists and did not easily accept that an editor could tell them what to shoot or how to crop the picture. "Sammies," they needlingly labeled each other, a reference to the character Sammy Glick from Budd Schulberg's 1941 novel *What Makes Sammy Run?* Like him, they were Jewish and on the hustle, clearing daylight between them and their past. The difference was that Glick's sweaty ambition defined him, but for Faurer and Frank there was little worse than showing how hard you were trying or coming to terms with the commercial setup: a true Sammy was desperate, conniving, unprincipled. No sellout.

They knew themselves best by declaring to each other what they weren't: they weren't sucking up to Hearst's horsey Gestapo, and they had their doubts about a lot of the artists in New York as well. And if photography hadn't achieved the status of painting or sculpting, then they reveled in being without status. Who needed the rankings of the art world, the culture of the airless museums? They worked for themselves in the streets. "I didn't want to be an 'artist' but I wanted to be respected for what I would put out," Frank said. "Photography wasn't an 'art' then, but I knew that you could somehow make pictures that were different from 99 percent of what you saw. I didn't think of that as art; I felt it was just my way of expressing something. I thought that it would be left alone . . . that I wouldn't be manipulated."[37]

One thing they emphatically were in favor of: the illumination of 42nd Street and Broadway. Coming from all directions, reflecting off freshly waxed cars and fortune-teller windows, backlit fluorescent panels carving out letters on movie marquees, neon cats and camels and peanut men with auras that changed the color of

your skin. Even in the middle of the day these signs exuded an undeniable attraction. As poet Frank O'Hara wrote,

> Neon in daylight is a
> great pleasure, as Edwin Denby would
> write, as are light bulbs in daylight.[38]

A torrent of associations bubbled up in Times Square, and two contrary ideas emerged: it promised to transform and overwhelm your identity, and it was a place you could truly be yourself. When these promises met, as O'Hara put it, "Everything suddenly honks." They gathered by the light of the Square and found that it was enough and everything.

The understanding was: available light. "At this time we were only concerned with photography—with available light photography," Frank has said. "And everybody who used flash or lights was the enemy. This little group would go out, and use no lights, and come back with these pictures, which were technically not as good, but they were different. We formed a solidarity, really [and] you rode with that group," he said.[39] There was a crew: besides Faurer and Frank, at some point or other it included Ed Feingersh, Ted Croner, Saul Leiter, Sid Grossman, and others.

By the glow of "SCHAEFER BEER" they lived or died. Faurer, especially, in his Times Square photographs, makes light into a malleable substance. Shooting in a studio you might use a flash or strobe lights to get a crisp picture. "Available light" meant you used what you found; you didn't inject what wasn't already there. "Available light" was about not cooking the evidence. It required that you lived under existing conditions, understood what you were seeing and bent to it, acknowledging the moment's power and comprehending that in this way you were a subject, not a master of the split-second. It was not an exercise in perfection.

"Available light" was a deep plunge into trial and error. And in the learning by doing, mistakes happened, the kind that sometimes looked meaningful the more you observed. They set rules, even arbitrary ones, in order to force improvisation. The photographer

Louis Stettner, another of the Times Square denizens, told writer Lisa Hostetler how he and Faurer used "zone focusing"—"the practice of setting the focus, aperture, and shutter speed at the beginning of an evening, and then leaving it there regardless of changes in conditions." Stettner intended to remain "steeped, trancelike, in the energy of the crowd without having to interrupt the experience in order to fidget with the camera."[40]

As they shot around Times Square and in the streets of New York, Frank and Faurer did various "wrong" things, thoroughly influencing one another. Faurer once accidentally exposed the same frame twice and decided he liked the result. He shot with slow-speed film in darkness, gauging his shutter speed by feel rather than using a light meter. Frank would shoot right into the source of light, creating halos and blurs, and he'd use a busted lens to see what image it might produce.[41] They were exploiting the nature of 35mm technology, but maybe they were exploiting the nature of Times Square too: a place where "wrong" things constantly rose to the surface.

"My eyes search for people who are grateful for life," Faurer wrote, "people who forgive and whose doubts have been removed, who understand the truth, whose enduring spirit is bathed by such piercing white light as to provide their present and future with hope."[42] Faurer's Times Square work moved between two poles. At one end are individuals straightforwardly engaging with the camera: a father and son dressed up for a night on the town, women in a movie line to see *No Man of Her Own* and resigned to the photographer's gaze, *Champion, New York, NY*'s anxious man standing in traffic, eyes searching for something to save him. Faurer had an amazing ability to show people's inner life, and he treated that life with a gentle respect. At the other pole there are Faurer's rapturous overlays of shadow and reflection, fusions of shapes, fluorescence, and steam. Faurer used multiple exposures—exposing the film more than once and capturing layers of imagery—to turn the city into a haunting expanse where objects and people lost their borders and joined with the essence of the place: the crowd.

The poet Charles Baudelaire was a patron of the crowd and celebrated the ways the modern artist lived in the streets. In "On Crowds" he wrote, "Multitude, solitude: two equal and inter-changeable terms for the active and creative poet. He who does not know how to populate his solitude, will not know how to be alone in the bustling crowd."[43] A photograph from a busy New York street, taken by Faurer not long after he and Frank met: *Robert Frank in Pinstripe Suit, New York N.Y., 1947–48.* People in thick winter coats gather on a sidewalk, a congress of hats and overcoats staring at something outside the picture. On the edge of things is Frank, hanging in a roomy slick suit—Faurer thought it was bor-rowed for the photograph—his hair shaggy, hands in pockets, hip cocked, weight on his heels. There is a conundrum in Baudelaire's quote: to lose yourself in the group, the poet says, is to be alone in it. Here is Frank, a New Yorker in the crowd.[44]

CHAPTER FOUR

ROAD TRIPS AND MIND TRIPS

IMAGINE: YOU QUIT YOUR JOB. Having left home for the bright beacon of Manhattan, in about a year you get restless and leave that behind for six months of concerted drift across South America. Now you are back, with prospects uncertain and self-confidence rising like sap.

Frank was living at 53 East 11th Street in Greenwich Village. This, too, was a difference. The Village was blowing up after the war, with the innovative university known as the New School ballooning with cerebral European émigré faculty and its enrollment more than tripling. The Village was bulging with abstract expressionists and aleatoric composers and Maya Deren and Ray Johnson and Judith Malina and James Baldwin and Jay Landesman and Patricia Highsmith and endgame anarchists, cartoonists, and congueros. Robert Frank knew his way around.

One day while photographing in the streets he shot a whole roll of Washington Square Park in the Village, "the consecrated navel of bohemia," as Milton Klonsky put it.[1] He is slightly above a flow of people moving through the park. So many of Frank's street photographs from this era show forces colliding, but here is a hypnotic circulation of people in unison, turning, turning, virtually in step, all hearing the same pulse—embodying more of Klonsky's words: the Park as "that inverted mandala around which generations of Villagers have met and turned each other on."[2] In Frank's Village the disparate formed a column.

Three blocks away from Frank's loft, in an apartment at 9th Street and University Place, lived the painter Eleanore Lockspeiser and Mary, her teenaged daughter. Mary Lockspeiser was majoring in dance at the Professional Children's School and studying with Martha Graham. In order to escape her mother's large personality and the cramped Village apartment (Mary slept on a mattress thrown over the piano), she explored the Village, running with artists, dancers, radicals, and writers. Mary heard Leadbelly and Woody Guthrie sing and folk danced at the Furrier's Union. "You got to dance all night," she enthused later in an oral history at the Archives of American Art. "You would wring out your clothes from all the sweat. And you did square dancing and a few Russian dances, troikas, Russian two-step. That was heaven for me."[3] She two-stepped with her friend Bob Kaufman, an African American Jewish merchant seaman. They went to parties thrown by the youth wing of the Communist Party, and at some point Kaufman took her to the loft of a guy he knew. That's how Mary met Robert Frank, before he left for Peru in late spring of 1948, when she was fifteen years old. Lockspeiser was a pulsing presence in the Village immediately after the war—exuberant, dark haired, challenging, able to hold her own with all the paint-spattered mansplainers. The men came around. Uncommonly beautiful, she has been photographed with adoration by Frank, Walker Evans, John Cohen, Elliott Erwitt, Edward Steichen, Joel Meyorowitz, and Ralph Gibson. A photograph of her singing in Washington Square Park in 1948 captures her overflowing with conviction, Joan of Arc leading the masses in a transcendent hootenanny.[4]

Her mother, born Eleanore Weinstein, came from a family of radical Russian Jewish atheists who had settled in Brooklyn in the nineteenth century and established themselves in progressive publishing and labor circles.[5] Eleanore studied painting with the modernist Max Weber. In Paris she met Edward Lockspeiser, a British musicologist and scholar of the composer Debussy, marrying him in London. Mary was born in 1933. Raised to be an English bohemian, she had a Scottish nanny, danced barefoot with silk scarves while her mother played piano, and ran naked through the house.

On the surface it was an idyllic existence, but there was darkness too, for Edward was uncommunicative and distant. As a girl Mary was capable of amusing herself with stuffed animals and music for long afternoons. She had an enormous imagination and a gift for disengaging from hostilities and focusing on whatever she put in front of her. And then everything changed as Germany threatened Europe.

At the age of six she was evacuated to the countryside, where she attended Episcopal boarding schools while her parents remained in London. "My family was Jewish but completely atheistic, and I absolutely knew when I went to school that I was different. There was all this hymn singing, prayers, going to church," Mary remembered. There were air raid sirens going off in the middle of the night, children woken from their sleep and chased into underground shelters. Cowering beneath rose gardens, they sang hymns she did not know in nightgowns and gas masks.[6]

During the blitz of London in 1940 Mary and Eleanore sailed to Dublin, then boarded a refugee ship to America. As they crossed the ocean they heard gossip of U-boats trawling the waterways and the endless crying of babies. Edward, a member of the London fire brigade, stayed behind. America became Mary's home, while her father would remain in England for the rest of his life.

Initially they lived in Brooklyn, and in school Mary found yet again that she stood out from her classmates. It was during the birth of the Cold War with the Soviet Union. "I got in a lot of trouble because I refused to stand up and pledge allegiance to the American flag. I told the teacher that my grandparents were Russian. I felt I was not American," she said. "In those days it wasn't a good thing to be Russian."[7]

Back in the city after his South American travels, Frank ran into Mary in Washington Square Park in early 1949, and they renewed acquaintances. Meanwhile the Cold War was hitting close to home: Sid Grossman, a photographer Frank knew who ran the New York Photo League from practically across the street, was fingered by the US Attorney General as a subversive, and the League, which was simultaneously an innovative school, studio,

and hangout, fell apart. In July 1948 President Harry S. Truman announced that men between eighteen and twenty-six living in the United States must register with their local draft board, as a standing Army would be necessary to respond to Communist military advances. Indeed, the Selective Service System floated the idea of registering the oldest people first, before they aged out of the draft.[8] In an oral history Mary says Robert became extremely concerned that he would be drafted and decided to leave the country. A deal was made with a friend, a Chinese painter named San-yu who lived in the Village. San-yu would stay in Frank's loft, and Frank would stay in one San-yu kept in Paris.[9]

Frank sailed to Europe in March 1949, meeting photographer Elliott Erwitt on the ship. Erwitt would later remember the early impression: "I knew him well, then. He was a reasonably depressed character, slightly cynical—*méfiant,* the French would say."[10] Before getting far the ship's crew discovered a stowaway on board: the fifteen-year-old Mary Lockspeiser, intending to travel with her boyfriend. She was removed and sent back to Greenwich Village.

Frank would spend many months outside the United States. In April he was in Switzerland visiting his family and then arrived in Paris. Meanwhile Mary's father, knowing nothing of his daughter's romance with Frank, had sent her word that he would be giving a talk in Paris and invited her to meet him for a visit. Mary jumped at the opportunity.

Things got complicated and then ugly when she arrived. Lockspeiser didn't really know her father, having left England when she was seven; Edward couldn't understand why his daughter was running around the city, coming home late or not at all. He demanded that she behave and threatened to send her back; she thought he was being absurd and continued meeting Robert. Finally Edward locked her into her hotel room and made plans to ship her back to New York.

Mary wrote notes—*Help, I'm being held captive*—wrapped around cherry pits and tossed them out the window onto the street below. A hotel employee unlocked her door, and she fled to Robert, who tucked her away in a working-class suburb. But now *he* had to

keep a low profile because Mary's father had told the gendarmes about the twenty-four-year-old who had spirited away his teenage daughter.

"He tried to put Robert in jail, but the French police were not very interested," Mary recalled. "Can you imagine how many 15-year-olds run away from their fathers, mothers, grandfathers, whatever, in Paris?"[11]

The people Robert had left her with, said Mary, also grew worried "because they saw a little thing in the newspaper, 'Englishman looking for his American daughter' or something, 'minor, minor.'" So they moved her, several times, and put Mary to work scrubbing floors. She felt isolated and embedded in a medieval scenario. The man whose floors she was scrubbing turned her in, and Edward, questioning her sanity, had her institutionalized. "I was put in, basically, solitary. First, they told me I could sit in the garden. But they took me up and then I didn't really see anyone. I mean, they brought food," she said. Robert came to visit but was told she had already left for America.

"It was very frightening. I had a little piece of paper and I wrote all the poems I could remember but then I ran out of paper. And then one nurse gave me a little bit of wool and knitting needles."[12] She mailed a letter to her mother, Mary's legal guardian; only after Eleanore appeared in Paris was Mary able to leave the country.

In New York she studied painting with Max Beckmann in the final year of the great German's life, and the painter Hans Hofmann, and she deepened an interest in sculpture. Robert remained in Europe, traveling to Spain, Italy, and then the South of France in the fall. That December he assembled a small book for his lover, using seventy-four photographs from Paris, and called it *Mary's Book.* "I promised you a little story. Maybe this is not a story," he writes in a defining contradiction at the front. Storytelling was very much on his mind, the way pictures and words together complicated a narrative. The work also featured his first use of a quote from *The Little Prince* that Frank would return to in the future: "It is only with the heart that one can see rightly; what is essential is invisible to the eye."[13]

"I was in love, very influenced by it. He was nine years older. He'd been a lot of places," Mary said. In February 1950 Robert returned, and they married that June. Mary was pregnant at the time, and Eleanore witnessed the ceremony: "I had to have my mother come, because I was underage when we got married," said Mary. Pablo was born in February 1951, and together they lived on 11th Street. Robert wrote to his family to break the news that he was now married and a father. He hadn't told them anything about Mary, though now he hastened to mention that, well, he *had* married a Jewish girl. "They wrote him back a scathing letter. It really upset him a lot, and he was always rebelling against his family, but he was really knocked out by that letter."[14]

His response was confrontation—send the family at once to Zurich. She didn't want to go. Robert persuaded her. "He was very domineering, no question, and he said his parents had to meet me." Mary arrived in Zurich with their infant son. It must have been sort of awkward, strangers meeting, a baby crying, and Robert back in New York, where he remained to compose his entry to a photography contest in *Life* magazine. Mary had begun making wood sculpture, and in Zurich she set up a bit of a studio in her father-in-law's workshop. While she worked she would leave Pablo with Robert's mother and her maid. "They thought that was an absolutely grotesque idea, because I should be knitting the little woolen things," she said. "I was never brought up to cook or to take care either of myself or of anyone else. I was brought up to be an artist. I got very scared, particularly because I realized that being a mother was intruding upon my work." Now she felt fear— being a mother was a role she struggled with. It threatened, and in Zurich it brought a palpable feeling of being judged.

After two months of taciturn Swiss scrutiny Mary took Pablo and headed to Paris.

FRANK WAS COMPETING in *Life*'s Young Photographers Contest, and one of its judges, the one whose word carried the most weight, was Edward Steichen. When Frank had first arrived in New York

he headed for exhibitions that Steichen curated in his role as director of the Department of Photography at the Museum of Modern Art. Steichen was the most important photographic gatekeeper in America. Which Frank knew perfectly well: he'd sent him a letter of introduction and several Peru pictures in 1948, but there seems to have been no response. A year and a half later he sent Steichen more pictures and again asked for his opinion: "Dear Mr. Steichen—These are some photographs I took over a period of two years. I would like very much to know what you think about them. I make a living as a fashion photographer."[15] Soon the director stepped into the role of mentor, meeting with Frank in his office for a chat and then buying several of his prints.

By the time Frank entered Steichen's orbit, the older man had cycled through several careers, any of which would have made for a noteworthy life. In the 1920s he pioneered a type of turf-marking photograph, painterly and sighing. Which was gratifying, but despite the respect he garnered as an artist Steichen was financially struggling, so he changed directions. In the 1930s he signed a spectacular deal with Condé Naste to become the house photographer for *Vanity Fair* and *Vogue* and made iconic portraits of celebrities and fashion models. The man who had once forcefully proven that photography was an art now declared that (a) "art for art's sake was dead—if it ever lived," and (b) "there never has been a period when the best thing we had was not commercial art."[16] His success divided his era's photographic culture, and from what we know, the guy savored it with a twinkle. Steichen saw photography becoming a bigger deal in every possible way—as art, as business, as the perfect wrapper for an advertiser's message in a magazine—and he saw no reason to slow its ascent by taking sides in an argument.

He cultivated relationships with young artists, was friends with editors of art journals, and had world-spanning ideas for exhibitions that brought crowds to the museum. As an arbiter of *Life*'s Young Photographers Contest, Steichen would administer two prizes, one for best individual pictures and the other for photo essay.

Frank wanted to show the judges that he could compete with any of the photojournalists *Life* used, and he took the competition most seriously. A great student when he was allowed to learn on his own terms, Frank broke down *Life*'s photojournalistic format and examined how a progression of images emotionally affected viewers. How magazine essays were assembled, how a typical story was told through interplay of words and pictures. He pondered what magazines considered a good subject, good pacing, how the storyline ended up making the viewer feel. The photo essay was a star-making medium. They could pay a photographer better than most assignments, they included a whole batch of one's work, and they were an opportunity to swing. But they also put images at the service of words and words at the service of editors with a rigid formula for the notes a successful essay had to hit, the bases that must be touched in sequence. The format appealed to his ambitions: photo essays created stars, like Eugene Smith or Henri Cartier-Bresson. They put the photographer in a bigger arena than did a picture of a handbag. Frank went all-out to win *Life*'s contest, the best kind of job interview as far as he was concerned—the kind where your work spoke for you.

The essay he entered, "People You Don't See," observed six folks Frank knew from his 11th Street block. There was the luncheonette worker, the fruit peddler, the kid who lived around the street, and the man who swept it. His entry was indebted to the kind of stark, humanistic photography that had come out of the Photo League: work with a social conscience and an unsparing eye for truthful detail. The people were blue collar and not all white, and Frank presented them without a false or sentimental narrative—he presented them in their daily context and boldly said *that* was the story.

In a statement accompanying his essay, Frank wrote, "As you walk through a short New York city block, these are the people you don't see. These six are—or represent—six million. . . . I have not tried to show moments of excitement or emotion, but to emphasize the scenes that I have noticed over and over again, day after day." He was avoiding emotional epiphanies, drawing attention

to rituals of work, to states of grace—a stillness that communicated life. In that way he was moving the notion of storytelling in more internal directions.

The November 26 issue of *Life* announced he had won second prize for a set of individual photographs, including images from Paris and one of Mary on the floor of their loft, nursing Pablo. It was a meaningful success. Something Frank had said to a *Life* writer appeared in the magazine as well, and it showed the ambitious way he intended his photographs to be viewed: "When people look at my pictures I want them to feel the way they do when they want to read a line of a poem twice."[17]

"People You Don't See" did not win. And having lost the big prize, Frank would spend time working through his feelings. There was certainly a belief that he would return and show *them* he could tell a great pictorial story, with pictures that were undeniable. He had, after all, selected subjects and a theme—the city made you disappear—that many *Life* readers would be allergic to. He wanted it all: to tell them they were wrong and then have them say it out loud. Frank would pursue a more traditional storytelling approach several times in the next few years. Still, "People You Don't See" shows he was thinking about how to put photographs into a structure that would surprise people—magazine readers, editors, judges of contests.

Winning second prize was a good thing. Not winning first was even better. It gave him the gift of anger. Later Frank would put it in words and be done with it. "*Life* magazine was very much on my mind then. I wanted to get in that magazine. I wanted to sell my pictures to them, and they never did buy them. So I developed a tremendous contempt for them, which helped me.

"As an artist today, I feel you have to be enraged. . . . I also wanted to follow my own intuition and do it my own way, and not make concessions—not make a *Life* story. That was another thing I hated. Those god-damned stories with a beginning and an end . . . if I hate all those stories with a beginning, a middle, and an end then obviously I will make an effort to produce something that will stand up to those stories but not be like them."[18]

He now had something to build on. Neither *Mary's Book* nor "People You Don't See" told one of those goddamned stories with a beginning and an end. He wasn't going to give them what they wanted. He would show them.

A NOTE TO STEICHEN as he was leaving—"I hope to send you some good photographs from Europe"[19]—and Frank sailed to Paris in November of 1951. In December he was shooting in London, then back to Paris.

In the Eleanore Lockspeiser papers at the Archives of American Art in Washington, DC, there are many letters to and from Robert, Mary, and her family as they hopscotch across Europe in the early 1950s. It was a tough, impoverished life that they chose, and the letters describe how hard it was and, once in a while, how fulfilling. Mary's dispatches can seem sad and fraught, though they often end with a note of hope—that Pablo will recover from an ailment, that a check is about to arrive, that diaper covers will be found. Mary has referred to this time as "a preindustrial age." They were living on very little money and arguing with Robert's family up close and at a distance; neither Robert's family nor Mary's mother can understand their decision to live like this.

In March of 1952 Robert, Mary, and Pablo lived in Spain for five months, settling into a dirt-poor seaside town in Valencia. It was just two years after Franco had opened the country to foreigners for the first time since taking power in 1939. Letters from Spain show Robert telling Eleanore how much harder it is to work in Valencia than it was in Paris and noting how Pablo was extremely demanding, which was hard on Mary, who had little peace from eight in the morning until ten at night.

They saw few cars in Valencia but many donkeys, mules, and horses. The Franks would splurge and pay an organ grinder to play for Pablo and the kids of the pueblo, all of them dancing with each other, with their dogs, or alone. Frank was photographing the community around him and assembling a photo essay he hoped to sell, the story of a local bullfighter. The place was full of fishermen

and Romani, and the Franks stood out, raising a certain amount of curiosity. They lived in a room over a restaurant on the Mediterranean. There were chickens on the roof. Mary befriended the landlady's family and cleaned mussels in the restaurant's kitchen. "It was the first time I had ever seen any family life that appealed to me," she said. "They were very poor people, but there was real life and spirit there."[20]

The pictures Frank took in Spain were different from his French or Peruvian work: he's not passing through, and most were taken within a stone's throw of his apartment—he was connecting with a scene and people in one place, up close. Heat soaked and extreme, woozy and slow and full of decay and birth in equal measure: a little military band marches down a dirt road while a figure laying in the dirt watches the parade. In the words of the Valencia-born curator Vicente Todolí, if the Peru work documents a "road trip," Spain was "more of a mind trip."[21] A wormwood feeling hangs over these photographs, and Valencia is a place that seems hard to leave except on a burro. He liked it there.

The family remained until August 1952; they would have stayed longer, but they contracted jaundice, probably from tainted cooking oil, which was a dangerous affliction for an infant. With little medical treatment available in their coastal town, they returned to Paris for rest. In France Frank aimed to meet with Robert Delpire, a medical student and editor of *Neuf*, a cultural magazine for doctors. Delpire arrived at his office one morning and found a photographer with a portfolio waiting to see him; "he had just come back from Spain, and was trying to sell photos nobody wanted," was how he put it.[22] The two hit it off, and Delpire became a vocal advocate for the work of someone unknown in France. He would publish Frank three times in about a year: once with a spread of his Peru pictures, again in an entire issue of *Neuf* dedicated to Frank, and finally publishing the Peru pictures, along with the work of Werner Bischof and Pierre Verger, in the book *From Incas to Indios*.[23]

In October the Franks were in Zurich, where Robert met with Edward Steichen, helping to introduce the curator to European photographers for an upcoming Museum of Modern Art survey

of postwar photography. Through Frank he met Jakob Tuggener and viewed his book *Fabrik* as well as photographs of the luxury hotel balls.

While in Zurich Frank probably met photographer Gotthard Schuh, who would become an important influence on Frank's work. He also assembled three copies of a new book he had made with Swiss graphic designer Werner Zryd, *Black White and Things.* The thirty-four photographs are grouped by feel, in sections labeled "Black," "White," or "Things." The time in Spain shaped the book, and images from it are in each section. He's not making a simple record, not evoking big thoughts—religion or class struggle or the prices of sardines in Valencia; he is using contrast and sequence to glean pools of feeling. The photographs have a sometimes obvious and at other times contradictory sense of belonging where we find them—is this one more visually black than it is emotionally white? Are these truly things? He delves into grouping, association, pigeonholes that can be useful or open-ended.

There are pictures from Paris, Valencia, Peru, New York; visual passages of tenderness and existential gloom. At the opening again appears the quote from *The Little Prince*: "It is only with the heart that one can see rightly / What is essential is invisible to the eye." You can view these words as a romantic statement of what it means to be an artist, and they are. But you can also see it as a pivot on the idea of what photography means: if, as so many believed, the practice amounted to a documenting of reality, Frank notes that the only reality worth depicting is one that comes from inside the artist, not outside his camera. Sometimes he has pictures facing each other on the two-page spread, paired in rhyme or contrast. More often there is one image to a spread, a momentary rest stop where the last image fades in memory, overpowered by the one now observed. Throughout he is breaking down the stations of the cross of the well-told magazine tale and turning the trip into a progression of question marks. The book is as much an argument as it is anything—it is a performance. It shows how the hand of the photographer, arranging the images according to personal logic, establishes the nature of the work of art.

Frank made three copies of *Black White and Things*—one for his parents, one for himself, and the third for Edward Steichen.[24]

Long distance, he kept a career going. Writing from across Europe, Frank asked Mary's mother to drop off his work with editors in New York, pay a visit to Steichen at the museum, pick up payment for a photo assignment. In November the family traveled to England, where Frank would complete two important series. While in London, in November 1952 he worked in the financial district, featuring wet streets and top-hatted bankers who look ready to hit him with an umbrella if they bothered to glance his way. The London pictures capture a time in postwar recovery when basics were unavailable—there was food rationing, J. G. Ballard wrote, and also "the far more dangerous rationing of any kind of belief in a better life. . . . It is hard to imagine how conditions could have been worse if we had lost the war."[25] This place was the opposite of Times Square: eye contact withheld, subjects thinking of some other place they wished to be, all life dwarfed by architecture and gloom.

Frank had sent some of these photographs to Steichen, and the director offered praise but also perceptive criticism: "I sometimes feel that I would like to see you more in closer to people. It seems to me that you are ready now to begin probing beyond environment into the soul of man. I believe you made a fine decision in taking yourself and your family away from the tenseness of the business of photography here. You must let every moment of the freedom you are having contribute to your growing and growing. Just as the microscope and the telescope seek a still closer look at the universe, we as photographers must seek to penetrate deeper and closer into our brothers."[26]

In early 1953 Frank went back to London, again photographing the financial district. He had read the hugely popular British novelist Richard Llewellyn's 1939 novel *How Green Was My Valley*, a reminiscence of family life in a Welsh valley before and after the coal mines come. While in England he met a Welsh man who got to talking about mining, and on the spot Frank decided to visit this

acquaintance's hometown. The work he produced "became my only try to make a 'Story,'" he would say later.[27]

He went to the village of Caerau in March and focused on fifty-three-year-old Ben James, who had been a miner since the age of fourteen. James's father-in-law had died in the same mine where James now worked. Frank had in mind a series that would tell a traditionally flowing tale, a magazine story, following James at work and home, from when he woke to late at night. The pictures are steeped in a liberal idealism of "common folk," though taken to visual and emotional extremes. When he looked at the blackened faces of these miners, Frank searched for signs of life and found a humanity coming across in the one spot not covered in coal dust—their eyes. Frank may well have been taking Steichen's advice, because he gets in close to the miners and views them with clear empathy. After eight days in Wales Frank sailed back to New York with Mary and Pablo on March 18, 1953.

Once again, leaving home gave him the freedom to see in new ways; the excursions to Spain and then England pushed him past the strictures of magazine work. He had held to the idea that every image should be able to stand alone. "I wanted to make a really strong picture, the one print that would get the essence of the place I'd been," he said. "Then after the trip to Spain, it seemed to me that there were many pictures."[28] Increasingly he thought beyond the photo editor's beloved silver bullet picture—the oxygen-sucking summation that took a bow and then swept the stage for change. "I went away from my early lyrical images because it wasn't enough anymore," he said. "I couldn't just depend on that one singular photograph anymore. You have to develop; you have to go through different rooms."[29]

While heading back to New York in 1953 Frank wrote a letter to his parents, explaining that he was returning "not with a great deal of enthusiasm." He added, "This is the last time that I go back to New York and try to reach the top through my personal work."[30] After a year and several months in Europe he was reentering a country he considered home, perhaps, but didn't feel a part of.

The Korean War would formally end later that year; Frank had aged out of the draft.

Two months later Steichen presented at the Museum of Modern Art the exhibition "Postwar European Photography," featuring seventy-eight photographers, including Brassaï, Bill Brandt, Henri Cartier-Bresson, and, from Switzerland, Gotthard Schuh, Jakob Tuggener, and Werner Bischof. The exhibition included twenty-seven photographs from Frank, fifteen of London and Wales. Jacob Deschin in the *New York Times* noted that "a comparatively large group of pictures by Robert Frank of Zurich, a photojournalist who works in New York as well as Europe, fills a wall with examples of his work that provide the most extensive cross-section of a single photographer's output in the show."[31]

The curator and writer Philip Brookman has said of Frank's contribution to this exhibition, "His unframed, Masonite-mounted prints appeared for the first time as expressive, moody, highly charged works of art."[32] Having crafted a first-rate, magazine-worthy depiction of the life of a coal miner (magazine editors all passed on it) at the Museum of Modern Art, Frank chops it up, mixing the different looks and tones of London and Wales, bankers and miners, bound together simply by black and white, by eyes locked and averted, by steam and dirt, and made the remix tell a different kind of story, one poetic and cinematic and intuitive—it didn't "say something" about money or rich and poor people; it engendered a set of feelings and relationships that worked on the viewer over time. Here was a way forward, and a poem you had to read more than once.

CHAPTER FIVE

EARLY MORNING IN THE UNIVERSE

The car, which was stolen, raced across Queens, breaking for the George Washington Bridge. Right behind was a police car, siren on, shots fired. When the lead car turned the corner of 205th Street and Francis Lewis Boulevard at a reckless sixty-five miles per hour, it jumped a curb, kissed a telephone pole, rolled over twice, and came to rest, wheels up. The driver's name was Little Jack Melody.

Jack and his girlfriend, Vicki, were houseguests of a Columbia University literature student. Jack and Vicki were stashing stolen goods in his apartment—they even had a cigarette machine up there—and knowing the cops were going to put it together sooner or later, the student wanted to get the cache out of the apartment. Also his journals, because in them he'd written candidly about his homosexuality along with details of his friends' larceny. The student's name was Allen Ginsberg.

The plan was to drop the loot with Jack's mom, then take Ginsberg's journals to his brother's place. But Jack turned the wrong way down a one-way street, and two cops waved him over. Jack hit the gas, and they were off.

The headline in the April 23, 1949, *New York World-Telegram*: "Wrong-Way Auto Tips Off Police to Narcotics-Ruled Burglary Gang." Ginsberg crawled out of the car and ran, even though his glasses fell off and all he could see were abstract shapes. He knew the cops would soon be at his apartment because he'd neatly written his name and address in every one of his notebooks that, along

with suits, silverware, and furs, were now scattered around the inside of the vehicle. So Ginsberg called the one houseguest who hadn't made the trip with them, a heroin addict named Herbert Huncke. By 1949 Huncke had already coined a word for a kind of feeling that came to mean the kind of person who felt it: *beat.* Ginsberg urged Huncke to clean up the apartment, the cops were coming, but even though Ginsberg meant get rid of the stolen goods, when the police arrived they found Huncke with a broom, tidying up.

They were quite a mix: a cultured six-foot-tall red-headed call girl who knew the best way to extract Benzedrine from over-the-counter inhalers, a gifted lit student with criminal thoughts, a criminal with literary ambitions, and a guy named Little Jack Melody. They were like a secret cell, but the secret was leaking out, and cells would form elsewhere. In the end Jack and Vicki got off lightly; word is both had powerful family connections. There was an outstanding warrant for Huncke's arrest, and he spent five years in Sing Sing. After reading Ginsberg's notebooks, the cops sent him to the Columbia Psychiatric Institute, where he'd live for the next seven months.

Beat: few outside of the carnival culture from whence it came and few outside the twenty-four-hour cafeterias of Times Square that Huncke and friends haunted even knew what it meant. But they would, as the word began to fit a growing number of people. They were hiding in the psych wards and jails, in the shelters and bus stations, and in graduate seminars and public libraries all across the country. They were like locusts, waiting seven months or seven years to emerge, but they would, and they grew in number.[1]

Meanwhile, in the middle of a parade Robert Frank tilted his camera up at some tickertape. Light hitting the paper pleats and spirals made it seem alive, the filaments floating overhead like drawing in the air. A force pulls the tickertape in various directions, droopy and animated. *Tickertape, New York* (1951) is a picture of crazy energy. At the time Frank made it he would have sensed the strange tendrils reaching across Greenwich Village. He

was already thinking in tune with the school of "action painters" stirring in New York, with artists like Willem de Kooning, Franz Kline, and Hans Hofmann making work lifted by spontaneity, using brush strokes and paint trails that emphasized energy and physicality.

They, too, were creatures coming out of the ground. Frank began associating with abstract expressionist painters more than he did with photographers. Mary studied drawing with Hans Hofmann in the early and mid-1950s, and the Swiss artist Herbert Matter was introducing the couple to his numerous New York artist friends. When Franz Kline began to see a little money from his work, he and Frank would buy two six-packs, slide into a car, and drive around Times Square. Another Frank photograph, *Street Line, New York* (1951), is a locust's-eye view of 34th Street, its white stripe down the middle rising vertically toward the light in the distance. It strikingly echoes the contemporaneous *Onement* paintings of Barnett Newman, his breakthrough series featuring a strip of vertical light. A light was burning hot in the arts of New York City, one so dazzling as to turn sand into glass. Frank was paying attention and viewed its makers as his true peers.

Both *Tickertape, New York* and *Street Line, New York* were included in the book Frank had assembled in Zurich, *Black White and Things*. Like the painters Frank bonded with, he was exploring muscle memory rather than memory, intuition and chance rather than statement making, and leaning on an inner confidence to justify creative decisions he otherwise might never explain. His work became open to "revelation, real and concrete," as Barnett Newman put it in an essay on the sublime.[2] Open, in other words, to the universal *now*.

WITHIN A FEW YEARS a practiced eye could spot them. Helen Gee, owner of a Greenwich Village photo gallery and coffeehouse called Limelight, noticed a contingent slouching their way down Bleecker Street. Around the time she opened her space in 1954

they too were making their presence felt—disheveled, dispossessed, self-possessed and making do, down by choice. Gee saw them all over the Village, the *bohos*, she called them, and over the course of the 1950s they would grow into something like a social swarm.[3]

In the early 1950s few commercial galleries showed modern art, fewer still photography. Julien Levy had made a go of both before closing his space in 1948; Roy DeCarava would exhibit photography in his home later in the 1950s. But there were few opportunities for photographers to display their art, a fact that had something to do with there being few in the public who considered photography art. In the absence of a photographic market, people like Frank and DeCarava scraped and hustled as best they could. Limelight was a revelation and a curiosity for showing work in a casual Village Beat ecosystem and selling photographs for $25 or $50 a print.

Gee wanted Frank to be the first photographer she exhibited upon Limelight's opening in early 1954. She hadn't met him yet, so she scheduled an appointment. Frank invited her to his studio at nine on a Sunday morning.

"I'd heard that Robert Frank was difficult; I didn't want to offend him by arriving late," she wrote in her 1997 memoir. No need to worry: when she arrived at his loft in a commercial district on West 23rd Street there was no doorbell to ring, and a locked metal gate blocked entry. She ran to the Chelsea Hotel, calling him from a pay phone in the lobby: "Who? Oh yeah. I'll be down in a minute." A little later Frank appeared, "rumpled and puffy-eyed, like he'd been pulled out of bed."

Gee got a better look: "He had a shy smile, soft dark eyes, flyaway hair, and several day's growth on his chin. His suit was baggy, his shoes scuffed, and his black turtleneck stretched at the neck. But there was something about him that was very appealing."

Walking up the stairs into his loft, she recalled what a friend had said about it—how it was hard to tell if they were moving in or moving out.

"Clothes were strewn all over the place—shoes, socks, underwear, and in front of a bureau with its drawers hanging open, lay

a pair of lacy, lime-colored panties. 'Careful,' Frank cautioned, side-stepping a toy truck and a pile of blocks."

A drowsy Mary was "hugely pregnant" and looked due any time.

They sat at a table with three coffee cups, a piece of cheese, a bowl of fruit, and some flowers in a jelly jar. Gee started her pitch, but Frank didn't seem too interested, opting instead to throw a few names at her.

Did she know Bill Brandt?

Yes.

What about Édouard Boubat?

Yes—she wanted to show his work too.

And what about Gotthard Schuh?

Gee knew he was a Swiss photographer, but that was it.

"They're friends of mine. I think they'd be happy to exhibit in your gallery. I'll write to them if you like."

"But what about *you*? That's really why I came."

"Thanks for asking but I can't. . . . I'm not ready . . . there are too many things." It got pretty quiet in there, and Gee didn't know what to say.

"Perhaps sensing my disappointment, he added, 'But I think you have a very good idea. Let me know if you want me to write my friends,'" Right about then Pablo bumped his knee and started crying. Her time was up.

Some of the finest photographers in the world would soon be exhibiting at Limelight, including Ansel Adams, Brassaï, W. Eugene Smith, and Paul Strand. Frank was being offered the inaugural slot at an actual space devoted to photography. He didn't particularly care—whatever success meant, whatever it was worth, it was something *he* wanted to determine at his pace and on his terms.

A week later at the gallery the doorbell rang. It was Frank. He apologized for turning her down, explaining, "I have too many problems. I can't think about a show." Gee offered him a cup of coffee, but he declined, and as he prepared to leave, handed her a manila envelope.

"I want you to have this," he said, departing.

"The minute the door closed I tore open the envelope. There, to my surprise and great delight, was one of my favorite Robert Frank photographs: a young man, waiting for his lover in a park in Paris, holds a tulip behind his back."[4]

He was comfortably impulsive and rarely did he know what he wanted. But when he did want something, he had considerable skills for making it happen.

IN THE EARLY 1950s Frank met a photographer destined to be an influential force in his life. He probably encountered Walker Evans at a party in 1950, and although they didn't become friends right then, Frank would have noticed at a glance that here was someone who paid great attention to how he faced the world. Evans made you look, with a presentation that included waxed calf shoes from Peal & Co., fine blue Chambray work shirts, and the deployment of arm garters intended to maintain perfectly positioned sleeves. He pulled his glasses out of his jacket pocket with great effect, as if extracting a lorgnette. To the wealthy mandarins he courted, Evans made a statement: *I'm more like you than you are.* That was his disguise.

By the time they crossed paths, Evans had a well-established reputation as an eminent American photographer. His work, particularly from the late 1930s, was viewed as great modernism from an unlikely field, and he was deemed a taciturn witness to unnoticed America. When they met, Evans was an editor at *Fortune,* the glossiest magazine for business and Madison Avenue on the newsstand; he was soon to join the Century Club, an elite society of artists, writers, and wealthy benefactors based in a marble Beaux Arts clubhouse near Times Square. Evans did a convincing impression of an Upper East Side Great White Wasp, and as the years went on, his mask became ever more like his face.

But the protective coloration really *was* coloration, hiding at least as much as it displayed. The work that defined him—the photographs Evans took for the Farm Security Administration; the

collaboration with his friend, the writer James Agee, published in 1941, *Let Us Now Praise Famous Men*; Evans's 1938 book and Museum of Modern Art exhibition *American Photographs*—were the work of somebody dedicated to peering into the world and obscuring his relationship to it.[5]

American Photographs was a revelation, and though not the first important photo book, its influence was unprecedented. It came with stern instructions: "the reproductions presented in this book are intended to be looked at in their given sequence," we are informed, and every detail was considered—typeface, the Bible cloth that covered the first edition, and, most of all, the order of photographs. These were images made in Maine, Pennsylvania, Alabama, Georgia, and elsewhere during the Great Depression. It was structured in two sections, with photographs on the right, no caption or identifying information, nothing on the blank white facing page. Evans's eighty-seven photographs display vernacular architecture, people in streets, walls. There is nothing casual or unconsidered in its order and cumulative expansiveness. Published at a moment in American history when it was far from clear that democracy would hang on or that families would be fed, the book is an overwhelming catalogue of ambition and fear, most of all the photographer's.[6]

It challenged prevailing views of artistic photography—Evans's works seems transparent, so empty of anything but what we see, that it seems to belong to a different category of pictures from the painterly photography of Stieglitz, say, or the luxurious surface and finish of Steichen. If that is art, then just what is this? *American Photographs* hit an assortment of emotions that, en masse, evoked a national mood—mysteriously, grandly so in the second half, featuring all but unpopulated photographs of American buildings and spaces. There is a culture in that emptiness. His goals were huge—to convey a historic moment, to attack art, to interrogate a people and battle rote ideas of what it meant to document the world. *American Photographs* ends fittingly with an eddying architectural detail, energy swirling around a dark hole at the center. He had an unmatched eye for what details revealed about us all.

EVANS LOOKED AT YOU, people said, like you were his model. Charming and witty, full of questions, he didn't need his camera to interrogate. He didn't need his voice. He glanced, and one felt examined. Evans himself was comfortably seen in a variety of settings: both the elegant dining rooms stuffed with cupids, ormolu, and brocade and the downtown third-floor walk-ups with paint-splashed canvases on the walls.

He was interested in working with talented younger photographers, and after he brought Frank into the *Fortune* fold, Evans became his champion. Frank shot the Concord Hotel in the Catskills for the August 1955 *Fortune*. In November he presented a muscular photo essay, "The Congressional," depicting the Pennsylvania railroad line that carried the Brooks Brothers brigades from Penn Station to Washington, DC. In his accompanying text Evans, who started out wanting to be a writer and remained a thoughtful observer in print, describes the train as "a kind of mobile executive suite, permeated with the very face and tone and accent of U.S. business." That face, in the younger man's pictures, is baldly nonplussed and fatuous. "There is almost literally not an irregular or a mysterious character in view," Evans wrote with enthusiasm. Instead, there's an abundance of exaggerated gestures—an executive leaning in to share a secret, dismembered hands clutching drinks, feet waiting their turn for a shine. Nope, no irregular characters here, until we get to the last page, where Frank captures the lone black face, a Pullman porter, on the other side, our side, of the train's door.[7]

He asked for Frank's assistance on several projects, notably "Beauties of the Common Tool," a July 1955 Evans portfolio. The assistant tracked down the handsome implements displayed one to a page—the tin snips, crate opener, trowel, and crescent wrench—and assembled them on a set in Evans's York Avenue studio. Balancing the tools on a thin wire over a white backdrop, using a two-and-a-half-minute exposure to capture the pitted surfaces of these objects, Evans presented a tour de force that was also, somehow, laconic, jaunty like a Bing Crosby vocal. From such work Frank would later say, "I learned what it was to make a simple

photograph."[8] For the photo essay "These Dark Satanic Mills" Evans brought Frank along as a driver, and they rambled through Yankee towns shooting nineteenth-century factories. They rarely talked a lot, and when Evans saw an old stone structure he fancied, he would ask Frank to pull over, then ask him to remain by the car while he went ahead to do his work, alone. That, too, resonated with Frank. "He never said much. But he understood. Guys who don't have to say much but you know they understand you, they understand what you're about. We had a good thing that way."[9]

The two had a lot in common: both had a gift for hanging with social scenes they never fully committed to. Evans exhibited Anglo Saxon reserve; Frank presented hipster detachment. Both had a proud disdain for high-falutin' claims about photography and the pretensions of the art world. Of museums Evans once said, "When you are young you are open to influences, and you go to them, you go to museums. Then the street becomes your museum; the museum itself is bad for you. You don't want your work to spring from art; you want it to commence from life, and that's in the street now."[10] Both were college dropouts who read a lot (Cendrar's *Moravagine* was a favorite in common). They were comfortable with each other: Evans had given Frank the key to the railroad flat apartment where he kept his work.[11]

Frank often spoke fondly of the man he called "mon cher professeur." But ultimately what Evans was was a spy. A master of blending in, nobody ever really knew him. He preferred to keep distant from those he photographed, hoping to be invisible; in one of his most famous projects Evans hid a miniature camera beneath his coat, operated by a wire strung down his right arm, and took portraits of people unaware on the New York subway. Yet when it was time for his portrait to be taken to publicize his 1938 MoMA show, he refused to be captured—he wanted the attention directed to the art. His own qualities eluded those around him, and maybe they eluded him too.

Decades after his death scholars are still writing essays defining his skill at evading meaning in his art. Of photography he once said, "I had a childish interest in the trickery of it, and the

invention and challenge of getting a photograph under very ad-
verse and difficult conditions, requiring the use of your wits and
manual skill."[12] There was some Kim Philby in him; he was spar-
kling and bottomless.

The word *protégé* is not right for describing Frank's relationship
with Evans; one was too independent to accept it, the other too
independent to offer it. But they were friends, and they observed
each other closely. The spy craft practiced over the next few years
would alter the course of Frank's life.

AT THE CENTURY CLUB Evans socialized with Henry Allen Moe
of the John Simon Guggenheim Memorial Foundation. The pho-
tographer had been a Guggenheim Fellow himself in 1940, and
now Moe was asking for help evaluating the merit of the increas-
ing number of photographers applying for fellowships by the early
1950s.

When he returned from Europe Frank and the family moved
to 23rd Street, renting a loft above the House of Winn, a chemical
supply store. Seeking work, Frank walked into the office of the
fledgling Magnum photo agency, largely established by European
photographers who had unhappy histories with *Life* magazine—and
seemingly a fine fit for Frank. But picture editor John G. Morris
turned down his application.[13] It ate at him, and he expressed his
desperation in letters home to his parents. The family had grown,
with a daughter, Andrea, born in April 1954. There was new pres-
sure for money, and although freelance magazine work helped
pay the bills, the grind was more irksome than ever. Evans feared
his friend was so disheartened by his lack of success that he would
soon return to Europe. In hopes of keeping Frank in New York
Evans encouraged him to apply for a Guggenheim Fellowship,
and in mid-1954 Frank got on with it.

The two went back and forth defining the project and decid-
ing what should be said in the application. Drafts in the Walker
Evans Archive at the Metropolitan Museum of Art show them
starting pragmatically, describing a sweeping journey across the

country by car for the sake of recording impressions of the American scene, echoing Evans's earlier work. The writing, too, echoes Evans's voice. The undertaking would have a strong documentary component, including caption notes, a concession Frank disliked making. Pledging a documentary approach was likely a way to assuage Foundation judges that the project was quantifiable and useful, which photography was expected to be. Elsewhere, however, it was clear to them that subjectivity would prevail. The result, they declared, would be "what happens when a strong man sets out to work with an untethered eye." (That sentence didn't make it into the final version.)[14]

There also was this: even before Frank had finished his application he sensed the impact the project was likely to have. In his notes and drafts he is laying out an effort bound to present a set of judgments of the national moment. The talk goes beyond what subjects might be photographed, what approach the photographer would take. It lightly brushes up against the certainty that the judgment would not be taken lightly.

A few years before he died in 1975 Evans gave a self-evaluation that might seem surprising for someone whose work seems so transparent. "My photography was a semi-conscious reaction against right-thinking and optimism," he said; "It was an attack on the establishment."[15] Both men were inured to the go-along. The year 1954 saw President Eisenhower fight to have the words "under God" included in the Pledge of Allegiance; mass currents of optimism were administered to the American patient in ongoing electroconvulsive treatments. Right-thinking was a weapon in the fight against the Red Menace, and to question it too directly was to risk having weaponry deployed against the critic. In any case, it was clear that Frank felt his strongly stated response to what he saw on the road had to be a part of the project, and he knew how *that* was likely to go down.

"America can stand it," one draft declares. Then, on a following page, "Americans can stand it" appears in a margin. If Frank had written it one more time, you might wonder how sure he was. Even before a proposal had been completed the writer of those

words knew that to respond to the moment would stir up resentment and charges of anti-Americanism. Something caustic and unstable was at large—both in the nation and in the untethered eye of the applicant.[16]

The émigrés, veterans, survivors of Depression and war, everybody staggering around Times Square and everybody else had been cast in an unfamiliar space. Robert Creeley felt it: "Coming of age in the forties, in the chaos of the Second World War, one felt the kinds of coherence that might have been fact of other time and place were no longer possible. There seemed no logic, so to speak, that could bring together all the violent disparities of that experience. The arts especially were shaken and the *picture of the world* that might previously have served them had to be reformed."[17]

New shapes emerged out of that brokenness, and among them were political, psychological, social forms that continued unfolding into a larger structure. For a growing subset of the populace the Cold War offered an unacceptable exchange: security and prosperity at the expense of possibility—call it freedom—on cultural and personal fronts. The Beats were maybe the most visible form of this rebellion, but they weren't the only one. There were Rat Bastards and Ratfinks, film societies and devotees of the orgone box, criminal cabals and anarchists looking for fissures in daily life to stick their beak in. Many bodies never gave themselves a name. And then there were two guys, one in a double-breasted suit, writing a letter to Henry Allen Moe.

Through the summer of 1954 Frank continued to work on his pitch to the Guggenheim Foundation, and while he did he was making photographs that pushed into unstable territory. In July he went to Jay, New York, in the northeastern corner of the state, to photograph an Independence Day celebration. Looking through a patched and worn American flag suspended from outside the picture, Frank photographed people trailing around and below the cloth; the flag seems to hang from the sky, dominating the celebrants wandering aimlessly around it. In September he shot a rodeo cowboy outside Madison Square Garden, the symbol of American individualism here looking smutty as he leans against a

trash can and rolls a smoke. This wasn't commercial work, though Frank wasn't averse to using these images for a commercial purpose; Frank was thinking about his adopted home, looking at its symbols in order to say something about a place that lived as symbol as much as it lived any other way and picking up momentum for a project that hadn't yet been launched.

His application, received by the Foundation on October 21, 1954, provided a concise statement of his thinking.[18] He would "photograph freely throughout the United States" in order to make "a broad, voluminous picture record of things American, past and present." The tone is relaxed, confident. The project will be "the visual study of a civilization." Having established his steep ambitions and giving himself as much freedom as he dares by defining his project so broadly, a little backtracking is necessary, and Frank says he knows how that sounds—"absurd"—and goes on to frame things more modestly. "What I have in mind, then, is observation and record of what one naturalized American finds to see in the United States that signifies the kind of civilization born here and spreading elsewhere." It is humble: *I'm just a new American looking at things that get my attention.* Alarmed, too: *the energy I'm seeing—do you see it too?—is contagious, jumping borders and opening franchise shops and safe houses around the world.* Finally this passage is one more quick thrust at definition: *sure, it's about making a record, a record of what I see.*

"I speak of the things that are there, anywhere and everywhere—easily found, not easily selected and interpreted": touching on what interests him and suggesting they are ordinary sights that yield infectious, unordinary feelings. "Selected and interpreted" also hints at his method, suggesting the way that choice, sequence, and flow will define the project and give a series of photographs the meaning he wants them to have. And then with words he offers a disarming rebus of the ordinary sights he intends to put before us: "A small catalog comes to the mind's eye: a town at night, a parking lot, a supermarket, a highway, the man who owns three cars and the man who owns none, the farmer and his children, a new house and a warped clapboard house, the dictation of taste,

the dream of grandeur, advertising, neon lights, the faces of the leaders and the faces of the followers, gas tanks and post offices and backyards." That catalog is an incantation of American fragments that keeps twisting in the light, moving from a moment to a place then to a person, a command, and a dream. It is stirring and the most explicit evidence of Evans's hand, for the photographer was a loving and resolute maker of word lists. At the heart of this single-page document, this list is entirely honest in describing the project ahead while carefully setting it in Coplandesque chords and sighing light.

He ends with practical matters: Frank knows "you" are thinking this sounds like a huge and formless enterprise, a road to forever. So he clarifies that though he will be exposing vast lines of film, he has a plan for managing it all: "I intend to classify and annotate my work on the spot, as I proceed." The moment will decide. Improvisation, guided by technique and learned reflex. "The material is there; the practice will be in the photographer's hand, the vision in his mind." The hand will think while the mind sees: this is a swagger conducted ten feet off the ground. Guided by the spirit of living in the moment, he will *know* what is worth photographing and what photograph is worth developing. He can't explain it, and even in this short amount of space, in a document only a few hundred words long, he has all but told the reader that even if he could, he has no intention of explaining what he is looking for, what this could amount to.

Letters of recommendation also came in. Edward Steichen wrote one, and in it was a knowing endorsement: "He seems less able to make the kind of photographs that the magazines could use than any other good photographer and that is largely because, 1, he lacks all practical sense and, 2, and more important, editors and publishers are not as yet aware of the importance of a poet with a camera."[19] A poet with a camera: a phrase Steichen was fond of when he spoke of Frank, it pops up in articles about Frank that Steichen had a hand in. He repeats it twice here, and it appears prominently in a 1953 article in *U.S. Camera* (edited by his friend and partner in various projects, Tom Maloney). Steichen

took it upon himself to develop what a Steichen of today would call Frank's brand, and over the next few years the concept of Frank, the poet with a camera, would take hold.

Other letters of support came from Evans, Alexey Brodovitch, *Vogue* magazine art director Alexander Liberman, and Columbia University art historian Meyer Schapiro. It is hard to imagine a group of names any more impressive bordering on overkill than this lineup. The day after he filed, Frank photographed a society ball at the Waldorf Astoria. He photographed gowned dowagers and tuxedoed gents; these, too, like cowboys and the Fourth of July, were part of the story he was beginning to tell.

WHILE HE WAITED to hear from the Guggenheim Foundation Frank was set to participate in a show that would give him mass exposure. The opportunity was distressing.

Steichen and his assistant, Wayne Miller, had been working on a project for several years, an exhibition he named "The Family of Man." In his seventies, the ego-driven impresario was on a legacy hunt, and "The Family of Man" was a sprawling, unstoppable representation of his appetites. It was big, featuring 503 photographs from 273 photographers from sixty-eight nations, taking over the museum's second floor. A quarter of a million people would view the exhibition in New York before it went on the road for years in various editions, ultimately to be seen by more than 9 million viewers. It was visionary, creating an installation environment that placed photographs everywhere: squeezed together, peering down from the ceiling and using pictures as traffic dividers throughout the museum. "The Family of Man" screamed that photography mattered, not merely as art, not even as mass communication, but as a tool for saving the world from nuclear destruction. The Cold War between the United States and the Soviet Union touched all aspects of culture, and the prospect of nuclear war scared people. Steichen thought that by putting photographs of families and children from around the world in front of a global audience, all would see how our similarities dwarfed our disagreements. The

exhibition was pitched as deeply humanist and was interspersed with quotations from the likes of Carl Sandburg, Bertrand Russell, and the Bible. Steichen felt the time was right for a "positive" declaration of "what a wonderful thing life was, how marvelous people were, and, above all, how alike people were in all parts of the world."[20]

When "Family" opened on January 24, 1955, there were seven photographs by Frank hanging, more than most other artists received. (There was also a Louis Faurer portrait of Robert and Mary Frank.) Frank liked the attention, but he probably didn't appreciate the supplemental texts on the walls and definitely didn't like the way in which work by individual artists was subsumed into the overall vision of Steichen. It gave him important exposure, but Frank would later dismiss the exhibition as "the tots and tits show."[21]

One more thing brought Walker Evans and Frank together: a dislike of Steichen. Evans had made that plain long ago in a 1931 piece for a literary journal where he referred to his "technical impressiveness and spiritual emptiness." Of Steichen's work Evans declared, "the general tone is money."[22] Frank was in no position to voice his own criticism of the director, but by the early 1950s he had learned all he would from him. Eventually he would call Steichen "the personification of sentimentality."[23]

Steichen described "The Family of Man" as "a mirror of the essential oneness of mankind throughout the world." Photography was the universal language, he believed, and with the right pictures seen by all, the world could be transformed. That was a worldview that Frank had doubts about. "The Family of Man" let viewers wander in multiple directions but ultimately led them to a single intersection, marking the exhibition's lone color image: a six-by-eight-foot mushroom cloud. The Russians had exploded their first thermonuclear device in 1953, the United States a year before that. It was waiting for us, Steichen exclaimed, unless the power of photography triumphed.

Atomic anxiety was settling in. In her published diaries actress and Living Theater founder Judith Malina described a telling

moment. She was protesting the Korean War, posting stickered messages in public spaces around New York, stuff like "War Is Hell. Resist It" and "All Politicians Make War. Don't Vote." She and husband Julian Beck were dead-serious, old-school Greenwich Village radicals when, on a fall 1950 night, they dropped in on a venerable Village haunt. Malina said, "We eat at Chumley's, where we join a group of gorgeous young people playing with a bouncing, melting, snapping substance called Silly Putty. When we leave, a laughing young woman calls after us: 'Soon everyone will be busy with this. No time for war. No atom bombs. Silly Putty will end wars.'"[24]

Delirious and sexy. The young people's antimessage sounded ridiculous to Malina but also so intriguing that she never passes judgment on them. Whimsy, absurdity, play, and a refusal to give in to fear. In the days and years ahead Silly Putty would roll into the Village—carried by the ones crawling out of car wrecks, the kin of Huncke and Ginsberg. Silly Putty readings and Silly Putty jazz and Silly Putty apolitics filling up the circles of Washington Square Park. You could side with anyone you wanted. Steichen's Cold War liberalism was very good to Frank, who didn't have a lot of Silly Putty in his soul. But there was something far wilder coming into its own, and Frank knew one thing: he wanted to be a part of it.

CHAPTER SIX

LIKE JUMPING IN THE WATER

AROUND THE TIME Frank was witnessing the top-hatted bankers of London, a new American president, Dwight D. Eisenhower, was sworn into office. Eisenhower did not wear a top hat. Breaking with tradition, he opted instead for a black homburg.

Robert Lowell's poem "Inauguration Day: January 1953" was one response, a sorrowful one, to the changing climate the poet deduced. Lowell described a cultural polar vortex lowering the national temperature, a vision of ice and wheels locked in place:

> and the Republic summons Ike,
> the mausoleum in her heart.[1]

Here in the form of a soulless soldier-in-chief, Lowell and other dissenters saw the embodiment of various Cold War forces—nuclear fission and consumerism and golf, forces beyond the control of a poet or picture maker. A growing number of poets and picture makers in the days ahead would weigh these forces and their impact on the landscape. Frank was one.

On April 15, 1955, he was informed he was a Guggenheim Fellow, and along with the honor came a $3,600 check. On May 1 President Eisenhower observed a new holiday that had just been created by Congress: Loyalty Day.

Frank started planning his route through America. A man with a penchant for hitting the road during times of stress (a family, a

war) suddenly faced an inversion: the highest-profile work of his life involved getting out on the road. For whatever reason Frank remained in New York City for the next two months. Freelance magazine work came first, including a job with Evans for *Fortune* ("Mills"). Frank began shooting for his Guggenheim project around New York City, photographing jukeboxes.

The coin-operated record player activated the senses; Frank would say later how much he wanted his pictures to be heard as well as seen. Jukeboxes provided rich symbolism as well. To a European their novelty evoked what Frank in his proposal called "the kind of civilization born here and spreading elsewhere." A *New York Times* think piece took the pulse of Europeans who wondered whether Americans were "sinister predatory imperialists," their destructive force exemplified by "our jukebox, push-button civilization."[2] At home Clement Greenberg wailed over our spreading "'jukebox,' or 'lowbrow' culture"[3] and warned of the lobotomies ahead. Frank photographed adolescents in a New York candy store, slumped around a jukebox. The kids in this picture have a distracted, sullen presence; they mostly look away from the camera. A partially visible sign on the back wall displays the words "made blinds." A kid sits beside the jukebox, his eyes in direct line with the metal trim decorating it—an arrow points at his eyeball. Seeing and sightlessness would become a theme for the entire project before him: that America in the mid-1950s was hostile to discovery and a land of the blind. That was the start. Looking, it was clear, would lead to greater clarity.

But first he needed to establish his ride. Frank's friend Ben Schultz was a true believer in the power of photography, a fan and art director zealous in support of good work. When Schultz mentioned he was selling his car, Frank bought it, a 1950 black Ford Business Coupe. The automobile industry's first model update since World War II, the car saw limited production and stood out in the early 1950s as a symbol of youth and modernity. "When Ford redesigned them in 1949 they made them bigger and squarer, and the hotrodders called them shoe boxes," says Steve Gibbs, former director of competition for the National Hotrod Association.[4]

For Frank the Coupe was a sound buy. With no backseat, the storage space made it a traveling salesman's favorite, and it would be useful for stashing photographic equipment and lots of film. With no radio, no working rear windows, and not much insulation, it was no luxury vehicle. "It was a basic car, but being a coupe, a real pretty one," says artist Hudson Marquez.[5]

Along with jukeboxes, Frank felt from the beginning that automobiles would have a strong presence in the work. They were an obvious unifying fact and symbol for a country spread over vast distances. What they symbolized, the open-ended way Frank envisioned it, was contradictory. Automobiles stood for American consumerism and conformity. At the same time a rootlessness among those who were critical of conformity was emerging, and the automobile gave youth culture and outsiders their freedom. There was the Business Coupe, with its ample space for product samples, on the one hand, and the chopped and channeled body of the coupe re-envisioned by drag racers, already regularly reinvented by the mid-1950s, on the other. For Frank cars would evoke both the hope and hopelessness he found by the roadside.

For luck or inspiration he carried with him a copy of Walker Evans's *American Photographs*.[6]

On his first extended road trip Frank drove across Pennsylvania to Cleveland in late June, then headed north to the home of the auto industry, Detroit. The city and surrounding areas—Ann Arbor, Dearborn, Grosse Pointe, Belle Isle—generated many pictures. A drugstore lunch counter, a factory's rooftop parking lot, a Motor City rodeo, families at the beach, families in cars, teenagers making out in a park. Once in Detroit Frank found his plans slowing considerably. The car needed work, and he waited several days for permission to shoot in Ford's massive River Rouge plant. He bided his time observing the city with a source who knew it better than he. In an interview for a Japanese magazine Frank said he picked up an African American prostitute, took her to his hotel, and then drove around with her for days, seeing aspects of the region he otherwise would not have experienced, hiding her

beneath the dashboard when a police car was in view.[7] A white man with a black woman in his car was an open invitation for arrest. One night, after seeing a music performance in a black neighborhood, Frank was stopped by a cop who *did* get a look inside his car. He spent the night in jail (he would sometimes say he was arrested because he had a set of illegal plates stored in his trunk). Waking up the next morning he was handed a mop and ordered to clean a hallway. "I sort of liked it," he said. "I knew I would get out." In the 1960s, at an INS interview for his application for American citizenship, a clerk asked Frank about the Detroit arrest. He became indignant: "I told her that if I could not become an American citizen because a black person was seen in my car, I wasn't interested in America."[8]

Sitting in a humid diner and "sweating like hell," he wrote Mary a letter, a response to one of hers he had just read. He was in a momentary funk, or a funk that would tinge the entire project, or the funk that would tinge his entire life: "Your letter is not cheerful but your letters are often sad. I would like to write to you something nice and maybe something nice will come out—eventually." He recalled how inspired he felt when he got word of the Guggenheim and said he was glad he kept pushing—implying part of him didn't *want* to push on. If he hadn't made it as far as Detroit, "I would call it a game and lie down anywhere where it is nice and not think about photographs." The arrest, he admitted, had scared him. "I was ready to give up when they let me out."[9]

The River Rouge plant, a huge and clangorous place, lifted his spirits, and for several days he shot perspiring men squeezed together on an assembly line where the air looked full of carbon fibers. He had the freedom to go where he wanted, though everywhere he stepped a Ford rep followed, but when a worker on the line shouted something and suddenly all the men were shouting together, the Ford shadow briskly said, "Alright that's it," shutting Frank down just as a wildcat strike jumped off.[10]

Head back to New York, pick up Mary, drive down the coast to the Chesapeake Bay, and cut inland and south into the Carolinas.

Elizabethtown, North Carolina; Columbia, Georgetown, down
through McClellanville, Charleston, Beaufort, St. Helena, and Sa-
vannah in South Carolina. Photographs include an African Amer-
ican caretaker holding a white baby, a jukebox, and a soldier. He
worked with one, sometimes two 35mm cameras simultaneously,
one frequently mounted with a wide-angle lens and another with
a 55mm lens and high-speed black-and-white film. A wrenching
picture of black mourners at a funeral, full of tender gestures and
averted gazes, though not uniformly averted: the man furthest
from the camera is looking right at Frank, and this note of en-
counter becomes a motif too, from the candy store in New York to
the courthouse square in North Carolina and beyond. A flickering
moment between photographer and subject, triggering pushback,
resentment, threat. A record of Frank's interaction with an instant.
Barbershop, empty café, a woman sitting gloriously on a chair in
a field. Hit a town. Get a room in a no-star bus station hotel. Look
for a Woolworth's, order a Coke. "Normally," he said, "it was the
first place I went to. For some reason I found it very heartening. I
mean everything was bad. And then I went to the cemetery. And
then maybe a golf course."[11]

He returned home around August, driving to Newburgh, New
York, to photograph a biker rally. He's walking up on a leather-
jacketed hellion from behind, and all of a sudden the young man
in aviator glasses and a breathtaking coif turns around and shoots
Frank a look that would have stopped most predators in their
tracks. Always he has his own skin in the game and is tipping
you off that he's recording his reaction to the world. One senses
Frank planned the turnaround—he certainly is prepared for it—and
that there's not a lot that could throw him; you get the feeling he
wants to get thrown, that he courts reactions and spontaneity. He
is stepping into a flow, not a frieze, looking for truth in what is not
in balance.[12]

His friend Miles Forst had watched him work this way, and it
stuck with him, Forst noting his extraordinary ability to move in
and out of groups of people without bringing them to a halt. Like

Buster Keaton, Frank had a priceless deadpan. Expressionless and apart, he could be anything or nothing. "He can become a chair or another person or he can be black, white. He can be a fisherman, a hunter, a soldier, it doesn't matter," said Forst.[13] Frequently Frank didn't look through the camera's viewfinder when he worked. It seemed to Forst that his hand controlled his thought, deciding when and what to shoot.

In Newburgh he gets a first exposure of the motorcyclist turning around, and it's a blur. A fraction later, the biker stops moving enough to be frozen in the camera, a portrait of defiance. *The Wild One*, the movie about young rebel bikers that made Marlon Brando famous, had appeared only months before. A new contagion in American culture about which nobody knew what to say other than *here it is*. Another Newburgh photograph, not in *The Americans* but visible on the contact sheet: a small gang of leathered young Americans on foot, black, white, and brown, moving as a group, in a surge of purposeful action, heading to a rally or a beatdown by the riverside. It's a multiethnic youth burst that might have been the least fathomable picture he took on the whole journey.

Rocketing through a blur. Early fall, driving solo again, straight down to Miami Beach, then to St. Petersburg, into Georgia, then Tennessee. Old-timers watching traffic in St. Petersburg, a Memphis train station men's room. He didn't much talk to people, and there are no notes or journal record of what he did.

Frank was drawn to technology that let him burrow into the scene. Another photographer who dove into Times Square in the late 1940s, Dan Weiner, wrote with precision about this attraction. Weiner too saw the need for blankness. "The photographer and the camera had to be made as unobtrusive as possible so that his personality would not intrude or the consciousness of the camera not change the natural course of events. Respect for reality must be the basis," he wrote.[14] Neither Weiner nor Frank was interested in a neutral record of a moment. Righteous documentation required digging into *yourself* and implicating yourself in the work. For photographers who wanted to make photography most like life, this

was the challenge, Weiner said. "This is what photography is made of: your relationship to yourself, to the people around you, what you feel, what you have to say, and then, how you see it."[15]

This was an immersion experience, not determined by "making a connection" with people. He shot into something vast and deep, and he could never see the bottom of it. "When I traveled around America at that time, it was like jumping in the water and being attacked by the waves. I liked it."[16]

It might have been in Tennessee, Frank thought, that something unexpected happened, so strange that he could only compare it to movies. In a town where almost nobody was out on the street, he held his camera, leaning against a storefront. "And then this guy comes up with his big hat," Frank remembered. Asking, well, telling him, "What are you doing here?" He pulled a large watch from his pants pocket and said, "I'm going to give you till one o'clock to get out of this town."[17]

The waves pushed at you, and you struggled to keep upright.

Escorted to the side of the road by two state police vehicles, Frank got out of his car around noon on November 7 in McGehee, Arkansas. Available paperwork shows no actual reason why he was pulled over on US 65; the New York license plates in a small Southern town were invitation enough.

They told him to put his hands in the air. The vehicle was searched. He looked over at the front of the car and saw a bird stuck in the grill, a little bit alive. One of the policemen kicked it off with his boot. "And I look at the guy and I knew this was serious, they were not going to fuck around."[18] They left the car and drove Frank to jail.

What officers found in their search had excited their suspicions. A foreign passport, cameras, and numerous rolls of undeveloped film. There was a bottle of whiskey inside—foreign, the officers wrote down—and somehow, either at the roadside or at the jail, they learned that the suspect was Jewish. The contempt of the arresting officer, Lieutenant R. E. Brown, comes through in a report filed a month later. "After stopping the car I noticed that he was shabbily dressed, needed a shave and a haircut, also a bath.

Subject talked with a foreign accent." Brown took Frank to the city lockup, where he shared a cell with an African American man who refused to speak to him. In a while a black girl was sent to get food from a diner. She came back and shot Frank a look of pity—"it was the only human face I saw that was sympathetic."[19]

Lieutenant Brown returned to question him, and Frank struggled to contain his responses under provocation. "He was very uncooperative and had a tendency to be 'smart-elecky' in answering questions," wrote Brown. Accompanied by a local who had counterintelligence training in World War II, Brown asked Frank a sloppy, threatening barrage of questions into the evening. *If you're Jewish, why don't you speak Hebrew? Why are your cufflinks stored in a small metal box? Are you a Commie?* They doubted he would have been given access to photograph the Ford plant in Detroit because one of the questioners had been there months before and was not allowed to take a tour. They noted the "foreign" sounding names of his children, Pablo and Andrea. Catastrophically, they threatened to develop rolls of film he had in his car; Frank forcefully but carefully said that that would risk his entire project and insisted it not be done.

The early years of the 1950s had seen a series of high-profile "atom spy" trials in the press, with spies sometimes Jewish and hailing from New York. This was not lost on the Arkansas State Police. In a place where outsiders were viewed as Red intruders sent to undermine segregation, various fears had converged on that 1950 Ford Business Coupe. But nothing cracked Frank's story that he was a photographer taking pictures of America while on a fellowship from the Guggenheim Foundation. Finally they told him if he would jimmy open a locked trunk still sitting in his car (Frank couldn't find the key) and showed them its contents, they would consider releasing him. Frank and the officers returned to the Coupe, and Frank opened the box. Inside they found something that instantly put them at ease. Frank's name and work printed in a copy of *Fortune.* He had packed the November issue, featuring his photo-essay "The Congressional." What could be more American than having your work published in the monthly instructional

manual of American capitalism? They fingerprinted him, made him sign his name in the space marked "criminal" on a form, and released him at midnight in McGehee. He was shaken.

The Arkansas detention has been the part of the cross-country experience that Frank has spoken of the most and one of the few chapters that he talks about with anything resembling eagerness. In the context of southern police history, a twelve-hour arrest and interrogation seems closer to an inconvenience than tragedy. However, later documentation sheds light on what a dangerous moment it was. McGehee was the home of the grand dragon of the Arkansas KKK. In a book valorizing the history of the Arkansas State Troopers, R. E. Brown is called "One of the most colorful characters ever to grace the department's employment roster." Although author Dempsie Coffman never says what made him so colorful, an oral history project made available in recent years helps fill out the portrait of Brown.[20]

One fellow trooper called him "hell on wheels." It was not uncommon for Brown to beat prisoners. In an interview retired state police officer Ray Carnahan fondly described him further. "Captain R. E. Brown was a great guy. It is possible that he killed more men in the line of duty than anyone else in the State Police." Carnahan recalls Brown using his belt to work over prisoners who didn't do what he wanted. "He was definitely someone you did not want to fool with."[21]

Driving south from McGehee at midnight Frank was followed past city limits to a motel. An officer came in while he was drinking coffee, and Frank braced himself to be arrested again.[22]

To Mississippi. From Port Gibson Frank wrote Evans, explaining, "During the examination I was as courteous as I could be—I realized what would happen if I could not do that." He asked for help in getting his fingerprint records returned to him; the cops in McGehee had mailed a copy to the FBI, and Frank was worried that would end his plans to become a naturalized US citizen. In Switzerland Frank had been rendered stateless by government paperwork, and now, he might have feared, it was happening again. He had been labeled a criminal, and the evidence was his accent,

his looks, his Jewishness. (An attorney Evans contacted wrote Frank that Lieutenant Brown had indeed sent his fingerprints to the FBI and that it would be difficult to have them returned.[23])

While in Port Chester Frank was fading back from the crowd, watching a group of white kids playing football, when one of them approached him with a menacing invitation. "Why don't you go to the other side of town where the niggers play?" What he did instead was photograph the group hanging out, a portrait of lazy-lidded teenage loathing.

Frank's self-chosen identity as an outsider suddenly became more complicated. Forces beyond his control now marked him as "not from around here." Four days later Frank was in New Orleans, fully informed by his McGehee awakening. He was watching a parade, standing in the street, rotating; in the contact sheet there are buses in one frame, then a band, then motorcycle cops as he turns. Unpromising compositions until one more turn and—a voodoo shot of a crowd on Canal Street, blacks and whites passing before him dead center. *Canal Street—New Orleans*, an image of tension and hypnosis, a feeling of distracted rage, oblivion as a sidewalk stroll. Turning, his hand takes two quick exposures of the crowd watching the parade. Now standing alongside a trolley car he photographed the people inside: five windows, whites in the front three, blacks in the back. The hate in a white woman's eyes, the exhaustion on a black man's face, the way each window seems to trap the individual behind it. Powerful as well are the glass panes above the windows that distort and reflect the street in weird shapes and flickerings. They become abstract thought bubbles that speak an incoherent commentary, giving a judgment that is emphatic—just not understood. Frank had observed American racism before McGehee—in *Charleston, South Carolina*, his photograph of an African American nanny holding a white baby, for instance. But after McGehee the work turned on a new axis.

"I wasn't thinking about segregation when I shot it," Frank has said of *Trolley—New Orleans*.[24] His point is he wasn't "thinking" of anything in New Orleans: he saw and felt and committed to an exposure. He's not framing a "response" to Jim Crow, nor is he

letting the people before him formulate their response to him. They aren't composed—Frank's reaching for the moment before or after people have arranged themselves. Two of the most amazing photographs anybody has ever taken, one autumn stand on Canal Street. "When you do something you have to feel about it—I knew the photographs were, um *true*, they were what I felt, they were completely intuited, there was no thinking," he would explain. "That feeling stayed with me. I never wavered from that."[25]

Head west. Mary and the kids met him in Houston. They went to a small-town Texas café, with few folks present. They get the look, the one that says we know who you aren't. The waitress takes a long time, and when she arrives, stands there staring. Robert asks for coffee. Stands there. "Do you have apple pie?" Stands there. "Yes." She never came back with coffee or pie.

"That was one of the things that must have really had a very strong impression on me in America," Frank said later. "The kind of injustice or open hatred toward certain people. Americans can be very brutal. They are very tough and they are not afraid. I was very sensitive to that."[26]

Further west to New Mexico, Arizona, Las Vegas. A handwritten letter to Evans on stationery from the Hotel Roswell in Del Rio Texas: "We are now in Carlsbad, N.M. No more arrests since I travel en *familie*."[27] They eked by. Mary: "We lived such a bohemian life. It seems to me I had no plans at all. We just took off in a car. It was freezing in Texas, a lot of snow, and I thought we were going to picnic on the grass. Two kids, one of them sick, no place to wash diapers. We didn't know where we were going or where we'd stay."[28]

A man standing before a jukebox in a deserted bar, one of the saddest pictures he took. A car accident, a body covered with a blanket by the roadside between Winslow and Flagstaff, Arizona, as snow falls. A bank in Houston, a tough bar in Gallup—that last one a blind shot between men in cowboy hats, the camera in his hand almost touching the floor. Some of the pictures, like the gambler in Elko, Nevada, seem to be taken by holding his camera over his head and blindly feeling it. Sometimes looking through your

viewfinder kept you from seeing, he said. He preferred to really see.

The Franks took Route 66 to Los Angeles, where they stayed in an apartment in the Hollywood Hills. "To live for two months in L.A. is like being hospitalized in a Paris hospital," Frank wrote Evans, "if you *have to* stay longer one gets worse quickly."[29] They stayed for three. Frank photographed movie premieres, both *The Man with the Golden Arm* and *Helen of Troy*, a TV studio, the crumbling Victorian boarding houses of Bunker Hill, a Daughters of the American Revolution meeting. He began developing some of the hundreds of rolls of film he had accumulated, using the darkroom of Shirley Burden, a photographer and associate of Steichen's.

Coming to rest in LA allowed him a chance to evaluate the undertaking so far. In the break, consciousness caught up with instinct: what he had seen now brought an awareness that altered his work. He had turned from a desire for observation to a desire for judgment. "I am working very hard not just to photograph, but to give an opinion in my photos of America," he wrote.[30] America was interesting, he told his parents, but he understood better than before that there was much he could never get used to. Now he knew he needed to get this emotional response into his images.

The apartment became a West Coast annex of their New York loft, furniture made of boards and boxes, a mattress on the floor, stuff everywhere. Frank was running low on funds and seeking commercial work from his East Coast contacts. The opportunity to freelance may have been part of why he lingered in LA, and while there he toured the film studios, went to stock car races in the desert and the Rose Bowl. While he explored, Mary and the kids remained in the apartment. He admitted to his parents that Mary had it rough because she couldn't drive and they couldn't afford a babysitter—to be carless and stranded in LA is a cruel isolation.

From Los Angeles the family drove up to the Bay Area, staying in Orinda with Wayne Miller, a photographer who was Steichen's assistant on "The Family of Man." Frank developed more film, with a confidence that impressed his host. "He developed in my darkroom, just the negatives. And he edited them," Miller recalled

later. "Interestingly, he edited them by holding the negatives up and looking at the images and then took a pair of scissors and cut out those that he wanted to save and he discarded the rest without making any contact prints. I thought it was quite courageous to do that. But he made his decisions and just went on."[31]

Wanting to continue his work but needing money, Frank requested a renewal of his Guggenheim Fellowship, consulting with Evans (who had received an extension on his own fellowship in 1940), laying out goals for the drive ahead. In the end he and Mary wrote and edited an application that was submitted in March 1956, and in mid-April he was notified he would receive an extension through May of 1957. Frank began planning a drive across the northern part of the country. Mary and the children went back to New York that month, and Robert mapped a drive taking him through Nevada, Utah, and across the Great Plains.

Northern California to Las Vegas and Elko, Nevada. He'd been gambling a lot, and he was tired, and in Blackfoot, Idaho, he picked up two Native American hitchhikers, asking them to drive so he could rest, but he wasn't too tired to fire off a few pictures of them beside him in the car. In the first one they look consumed by the road ahead, their faces weary masks seemingly ready to fall off if Frank so much as touches them. In the next shot they are smiling, talking, relaxed. He printed the first one.

Highway 91 was icy, and the car "spun around many times!" he said. The three drove to Butte, Montana, where his passengers went looking for work.[32] The view through a Butte hotel window, coal pumping into the sky; a gloomy farm, no people, between Ogallala and North Platte, Nebraska; flowers and crosses on sale in a Lincoln store. It is a foreboding stretch of highway. Across to Chicago, then down to Indianapolis for one signal image, another motorcycle vision: an African American couple dressed in denim and studs, on a darkly gleaming Harley engine. This image is as audible as all of his jukeboxes: they are roaring past us and framed forever before us. On their way to somewhere loud and free, a picture of "Jesus and Mary on the flight to Egypt," as the photographer Emmet Gowan would describe it to his students.[33] Insofar as

the photographs of his Guggenheim project had a shared concept, Frank said it was *elegance, life, and mystery*. All of those qualities are here in this Indianapolis launch. The riders went to Memphis, Tennessee, or Memphis, Egypt. Frank, exhausted after the better part of a year on the road, just went home.[34]

BY JUNE HE WAS BACK in New York and living in a Greenwich Village loft at 34 Third Avenue. It was a neighborhood, to paraphrase the art historian Judith Stein, that had more artists per square foot than any other part of New York City. Frank's next-door neighbor was a gregarious painter and former bodybuilder, Alfred Leslie. The two hit it off quickly, and Frank met others through their friendship. One day Robert and Mary dropped in on Leslie—one didn't knock—only to find two naked strangers wrestling on the floor. It was Frank's introduction to the poet Allen Ginsberg and his lover, Peter Orlovsky. They all became friends.[35]

Robert and Mary Frank were part of a coterie that formed around the Hansa Gallery, a small but influential art space of the 1950s that was originally on 12th Street in the Village. The Franks had known the artists Miles and Barbara Forst in the early 1950s and through them met art dealer Richard Bellamy, and these friends were all present at the founding of the Hansa Gallery. The Hansa was an artist-run cooperative, and a statement attributed to member and painter Wolf Kahn said something essential about the place: "to sell is to sell out." Bellamy would slap an outlandish price on a piece of art—oh, five thousand for a Jean Follet drawing—because they didn't really *want* to sell art so much as they wanted to share it with people capable of seeing. Their way of thinking about the work of making art was one that Frank already appreciated, and doubtless he appreciated living in a part of the city where that idea carried special weight. Bellamy's biographer Stein says that although Frank was never a member of the Hansa cooperative, he was embedded in its origins, noting that planning documents for the gallery were handwritten on Frank's personal stationery.[36]

Mary Frank and painters Barbara Forst and Dody Muller formed a trio of black-clad goddesses that spun heads from Tenth Street to Provincetown. In an ethereal Robert Frank photograph the women and Pablo Frank are dancing and twirling sparklers on the beach at Cape Cod. The three were bewitching and fully owning it, shooting sparks in a Village scene that provided little space for female artists. "Everybody was screwing everybody else compulsively," Barbara Forst told Diane Arbus's biographer Patricia Bosworth. "We all thought . . . that sex was very important; that our bodies were a source of power—maybe our only source of power."[37] Miles Forst likened the scene to the Max Ophuls film *La Ronde*, where partners changed freely.[38]

They lived in the middle of a heavily male enclave, spiked with gin and gamecock squawks like Willem de Kooning's "History doesn't influence me. I influence it."[39] On 10th Street, Mary Frank said, the houses had front steps where the painters hung out yakking about "who used the biggest brushes, who used more paint, who used much more paint, and whose paintings were heavier."[40]

The building the Franks, the Forsts, and Leslie all shared looked out on a central courtyard, and across it they could see the back of a Tenth Street building. At night you could watch one of its residents, Willem de Kooning, standing over a canvas, pacing for hours, shirtless and locked in thought over a painting that might take years to complete. Since before he had gotten in the car Frank was moving toward an approach that incorporated intuition. Technique, finish, the lore of the "fine arts print" inherent in the work of Ansel Adams or Edward Weston or Edward Steichen had long run the table, while Frank was playing a separate game. Looking at the early applications of the Leica in America, observers have made a connection between the art of the abstract expressionists like de Kooning, Jackson Pollock, and Hans Hoffmann—with their slashing brushstrokes and off-center compositions—and what has been called the New York School of photography. "I always think of Robert as an abstract expressionist," said Frank's friend, the photographer Ed Grazda.[41] But Frank and his cohorts were most of all simply exploring 35mm camera technology and its

implications, which encouraged speed and movement and courted an openness to mistake and imprecision. More than the art of the action painters, Frank was drawn to the way they worked and lived—their obstinate belief in themselves, their indifference to the marketplace and devotion to their own terms of success. The spirit could be summed up in a phrase from the composer Morton Feldman, who was a friend of Frank's, a lover of Barbara Forst's, and a fixture on 10th Street: "The painters gave me so much, and they gave me resistance. Resistance to pressure, what is it, the pressure to ingratiate audiences or performers."[42]

IN JANUARY 1957 Frank took one last road trip for his project. With Mary, Alfred Leslie, and his girlfriend, the four drove to Washington for the second inauguration of Dwight D. Eisenhower. A benevolent father figure, Eisenhower was the last president born in the nineteenth century and might have been elected a third time if the Constitution hadn't been amended in 1951 to bar third-term presidencies. The celebration included Marian Anderson singing the "Star-Spangled Banner" and the president's speech, which spelled out the high stakes of the Cold War and was broadcast across Europe over the Voice of America. Afterward, *Life* reported, "the president ate a hearty, salted lunch," took a second helping of roast beef at the buffet, and then went to the reviewing stand—where he stood for the parade's three and a half hours, waving with clasped hands over his head. Eisenhower cheered the gold-star mothers, the tuxedo-wearing glee clubs, the Army's Redstone ballistic missile, and Northrop's new intercontinental ground-launched missile, the Snark. Perhaps the highlight of the parade was a mammoth float—408 feet long and mounted on 164 wheels—which introduced the theme "Liberty and Strength Through Consent of the Governed." All in all, the *New York Times* said, it was "a diverting cameo of Americana."[43]

There were multiple ways to view it, of course. For the Beats, the 10th Street people, for an unloosening knot of artists and discontents all over the country, Milton Klonsky noted, "there was

a low-barometric dead calm of boredom during those late Eisen-hower years of the sort that precedes social hurricanes and private hysteria."[44] As for Frank and Leslie, whatever they made of the in-auguration, it was what was seen away from it that mattered more. They slept in their car, and when they woke up Frank spotted a window display in a Washington, DC, formal wear shop featuring a headless mannequin draped in a tuxedo and bowtie beside a picture of the president. But Eisenhower's portrait is askew and curling from the wall. Light shines off the plate-glass window, and a sign from across the street reflects in reverse over the picture. The result looks like a disheveled stage set, a pastiche of symbols that not even the set designers believe in.

"America has always been presented with a smiling mouth and good teeth," Frank later declared.[45] But in his *Store Window—Washington D.C.* you can't tell if Eisenhower is smiling. The light bouncing off him blurs our view. *Store Window* was the last pho-tograph he made for his project. Now he would go into the dark-room and see what he had.

CHAPTER SEVEN

FIRST THOUGHT,
BEST THOUGHT

A PHOTOGRAPHER named John Cohen lived in the next build-ing over from the Franks, and Pablo and Andrea could climb into his loft from the fire escape they shared. Cohen was also a musician, and his bluegrass group, the New Lost City Ramblers, would jam at home with friends like Woody Guthrie, Roscoe Hol-combe, and the Stanley Brothers. In the building and on the street a crazy mix was settling in.

One day Frank invited his neighbor over to see what he was working on. It was—a lot. "Robert showed me stacks of photographs he was looking at from his travels in America. I remember he had the floor covered with prints and he would just look at them. From thousands of images, he sought reactions—from friends, from him-self. He was deliberating how to put them together."[1] Most of the summer of 1957 Frank developed the more than 767 rolls of film, some twenty-seven thousand exposures, which he had brought back from the road. Then he selected more than one thousand frames to enlarge to eight-by-ten work prints, and from that group got it down to under one hundred before he turned to structure and sequencing. Frank had prints stapled to his walls, scattered on the floor, and covering flat surfaces all over the loft.

When he thinks about it decades later Cohen draws a line be-tween life before *The Americans* and what came after. In the time before Frank's book was published Cohen remembered Robert and Mary as "so totally generous and giving.[2]

"Everybody was taking care of each other in those days. They cared about each other, and they were suspicious of what was uptown. I loved the kids, Pablo and Andrea. They would crawl out the fire escape and come in my back door. They played with my cats. I heard their dilemmas. I think when I first moved in and Mary was wheeling Andrea with a little carriage and we strolled down to Washington Square Park together. It was nice. I didn't know how nice it was."[3]

Alfred Leslie came over to see the Guggenheim project, as did Richard Bellamy. Hoping to nail down a publishing deal, Frank met with editors at Viking and Random House. He even wrote a letter to William Faulkner, asking if Faulkner would write the introduction to his book. Everybody passed.

Frank also asked Walker Evans to write the introduction, knowing full well the esteem cultural gatekeepers held for Evans. Evans could write well, and his support would attract the interest of critics and viewers. His friend agreed, and Frank traveled to Paris to meet with Robert Delpire, the young publisher he'd met in 1952. When he was assembling his Guggenheim application Frank had gotten a pledge from Delpire to publish the work, knowing that would make an impression on Foundation officials. Now Frank was in Paris, with a stack of pictures, ready to go over the details.

Laying out Photostats on Delpire's floor, the two pondered the book's final count and order. Frank explained how he wanted to print one picture to each two-page spread, leaving the left page blank. From Paris Frank traveled to Zurich, sitting down with the photographer Gotthard Schuh. The two had become good friends. Frank showed Schuh the maquette of his book and other prints, and Schuh agreed to publish seventeen pictures from the maquette in the August 1957 issue of the Swiss magazine *Camera*. Schuh wrote an introduction for the *Camera* portfolio, an essay that presciently understood the forces Frank was about to provoke. In the form of an open letter to his friend from New York, Schuh speaks bluntly to the younger photographer and indirectly to those about to view his work, while stepping with extreme precision.

The photographs, Schuh admits, are strong stuff. "I would never have thought that I could be so shocked by your latest, great work, the fruits of your two-year journey around America. . . . How little there is in it of what was familiar to us and what we loved in your photographs. No smile, no flower, no vegetation, no beauty. Tortured and stubborn human faces, caught up in machine parts, waiting expressionlessly at filling stations and in buses." It doesn't matter if you knew Frank already: there is no preparation possible for the work. But knowing the man and the earlier work, Schuh strikes a note of lament for something lost. He unpacks his other feelings: "I don't know America, but your photographs frighten me because in them you show, with visionary alertness, things that affect us all. I have never seen such an overwhelming depiction of people as a mass . . . full of insidious aggression.

"Your book is bound to suffer the injustice of having its artistic strength forgotten in the heat of the debate about its content. . . . My estimation of you has deepened but not changed. Anyone who accuses you of an over-bearing indictment has failed to see how much you love people, and how much you suffer in the face of their metamorphosis into a mass."[4]

What Frank is saying will be ignored as viewers revolt over the imagery, Schuh predicts, and revolt over their sense that they have been judged—and Schuh can see the danger in that. It was a clear-eyed view of Frank's new work and the way it would affect Americans. A small effort to prepare if not the audience, then the artist for the storm he was heading into.

Delpire was set to publish Frank's photographs, but it became clear that he would present them in a way suited to his specific needs. Including the work in a series of educational books he was publishing, united under the concept of "history," could work if Frank's book was presented as an impressionistic history of American culture. So Delpire included something the other volumes had: a text that spoke to the theme. He hired poet Alain Bosquet to assemble a pastiche of quotations, in French, addressing America from assorted angles that would fill up the left page on a given

spread—the space Frank wanted to leave empty. At a time when France was being tugged in opposite directions by the two Cold War powers, the quotes pulled the book in the direction of the Left Bank: statistics as well as passages from William Faulkner, Langston Hughes, Adlai Stevenson, Henry Miller, and others ultimately assemble a somewhat sour critique of the United States. And the overall effect was to suggest this was the collaboration of an editor and photographer, with Delpire's cover selection—a drawing by artist Saul Steinberg—underscoring the idea that this was something other than a book of photographs.

Frank came back to New York searching for a way to toss Bosquet's word salad. A buzzy networker named Emile de Antonio had been telling Frank about a wild writer who had his own book coming out. In the fall of 1957 Frank went to a party thrown by Lucien Carr, a member of the Beat circle, and sitting on the sidewalk outside was the guy de Antonio had been talking about, Jack Kerouac.[5] Frank struck up a conversation. Kerouac's novel *On the Road* had just been published, and Frank knew of the *New York Times*'s rave review, which said *On the Road* marked "a historic occasion" and was "a major novel."[6] Impulsively he asked Kerouac to write an introduction for his book. Ten days later Kerouac turned in his prose.

They had a great deal in common—a desire to get in the car and drive as well as a conviction that a heavy-handed editor could screw up a work faster than a Stan Getz solo. There was, nonetheless, a sizeable problem with asking Kerouac to write the essay: Frank had already asked Walker Evans, and Evans had composed one. It could not have been easy to cut his teacher out. "If I had been Robert, I would have been so scared to move away from Walker Evans and jump into something new," said Allen Ginsberg. "I think he wanted to gamble on the great reality of the present."[7] "Walker was not happy," said Frank.[8]

That wasn't even the end of it. What Kerouac wrote was great, but not enough—not so long as to knock out all those ready-made snippets Bosquet had curated. So Frank asked Kerouac to go back and rewrite to make it longer. Nobody who asked Kerouac for changes got off easy. ("Goddamn it, FEELING is what I like in art,

not CRAFTINESS and the hiding of feelings."[9]) He groused and then agreed, and when he turned it back in, everybody seemed satisfied.

Anyone who has ever experienced *The Americans* sees it through the prism of their own encounters with America, their own understanding of what that idea means. What makes Kerouac's vision so useful is that he experienced everything Frank photographed, for he had been frantically covering ground from one border to the other, running to and from, judging Americans harshly and embracing them absolutely; he had warmed his hands by the trashcan fire. Kerouac's introduction sings because he views the photographs as reality waiting to be discovered. He declared, "[Frank] will definitely be hailed as a great artist in his field," all but adding, "once a field has been invented for what he is doing here" because Kerouac couldn't care less about placing the work in anybody's literary tradition or photographic movement. What he cares about is that the photographer knows these things—mystic preachers and weary families with etched lines, gay teenagers and black bikers—they exist, they *are*, Kerouac has seen them and woken up beside them, they exist everywhere except in places where "traditions" and "movements" were determined. The photographs hummed with the vibrations Frank heard—he and an ever-growing overlapping nation of shruggers and hoodlums and ranters and anybody who escaped culture to hit the road and see. That's what he loved about this work: its seeing. And Kerouac fucking loves America! From the opening lines summoning "That crazy feeling in America when the sun is hot on the streets and the music comes out of the jukebox," he's not a booster—he's clear. The words are bare skinned and depantsed, fearlessly, carelessly vulnerable. They are sad—he knows this and embraces all sadness—but "you end up finally not knowing anymore whether a jukebox is sadder than a coffin" because his love is a 360-degree embrace, he has the backseat vision to understand that everything is everything, that you don't understand America if you don't have your arms around the grimness too: "the faces don't editorialize or criticize or say anything but 'This is the way we are in real life and if you don't

like it I don't know anything about it 'cause I'm living my own life
my way and may God bless us all, mebbe' . . . 'if we deserve it.'"
Kerouac is high, old, and worn out, and he describes the work and
then makes an imposing rhythmic cut, taking off from the pictures
for a bender of his own—in the car with Frank and the two Native
American boys—and he's driving into the sky—no literally, he is—
as he keeps writing, "Wow" and "To Robert Frank I now give this
message: You got eyes."[10]

There were great differences between them too. Frank lived
through those eyes; he didn't need or like to get to know folks
along the way. Kerouac had to feel a connection with somebody to
know he was alive, and then he needed somebody else. As sure as
that, he had to make a connection with the place he lived and was
starting to realize that the thing he loved was becoming his poison
of choice: America. Kerouac was in 1957 at a fever pitch, tilting
toward desperate. Frank was in the pocket, watching. He was the
Swiss hedgehog, hunkered down and ever present, always ready
to depart. They admired the spontaneity they saw in each other.

IN HIS NEIGHBORHOOD and around the city spontaneity was
bubbling up. A few blocks south from where Frank lived, Third
Avenue turned into the Bowery, as it was called, the border be-
tween the Village and the Lower East Side.

On the Bowery between Fourth and Fifth Streets was the great
jazz club the Five Spot, where Thelonious Monk and Bird and
Charles Mingus played. The art galleries of 10th Street were full
of paintings by Guston and de Kooning, but they were also where
Jack Kerouac improvised poetry to a jazz accompaniment. On
Frank's block lived the composer Earle Brown, one of the first
musical modernists to explore improvisation in composition. And
all over the Village post-bop and Ab-Ex and sick humor were all
courting the glitchy, sidestepping improv moment.

Frank's friend Allen Ginsberg embraced the concept of the
"spontaneous mind," an idea that might as well have been born
at the Five Spot, where saxophone solos could stretch to twenty

minutes and beyond. "First thought, best thought" was Ginsberg's construction, a faith that a truly open mind, free of orthodoxy and self-consciousness, was the cargo bay of creation.[11] The Leica technology that allowed a photographer to fire off twenty shots and the raw, personal approach that the Leica made possible pushed Frank ever deeper into instantaneity that short-circuited self-awareness. What was "available light" but a visualization of "first thought, best thought"? Photography had been exploring immediacy since it began, and perhaps it is most accurate to say that in the 1950s the rest of the arts were finally catching up.

"I think that all the good things one does are unconscious, one just has the feeling," was how Frank put it.[12] To have watched him photograph the frieze of pedestrians on Canal Street and then spin and discover the trolley before him would have been as riveting a moment as Hans Namuth's famous film of Jackson Pollock painting on glass or to have watched de Kooning from your fire escape. It was to view a physical performance in touch with all aspects of the moment. Frank said, "I think that the trip was almost pure intuition. I just kept on photographing. I kept on looking. I think at that time that I was compassionate. I had a feeling of compassion for the people on the street. That was the main meat of the book—that gave me the push—that made me work so hard until I knew that I had something but I didn't even know I had America. It's like you are fishing—you fish."[13]

People who have seen Frank at work describe an uncanny triangulation of hand, eye, and mind. Helen Gee recalled walking down the street with him, carrying on a conversation long before she realized he was holding a camera low at his hip, taking pictures of things they were walking past. Rudy Wurlitzer believed that he had a kind of extrasensory understanding of place, that when Frank took a picture he took it "before thought enters the room." He was a floating eyeball, vision detached from consciousness.

The first views Americans got of Frank's Guggenheim work came in the journal *U.S. Camera Annual 1958*, which strongly endorsed Frank's work by running thirty-eight photographs in a specially printed insert section created to fit the dimensions of the

photographs. The package also included the essay Walker Evans intended as an introduction as well as a statement written by Frank.

His statement is emphatic, creating as much space as he can for what he wants to do. Feeling a need to explain himself, Frank explains what he is not—not a joiner, not a snapshot maker. "I have a genuine distrust and 'mefiance' towards all group activities," he writes. "Mass production of uninspired photo journalism and photography without thought becomes anonymous merchandise. The air becomes infect [sic] with the 'smell' of photography. If the photographer wants to be an artist, his thoughts cannot be developed overnight at the corner drugstore."

Frank attempts to define who he is to a still nonexistent audience, to frame a conversation he can hear heating up—it just hasn't started yet. "I have been frequently accused of deliberately twisting subject matter to my point of view," he says. "Above all, I know that life for a photographer cannot be a matter of indifference. Opinion often consists of a kind of criticism. But criticism can come out of love."[14] Nothing is callow or by accident, and nothing comes easy for him: he wants viewers to know how seriously he takes his work.

His book was still unpublished, yet Frank was seizing opportunities to define the terms on which it should be viewed, to slip the yoke he sensed folks were sizing him up for. He'd had his worries about Schuh's open letter—readers might come away thinking he was a Communist—but he knew it was a valuable statement.[15] With Schuh's open letter and now his own writing, it was clear that gatekeepers in Europe and New York were going to significant lengths to build a positive reception.

Nothing came easy. Frank had hoped *Life* magazine would publish his photographs from the road. They sat on them a long time, and then mailed his work back. Four years after he first asked to join, in 1957 Frank was invited into the Magnum photographic agency. Members Cornell Capa, Elliott Erwitt, and Henri Cartier-Bresson came to his loft and viewed his new work, offering compliments before they left. A few days later *Magnum* editor John G. Morris formally invited him in, but what stuck with Frank was that

he was told he should shoot more vertical pictures because that's what worked in magazines. It's an inconclusive remark, maybe tossed off, but he took it as criticism. And it stung. They made him a financial offer, and he took it as an insult. "I felt they didn't really want me. It was more of a personality thing," he said. "As life goes on, you learn that these are small details. But at that time these details were monstrously big."[16]

He had as much ego as anybody, but he also had an uncommon shyness and lacked that protective coating that shields people who knock on doors for a living. Rejection stung him more than it did most people; it left him capable of leveraging a victory into a failure. He wanted to prove himself, but he wasn't built for competition.

Finally work materialized from the *New York Times*. The newspaper gave him the most agreeable commercial gig he would ever have, a job he would stick with from 1958 until the mid-1960s. The director of the *Times*'s promotion department, Lou Silverstein, was a Brooklyn-born artist with a background in abstract painting and design. Silverstein hired Frank to promote the *Times*, most famously in the "New York Is" campaign, a long-running set of advertisements that were stylish and redolent of the city. Silverstein would send Frank out with a loose idea, like New York is "up in Central Park," "an office in the sky," "children at school," and Frank would illustrate the concept. Unlike most employers who demanded a variety of options, Silverstein didn't insist he come back with a full contact sheet—Frank would show three or four images, and Silverstein knew there'd be something to use. He trusted him. "Lou is the only person Robert never had a bad thing to say about and I think it had do with the work Robert had—Lou treated him like an artist," said Helen Silverstein, wife of the late *Times* editor.[17]

He followed Frank's progress after getting a lucrative assignment to shoot pictures for a steel company commercial. A big ad agency was behind it, and they sent Frank to Florida, where there were money and models. Upon his return Frank stopped by the *Times* on his way to drop off his stills to the ad agency and

shared his work with Silverstein. There were pictures with glue smeared all over them, stuck to a black piece of paper, and Silverstein was convinced Frank had let a truck run over the page, it was so messed up. Frank wasn't feeling the work, and when he wasn't feeling it he was capable of sabotage.

Silverstein liked the guy. Lou and Helen drove down to the Village to pick up Robert and Mary for dinner, and as he climbed into the car Robert discovered a banana peel on the backseat. Although he couldn't remember what Robert said specifically, Lou could recall Frank's enthusiastic approval. They didn't take personally his need to define himself against his surroundings. Lou recalled a jacket Frank wore, the seam exposed and innards peeking through. For weeks Frank wore it proudly, never making a single adjustment to the lining. "I have no doubt that while other guys were applying after-shave lotion, Robert was making sure that his lining was going to be just irritating enough to let people he was dealing with know what was up," Silverstein understood.[18] Between the commercial fiasco and the coat, he figured Frank had lost several million dollars in work.

On the Road brought Kerouac to public attention, and *Life* assigned him and Frank to drive to Florida and create a story about their trip. That worked for Kerouac, who needed to pick up his cat and his mom and bring them back to New York. In the end the story was rejected; "On the Road to Florida" would finally appear in the January 1970 *Evergreen Review.* Kerouac's writing is notable for the attention he pays to Frank, marveling at how his friend could be behind the wheel (for all his love of the road, Kerouac did not drive), when suddenly he would reach for his Leica with one hand and shoot through a dirty windshield while his other hand gripped the wheel. They were eating in a Delaware diner off Highway 40 when "suddenly Robert was taking his first snap, from the counter where we sat." Frank spun around on his stool and crafted a shot that was like a collage—at the bottom a pile of leftover plates on a diner surface and through the window a trailer piled with layers of cars driving into the lot. "I suddenly realized I was taking a trip with a genuine artist and that he was expressing

himself in an art-form that was not unlike my own." The whole
trip, Kerouac declared, made him wish he had brought a camera
so he could photograph Frank "prowling like a cat, or an angry
bear, in the grass and roads."[19]

For his part Frank had great affection for Kerouac and loved
his sense of humor. The writer would be driving with Frank and
his children when, pulling beside another vehicle at a light, Ker-
ouac would lean out the window and ask a stranger questions in a
made-up foreign language, making Pablo and Andrea laugh. "He
was—well, he was a good guy," said Frank. "It was a lucky break
for me, really, that I got to know Ginsberg, and through Ginsberg
I got to know him and the other Beat writers, because it opened
a whole new window on the world for me. Because I didn't know
people like that from my time in Switzerland. . . . And it was
probably the most important part in my career, to watch them and
learn from them, and so I guess it helped me to take the pictures
I took."[20]

Meanwhile, as Kerouac and Frank returned from Florida, in
Paris Delpire was sending Frank's book to the printer. It would
come out without Kerouac's introduction—Delpire stuck with the
assortment of quotes he'd planned from the beginning. But now
there was a title. On the back of Frank's original maquette it had
said "American"; on his second version, "America America." Helen
Gee said Frank wanted to call it *America, America*; Evans's introduc-
tion manuscript is titled "In America," and Kerouac's manuscript
is just titled "Robert Frank's Pictures." When all was said and done
the French publisher went with *Les Américains*.

The owner of the small Grove Press, Barney Rosset was a one-
man band who like dissonant chords. Rosset was an adventurous
publisher based in the Village, he had brought out the English
edition of *Waiting for Godot* in 1954 and soon expressed interest in
publishing Frank's book. Grove bought twenty-six hundred sets
of pages printed with Frank's photographs from Delpire's printer.
Frank was fixated on getting the book out in America in a fashion
closer to what he had in mind. Rosset jettisoned the quotations,
kept the left-hand page blank as Frank had always wanted, and

ran Kerouac's introduction. Frank wanted a de Kooning or Franz Kline replacing the Saul Steinberg drawing on the French cover, then an Alfred Leslie one. In the end a Leslie drawing would appear on the back of the Grove dust jacket and on the front Frank's photograph of the Canal Street trolley car, *Trolley—New Orleans*. Frank got a $200 advance.

By letter Frank asked his American publisher what he wanted to call the book. Rosset said he would just translate the French title into English and call it *The Americans*, though the grammatical article in French is automatic, so maybe a better translation would have just been *Americans*. If the final title ever upset Frank, he's never said so: the one writer who asked whether Frank liked Rosset's title said he didn't really voice an opinion; he just seemed glad to *have* an American publisher.[21]

AROUND THE TIME *The Americans* was at the printer Frank and Ben Schultz were driving down to Florida to make a movie. They shot perhaps half an hour of film and then came back to New York. Money was tight, and Frank never developed the footage, deciding, as what he had shot was so similar to his still photography, that there was little reason to pursue it further. Later he'd wish he had developed the film. "I'm sorry about that now, but I wanted to take a bigger step than just to continue that work that I did with a still camera. I wanted to remove myself further. I wanted to work with a writer who would give me a story, to make me go further away from still photography."[22]

A *US Camera* article from 1954 declared, "Frank looks back on his work with a certain pride mixed with resignation"—this at a time when he was all of twenty-nine—and is "at present investigating a field that seems to him to be the next logical step—movies."[23] In the summer of 1958 Frank and Ivan Karp, the art critic of the *Village Voice*, had decided to make an 8mm silent film together on Cape Cod, using a camera Frank had borrowed from Rudy Burckhardt. It was a whimsical summer effort featuring many from their Village scene. The story concerned a procession of men who find

bottles on the beach, each with the same come-hither message in it, saying they should rendezvous with a beautiful woman at a certain locale. The beauty they meet is Mary Frank, a mermaid with big eyelashes.[24] For his scene Richard Bellamy gently put his head in the lap of his enchantress. Then Allen Kaprow, as King Neptune, was supposed to rise up out of the ocean and frighten away the suitors. While everybody watched, Kaprow attempted an appearance, but the combined weight of chains, ropes, and seaweed pulled him back down, nearly drowning him on a sunny Cape Cod afternoon. The film sat in storage for years, and then Frank offered it up to a class in the 1960s as an editing exercise.[25]

The Franks summered in Cape Cod throughout the 1950s along with many from their circle of friends: the Forsts, Walter Gutman, Lester Johnson, Jan and Dody Muller. According to Yvonne Andersen, cofounder of Provincetown's Sun Gallery, Mary and the kids stayed in a house in the woods, and Robert would come and go while working in the city.

In Provincetown, too, a fresh spirit of improvisation was coming into its own. The Sun was a freewheeling storefront with exhibitions constantly changing. Artists explored ideas there, and in recent years some historians have come to think of the Sun as a birthplace of the "happening," a predecessor of performance art. Several Sun exhibitions mixed media and incorporated movement. In 1958 Red Grooms, a friend of the Franks, presented "A Play Called Fire," which featured him standing alone, his back to a gathering crowd as he painted an expressionistic fireman encircled by fire. Grooms completed the painting in twenty-five minutes— when he was heckled by sailors, he painted his response into the picture. A relaxed riff on the notion of "action painting," Grooms's piece was action as much as it was painting. "A Play Called Fire" was followed by "The City," an installation that bound up photographs by Frank, stark-black cutouts of cars and people by Andersen, drawings by Lester Johnson, poetry, and more in a gritty gallery environment.[26]

In Provincetown and in the Village the Franks were not outliers. Living on the cheap and putting their art at the center of

their existence didn't cut them off from society—it was how they found others. It was funny: America famously—and sometimes accurately—is said to be a place where a newcomer can, through hard work, luck, or money, raise themselves to a higher level of comfort and security. But Frank had come to New York dead set on falling downward—finding a group who would have him far from the orderly center. If he had stayed in Zurich, he might have ended up like Tuggener, living in a basement, his cupboards filled with unpublished photographs, a legend who did not make sense in the national context. But in New York in the 1950s Frank made sense. He was swimming with abstract expressionism and the beginnings of the world that would move beyond it: happenings and assemblage and pop art. He was friends with the Beats, though not a Beat himself. Frank had a gift for being around some of the most interesting people wherever he went and another gift for remaining on their periphery.

Writers took note of the expanding "beatnik" scene, and the *Saturday Review* assigned a weighty, condemnatory piece. "The Revolution in Bohemia," from September 1958, looked at the history of creative people rejecting social mores and used freighted historical references to explain why those strumming guitars in Washington Square Park or throwing back beers at the Cedar Tavern were so deficient. Illustrating "The Revolution in Bohemia" was a portrait of a stunning, scruffy young bohemian couple who easily stood in for the allure and funk of their whole scene. It was a Louis Faurer photograph of Robert and Mary Frank.[27]

The Franks weren't quoted in the piece, nor were they even identified in the picture. They just happened to be a fitting summation of bohemian New York circa the late 1950s. That very idea was enough to outrage Robert who, he would boast, sued the *Saturday Review* over the insult. "I'm not a bohemian; I have nothing to do with the French bohemians," he explained. "I went to a lawyer and they settled right away and I got, like, $3,000."[28] It was an extremely bohemian dispute: nobody could put a label on him and make it stick.

THE NETWORK
OF HUMAN
MAYONNAISE

LES AMÉRICAINS was published in November 1958. "The book wasn't a success," shrugged Delpire.

An Italian edition, *Gli Americani*, appeared in 1959.

The Americans came out in the United States in late 1959, though the copyright page says January 1960.

And by the end of 1959 *The Americans* was in the process of disappearing. Grove had printed twenty-six hundred copies and sold eleven hundred, netting the artist $817.12.[1]

From the start the title of Frank's book put some people off, those who saw it as judgment rendered. Criticizing America in public was equated with taking sides during the Cold War, especially if the critic was foreign-born. Frank's own enthusiasm about America was more reserved than Kerouac's, but anybody's feelings would be more reserved than Kerouac's. Yet like his friend, Frank had an attraction to and empathy for the country. Allen Ginsberg later put Frank in a current of American rhapsodists that included William Carlos Williams, John Marin, Hart Crane, and Kerouac. What made Frank's yearning distinctive, Ginsberg said, was that mixed with it was his "glum Swiss sympathy and compassion, and a slightly different naivete."[2]

Nonetheless, some saw the book as a repudiation of America and they responded with anger and ad hominem attacks. Critics

seized on the fact that he was not from around here and were irked that he seemed less than suitably grateful to be in America now. To depict was to judge, and to judge was to attack—to attack in a way that has often and forever been taken personally in the American context (de Tocqueville: "As the American participates in all that is done in his country, he thinks himself obliged to defend whatever may be censured; for it is not only his country which is attacked upon these occasions, but it is himself"[3]). This defensiveness may have been at a high point in the 1950s, when Americans were purging foreign influences from public institutions, and foreign-born spies were hunted in movies and on the streets.

The worst reviews were brutal. In *Aperture* photographer and editor Minor White called *The Americans* "A degradation of a nation!" Frank's vision was dreary, White said, and he made all of America look like the Bowery.[4] A *Modern Photography* writer said, "You may find it interesting photographically, for it includes many excellent pictures, but you will probably loathe it."[5] Along with his loyalty, Frank's technique was frequently questioned. Right when cheap portable cameras were spreading into the mass market, creating a flood of shutterbugs and an emerging popular press to teach them how to shoot "like the pros," here was a pro disavowing all that learning. The worst attacks were bundled together in the May 1960 issue of *Popular Photography,* where the book was labeled "A wart-covered picture of America. If this is America (the United States) then we should burn it down completely and start all over again." Another *Popular Photography* reviewer deemed *The Americans* "A sad poem for sick people" and asked, "do such personal statements merit publication?" One more declared it "flawed by meaningless blur, grain, muddy exposure, drunken horizons, and general sloppiness."[6]

Frank wanted the respect given to an artist. He hated the feeling the wish installed in him. It was a paradox hard to undo. After the negative reviews appeared in *Popular Photography,* Barney Rosset wrote a letter to the magazine's editor in the July issue. "I was very interested in reading your review of *The Americans* by Robert

Frank," he said, "but in the end I felt rather mystified by the almost complete failure to consider Frank as an artist (for better or for worse) and to look at the pictures, not beyond them."[7] Frank's American publisher can't understand why anyone would write about the photographs as social propaganda rather than works unto themselves with or without merit. Meanwhile Frank listened to the opinion of his true peers: de Kooning and Kline both told him they felt photography was as much an art as painting or sculpture. Frank was suspicious of painters who felt otherwise.[8]

The negative reviews made an impression on Frank. Helen Gee ran into him soon after the book was published. "I wondered how he was holding up. The criticism was some of the most fierce I'd heard leveled at anyone, other than politicians." After small talk she brought up the reviews and was surprised to find that he didn't look pained—in fact he seemed oddly cheered by the hostility. Something in him came alive in contempt. "All he had to say was, 'Well, at least they'll stop calling me the poet of the camera. How I hate that!'"[9]

And yet for all the disparagement, a myth has grown since 1959, one suggesting that the critical response was unanimous. The artist himself has described it this way on numerous occasions: "They thought it was terrible. They thought it was anti-American, un-American, dirty, overexposed, crooked."[10] Those gut punches in *Popular Photography* and *Modern Photography*, the two most influential American photography magazines, must have been dispiriting, but overall the response was varied and often positive. Various supportive reviews appeared; the *New York Times Book Review* gave it a favorable evaluation, as did the *New Yorker*, *Library Journal*, and *Canadian Forum*. Dwight Macdonald in *Esquire* would champion Frank's work. The contemporary praise never reaches the extremes of the hostile reviews, but a false impression exists today that America hated *The Americans*. And yet, however alloyed the judgment, that it *felt* like a rejection to Frank is clear.[11]

Critics complained the pacing was haphazard, and none seemed able to grasp it as anything but a mass of individual images. It is

the order and internal structure of *The Americans* that is its most revolutionary aspect, and it's this accomplishment that makes the book singularly alive.

This is not a disorganized stack of pictures. An order is asserted from the beginning, as we fall into step with his methodical pattern of one image per spread. An order emerges elliptically, intuitively, and it grows as you move through the book. Frank uses symbols throughout that become signposts: crosses, cars, words, windows. Inside that order, from page to page, the images sometimes share a design or theme; sometimes they establish a contrast. Everything is always turning over in *The Americans.* Expanding, revising, restarting. There is no story line, but there is a story. There is no visual unity, as Frank conjures a broad variety of photographic approaches, and flipping the page can mean moving from a deeply thought-out visual structure to a Hail Mary camera grab. Many traditions are abandoned in this work, but two departures are central to understanding his intentions. In the previous decades numerous photographers had gone on a mission to photograph the countryside, motivated by an interest in effecting change by exposing conditions (poverty, racism, housing). But Frank isn't lobbying to make a difference; he's working in a more personal way. As Leo Rubinfien has written, even when, in one of his most famous pictures, Frank shows us a white baby being held by a black caretaker, he isn't "exposing" segregation; he has seen something and is struck by the feeling it has left him with and finds a visual way to make *us* feel it too.[12] When we turn the page to a woman in a Hollywood market, we struggle to divine a continuity. *The Americans'* repetition of symbols and visual echoes pulls us along and brings us into his world. The sudden emotional turns and mysterious images that seem to come out of nowhere don't appear random because he has so powerfully established the world we are inside.

The other tradition overturned is the magazine-style photo narrative, in which images relentlessly follow a predictable story arc. What guides us through the work aren't plot devices—we are in a new country and don't know the conventions. The internal life of *The Americans* may be the most revelatory thing about it—and the

least talked about aspect upon publication. Perhaps this shifting, intuitive, illusory, never-really-finished approach is the only possible way to represent the currents of this artist's character. Robert Frank wants to connect with his country—the Coca-Cola, the golf course, the apple pie in the Texas diner, the military uniform, the wreck on the highway, the smoke rising in the sky—and he hunts for a shared identity. But he also wants to be profoundly lost and unknown. He lives in the street and yearns to move silently among people who don't recognize him. "I need to be plugged in to the Network of Human Mayonnaise," he joked to a Canadian writer.[13] It wasn't just a joke.

The oblivious reviews were one part of the unfolding story. At the same time, though, Frank was well known among photographers and those who followed the field. His neighbor, John Cohen, gathered a loose crew of young photographers who met in his loft—Garry Winogrand, Lee Friedlander, Saul Leiter, David Vestal, Harold Feinstein, and others. They met to talk about ways to get more work, but Cohen notes that some also came in hopes of meeting Cohen's next-door neighbor. To this small number, *The Americans* was devastating. Or it inspired hugely—moving some to do their best work and others to find different things to do with their time. Hugh Edwards, the curator of photography at the Art Institute of Chicago, had been rocked by the book. *The Americans*, he would say later, was so overpowering that he gave up trying to be a photographer.

Edwards was assembling a one-person exhibition of Frank's work, the first the photographer would receive. The curator wrote Frank a letter, explaining how much his photography meant to him. "I hope this does not have too pompous a sound for I feel your work is the most sincere and truthful attention paid to the American people for a long time," Edwards wrote. He placed him in a league with Frank Norris, Sherwood Anderson, Hart Crane, Jon Dos Passos, and Walker Evans—artists who wanted to turn the whole country inside out and shake it till the coins dropped. "It is a real privilege to have known your pictures in their first freshness and newness. Someday they will spread to everyone and even

the most sterile and analytical of intellectuals will accept them at last."[14]

Edwards's excitement inspired one of his assistants to visit a New York bookstore to get a copy of *The Americans*. The shop had two, one French edition and one Grove Press. Both were remaindered, selling at a steep discount in order to cut losses.

"I know what impressed me," the young man, photographer Danny Lyon, would recall later. "Here was a photographer who had walked away from the entire world of magazine photography and presented his work as a book. And implied in that decision was a man, a photographer at that, of enormous integrity. For a nineteen-year-old that was the beacon in the night. In a world where any normal young person dreamed of working for a corporation, or academia, where the Ivory Tower was completely silent about segregation, in a nation where 'business was the business of America,' now appeared in the photography world a person of integrity. Frank cared about something besides money."[15]

Others noticed too. A photographer named Paul Katz was friends with photographic pioneer Berenice Abbott, who was sixty-one when *The Americans* came out. Abbott wasn't familiar with the work or the artist, until Katz showed her. She opened up the book to the picture of the cowboy leaning against a garbage can in New York City. Abbott ran her hand across the figure and said it was beautiful. "This guy," she said of Frank, "is as great as Atget." There could be no greater estimation, for Abbott had known Eugène Atget in France in the 1920s and helped preserve his legacy after he died.[16]

Such was the underground opinion of *The Americans*—that Frank was cutting against the grain of his trade, art, American culture. It would be years before such opinion was celebrated.

Meanwhile, on Third Avenue, a banjo player was picking on the fire escape. John Cohen invited his folk music confederates over to his loft and played them records he thought they might like to hear. Cohen was a passionate fan of *The Anthology of American Folk Music*, a collection of mysterious American sounds accompanied by occult drawings and cryptic passages from Theosophists

and other mystics. The collection was put together by a prophet named Harry Smith. "Most people in folk music thought his was a fictitious name," Cohen said, "because it was so bland and he was invisible on the folk music scene."[17] After Cohen lent his copy of the *Anthology* to Frank, his neighbor became obsessed with it, constantly playing one song, the Memphis Sanctified Singers' "He Got Better Things for You."

One afternoon Cohen invited the Franks over for an impromptu concert on the roof—a skinny kid from the neighborhood was going to sing. "He was playing a guitar and a mouth organ, and he looked like a yeshiva *bocher*, like he was seventeen," Mary Frank remembered.[18] It was Bob Dylan. *The Americans* was published at the time that Dylan, too, became an obsessive listener to the Harry Smith anthology circulating through the Village. Dylan listened to the songs presented as true stories, the news reported in murder ballads and disaster songs, the homilies and broadsides that functioned like a community press, and he braided them together to tell an American story.

That kid on the roof would eventually take a musical documentary tradition, a way of relating history and events through song, and make it his own, creating an America that didn't exist until he played it. The photographer listening to him, in his own fashion, had already done this. Their choices took each of them out of the past and put them on a road they had discovered. What you found in their unpretty reworking of traditions said something about them and even more about you. It separated those who knew what was going on from everyone else.

When *The Americans* came out in 1959 Robert Frank went electric with something so new that nobody was prepared to give it a name. Other than sick, hateful, un-American. People thought he was reporting, which he was not, though he started with simple facts found on the road. In the words of photographer Garry Winogrand, "There is nothing so mysterious as a fact clearly described." *The Americans* put its viewers on one side or another of a dividing line. There was an emotional life to the work that not only referred to a nation and its people but was also parallel to

them; it did not belong to them. Robert Frank created something that did not exist before. The work talks to us, though not about a theme—a through line, an editorial statement. So we lean forward and look. There is an abiding interest in race and class, but even these images mostly lack a message; the sounds they make are muffled. They are far more "all men are created" than "all men are created equal." People thought Frank was hurling arguments, which he was, but they were never the kind that one could put into a simple sentence because *The Americans* never *proves* anything. It brings the photographer's roiling feelings into the record—his wish to dissolve into the life of a nation and his desire for a separate sense of himself—an act that obliterates the record he is making while it also obliterates him.

The work was done, and the people on the roof come down and re-enter their own stories. The photographer walks around the Village and makes a plan to go to Coney Island and take some pictures. Frank sized up his moment, his options, his work.

And then he threw it all away.

THE FILM WAS OVER, and two Europeans talked excitedly in the lobby of the Paris Theatre in November 1958. Frank and the Lithuanian-born filmmaker and writer Jonas Mekas were at a midnight screening of John Cassavetes's *Shadows*, perhaps the first time anyone was seeing it. *Shadows* was laced with a love of New York at night and a naturalistic acting style distilled from hours of improvisation workshops conducted over the previous two years. *Shadows* shook Frank up, as he shared with Mekas in the lobby.

"It was a very exciting moment—the film was so fresh and so open in its improvisational style. It was like a piece of jazz," Mekas remembers. The word was out, and in the audience were actors and painters and people interested in making their own movies. "Of course, Robert was there and a number of his friends, and I remember Robert saying to me right there, 'Now it's time maybe I should make a film also.'" Within a few years a New York film underground would be roaring. "People said, since this was not a

high-budget film but one made with no money, it proved to others that, yes, anybody—we, *I*—can do it too," says Mekas. "It was the inspiration of that evening that helped many others to make up their minds. That was the beginning."[19]

Empowered, Frank reached out to his many friends, one of whom was Alfred Leslie. An excitable creation, Leslie had been a teenage zoot-suit-wearing jazz kid, a prize-winning bodybuilder from the Bronx, and by the time he and Frank became friends he was an idea-burning abstract expressionist who didn't take much too seriously. His 1952 show at the Tibor de Nagy gallery included a large abstraction with the words "fuck you" painted in the middle. Clement Greenberg was an early supporter. Leslie was both provocateur and pioneer, and there was nobody else like him.

Leslie had already made three films by the late 1940s before he turned to painting. But in 1959, he and Frank were sharing their mutual interest in film and scheming together on not one but a trilogy of films. They wanted to do a project with their friend, the actor Zero Mostel, a film they called *Mr. Z*. Leslie was also eager to film "The Sin of Jesus," a short story by Russian writer Isaac Babel, for which he had written a movie treatment. Finally Frank's Provincetown friend Dody Muller encouraged them to take on Jack Kerouac's *On the Road*. She had met Kerouac at a party at Frank's loft and was now dating him. When they talked to Kerouac about the possibility, he seemed more interested in having a major studio film it, offering them instead a play he had written called *The Beat Generation*. That work was written in one night in 1957 and describes a sozzled twenty-four hours in the life of Kerouac and his crew.[20]

The third act of Kerouac's only play depicts a slapstick encounter with a bishop from the Liberal Catholic Church, a small esoteric faith with roots in Theosophy. It was this third act that Frank and Leslie used as the basis of the final movie in their trilogy, the only one they would actually make, a film first called *The Beat Generation* but would later be renamed *Pull My Daisy*.[21]

They approached composer Earle Brown as well as Tony Schwartz, who recorded albums of New York street sounds, for

technical advice. Money was an issue skirted in life, but it could not be avoided if they were going to make a film. Frank, Leslie, and Kerouac formed a limited partnership, G String Enterprises. They approached a Wall Street sage named Walter Gutman, whom Frank had known from Cape Cod, who said he would invest in their film if the filmmakers also put skin in the game. So Leslie sold a canvas for $1,500 and Frank raised a thousand, and with that, Gutman was in, investing $1,500 and rounding up seven other investors, each contributing $750.

A well-known financial adviser, Gutman wrote an investment newsletter noted for its candor and prophecies. He was a great salesman, and his columns included references to abstract expressionists and the Beats.[22] He liked art, and he really liked women he met while talking about art; a Frank portrait of Gutman shows him reclining by the living room fireplace, drink in hand, conversing with a stripper named Sugar Candy. Gutman once said that he only invested in *Pull My Daisy* because Mary Frank had visited him and gently stroked his fingers.[23]

The filmmakers brought in their friends and acquaintances to be the actors. Allen Ginsberg, Gregory Corso, David Amram, Richard Bellamy, painters Larry Rivers and Alice Neel would all be cast. Frank's son, Pablo, was in the film as the son of the railroad brakeman named Milo. The film was almost entirely shot in Leslie's new loft at 4th Avenue and 12th Street, a former employment office eighty feet long, twenty-four wide, and sixteen high. In lieu of a full cleaning, Leslie quickly spray painted the whole space white. Walls, ceiling, dust balls, mice—everything white.

They shot over fourteen days starting on January 2, 1959, eight hours at a stretch. Kerouac, Frank, and Leslie had hit upon the idea of making essentially a silent movie, to which they would later add a voiceover of the author reading all parts. Leslie assumed the role of director, trying to control his actors and the script. He was thorough and had blocked out everything, down to how many steps actors were to take when crossing the floor, and he was obsessed with hitting his quota of two usable minutes of footage per day. Frank was the cameraman, and he hired his friend

Gert Berliner, a German photographer and painter, as camera assistant; they worked with a rented Arriflex camera and bought quality black-and-white negative camera stock.

The two settled into their roles; Frank arrived on set one day with a megaphone for Leslie, on which Mary had painted "the director." "I should have a whistle too," Leslie retorted. According to composer David Amram, Leslie was "like a great hostage negotiator—he could take a homicidal maniac and manage to calm them down. When Gregory Corso would leap out the window onto the fire escape or run down the street to accost a lovely woman in a convertible and tell her to come up and see us because he was the famous Italian director Fabian Fongool! Or, when Allen would suddenly drop his pants in the middle of a scene, Alfred, instead of getting angry, would just calmly say, 'Your ebullience is marvelous, but in this scene could you please . . .'"[24]

Understanding was required. Although Leslie had prepared a script from Kerouac's play, which Ginsberg had then distilled into a two-page treatment for the actors to use, in no time at all Leslie's apartment was full of smoking, drinking, and laughing bohos who commenced to improvise as much on camera as off. They were Beat Bowery boys, debating Apollinaire and rolling in ketchup on the floor. Delphine Seyrig was the crucial exception. At the beginning of a film career that would include work with such directors as Luis Buñuel, Marguerite Duras, and Chantal Akerman, she had been hired to act in her first film role. Seyrig was the single profession actor on the set. She plays the wife of a character based on Neal Cassady and conveys the weight of what her character had to put up with from the men around her—a weight like the one Seyrig (married to the painter Jack Youngerman), Mary Frank, and the women around Beat culture were carrying in real life.

Life didn't stop when the camera was rolling. Orlovsky strutted around, wrapped in towels, brushing his teeth and waving a toilet plunger while he proclaimed, "I'm here to clean up America!" The dishes stacked in the sink; the cigarette butts filled up the ashtrays. "We were able to stay up late so the mantra was always, 'Where's the party?'" said Amram. "Invariably it would be at some loft like

Alfred's, and the painters would put their stuff eight or ten feet up off the ground so nobody put a cigarette butt on it. People would bring a bottle of wine or Dr. Brown's black cherry soda, and people would do their monologues or poetry, and we'd be our own entertainment. It was the same thing as the ambience of the jam sessions or what the folk people called hootenannies and what the Latin folks called a *descarga*—a slang word for a jam session. The ambience was all coming out of that same larger picture of people getting together, hanging out with a low or no budget, having an incredibly good time."[25]

On the edge of the party Frank was figuring out what to shoot. "His nature was to be a spectator," said Leon Prochnik, who worked on the film. "In public he was a spectator, which gave him a certain freedom," he says. As the party rolled before the camera, Prochnik notes, Frank stayed behind it. "You can't see Robert in the room." Frank's camera was set on a wooden tripod, and his friends had fun trying to get him to laugh so hard that the setup would shake. "He was very quiet, very studious, with an incredible dry sense of humor," recalled Amram. "He would be there sometimes with tears rolling down his cheeks, but he would never have the camera shake! He had such a great level of concentration."

Once, when they were filming an actual jam session in the loft, workers suddenly appeared. That wasn't in the script either—they came to take the canvas Leslie had sold to finance the film. The band keeps playing as the laborers take it down, and Frank captured it on film.

Once the filming was finished, a heated argument between Frank and Leslie emerged over whether the performances were improvised or scripted. It has raged on into the present. Leslie has declared that he is responsible for essentially everything recorded by the camera, and he perceives the claims of improvisation as a challenge to his importance. He has argued for decades that the action followed his direction of Kerouac's words. Various people on the set saw it in various ways. Frank has said the film largely captures the performers goofing and making scenes up as they went along.[26]

"Well, there was sort of a script, but sometimes the script was forgotten," explains Gert Berliner, who was present on the set as photographer. "There was a lot of improvisation." Art dealer Richard Bellamy, who played the bishop, told Blaine Allan that Frank and Leslie conferred together about how each scene should be filmed. Each was shot three times, and within a general framework, ad-libbing was allowed. Amram said Kerouac arrived one day to what was supposed to be a rehearsal but was instead a big stoned party, and he loudly protested, "Man, they're not following the script." For his part Ginsberg has stated, "[Robert] didn't make us memorize the script and we didn't have to act, basically." Leon Prochnik said, "These guys wouldn't have listened to a director if he was Hitchcock!"[27]

The credits for *Pull My Daisy* list Leslie and Frank as codirectors. Leslie has long declared he is the sole director of the film and Frank the cinematographer. (At the time they both agreed to the billing.) But it has always been understood as a collaborative project, and sometimes Frank has received more credit for its making. This deeply troubles Leslie, whose comments remain barbed decades later. "Ask yourself if you believe that as a cameraman [Frank] sat around and turned on the camera and made this all happen? Give me a fucking break. He didn't know what the fuck he was doing," said Leslie. "He wasn't my first choice to work on the film." Leslie said that the look of the film, along with the loose performance style and much else, was his idea. "I knew everything that was going on. That was my job. I had imagined that film from the very beginning."[28]

Jonas Mekas, who dropped in on Leslie's loft during the shoot, takes a diplomatic position of compromise. "We touch on a very subtle point regarding the friendship of Alfred and Robert," Mekas sighs. "Robert's contribution was such strong images that the credit went always to Robert and of course Jack. . . . Leslie became invisible. But . . . the humor, much of it came really from Leslie. He has a very sharp sort of hidden sense of humor, which Robert totally lacks." Ultimately the argument about whether directions or improvisation shape the film is about who deserves more credit:

history has focused on Frank's involvement, and Leslie has some-
times overstated his own role as a corrective. Maybe the argument
hangs on one's definition of improvisation: is it a performer's total
invention, or is it the definition Frank has used, in which accident,
artistic intentions, and *other people* collide? "I can't say anything
bad about Alfred. He was a really nice guy and also ambitious and
a good painter," says Berliner. "I think what he wanted really was
to be the director of the film, which is very difficult if you have
to deal with Robert. He is a stronger personality; even behind the
camera he is. The film is silent, there is no sound, so it's very vi-
sual, and that's Robert. That's not Alfred."[29]

WHEN HE WASN'T WORKING on *The Beat Generation,* Frank spent
hours riding the bus. Between the end of 1957 and May 1961 he
took a seat and photographed the streets of the city from a moving
window frame. Shooting what he could, knowing—perhaps savor-
ing—how there could be no second shot, control was not his, the
image a forced collaboration with the Metropolitan Transit Au-
thority and the driver behind the wheel. The people standing on
the sidewalk in his bus pictures are far more cryptic and remote
than people in *The Americans,* their connection to the man behind
the glass more distant: they don't occupy the same place. These
are images of Frank pulling away and taking a liberating exposure
as the bus pushes off.

The Leica becomes a moving camera, the bus window his view-
finder, the bus a dolly. "I liked it because I had no control over
it," he explained later. "I mean, the frame kept on moving, that's
what I really liked about it. That way it seemed to be very filmic.
I didn't know really when it would stop, when it would go, when
it would go fast. Yeah I liked these photographs a lot. That was the
end."

The bus series is a step away from the heat of *The Americans,*
but a step forward too, a new attempt to explore the realities of
the moment—he's found another way to relinquish control. It was

a lightening of the load. "I like to see them one after another," he said of these images. "It's a ride by and not a flashy backy."[30]

The Americans was not even out yet, and Frank was plotting multiple escapes. From the weight of accomplishment, from criticism, from having to repeat himself. Dead set on the ride, no looking back. Gotthard Schuh, the photographer in Switzerland, his friend, looked into the future and saw the anger his pictures would bring down on him in the United States. Having lived with a single project for years and fully aware of his accomplishment, Frank could see the role of the Great Artist waiting for him up ahead. Inhabiting the spaces *The Americans* would open up, turning the admiration of highly placed peers into lucrative commercial assignments, institutional acknowledgments, fruit baskets. Greatness and bills paid.

He went another way, throwing himself into filmmaking. At first he just seemed busy doing other stuff—it wasn't like he took out an ad and announced his departure. Throughout the rest of his life people have asked Frank why he stopped taking photographs. Soon a legend would emerge, one he signed off on and probably saw coming long before anybody else. The *Guy Who Walked Away from Success.* An unknowable figure, like Miles Davis with his back to the audience, an artist who changed it up rather than cash it in. That was later. In 1960 there *was* no success, no nothing bigger than his own understanding of what he had done.

In a chronology he wrote for *Aperture* in 1976 Frank pegged the moment to the beginning of the new decade: "1960. Decide to put my camera in a closet. Enough of observing and hunting and capturing (sometimes) the essence of what is black or what is good and where is God."[31] He continued working commercially for the *New York Times, Esquire* hired him to shoot a political convention, and more. But a fadeout happened fast.

No flashy backy. Eyes forward. He saw it from the bus window and made a different calculation.

CHAPTER NINE

TOUCHED BY THE HAND OF GOD

FAME HAD COME to the Beats, and they were taking it pretty hard. A literary movement built on freedom—the ability to head anywhere anytime, the need to head out because there was so much *now* to drink up—was barraged with obligations, invitations, contracts. *On the Road* was a hit, and that (and alcoholism) would slowly yet steadily undo Kerouac. He spoke with the flow and conviction of an oracle, and now strangers approached and expected him to perform truth. Again and again. Movie deals and TV appearances were proffered, complicating a process that began for Kerouac as an unfettered offering. Life was in danger of becoming a career and the oracle at risk of becoming a celebrity.

It wasn't just his problem. Ginsberg's 1955 reading of *Howl* in San Francisco had made him famous. Greenwich Village was filling up with tourists, and the nonfamous Beats, the *subterraneans* as Kerouac called them, were moving into the East Village. The arrow had hit the target, a target so big now that others took aim: those who were Kerouac's "mad ones," those who meant to do the mad ones in with their own dazzle, and those who just wanted to watch the sport. The late-night jam sessions and 4 a.m. literary arguments where nothing was on the line and therefore everything seemed possible were no longer so possible. By the time Frank and Leslie's *The Beat Generation* was underway, everyone involved sensed that fame and scrutiny were pressing in. Leslie's loft was a place to hide, where Ginsberg and the rest could

unself-consciously display the friendship that the press and fans were peeling away.

Frank was studying how his friends handled it and not finding a response to his liking. He saw Kerouac, shy and too heavy with internal conflict to welcome the praise he had earned, drink himself into a state where he could talk to the strangers staking out his Village haunts. Ginsberg was another way: to Frank he seemed to be falling apart if he *didn't* get recognized, and he would park himself in a coffeehouse until someone finally came up and asked, "Are you Ginsberg?" Then he would visibly relax.[1]

Frank and Leslie finished filming in a few weeks. No need for a wrap party. The next step would be more methodical. They had hours of footage and multiple takes.[2] Frank called up Leon Prochnik, a film editor he knew, and described the task. He said he and Leslie would be editing the film, but they were inviting Prochnik to come over and view their work. "As soon as I got down there and saw the footage I knew exactly why he wanted me there," said Prochnik. "Because he and Alfred had gone off the rails and shot barrels and barrels of footage." (Prochnik says there were bins full of unmarked film.)

The three viewed footage, which appeared way out of focus. "Oh my God, I don't think I had the lighting," Frank moaned. Prochnik fiddled with the Bell & Howell projector and suddenly the focus was fine. He got the job as one of the three—or maybe the real—editors of the project.

Leaving the cutting room that first day Prochnik asked where the soundtrack was, and Leslie responded proudly that there *was* no soundtrack.

"Is this a silent film?"

"No, we're going to get Jack to dub in all of the voices."

Prochnik knew how hard it would be to have one person realistically voice all the parts. And having lived downstairs from Kerouac a few years earlier, he knew the writer and understood how unlikely he was to spend hours saying the same line over and over into a microphone. The idea for a more impressionistic narration, in Kerouac's own voice, began to take shape. Frank, Leslie,

and Dody Muller took a projector out to the Long Island house Kerouac shared with his mother to show him footage. But Kerouac didn't want to see it in advance of narrating, and he definitely did not want to write down what he planned to say. When they returned Leslie shrugged and announced, "Well, Jack is gonna do whatever Jack is gonna do."

Kerouac insisted that he record his voiceover late at night at a small studio on the Lower East Side. At the appointed hour he arrived with a large group of friends. A performance of some kind would be delivered. "I thought we were fucked," says Prochnik. "We get there, and there are thirty or forty people, everybody stoned out of their minds, and Jack was stoned and Jack was drunk and on the table where he was going to put his script someone had solicitously laid out three joints and a bottle. I thought, *this is going to be a very difficult night.*"

Kerouac took at long pull on a bottle of Châteauneuf-du-Pape, put his head down, then told the assembled "*je . . . suis . . . prêt.* I'm *ready.*"

The writer would improvise his narration three times, some claim; but Prochnik says the film was shown on three reels, and when each reel was changed, Kerouac took a break before continuing. That means there were no do-overs, which seems more likely.[3] Headphones covered his ears, and Amram, playing the piano, gave him a beat.

As the first reel began, Kerouac immediately spat out a few liquid lines. Then the film continued, and Kerouac continued too, in synch with everything going on visually in a way that was impressive and electrifying, and soon it was evident that he had no intention of stopping, never taking a break to let the images play or to give himself a moment to look. He was narrating as if he were a radio announcer describing a ballgame to listeners, remembers Prochnik. "There was no breathing time, he just was going with it—'ahh, and here comes little Pablo and now the wife walks in she's frumpy and she's got this dress on . . .' but strictly nonstop. And I'm going, *WE ARE DEAD.* This is not going to be a fucking movie; this is going to be Jack talking with some pictures running."

When the first reel finished, nobody spoke. No one dared say anything to Kerouac except for Prochnik, who was young. The editor asked Kerouac to do a second take to fix a place where his voice went scratchy. The writer shot him a murderous look.

"Don't say anything more," Frank directed. Everybody got quiet.

In a moment Frank spoke up again. "Amazing, amazing," he said to Kerouac. "But I'm scarcely surprised. I knew it would be. I knew it would happen. We've captured a moment in time. That's all one can do."

Leslie, however, wanted to do more. Making clear he loved what he'd heard already, Leslie said, "You've never even seen the film before. How can you possibly think your first instinctive improvisation, as brilliant as it was, was the correct one?"

"Because I'm touched by the hand of God," Kerouac said quietly.

"There would be no 'takes.' There are going to be three reels and three Jack responses to reels," said Prochnik. "Beautiful moments, followed by moments of gibberish, because don't forget he's been drinking, stoned—he knows how to do it, but there's a limit." They completed a run-through. Kerouac waved and left.

The next day Prochnik listened to the recording with a sinking feeling and then came up with an idea. What if they reorganized the prophet, picking and choosing his best lines? (Room needed to be carved out anyway to accommodate a musical score by Amram.) Prochnik stayed up all night taking out passages and leaving blank air between expository moments. He also transferred a line from one place to another when he thought it worked better. "At first it feels like taking out some of the commands from the Ten Commandments," he said. "By the end of the night I've taken out maybe half of it." He called up Leslie and Frank, telling them to come over. "I've done a little editing, moved some things around."

Leslie: "Who are you to take out Jack's narration?"

Prochnik: "I can put it all back in an hour."

He thought he was fired.

And then Frank, in a characteristic act of direction, gently said, "You know, there are some places where this . . . is . . . kind of . . . *interesting.*"[4]

The narration that came out of the editing room became the film's voice, complicating and giving meaning to what we see. Kerouac's words were from the start only intermittently bonded to the action; sometimes he is the voice of a character while elsewhere he describes what is seen. Sometimes taking the role of performer and other times that of viewer, his push and pull of voices make the piece strangely alive.

Frank's camera circles the room in a stately pan, taking in its contents. There's a cut to Seyrig throwing open the shutters to bring light into her bedroom.

Kerouac: "Early morning in the universe. The wife is getting up, opening up the windows, in this loft that's in the Bowery in the Lower East Side, New York. She's a painter and her husband's a railroad brakeman and he's coming home in a couple of hours, about five hours, from the local."

This isn't a sports broadcast. If anything, it sounds like Kerouac's friend, the radio storyteller Jean Shepard. Time to send the kid to school. Someone is at the door; her husband's poet friends have arrived.

Kerouac: "Gregory Corso and Allen Ginsberg there, laying their beer cans out on the table, bringing up all the wine, wearing hoods and parkas, falling on the couch, all bursting with poetry while she's saying, Now you get your coat, get your little hat and we're going to go off to school."

And then, soon: "Look at all those cars out there. There's nothing out there but a million screaming ninety-year-old men being run over by gasoline trucks. So throw the match on it."

Kerouac offers this in the same conversational tone he uses for beer cans, parkas, and poets. Inside: friends, shelter, and verse. Outside: the end. A living death that brings out a nihilist impulse in Kerouac. In Leslie's shelter that Prochnik labeled an "odor-filled submarine packed with poets, hustlers, painters, art dealers, dancers," everything is laid out for the evening's descarga. It makes Kerouac rocket forward, dipping his tongue into something potent and spitting truthful gibberish and visionary poetry in black and white.

"Yes, it's early, late, or middle Friday evening in the universe. Oh, the sounds of time are pouring through the window and the key. All ideardian windows and bedarveled bedarveled mad bedraggled robes that rolled in the cave of Amontillado and all the sherried heroes lost and caved up, and transylvanian heroes mixing themselves up with glazer vup and the hydrogen bomb of hope."[5]

Time is passing and things are being born and are dying—and this is how it makes him feel: inspired to sing on the spot, to dream of a beginning in an ending.

WHEN HE STARTED the job, Prochnik says Frank's camera work seemed amateurish to him. He had little context for viewing it—movies that he knew didn't look like this, and neither did photographs. It was from sitting at his Moviola editing machine and watching Frank's photography that he slowly came to *see* it, and then he wanted to make the film succeed. It had to grow on him.

"As often as I could I would get Robert alone, often at night after we'd worked long hours. I'd sometimes drag him away to 42nd Street to a place called Grant's. It was famous for its hot dogs, and we'd stand there at two in the morning in Times Square, me telling him this would be a very special film. Because Robert, basically, presented a worried face, that was his nature. There are not many photographs of Robert smiling overmuch. I wanted to cheer him up."

After they finished editing, music was recorded and a theater booked for the film's first public showing. Leslie took out a goofy ad in *Variety*, announcing *The Beat Generation*'s imminent release: "At all times a splendid entertainment for the entire family—no sex—no violence."[6] That ad produced an unexpected response, a cease-and-desist letter from MGM Studios declaring that *they* owned the copyright for the name "Beat Generation." It may have been the title of Kerouac's unpublished play that gave birth to the film, but MGM had beaten Leslie and Frank to copyrighting the words. Hollywood drive-in movie king Albert Zugsmith was about

to release his latest exploitation flick, *Beat Generation*, starring Ma-
mie Van Doren and Jackie Coogan that July in a story about the
police hunt for a serial rapist–beatnik.

A San Francisco newspaper columnist in 1958 had crafted the
pejorative *beatnik* for the mad ones who within a year seemed to
be everywhere. In July of 1959 alone, the month Zugsmith's *Beat
Generation* premiered, poet Rod McKuen released his would-be
anthem "Beat Generation," and *Playboy* featured their first beatnik
centerfold (Yvette Vickers). The Beats were an underground force,
but beatniks belonged to anyone, and there were thousands of
youths toting bongos and sticking their turtlenecks out on week-
end coffeehouse safaris. Beatniks were pop culture in 1959: TV's
The Many Loves of Dobie Gillis featured the character Maynard G.
Krebs; Alfred E. Newman wore a beret on the cover of *MAD* mag-
azine; the film *A Bucket of Blood* depicted them as possibly socio-
pathic killers. An artistic avant-garde no longer could claim own-
ership of its name.[7]

Zugsmith had the copyright, so Leslie and Frank went with *Pull
My Daisy*, a cockeyed line from the song recorded for the title cred-
its. Not shy about attracting people to his film, Leslie designed a
poster for *Pull My Daisy* and reached out to the R&B songwriters
Leiber & Stoller, asking them to contribute a number (no luck).
Frank kept whatever ambitions he had to himself—it was his na-
ture, and looking ambitious was unforgiveable. But Leslie carried
himself away, imagining that they would create "a production
company, like the Mercury Theater, that's how I envisioned it,"
and contemplating the merch he could crank out to keep his the-
ater afloat: "if there was anything that I could have dreamed up
that could have been merchandised, including little statues of Al-
len and Gregory, I would have done it."[8]

On November 11, 1959, Cinema 16 in the Village scheduled "A
Night of Cinematic Improvisation," featuring John Cassavetes's
Shadows (a refilmed version) and the film it inspired, *Pull My Daisy*,
contrasting work that together highlighted a new independent
cinema. Soon after, the filmmakers were out on the West Coast,
screening *Pull My Daisy* for a private Hollywood audience that

included Vincent Price, Gypsy Rose Lee, and producer Ray Stark. The mogul hated it. Another screening, this one at the home of producer Henry Blanke (*The Treasure of Sierra Madre*, *The Fountainhead*); Joseph von Sternberg attended, Leslie said. People seemed to like it, but in that Hollywood way, where everyone covers their asses until the most powerful figure in the room weighs in. Finally Blanke did, pointing a finger at Leslie and exploding, "It's shit. He's shit. It's pure shit. I don't want *Pull My Daisy*, I want Shakespeare." Decades later Leslie would remain convinced that, had a few things gone differently, *Pull My Daisy* might have launched his Hollywood career.[9]

Leslie, Frank, and Kerouac then went up to the Bay Area, where *Pull My Daisy* screened at the 1959 San Francisco Film Festival, winning an award for Best American Experimental Film. A drunk Kerouac fell off the festival stage. The film was becoming part of the legend of all three men, even more so at the end of November, when *Life* published a story by a reporter who had commiserated with the *Pull My Daisy* team. "Beats, Sad but Noisy Rebels," it said on the cover of the November 30 issue, and inside, Paul O'Neil's murderous feature, "The Only Rebellion Around," strung together what were even then clichés to reassure non-Beats that revolution was not imminent.[10]

In April 1960 *Pull My Daisy* had its first regular commercial booking at the New Yorker Theatre. Frank sprung for a hansom cab for the premiere, which escorted Mary, Andrea, and Dody Muller up Broadway to the theater. They tossed daisies to pedestrians along the way. The film shared a screen with Orson Welles's *The Magnificent Ambersons*, and out front, there it was: Welles's Mercury Theatre and Leslie's reinvention, sharing a marquee over Broadway.

Whether the Beat vision had won or been paralyzed by success became a rich topic for argument in the years ahead. But already, by 1960, the ideas given flight by friends gathering in Leslie's loft had long flown the coop and were now the property of suburban high school students and Hollywood writers and anybody who shared a belief that tomorrow is a drag, man, tomorrow is a king-sized bust. Frank and Leslie, at the very least, had made a home

movie with outrageous ambitions. As Frank said, they had cap-
tured a moment in time. That's all they could do.

PULL MY DAISY would receive plenty of attention in the years
ahead, but the attention that mattered most was that of Jonas Me-
kas, filmmaker and champion of the new cinema. In his *Village
Voice* column Mekas found the film to be a homing signal for a
new movement, one that nobody saw coming more clearly than
Mekas himself. "I don't see how I can review any film after *Pull
My Daisy* without using it as a signpost," the columnist announced.
"The photography itself, its sharp, direct black-white, has a visual
beauty and truth that is completely lacking in recent American
and European films."[11] The entire picture "pointed towards new
directions, new ways out of the frozen officialdom and midcentury
senility of our arts."

There were other positive reviews: the *New York Times* critic Bos-
ley Crowther called it "an arresting little item" and gleaned that
Leslie and Frank were not simply celebrating beats but had cap-
tured "the pathos of their puerilities." *Time* dug it—"Zen-Hur" was
their crack. In *Esquire* Dwight Macdonald found it "as refreshing
as anything I've yet seen" and viewed Kerouac's narration as a
parody "of the stage manager in Our Town, substituting a raucous
city streets accent for the latter's folksy twang."

But it was Mekas who did the most to keep the film in front of
audiences and the one who most saw in *Pull My Daisy* not a di-
version but something startlingly new. Born in Latvia, Lithuania,
Jonas and his brother Adolfas had been imprisoned in a German
labor camp during World War II. They lived in a displaced per-
sons camp after the war before immigrating to New York in 1949.
Mekas was an institution builder who, ten years on in New York
City, was beginning to see results from the connections he had
been forging. Mekas was approachable but enigmatic, purpose-
fully hard to read in person. Slender, short, and stark, to film-
maker George Kuchar he resembled Mr. Scratch, the devil in
southern folk culture. "The eyes were always going here and there

and he appeared happy but I don't know if that is what it was like underneath."[12] Mekas had been present throughout the making of *Pull My Daisy*, visiting Leslie's loft during filming, attending Kerouac's recording session, dropping by the editing room, and present at the Cinema 16 opening. A true believer who didn't hew to fixed ideas, Mekas came with diverse views and tools for making sense of what was happening around the Lower East Side—and all around the world.

A 1959 entry from Mekas's diary: "Ron Rice called. He says he read my *Voice* column, got all excited, wants to make movies."[13] Rice was a high school dropout from New York who had drifted to San Francisco in the late 1950s. There he bought an 8mm camera so he could film a bike race. Rice wandered into the Coexistence Bagel Shop in North Beach, where a sarcastic, pixilated ex-stockbroker named Taylor Mead was reading poetry off scraps of paper—the work wasn't Beat, exactly; it was dark and surreal and funny, like Mort Sahl in leather chaps. The two hit it off and discovered a mutual interest in film. They took in a screening of *Pull My Daisy*, and "we both said, 'that is what's happening,'" Mead recalled. Right then they knew they weren't nuts: the film's lurching whimsy, its disinterest in characters, the very fact that nothing particular happened, and happened wonderfully—all of it reflected the sensibility they shared.[14]

"Ron said, 'That is the movie we have to make.'" The movie they did make, *The Flower Thief*, follows Mead for seventy-five minutes as he bops around the fading haunts of bohemian North Beach, a pleasure-seeking Pee-wee Herman who radiates innocence and experience in equal measure. *The Flower Thief* was filmed largely with discarded magazines of World War II military surplus fifty-foot film. They shot it on a handheld 16mm Bolex camera. Scenes are roughly stitched together and shudder to a halt when film runs out of the camera. The two were living meal to meal, and their double-digit budget made *Pull My Daisy* seem like a Hollywood extravagance. They paid for it by having Rice forge checks on his girlfriend's account. For this and other reasons, Frank said of Mead and Rice, "They were really outsiders."[15] Upon its release in

1960 Mekas called *The Flower Thief,* "The craziest film ever made, a peak of spontaneous cinema and one of the five landmarks of new American cinema."[16]

Ultimately Mekas would speak of a "post–*Pull My Daisy* approach" to moviemaking, one he dubbed the Poetry of the Absurd. It was extreme bohemianism, steeped in queer culture and non-naturalistic performance styles, outrageous and damaged. The critic Parker Tyler nailed it when he noted a tendency among new filmmakers to extract a slapstick banana peel from old movies and drop it in the world—suddenly "the actors are not in comic uniforms, as if the parody were part of real life."[17] But what made it new was more than just a comic style: part of the post–*Pull My Daisy* approach was to experience life as a character cast-off from Hollywood melodrama, as an unstable construction (a star) planted on an unstable set (the world). This was subcultural and sub-cultural too: meaning cultivated in queer, poetry, and sexual undergrounds, formulated below reason as much as beyond it. It came from a lot of places up and down the Lower East Side, but from no place more than Leslie's spray-painted loft. And when Ginsberg and the boys rattle down the stairs at the end of *Pull My Daisy,* throw open the door, and hit the street, geeked and loaded, they were like sailors heading for the wildest port any of them had ever seen. The New American Cinema.

A group of filmmakers began meeting monthly at Mekas's loft in the fall of 1960. Among them were Frank, Peter Bogdanovich, Shirley Clarke, Emile de Antonio, Stan Brakhage, Robert Downey, and Gregory Markopoulos, all gathering to share technical information, discuss ways to put films before a wider audience, and, most of all, share how to get their films made. "See there was in '59, '60, '61, like a dream among the New York up and coming young filmmakers that everybody was talking about us so maybe there would be also money coming in," said Mekas. "There was this wishful thinking that never materialized."[18] Someone was always around Mekas's loft, working on a movie or arguing about one, using his equipment or bringing a reel he had to see now. A manifesto was drawn up, and it sounded pretty good:

"The official cinema all over the world is running out of breath. It is morally corrupt, esthetically obsolete, thematically superficial, temperamentally boring. Even the seemingly worthwhile films, those that lay claim to high moral and esthetic standards and have been accepted as such by critics and the public alike, reveal the decay of the Product Film." They called themselves the New American Cinema Group. "There is something decidedly wrong with the whole system of film exhibition: it is time to blow the whole thing up." They fumed over the lack of distribution and how their films had a better chance of being seen in Paris, London, or Tokyo than in New York. It ended, "We don't want false, polished, slick films—we prefer them rough, unpolished, but alive; we don't want rosy films—we want them the color of blood."[19]

That was the group around Mekas, but filmmakers were raising similar concerns in Los Angeles, San Francisco, Chicago, Europe, and Asia. Out of such concerns a distribution network emerged, as did countless arguments that the blood was not red enough. The New American Cinema Group became the Filmmaker's Cooperative, became Andy Warhol's de facto film school—it was in Mekas's loft that Warhol saw many films and met many of his Superstars. "There was like a camaraderie, friendship, solidarity. There was this dream that kept us close together," said Mekas. "Though we were all very, very different—Emil de Antonio was a political documentarian; Lionel Rogosin was very race-problem minded, he made films in Harlem and Africa; and some like Gregory Markopoulos or Stan VanDerBeek were in those days what was called experimental avant-garde or poetic cinema—different, each one was like a different branch of the same big tree called cinema. And Robert was always interested in, like, a darker thing, the Bowery, the bums and the lost sad souls of humanity, the invisible part of the society."[20]

From the Cooperative came a distribution system that put the work of the new filmmakers on campuses and in film societies across the country. Today Mekas sees the success of it but also sees what didn't happen: they were never able to create a funding structure to make more films possible. He had an unrealized vision

of a movement. "The whole generation of young filmmakers that was very promising did not really materialize and did not really reach their potential because the dreams were too big," he said. "To me it's like a lost generation." He runs through a list of names of projects and funding walls—what might have happened for Shirley Clarke, for Jonas's brother Adolfus, for Lionel Rogosin or Barbara Rubin. Of course, it's possible to look at what *did* happen for each of them: each made work in the late 1950s or the 1960s that mattered to audiences. But Mekas knows of more unfulfilled projects than anybody alive, and he hasn't forgotten them. "There was initial success for someone like Lionel Rogosin, and then after that initial success they wanted to make much more ambitious projects, and they felt like at least they needed one million, say. But that one million was not there."

The notebooks kept by Mekas show him constantly dealing with money, with the disrespect that comes from not having it and with not particularly wanting it. In a 1958 entry he describes working on a film with Edouard de Laurot and shooting a scene at a gas station. A police officer arrived and said he was arresting them all. "They couldn't understand," de Laurot explained, "why we were making a film without being paid, just for the love of making it. The cop even called his superior, on the phone, and told him all about our case, asking if such a thing was possible that someone would make a film without being paid."[21]

On September 16, 1960, Mekas ran into Mary Frank on Avenue A and lent her 50 cents so she could buy some fruit. "Robert is still editing, and out of money," he wrote in the day's entry. The entire situation put Mekas in a foul mood. "I stood on the corner, overlooking the wet park, waiting for the bus, and cursing the brown trees." He continues, "Art, art, art. . . . Always goddamn art. Who needs it! And who said that Kerouac is not literature? Always the same art bull talk. . . . They are going to teach Robert Frank and Kerouac art! They are going to teach me, who went through the forced labor camps of their culture and their tradition! I put the match to it, pow! Culture and art are O.K. as long as it's not used as a club to hit life on the head."[22]

He cursed the invisibility that came from making a film that asked the wrong questions. And then he got on with it. The only way forward was to live like that, Mekas could see. It was something few were prepared to do. "Robert stuck to it, doing it his way because nobody would put up money," said Mekas. Frank benefited from Mekas's early critical support and learned from his example. "This is where Jonas was ahead of us. He always said: 'There's no other way. You must believe in what you do. No compromises,'" said Frank. "He was a kind of visionary priest. Everyone else, including me, was still playing with a thought that suddenly a door might open."[23]

New York was fortunate to have Mekas, who threaded a disharmonious array of sensibilities and personalities into something larger, exhibiting a passion and judgmentalism (he disliked Maya Deren and famously turned on John Cassavetes) that was perfect for the time—it united at least as much as it divided. He was not quite a leader and far from a mandarin, remaining a front liner, wave breaker, all the way into the twenty-first century. He founded the still-thriving Anthology Film Archives. He slept beneath his editing table.

THE SUCCESS OF *Pull My Daisy* gave Frank the ability to produce his next project. He chose *The Sin of Jesus*, one of the short films he and Leslie planned to make together. But after their squabbling, Frank and Leslie weren't much talking. Walter Gutman put $20,000 up for *Sin*, and Frank invested $5,000. The film, released in 1961, was ambitious—it had music by composer Morton Feldman—and it was serious. A woman on a New Jersey chicken farm pleads with Jesus to cure her of her promiscuity, and he sends a guardian angel whom she seduces. Misery ensues. Mekas said he didn't like it at first, but after five viewings he had changed his mind. It was one of the gloomiest movies he had ever seen, he said, but in a good way; pessimism was what *The Sin of Jesus* had going for it.[24]

After a screening in Paris, Francois Truffaut said to a friend, "That's the worst movie I've ever seen. I guess I'm just not an

original sin boy." Frank himself later explained, "[It] didn't turn out very well, because I decided to shoot it in a very professional way—35mm, sound, actors, all that. I couldn't manage. I couldn't manage the machinery, I couldn't manage the people, I couldn't manage the actors."[25]

Frank hired Gert Berliner, who had done camera work on *Pull My Daisy*, to be cinematographer for *The Sin of Jesus*. Berliner was a friend of the family; when Frank drove through New Mexico while he was working on his Guggenheim fellowship, the Franks stayed at Berliner's ranch. One night during the making of *Sin of Jesus* a visitor came to Berliner's door. "There was this thing with Mary. I remember one late evening Mary appeared in my apartment, tears in her eyes, and I didn't ask her but I knew . . . they were starting to break up," he said. "Robert had his little affairs. He was very attractive to women."[26]

OK End Here, a thirty-two-minute film made in 1963 and set in contemporary New York, followed *The Sin of Jesus*. *OK* was based on a short story by New York writer Marion Magid that fictionalized the end of her relationship with Berliner. Bankrolled by Eddie Gregson, the son of a California real estate tycoon, it was also shot on 35mm film with a professional crew. Like *Sin*, with its deep bow to Bergman, *OK* showed Frank absorbing art house influences. Later he would acknowledge the film owed a big debt to Antonioni and called it the worst film he ever made.

He would eventually describe his turn toward movies in various thoughtful ways, but undoubtedly Frank was interested in making them for visceral reasons too because movies were attracting artists across all disciplines, as New Yorkers as varied as Ed Sanders, Andy Warhol, James Baldwin, Susan Sontag, and Tony Conrad had all come to believe. There was an excitement about filmmaking and Frank was caught up in it, and while he kept his enthusiasm in check like Alfred Leslie never did, he wasn't yearning to make quirky movies that twenty people would see. Connection was the plan. But after *OK* something was different. Frank learned how to make polished films steeped in New York intellectual mores ("He really tried," said Berliner) and discovered how unfulfilling

it would be to make more. *OK End Here* won the grand prize at Italy's Bergamo Film Festival and marked an ending for Frank. Made just a few years before, *Pull My Daisy* had been a celebration of group improvisation: a jazz band jamming, juiced up friends flapping their gums, two coots behind the camera tiptoeing around a million disagreements while dropping words like trump cards. That was over. So was the notion of a complicated project with a large crew, budget, and planning. After 1963 the films he made were usually produced on the fly, dodged teamwork as much as possible, and lived or died hand to mouth.

THERE WAS A DIVE on the Bowery that served hog jowls for a quarter, rice and potatoes for fifteen cents. "That's a hell of a good restaurant," he would tell his friend Emile de Antonio as the 1960s began. Robert Frank loved a good bargain. Around this same time de Antonio happened to be walking in midtown when he spotted Frank driving down the street. He was behind the wheel of a Cadillac convertible packed with five fashion models, en route to a commercial photo shoot. Spotting his friend staring at him, Frank did not look too happy. De Antonio used the moment to reflect on the contradictions of an artist trying to make it in New York amid the possibility of financial gain and the reality of fifteen-cent hog jowls. Frank had a taste for both, more than he sometimes acknowledged for the former, de Antonio suggested. He saw it as one of "the strange contradictions in Robert's life." Both could be a pose. What would be helpful would be someone who knew how to thread the needle, walk the line between the necessary and the desired.[27]

As it happened, in 1963 an old friend came back into his life, a champion balancer of his own diverse, ample hungers. Allen Ginsberg had fled New York in March of 1961 on a ship bound for France. From there he journeyed to Africa and India to wander barefoot, bathe in the Ganges, and get turned inside out for a good year and a half. It was a trip he took for spiritual reasons, yet leaving the United States made sense on other grounds as well.

The Beats had spawned beatniks, and stardom—or infamy—was raining down on the movement's biggest figures. Old friends were attacking him viciously in print, and what Ginsberg symbolized risked eclipsing what he could accomplish. Ayn Rand was calling JFK a "high-class Beatnik," and the director of the FBI, J. Edgar Hoover, warned at the most recent Republican National Convention that "communists, beatniks, and eggheads" were the three biggest threats to the American way of life. The Beats had lost control of the narrative and risked becoming fixed as caricatures. It was a good time to get gone.[28]

But in late 1963 Ginsberg came home. Nobody was talking about Beats much anymore. He and his partner, Peter Orlovsky, stayed in San Francisco for several months and then moved into an apartment above the 8th Street Bookshop in Greenwich Village. When he saw what was going on in the New York neighborhood, Ginsberg too caught the filmmaking bug.

"But what's happening now in the U.S.?," he asked rhetorically in a piece called "Back to the Wall." "Amazingly enough, MOVIES. After having been absent from the land for three years, I found on my return an excitement, a group, an art-gang, a society of friendly individuals who were running all around the streets with home movie cameras taking each other's pictures, just as—a decade ago—poets were running around the streets of New York and San Francisco recording each other's visions in spontaneous language." It was film that best captured the current moment, "The film of cranks, eccentrics, sensitives, individuals one man one camera one movie."[29]

After reading Ginsberg's poem "Kaddish" Frank spoke excitedly with him about translating it into a movie. "Kaddish" was a mournful work, a remembrance of his mother, Naomi Ginsberg. Naomi had attempted suicide and been institutionalized at Pilgrim State Hospital in 1956; she received insulin shock therapy and then a prefrontal lobotomy before she died of a stroke at the asylum the same year. "Kaddish" was mostly written in New York in 1959 during a thirty-six-hour binge on coffee, boiled eggs, morphine, and methamphetamine. The result is one of Ginsberg's

most celebrated works and one that Robert Lowell would call "his terrible masterpiece."[30]

The two met in California with Eddie Gregson, the Hollywood playboy and actor who had produced *OK End Here*, and Gregson promised money (they also met with Philip Roth at the Sam Reno, gauging his interest in joining the project). Frank started work on a script by himself—no easy thing: from the beginning he struggled with how to turn a prayerful look back at a woman's life into a narrative that moved forward in time. As the two talked, their film grew beyond the poem itself. It would be an account of Naomi's nervous breakdown and death in a mental hospital, incorporating new material to tell aspects of Allen's childhood in Paterson, New Jersey, and his life with his mother. Frank saw a need to set the story in the contemporary world—modern man, he said, must be in it.[31] Ginsberg imagined orgy scenes and March of Time news-reel clips of Hitler intersecting with scenes of his mother's mis-treatment. The two argued about the storytelling, and then Frank backed off, acknowledging, after all, that it was his friend's story to tell.

"Kaddish" grabbed Frank, and he brought his own reading to it, but as the two argued, it became clear to him that Ginsberg would need to write the script. He had no more experience writing one than Frank, however, so after he moved from San Francisco to New York, Ginsberg came to Frank's loft, parked at a typewriter, and was paid an hourly rate by Gregson to compose a screenplay. For several months while at Frank's residence Ginsberg cut up his poem, arranging the lines in strict chronological order, and orga-nized a tally of all the visual images in the work.[32]

As this went on, Frank took the opportunity to observe Gins-berg, and his friend knew he was being studied. "He was curious of how I stood up under fame, under light, under actually grow-ing up and what my character was, in a way," Ginsberg said.[33] Meanwhile both were watching what was happening to another friend. Kerouac was getting strange—pulling away from his friends, drinking heavily, becoming mistrustful and ever more vocal of his contempt for the idea of a Beat "movement." A photo Frank

made in 1962 on the beach at Cape Cod: Andrea Frank sits on the sand, a long American flag draped over her shoulders trailing toward the viewer, as she reads a tabloid newspaper headline that shouts "MARILYN DEAD." Fame kills, and it was slowly killing Kerouac.

Like Kerouac, Frank had little protective coating for the way fame burned. But Ginsberg was different—strategic and hungry for attention, attention that could be put at the service of your work. He was someone Frank learned from just by watching. Also, Ginsberg perhaps offered, as did Mary, a connection with his Jewish identity. It was not something Frank talked about much.

John Cohen recalls a time when he, Frank, and Miles Forst all went for a walk on the Lower East Side. "Well, I had no sense. I was just looking at people as people. I had no idea about anybody's religious beliefs and no idea about Robert's—he was just this guy from Switzerland. So we walked and walked, talking, and at the end of the walk we came across a synagogue that was packed. I forget what holy day it was. Robert said, 'Hey, let's go in.' I didn't *know* he was Jewish. We just related as people. . . . Well, they wouldn't let us in. But in my mind he was stepping out and reconnecting with who he was, though they wouldn't let him."[34]

Fame was a bulldozer, and understanding who you were gave you a better chance of surviving it. Years past "Kaddish," the guy Frank had become would look back at the guy in the convertible Cadillac and deliver judgment. "I was very naïve, I believed that would solve a lot of problems," he said. Fame. "The problem of being alone, of not knowing exactly where you are. So if you're recognized, you'd see some way in front of you. Also it would solve, maybe, some material problems. And it would make you happier."[35] With huge successes behind him, now came the thrill of repeated failures. He was into it. Frank had found a new way to be.

CHAPTER TEN

NEW PROJECTS

FRANK HIMSELF was getting good at weird. There was no end of interesting people downtown in the early 1960s, and the photographer-filmmaker had an inner transponder tuned to pick up what others were sending out. Frank admired Ginsberg and Kerouac and the others, but he never identified as a Beat. Belonging to a group just wasn't in him. "Robert Frank was not involved in the art world," says Cohen. "He was mistrustful of movements and organizations and was more drawn to individuals with quirky human qualities. People I met around him happened to be artists and photographers, but they were totally unique."[1]

He preferred people like Robert Thompson, joiner of no schools, just a fearless African American figurative painter that Robert and Mary had befriended in Provincetown and who was now living on the Lower East Side. People like filmmaker Jack Smith, who was decadent, needy, his antimaterialism no position—it was his very skin. Smith loathed the idea of owning stuff, a condition he called Landlordism. He had his own term for the sellouts he saw everywhere around him: "walking careers."[2] There were plenty of radicals around the loft. Once, when a grade school friend of Pablo's came over for lunch, he found his chum getting a clarinet lesson from jazz outlier Ornette Coleman. All around were artists whose lives seemed every bit as interesting as their art and whose art made you want to seek them out. He admired Jack Smith and believed Smith's *Flaming Creatures* was the strongest film of the era. "Although when I saw it I really didn't like it . . . it had a certain freedom, in making films there were no rules . . . you know I am too ordered, I am too square . . . so that film meant a lot to me."

Frank added, "I could see that he was an important artist, and he had a vision that was completely original and singular and . . . quite sad, in a way, poetic."[3]

Perhaps the most intriguing of all was Harry Smith. Frank, Ginsberg, Cohen, and others on the Lower East Side were all enthralled by Smith—and afraid of him too. He was a self-taught artist, filmmaker, practitioner of magick, collector of Easter eggs, and a wizard in disciplines nobody has a name for today. When he chose to be, Smith was a volcanic conversationalist, equally capable, Frank said, of talking with a homeless man on the Bowery or an academic scholar.[4] Ginsberg had introduced Smith and Frank in the 1950s at a time when Smith was making profound, intricate films and paintings that embodied the intensity and higher calling Frank also saw in de Kooning. Then, in a fit of drunk rage, he might roll the only reel he possessed of a film down the street. Smith was possibly larger than life, and you never knew what about him was true, only that the stuff that checked out was difficult to believe. At a time when his films were becoming known to a wider audience, Jonas Mekas opened a 1965 *Village Voice* column by asking, "Does Harry Smith even exist?"[5]

He was short and a bit hunched, with glasses and a kelpy beard. Arriving in New York from the Bay Area in the early 1950s, Smith met the author of a book on UFOs, who slipped him the Lower East Side address of a fellow named Lionel Ziprin. The flying saucer acolyte suggested the two would hit it off. Ziprin was the author of the 785-page poem "Sentential Metaphrastic" as well as an authority on the mystical knowledge of the kabbalah and a peyote eater. He, Smith, and the artist Bruce Conner launched a greeting card company named Inkweed Arts, Smith's specialty being the construction of 3D cards you had to wear special glasses to experience. Smith had uncanny awareness of where the metaphrastic ideas were stored, and he gravitated to those spots.[6]

Frank was a guest at Ziprin's apartment on East Broadway, and though it is unclear what they might have talked about, it's likely Ziprin did most of the talking. He once explained himself: "I am not an artist. I am not an outsider. I am a citizen of the republic

and I have remained anonymous all the time by choice."[7] It was a fine description of the kind of person Frank admired, the kind of person he was. In that space—in that clearing of *nots*—was room sufficient to get a lot of work done.

Another original, a wealthy filmmaker named Conrad Rooks, met Harry Smith in the early 1960s. He too was drawn to the short zealot who seemed to be having a special kind of fun. Rooks hired him in 1963 to edit a film he was making, installing Smith in a space he rented at Carnegie Hall before departing for Europe and leaving Smith in charge. Months later Rooks returned to a stack of unpaid bills and a forty-foot sand mound erected inside the hall. Smith explained that he needed the earthwork in order to film a peyote vision. Rooks inquired what he'd accomplished since he'd left town, and Smith explained "nothing," and so Rooks fired him. Soon enough, though, he would be back.[8]

Rooks had started an unusual project, a world-traveling epic film documenting the inner struggles and visions of a bon vivant not unlike Rooks himself who checks into a freaky European spa to kick his heroin addiction. The movie he was making featured scenes of rituals and drug-fueled hallucinations that, while conceptually confusing—should a treatment facility really be so psychedelic?—at least explains the vampires, naked women, and Indian ragas that were part of the film. In search of accuracy Rooks wanted to go where the real visions happened, and this is where Smith could help. He knew some things about the peyote rites of the Kiowa tribe, and so Smith was dispatched to make contact with tribal leaders who would let Rooks film their religious ceremony.

But Smith made a spectacle on the Lower East Side; it's hard to imagine what the citizens of the small town in Anadarko, Oklahoma, made of him when he got off the bus in 1964 and began poking around. He didn't get far. The sheriffs of Anadarko threw him into the local jail (an unfortunate business involving stolen firearms). The only non-Native American in the jail, Smith made the most of his time—he was transfixed by pictures on his cell wall, Hopi drawings depicting dances and the image of an altar, and he made important contacts among the Kiowa inmates. While

Smith was still incarcerated, Rooks came to town to film. He shot some seventeen hours of peyote ritual footage, but the crew were as high as the celebrants, and the Kiowa footage was decidedly unsalvageable.⁹

Eventually the Smithsonian Institution would release phonographic recordings Smith made of the Kiowa, and they have become widely celebrated; Smith said they were the best work he ever did. By the time he got his due Smith was a smelly, confirmed sponge, someone who crashed on your couch and stole or destroyed your stuff. He gossiped and grifted and ranted when intoxicated on alcohol or amphetamine—Harry Smith exhausted the people who admired him until they spun around quickly when they saw him coming. And yet Frank, who was known to burn through friendships, never changed his mind about Harry Smith. For the rest of Smith's life he would remain warily loyal to this friend, the visionary with the world's largest collection of paper airplanes.

BY THE TIME Smith was freed from the Anadarko pokey Conrad Rooks was in France, setting off the crisis du jour. He wanted what he wanted instantly, and in France, Rooks decided he wanted a new cinematographer. The one he already had was not just any cameraman: Rooks had hired Eugen Schüfftan, who had worked on *Metropolis* with Fritz Lang and *Napoleon* with Abel Gance and had just won an Oscar in 1962 for *The Hustler*. But Rooks was displeased with Schüfftan and invited Frank to come visit the Medieval castle in France where the cast and crew were staying. When Frank arrived, the director was nowhere to be found. After two days of waiting Frank woke up to the sound of screams coming from the room next door. Creeping onto the terrace, he peeked over the next balcony and finally found Rooks. Standing on his head, reciting his mantra. Noticing he had company, the director sprung to his feet and launched into a tirade. "Goddamn it, where's your camera?" he yelled at Frank. "What the hell did I hire you for?" It was as good a way as any to find out that you had been hired.

Conrad Rooks toggled unpredictably between student and master. He latched onto people he wanted to learn from, sat at their feet and soaked up their wisdom. Others saw him as somebody you couldn't tell anything to: his self-confidence was oppressive. Between those poles was an enormous empty space he spent a lot of money to fill. His father had been an executive for the Avon cosmetics company; when Dad made company vice president, he moved the family to the affluent Westchester County town of Chappaqua, New York. Young Conrad was asked to leave at least three prep schools and sent to a string of psychiatrists. "They said I was a master con man, an expert salesman, as long as I was selling myself," he said. "Later on their diagnosis got more specific. They said I was a paranoid schizophrenic. Delusions of grandeur, they said, and I guess they were right." In trouble with the law, he entered the Marines. After the military bounced him Rooks lived at the New York Athletic Club in the mid-fifties, drawing on his dad's bank account. Rooks hung out with a Times Square sexploitation film director, and together they made grindhouse features with names like *White Slavery* and *Girls Incorporated.* "I learned that we could make a movie for $29.00! That blew my mind," he said. "I couldn't believe it. When I realized that, I also realized what an enormous crock of *merde* Hollywood is, from start to finish." Unfortunately the lesson Rooks learned wasn't that Hollywood movies were wasteful but that if you could make a film for the cost of a round of drinks at the Stork Club, imagine what could be done spending a family fortune far from the Hollywood sphinx. He vowed to give it a try.[10]

He married a Russian royal mystic. They went east in 1959, smoking opium with Italian aristocrats and Jean Cocteau before parking in Thailand. "I was up to 72 pipes a day," he radiated, "that really is the limit. If you go beyond that, you're a dead man." His father wrote from New York saying he was sick, asking him to come home. Rooks made it as far as Hong Kong before a rickshaw boy hooked him up with heroin; at that point he sent his wife and son back to New York and lived in a tin shack with a group of rickshaw boys.

It was a good thing Rooks's wife knew a Viennese doctor in New York with a radical method for treating heroin addiction, one that involved a mixture of vitamins and speed. "It takes your metabolism and puts it right, almost instantly. Remarkable," Rooks enthused. The Viennese doctor forwarded him to a clinic in Zurich, where the treatment rendered him unconscious for thirty days, Rooks said. When he woke up, he was clean.

Rooks was what happened when the Beat mystique collided with a massive speedball of money. Of his friend Allen Ginsberg he raved, he "is the greatest showman in the world. He grows out of the Jewish tradition of the Messiah, but my own is different. I come out of the tradition of the Buddha. The Buddha, you know, was just a prince who renounced his father's throne. Do you follow?" He was desperate for a following. In the early 1960s Harry Smith was one of Ginsberg's spiritual advisers, introducing him to hallucinogens while feeding his interest in experimental movies. William Burroughs was a teacher too, and Rooks studied his cutup methods for months, carrying an oversized pair of scissors everywhere he went. (For a time Rooks owned the movie rights to Burroughs's *Naked Lunch.*) "Like Robert, he came out of a time when you were hit in the face every day by things that just didn't make sense," said Alexander Rooks, Conrad's son. "And he certainly felt it and rebelled against it as much as anyone."[11]

The road beckoned: he rented a car for six days with a New York experimental film hustler named Sheldon Rochlin. They chased white line fever for five months, driving around the country with a camera. He wasn't wrong to think his life was rich material for a film, and he set out to make it, one that became *Chappaqua.* He shot hours of footage on 16mm black-and-white film, taking eighteen months and five rental cars to finish it, and then he started all over in color, hiring a full cast and crew. His ambition was now to make a movie that would be shown in the places where both *Girls Incorporated* and *Pull My Daisy* were screened—and to outdo them both.

WHILE WORKING FOR Rooks Frank was continuing preparation for *Kaddish*. Ginsberg was aware the effort to translate his poem to film was going nowhere. Frank pursued investors while broadening his ideas about what might be included in the film. He had been seeing a lot of Ginsberg and Orlovsky and was intrigued by Peter's brother Julius. Sometimes described as a catatonic schizophrenic, Julius had recently been released to Peter and Ginsberg after spending years in Pilgrim State Hospital, the facility where Naomi Ginsberg had been kept. Julius had a special presence and a way of communicating that could seem richly meaningful, profound even, to those around him. "Robert couldn't raise money to film *Kaddish*, so he started shooting my roommate Peter and his mental hospital brother Julius Orlovsky in New York," said Ginsberg.[12] Though there were times when he was talkative, Julius had also gone years without speaking, and Frank began to think about a film structure that would simultaneously tell the story of Naomi and her son as well as Julius's story.

In a prospectus written for investors Frank described a film in which Julius would be seen wandering around New York while interacting with other characters, and in their interactions he would reflect the madness of those around him.[13] That the psychotic could teach society lessons was an idea drawn from the ideas of Scottish psychiatrist R. D. Laing, then in vogue, which connected mental illness to societal illness.

Late in 1965 Bob Dylan gave Ginsberg $600, enough to purchase a German Uher portable tape recorder. With it Ginsberg, Julius, and Peter drove from the Bay Area to the Midwest, where the poet Charles Plymell had set up readings. As they drove, Ginsberg coaxed out various voices in his head—radio voices, coffee shop conversations, bantering roadside signs, Dylan lyrics, the rhetoric of advertisers and editorialists—and put the assemblage of words on tape in a free-flowing outpour. He was heading to Kansas, the geographical and, Ginsberg imagined, ideological center of the country. Having absorbed the art that came from friends' earlier drives across America, Ginsberg was ready to make his own report from the road, and to do it he traveled in a quintessential

vehicle of the time: a Volkswagen minibus. The trip yielded the poem "Wichita Vortex Sutra," an auditory collage that ferociously criticized the Vietnam War and the heartland that fueled it. Ginsberg wasn't shocked by what he saw, unlike Frank, and he fought back with the tools he had—a literal invocation of magic and the symbolic power of words.[14]

In Wichita they were joined by Frank, who made a memorable photograph of Ginsberg and the Orlovskys in a grassy Kansas field. Then they pulled into Lawrence. "Peter Orlovsky was the driver, and Julius was along, and Robert Frank and his girlfriend had come from Wichita," remembered Terrence Williams, a librarian at the University of Kansas. Williams had set up a reading at the university and let the whole party stay in his attic. At the Student Union a packed poetry reading was covered by *Life*, and Frank filmed Ginsberg reading passages from "Wichita Vortex Sutra." "I was petrified because I knew how sharp and shocking Allen could be, and Kansas was still, well, Kansas, and things were pretty buttoned-up still," said Williams. In Lawrence Ginsberg stood at a podium, wearing his linen "guru costume," with Peter seated next to him on an oriental rug as a tambura droned on his lap. "The two of them played and sang for an hour and a half to an audience that was mesmerized, really swept away by the power and the beauty of the language, the rhythms, the message of peace and love. This was truly a high point of the 1960s for those of us who were there," said Williams.[15] Frank filmed the event.

Topeka's Menninger Foundation ran a sanitarium and a school of psychiatry, and Williams had arranged a small reading there for the visiting poets. "It was tense, to say the least. I think all these guys were quietly diagnosing Allen and Peter as they read." But it went well enough, and afterward a reception was held. Things began promisingly, up to the moment when Peter Orlovsky began taking his clothes off. When he got down to his red underwear the hostess fainted. "That was the end of the party," recalled Williams.

It wasn't the end of the fun, though. "I was kind of shocked at the sexual activity that was happening," recalled a Kansas poet who says he opened an attic door to a room where the visitors

from New York were staying and stumbled upon a bacchanalia. "I wasn't quite used to the New York sexual ways. . . . Robert and Peter seemed like old friends all of a sudden!"

Between New York and Wichita *Kaddish* had mutated into a film titled *Me and My Brother*. Ginsberg would be in it a bit, but the story of his mother and his poem was gone. *Me and My Brother* would feature the stutter-step rhythms that "Wichita Vortex Sutra" was steeped in, the film a similar ruckus of tones and textures. Things kept happening, and Frank's direction kept changing: he got so good at making adjustments that making adjustments became one thing the film is *about*. A new source of money emerged, but the investors insisted that the film be shot in color, a problem given the reels of black-and-white that were already exposed. Then disaster struck when Julius, now squarely the subject of the film, disappeared. While people looked for him, Frank hired the Living Theater's Joseph Chaikin to play Julius and kept on shooting.

"We found him months later in a provincial hospital north of Berkeley," Ginsberg explained.[16] Chaikin didn't look like Julius and doesn't attempt an imitation, and yet his scenes—alternating with scenes of the real Julius—utterly work because the film constantly plays with the notion of what is real and what is film fiction. Elsewhere the actor Roscoe Lee Browne plays a photographer, and Christopher Walken (in his movie debut) briefly plays the director in a film within the film. This frenzied playfulness also becomes part of what *Me and My Brother* is about.[17]

FOR A PERIOD of the mid-1960s Frank was working simultaneously on *Chappaqua* and *Me and My Brother*. Rooks could easily have taught Frank a few things about living in the moment. Three times he took the *Chappaqua* ensemble to Lame Deer, Montana; he went to a Pentecostal church in Savannah, Georgia, the Ganges and Merida, Yucatan, and many places beyond. He would see a magazine photograph of redwood trees and charter a flight to Monterey because suddenly these trees *had* to be in the picture. Frank would receive a cable in the middle of the night saying, "Meet me at the

Taj Mahal on Tuesday." When the crew left Kingston, Jamaica, it was so abrupt a departure that reels of film were left at customs, never to be claimed. There were mushrooms and coke and acid and pot and alcohol around the set, and impulsiveness prevailed. "We had to learn to take advantage of the accident. That's why Robert was the only one I could work with," Rooks said. "The accident—that was the thing."

The *Chappaqua* cast itself featured diverse talents. In France Rooks prevailed upon actor Jean-Louis Barrault to play a doctor, though Barrault at first turned him down. "However," the promotional material for the movie explained, "when Rooks mentioned Peyote, Mexico and pyramids, Barrault grasped immediately the general direction of the film" and signed on at a fee of $1,000 a day. Rooks snagged *Playboy* model Paula Pritchett for the female lead and cast English beat poet John Esam, the first person to be arrested for possession of LSD in Britain. Rita Renoir, aka Vedette, a legendary French stripper who had appeared in Antonioni's *Red Desert*, was on board. Ginsberg, William Burroughs, and Hervé Villechaize all had cameos. Ideas—at least those belonging to Rooks—were always entertained. Frank and Rooks were walking around New York when they came across the blind street singer Moondog, toting his spear and wearing his Viking helmet. "I want you to come to Montana with me and Ornette," Rooks blurted out. Oh yeah, Ornette Coleman was doing music for the film (a score was composed, recorded, and vetoed by the director). Rooks wrote Moondog a check on the spot, and before he was anything like done he had also paid Philip Glass and Ravi Shankar and the Lower East Side rock band the Fugs to be in the picture too. *Chappaqua* may not have been the best film ever made, and it definitely was not the cheapest. But few were anywhere close to as much fun to have survived.

At one point Rooks was sulking in his French chateau room for several days, and Frank and the crew rounded up a cluster of beautiful French women to concoct something to shoot until the maestro reemerged. He did, demanding that they film an orgy scene. Rooks was wearing a garish Indian costume, and one of the

girls started giggling, and the silliness of the moment was suddenly visible to everyone, even Rooks, who spun around and glared at Frank with a murderous look. "I turned the camera on him and filmed him for about 15 seconds, and I got him as I never had before—just staring into the camera; angry, and terribly frightened. Then he walked away," said Frank. "Those 15 seconds—I saw them in the rushes, and they were maybe the best of all the footage." Perhaps this was the day in Paris, mentioned in Jack Sargeant's book *Naked Lens*, when Jean-Luc Godard visited the set. The master watched the process for a while before, while gesturing in the direction of Rooks, Godard said to Frank, "you ought to make a film on him."

As they bolted from country to country in search of the next backdrop, events would occur that tested Rooks's often-wobbly cool. The auteur and his cameraman were in a cab one night in India, motoring from Allahabad to Bombay. Rooks had dosed Frank with two hits of Owsley acid, and now both were sailing across the Indian countryside. They responded differently to their condition: Frank felt the hot air on his skin and, as he looked out the window, hallucinated that he could see the entire history of India, elephants, untouchables, British regiments, all lined up along the roadside staring at him. They listened to Ravi Shankar on headphones. Meanwhile Rooks was in full panic, throwing possessions out of the car window, demanding the Sikh driver pull over at gas stations, getting out and crawling around on all fours, terrified, taking off all his clothes and drinking coke and milk to induce vomiting. Frank finally left him at a hospital for observation.[18]

"The guy was interesting," Frank recalled later. "He was a real nut."

After he had a chance to view all the footage that had been shot, Frank told a writer that in sum it was "a monumental waste of film—there are long stretches of Rooks holding a microphone, nothing else, and then endless shots of things like car trunks and road signs." Rooks asked him to edit *Chappaqua*, but Frank had had his fill. "You couldn't work with a madman like that. It was totally impossible."[19] When it was all over—after being fired and

rehired five times and shooting untold hours of film for immeasurable sums of money—Frank's reaction was revealing. He called *Chappaqua* the only film he worked on that he ever truly regretted. "I spent a lot of time and energy working for that guy, it was interesting, all around the world and all that. But it didn't make sense, it wasn't personal," he said. "It had nothing of me in it. It was Rooks's thing. It was my camera doing it—and I did try to twist the film as if it were my own, but he was just too difficult to work with." Obviously Frank knew he was a hired hand, but something about the experience got to him: something about the promise of spontaneity and all the possibilities rendered and ruined by the man signing the checks. Rooks got to Frank and left him with quite a tattoo.

One thing about inhabiting the moment—channeling all the energy and skills and mistakes shining before you—was that it kept your mind turned outward. It keeps a morose person from falling into the pit, and Frank definitely had a depressive streak. The perpetual motion was a druglike distraction for a time. For Rooks's part, he viewed the film as a mission he was honor-bound to complete. "He looked upon it as a very painful and expensive rite of passage," Alexander Rooks explained. "He knew he was going on this trip, but he honestly believed that it was a good thing—but he didn't understand why it was a good thing until later."

Chappaqua was released late in 1967 to mixed reviews (*Variety*: "a three-quarter million dollar fur teacup"[20]). Frank's photography is incredible, including several stretches of gorgeous Times Square footage in black-and-white. All but forgotten today, in its time *Chappaqua* was viewed as a harbinger—a record of important altered states. At the 1966 Venice Film Festival the film came in second in the competition, besting movies by Bresson, Varda, and Truffaut; *The Battle of Algiers* was the only picture the judges liked more.

Sitting at a Venice outdoor restaurant in 1966, four empty bottles of wine orbiting around him, Rooks laid out the next step of the revolution to a visiting journalist. *Chappaqua* was just the beginning. If he had his way, movies and very powerful drugs would

make America great again. "The pilgrims found an hallucinogenic world in America when they came and they destroyed it. Now the drugs will bring it back. They will give us a world with no separation between past, present, and future. They will give us back reality."

Universal Studios was worried about the nudity and drugginess of the film and created a subsidiary for the purpose of masking their involvement. That wreaked havoc with distribution plans and limited the film's release.[21] Not that any of these details gave Rooks pause. He announced plans for a cross-country tour in a VW bus customized with a high-fidelity sound system with which he would bring his movie to the masses. He would hit the road with Ginsberg, Orlovsky, and the Fugs. Perhaps also James Brown and Ornette Coleman, on a tour that would stop at gyms and college auditoriums and have poetry and music where *Chappaqua* would be shown. After that: party time.

CHAPTER ELEVEN

AN IMPRESSIVE BUNCH OF GUYS

THE FIRE STARTED in the basement, possibly in an area where cloth and plastic were stored. It spread to two adjacent buildings, and before it was extinguished, the blaze at Broadway and 23rd Street cost the lives of twelve New York City firemen. All city flags were at half-mast the following day, per mayor John Lindsay's decree. The fire also destroyed Alfred Leslie's studio at 940 Broadway, incinerating a large amount of his work from the past two decades.[1]

Lost in the fire were prints and numerous outtakes from *Pull My Daisy*. Frank and Leslie were feuding, and the fire destroyed whatever was left of their friendship. Frank blamed Leslie for the destruction of reels in the loft, while Leslie felt Frank tried to assert ownership of the film afterward.[2] "It was very simple: Some partnerships work, some partnerships don't," said Leslie. "It only worked on one film, what came to be known as *Pull My Daisy*."

Frank's current film projects made that first film seem part of another era. Strangely enough, though, his photographic work was now enjoying an acceptance broader than ever. While he chipped away at *Me and My Brother*, using Rooks's money to buy more film stock, a funny thing was happening to his photographic legacy: he was being celebrated as a prophet who had seen the dark side of America when few wanted to look, a crucial influence on emerging photographers of the late 1960s and 1970s. Almost from the moment he stopped taking photographs, his stature was on the rise.

In January 1962 Edward Steichen assembled an exhibition of work by Frank and Harry Callahan. He had wanted the title to be consistent with a series of previous exhibitions, all titled "Diogenes with a Camera," but Frank had had it with Steichen's grand concepts and threatened to pull out unless the title was changed to the simpler "Photographs by Harry Callahan and Robert Frank." The retitled exhibition more or less finished off whatever was left of their friendship.[3] Meanwhile, at the George Eastman House in Rochester, curator Nathan Lyons assembled a one-man exhibition of Frank's work, and he also struck a deal with Frank, giving him a supply of raw film stock for every print he donated to the institution. The Eastman's 1965 presentation of *The Americans* took Frank's work on the road to museums and galleries on campuses and in small towns and remained on view for fifteen years, helping introduce *The Americans* to America.

Tribute was being paid in absentia. There was Lyons's seismic 1966 "Toward a Social Landscape" at the Eastman House, an exhibition featuring photographers Bruce Davidson, Lee Friedlander, Garry Winogrand, Duane Michals, and Danny Lyon, all of whom had been inspired by Frank.[4] Through the artists he selected, Lyons argued that "point of view" was as essential a subject for contemporary photography as was the natural environment. A year later came the Museum of Modern Art's marquee "New Documents" exhibition, presenting the work of the then fairly unknown Diane Arbus along with Friedlander and Winogrand. In his introduction to the "New Documents" catalog, MoMA photography curator John Szarkowski wrote, "In the past decade a new generation of photographers has directed the documentary approach toward more personal ends. Their aim has been not to reform life, but to know it."[5] Selected by Steichen in 1962 to take his seat at MoMA, Szarkowski would be a champion of point of view. He no longer felt it imperative to ballyhoo to the public photography's potential as art; he *assumed* it was art and instead focused, as a critic and curator, on identifying its qualities as a branch of modernism. In twenty-nine years at the museum and through some 160 exhibitions, he never put up a show of Frank's photography, yet he

celebrated the spontaneity, mobility, and daring that began with Frank.

The background and foreground had reversed: suddenly, encountering the nobody people, the pop detritus, the street life, the subcultural 1960s became the best way to understand what was happening in the country. Szarkowski knew this when he said in 1968, "It is difficult now to remember how shocking Robert Frank's book was ten years ago. The pictures took us by ambush then. We knew the America that they described, of course, but we knew it as one knows the background hum of a record player, not as a fact to recognize and confront. Nor had we understood that this stratum of our experience was a proper concern of artists."[6]

The idea that if Americans all shared the same information they would all agree on how to move forward was rapidly falling away. Frank had pushed off from the documentary tradition, and now those he had influenced were delving deeper into associations with the world that were not simply literal, shared, and consensual. Szarkowski didn't believe in photography's ability to engage with issues so much as simply share an experience of how specific things looked. Where the viewer took that experience was outside the museum. It was clear in the work of Arbus, Friedlander, and Winogrand; clear in the work of Dylan and Robert Altman and Richard Pryor and Laurie Anderson too, for that matter. We were losing whatever faith there was that we saw the same thing when we witnessed a picture, a document, a testimony.

Szarkowski's statement that now Frank's America looked familiar to us all appeared in an unlikely place: on the back cover of the 1968 second edition of *The Americans*. Published jointly by *Aperture* magazine and the Museum of Modern Art (and in a subsequent 1969 *Aperture* edition), *The Americans* became real to a new generation. It was meaningful that the new edition was reviewed in *Rolling Stone* and the *Village Voice*, countercultural publications, but was mostly ignored by the US photographic magazines. Important too that observers seized on it as an opportunity to talk about the country and the artist. "Robert Frank is usually a deft, coruscating artist spitting bitterness, nihilism, and disdain," Walker

Evans wrote in 1969 in a voice—his own—that he had rarely shown to the public. "His always mordant, sometimes vitriolic photography seems an act of personal revenge, to a degree which gives it a certain power, permeated with nausea and despair."[7] Ten years before, Frank had turned aside Evans's much more presentable prose. But now even this cautious man felt free to bare a heart full of napalm.

The 1968 edition attempted to imitate the original's gravure printing process through alternate means, creating pages that registered less detail and looked murky.[8] That angered some, as did Frank's decision to feature different croppings for certain pictures. The fact that the only controversy was about a classic being messed with was one indication of how readily *The Americans*' content had been accepted. Meanwhile a multitude of photographers pointed to him as a defining influence.

The masterpiece was finally visible: Where was the master? His departure was the ultimate mic drop, the definitive brag that if nobody else knew what he had done, he did, and someday others would too. And although the move was meant to preserve his ability to make work that interested him, it served other purposes too, none of which were lost on the artist. He knew the landscape. He understood the impact reticence had on fans. Nobody, his friend Emil de Antonio noted, becomes a legend "absolutely passively." One way to do it was to make a lot of noise and behave in ways that attracted attention. The other was to disappear, a method, de Antonio noted, that drives people nuts.

"Robert intentionally made himself inaccessible as a way of making himself a legend and more famous," de Antonio believed. "It came easy to him because he disliked so many of the people who stood out there who might have been able to help him."[9]

CHAPPAQUA and *Me and My Brother* were so bizarrely complementary that they should have been projected simultaneously on opposite sides of a screen. They each flowed out of earlier, small-scale undertakings, and they threatened to remain in production

forever, or until the ideas or the money ran out. Like Rooks's film, *Me and My Brother* had some interesting casting ideas; according to actress Cynthia MacAdams, Frank had offered Shelley Winters a part. (While MacAdams says she couldn't recall too much else about the making of the film, she *did* state for the record that Frank was "a revolutionary lover."[10]) But with *Chappaqua* finally out in November 1967, Frank could focus on *Me and My Brother*. It had stopped and started, as money came and went, until he brought in Louis Silverstein's wife, Helen, to work on the film. In 1964 Helen Silverstein assisted on the set and also became de facto producer. Later she edited film and handled publicity. Her arrival changed the nature of the film, but its nature kept changing anyway, so things worked out fine.

The Silversteins and Franks were close friends, and one day Robert asked Mary and Helen what he should call the production company he was forming. They were at the Franks' new apartment on the Upper West Side. "Mary was scurrying around the house, and I said, 'Let's call it 'Two Faces,'" said Silverstein. "He said, 'Why do you want to call it that?' I wouldn't say anything. Mary laughed. But he knew what I meant by it, and he agreed on the name.

"He would butter up people for money, and then run them down behind their backs. He was a gossip. The name just seemed to fit."[11]

After Ginsberg's attempts to shape a *Me and My Brother* screenplay had floundered, Frank brought in the emerging playwright Sam Shepard to write, and his name appears in credits beside Frank's as a cowriter. Shepard's exact impact on the final film has never been fully clarified; Frank has said that Shepard wrote for a while until filmmaker Michelangelo Antonioni hired him away to write the screenplay for *Zabriskie Point*. Silverstein said his role on *Me and My Brother* is overstated: "He came, we met, he wrote some stupid script, we didn't use it. That was Sam Shepard's contribution," she said.

Silverstein traveled with Frank when he went to Kansas with Ginsberg and the Orlovskys, and she was there when Julius Or-

lovsky disappeared. "It was a disaster, a big scary event, but to be honest, Robert was happy and I was delighted," she said. "He said 'My God, that's marvelous.' And Mary said, 'What's the matter with you two?' But it made for a wonderful part of the movie—something happened; it created some drama."

When the shooting was completed, four editors spent many months shaping the film. It ended up feeling like assemblage art, big chunks of continuous footage sutured to passages with a completely different look and narrative style. Frank has said that a structure emerged while he edited. His first feature-length film, *Me and My Brother*, seems influenced by the images of "freaks" that Diane Arbus was making around the same time, complicated portraits of the relationship between viewer and subject. The movie-within-a-movie structure and the "who among us is really sane?" theme haven't aged well. Frank fills the film with numerous passages of inspired play and intensity—there are enough ideas for two or three interesting films. It is angry and sour and captures a post-Kennedy moment of itchy political pointlessness. Most of all it has Julius, compelling and withdrawn and, at the very end, offering in response to Frank's goading an understanding of the entire film. Frank asks him to say something "to the camera." Refusing to do what he is told, Julius looks away and responds, "The camera seems like a reflection of disapproval or disgust or disappointment or unhelpfulness, inexplainability to disclose any real truth that may possibly exist." His words hang over the whole film.

When it was released in 1969 *Me and My Brother* had Jonas Mekas wrestling in public with its structure and editing, declaring it too clever by half—then adding a defense of the filmmaker. "Where does Robert Frank's morbidity come from?" he asked rhetorically. "From this world, you fool."[12]

People approached Frank out of the blue, wishing to get close to a legend. In Max's Kansas City nightclub one evening a photographer from Los Angeles, Ralph Gibson, asked if he could show his work. Come by the apartment, Frank said, though he explained he was making movies now. But Gibson had been employed on film sets, and soon he was working on *Me and My Brother*.

Gibson lived in the Chelsea Hotel, and in 1967 he got a letter from Mexico, where Frank, Mary, and the kids were vacationing on the Oaxacan coast. "If you've got the dough, come and join us," Frank wrote, and he did. When Gibson arrived in Mexico he and Robert dropped Mary and the kids off at an airport—they were flying back to New York. Frank and Gibson went on a road trip, driving a Ford station wagon from the abandoned oil town of Salina Cruz overland through mountains and jungle to the Seven Plains of Juajuaca. He never would have taken on a trip like that on his own, said Gibson, "But Robert was in his element." They met up with "these crazy cross-eyed Indians with machetes hanging all over their bodies with pistols and bandoliers and bullets." Frank would just look them up and down, offer them a "hey, amigo," "and these jungle cats would start breathing slower and their eyes would uncross and the *pulque* would go into [our] veins."[13]

In a Mexican town Gibson saw the guy go transparent. They approached a little marketplace. Frank held his camera against his chest. "And he could take two paces in and—disappear. He really knew how to just . . . completely . . . blend. Just become amorphous in a space."[14]

Theirs was no idle ramble. Frank was on a mission for *hongos*, the magic mushroom of Oaxaca, and several times he was close to meeting the *bruja* who would lead them to the local psychedelic fungi. They never found them. The two drove north, making their way back from Mexico to New York. "I got to know the man pretty well," said Gibson. "Sometimes we had stuff to talk about but . . . I think he suffered a lot from depression." One thing they talked about was how Robert and Mary were drifting apart.[15]

THEY CALLED THEMSELVES the Pig Farmers, and they formed by accident—through a surplus of Hollywood dollars. Director Otto Preminger was shooting a scene for his 1968 comedy *Skidoo* in New Mexico. Preminger needed some prop hippies, and so the members of a southern California commune were brought to the set in New Mexico. The extras earned enough bread from this

now-forgotten debacle to buy a hog farm in Llano, New Mexico. The Pig Farm one of them dubbed it; he was a rustic holy fool who went by the name of Wavy Gravy. In 1969 the Pig Farmers were returning to Llano from the Woodstock festival. And who did Wavy Gravy see plodding down the chartered jet that would take them home? A certifiably antihippie grouch, a Swiss fellow who nonetheless ingratiated himself with the hog sloppers. "We were thrilled to have him, though we weren't sure who he was," said Gravy.[16]

Wheels up, blotters out, Wavy Gravy laid on his back and read underground comics over the intercom while Frank wandered the cabin. "He was trying to get people to read stuff in Latin and Greek. It was really bizarre," cackles Gravy.

When the plane landed in Albuquerque Gravy received word that his beloved old basset hound, Rex, was sick and needed to see the vet. Frank had a camera and sensed possibilities. "Let's make Rex the star of the show!" he said. What show? "Just—a show. A happening, I think. A situation's unfolding," Gravy explained. Frank, Danny Lyon, the photographer who was accompanying Frank, and Gravy drove up to Llano, where the Farmers lived in adobe shacks. They put Rex in a car and took him to a veterinarian in Taos.

The vet was not amused, glaring at Gravy while saying, "I've been burned before by hippies." He demanded cash, and Frank laid out a stack of bills, then pointed to the dog. "Here's 100 American bucks. Start at the front and work to the back!" After Rex received his checkup Frank took him to a grocery store meat counter, buying a thick slab of red meat. "Nothing is too good for my star," he cooed.

With Lyon, Frank landed in the foothills of New Mexico, where they filmed a get-together of dome makers, alternative energy advocates and futureologists. It was a time of drift, and drifting into loopy, powerful ideas. Frank and Lyon rendezvoused with Wavy Gravy months later in Hayward, California. They were invited by Stewart Brand, the editor and publisher of the *Whole Earth Catalog*, a clean concept guy who was hippie adjacent. Brand had an idea

for an event that would spotlight the coming global famine caused by overpopulation. He dubbed it "The Hunger Show."

"That was my creation," said Brand. "It was a big mistake, actually! My old teacher from Stanford, Paul Ehrlich, was totally wrong about the world population being in total explosion mode—it leveled off, and he's never acknowledged that. But anyway, I came up with the idea of The Hunger Show, an event where we'd all starve ourselves for a week to show the kind of famines we thought were coming in the not-distant future."[17]

About a hundred participants would go a week without eating; Gravy was in so long as he could dress as a hamburger. There would be Pig Farmers and activists and political theater, and Frank and Lyon would film the proceedings. "Our mothers were all panicking that our teeth were going to fall out," laughs Brand. "Many of the people there, they'd never undergone any kind of privation before in their lives, so it was news to them. And the sheer inaction, the boredom of sitting around starving . . . what do people talk about when they are looking at five more, three more days? That's pretty good film material."

It held promise. The San Francisco artists' collective the Ant Farm supplied an inflatable plastic shelter for the starvers to inhabit, but local fire officials came, lit it on fire, declared the structure flammable, and banned anyone from inhabiting it. Instead, the demonstrators clustered within an enormous intestinal coil that looked a bit like a giant life raft. After it rained, everybody moved to a parking lot in Menlo Park. *Life-Raft Earth*, Frank would call the thirty-seven-minute film he made.

"We were doing things like, at breakfast, somebody would get on a microphone and announce, 'Today we are not eating eggs benedict and hash browns' and read off the whole menu of what we were not eating,'" said Gravy. "When it got dark we would project giant food on the side of buildings, which was hilarious. Also there was a pig."

Lyon went four days without eating then sneaked half a brittle bar in a Porta Potty and devoured it. Frank gave it a shot too while he weaved among the protestors. "I was not even that much aware

that Robert was filming," explained Gravy. "He was casual, and it was not like he was making a film. You barely knew Robert was making *Life-Raft Earth*. That's how I look at it in extreme hindsight—the lighter the touch, the more amazing the photographer."

It was puzzling: stylistically and thematically *Me and My Brother* was nothing like *Pull My Daisy*, and *Life-Raft Earth* was nothing like its predecessors. In talking about this point in Frank's career, Ralph Gibson mentions some prominent directors of the era. "Let's look at where cinema was when *Me and My Brother* came out—Antonioni, Godard, Bresson, were riding high. Film was being analyzed in their context. But he got in the game. He was at his most ambitious and still young. He was in his mid- to late forties and still had a lot of physical power. But look what he was up against. His films went from one to the next in a personal manner but never held a formal or allegorical cohesion the way these other guys did."[18] In other words Frank's films were strong and challenging, but they weren't making for a cohesive body of work. *Pull* was jazzy and nostalgic, but *Brother* was sour and looking for a fight. *The Sin of Jesus* and *OK End Here* were both eager to be taken seriously in literary circles. *Life-Raft* was some kind of Godardian documentary. The director was an impressive bunch of guys.

Not long after *Life-Raft* was made, Frank was driving around New York City with Gibson. The younger man was head over heels in love with a successful, beautiful, commercial photographer. She made a lot of money, more than Gibson for sure, and was hanging out with a fancier crowd too. Gibson could feel her slipping away, and it was driving him nuts. While cruising down Park Avenue and circling the Seagram Building Frank provided him with "a messianic epiphany." The man was in love, but she wanted a life he couldn't give her. Two guys talking.

"Well, there are two choices," Frank said. Pretty fast he could become a successful commercial photographer. Make a lot of money and keep the girl. That's one. "Or you could remain an artist and wait a while, until you become famous like me." Then Frank turned to Gibson and delivered the jiu-jitsu finish. "Actually, you only have one choice."[19]

When he had you up close his intensity could puncture. A friend of Pablo's remembers coming to the house for lunch and having a conversation with his buddy's dad. "When I was a kid Robert was taller than me, of course," said Paul Handelman, who was a classmate at the progressive Downtown Community School.[20] "Pablo had one of these old record players, with a plastic arm and a needle. And Robert puts on a record and looks down on me and, with a Swiss accent, he said '*So*. Paul, tell me, do you like Johnny Cash? I'm really fond of Johnny Cash.' And even as a kid I was thinking, 'Huh? You like Johnny Cash, man?'"

He was the center of events, even when he wasn't around. And between the absences and the intensity of his presence, Pablo and Andrea, eighteen and fifteen years old in 1969, struggled to feel a connection with their father.

"Andrea was very down to earth," said Marty Greenbaum, an artist and photographer who had known Frank since the early 1960s. "Her interests were just, life itself. She liked music. She was excited about the city but also she wanted to escape it—'Look what happened to my parents.' Andrea had strong feelings; she wanted to straighten out her life. She was surrounded by a lot of people doing crazy things, and she wasn't going to get caught up in that drama. It was in her hands; she felt she could do something about it."[21]

When Mary brought Pablo over to Greenbaum's apartment he remembers the boy drifting out into the yard to pick flowers. "As a kid he was very poetic. He responded to the world, to the changing of the seasons, the nighttime, the lights—he was moved by nature. He had a wonderful spirit." Handelman remembers befriending Pablo. "He was a nice kid. He was a bit unusual, and I liked that. I just gravitated toward him. He looked like a little beatnik! They dressed their child like a little beatnik, and since I liked beatniks, I gravitated to him. He looked like Linus in the Peanuts cartoon. Just a nice kid."

The Franks now lived on the ground floor of a building on 86th Street. The rooms were full of Mary Frank's bronzes, paintings by

friends like Willem de Kooning, sculptures from India and Africa. It reflected the presence of Mary.[22]

When Robert was home he could be an intimidating figure. "I would have been very scared to have him as a father," said Emily Socolov, who went to school with Pablo. "He was a real disciplinarian. He was extremely exacting and demanding and judging. And I think Pablo was dwarfed by Robert." Andrea might have had a resilience that let her thrive, Socolov believes. "But there was something too innocent about Pablo, something too vulnerable about him. I think Robert just steamrolled over him."[23]

Over the years that she worked on *Me and My Brother* Silverstein saw the children every week. "They were sort of wild and sad," she said.[24] "They had hangdog expressions. It was a big apartment with practically no furniture in it. No drapes on the windows, no conventional anything, just a bunch of rooms with a bed here and a bed there and a desk.

"The children were kind of neglected. But—it was strange. They were loved. They were loved."

PABLO AND ANDREA were attending a Vermont boarding school in 1969. A filmed visit became *Conversations in Vermont*, a calm portrait of family crisis. "Maybe it's about the past, and the present. It's some kind of a family album," Frank says at its beginning. Relationships are disintegrating off-screen; we witness his children's resentment of the times he wasn't around. In the rural New England setting he confesses to Pablo, "I realize how tight Mary and I were about living our way and not giving in to the children." She's nowhere in the film. Pablo calmly says at one point, "I feel the burden of bringing myself up." The way Frank talks to his son echoes how he spoke to Julius Orlovsky in *Me and My Brother*. He asks questions that are really more like orders, pushes Pablo to say what he wants to hear, be what he wants. You can see Pablo squirm and nervously push back. And throughout you can see Frank coming to terms with his children growing apart from him.

Gibson accompanied him to Vermont and worked the camera for *Conversations* while Frank was before it. He recalls filming a flashy scene, a stunning unbroken eight-minute tracking shot that would have gone even longer if the two-hundred-foot magazine hadn't run out. He follows Robert, Andrea, and Pablo from a barn to a schoolhouse, where they move inside to eat lunch. Just as the film runs out, we hear Robert say, "Get a shot of the liver."

He was making a movie that observed the dissolution of his marriage and his troubled relations with his kids. Not that he was sitting around moping. In Vermont Frank and a few others in the film crew were out in a country field when Frank challenged Gibson. "You think you're pretty good with that camera? Let me show you one you don't know." Snatching Gibson's Leica, he set the self-timer and, as it buzzed, tossed it high into the air, where it clicked an aerial portrait of the small group surrounded by New England grass. When it was developed, it looked like a Robert Frank photograph.[25] To Gibson it showed how good he was at turning camera movement into a compelling photograph, how ingrained was his sense of picture taking. Allen Ginsberg observed similar experiments, in which Frank flung the camera overhead and allowed the forces in play to take the picture. He had gotten good at this: a powerful way to surrender control yet maintain mastery.

He got a shot of the liver; he floated above the group. A story recalled by Helen Silverstein: It was the summer, and she and Robert were editing film while Mary and the children were at Cape Cod in a rented house. "This particular night was a Friday, and Robert and I were working late and I went home—I always drove in and he went home.

"Robert had been wantonly sleeping with any model girl he could find. He was not faithful to Mary—I think there was quite a lot going on. And it was the women telling me, not him. I assume they were telling the truth."[26]

On a Friday, when Mary went away to the country, she'd asked Silverstein to let her know if there were changes in Robert's plans.

"To tell her if he was going home or coming to Cape Cod. Two women talking, why shouldn't I?

"Friday he tells her 'I'm not coming out.' Monday Robert comes in with a black eye."

"Robert, what happened?" Silverstein asked.

"I got this from seeing too much."

Deciding to drive out and surprise Mary, he was the one who had received a surprise.

"After that I could just see that Robert was going to take it apart. And he did."

They separated, and soon after, Mary was hospitalized with pancreatitis. Robert and Andrea were visiting a friend in the West Village, watching a football game with the photographer Marvin Israel. Mary's name came up, and Frank told them that she was in the hospital. "Why? Are you spiking her tea?" Israel joked. Andrea ran from the room, crying.[27]

CHAPTER TWELVE
FINALLY, REALITY

SINCE FOREVER, New York City's Bowery was a superb place to head when you'd lost something important or when you felt a need to lose yourself. Frank was returning to the part of town he liked best.

It was also a piece of New York that had changed radically since he had first set eyes on it. Europeans coming to New York after World War II adored the Bowery. Perhaps it was the existential writers, the ones Frank read avidly in his twenties, who responded most powerfully to the place. When Albert Camus came to New York in 1946 he raved in his journals: "Night on the Bowery, Poverty—and a European wants to say 'Finally, reality.'" The existentialists loved what they thought the Bowery represented—a lack of pretense or sentimentality, the place where human nature came out after dark. When Claude Lévi-Strauss entertained the visiting Jean Paul Sartre, their party ended up at Sammy's Bowery Follies, a voluminous beer hall with singing waiters who served bums free drinks—the better to give tourists what they came to see. Simone de Beauvoir too loved Sammy's, declaring it "wonderful" and "absolutely dissolute" (actually she said it was *crapuleux,* which sounds even better.)[1]

At the time Frank was returning, the Bowery was more an existential paradise than ever. Here community was fractured and made provisional by outside forces, and here community flourished when residents took the law—and their own liberty—into their hands: homeless who had been swept out of other parts of town, artists settling into quasi-legal conversions of industrial spaces, everywhere the rag-popping sound of the street hustle. It was a

righteous frontier for one who saw the world through Johnny Cash eyes.

"I keep my eyes open in New York," Frank wrote in 1969. "I have friends that I listen to, girls I'd like to make love with, drunks in the subway which amaze me, blind beggars which are not blind if you watch really carefully, taxi-drivers who drive around stoned. . . . New York is full of life. Sick? Yes sir, it's sick all right; why do I stay here? Just to be in IT, to see it coming and going, to let it drive me crazy if it hasn't driven me half-crazy already."[2]

He moved into 184 Bowery, a solid five-story edifice with big bay windows. It was built in the 1880s by a cigar maker who was ride or die for the Bowery, putting roots down on a block when other cigar makers were fleeing for uptown respectability. In the following years the address became working-class apartments, then a rooming house, a single-room occupancy hotel, and by the 1960s, the artists arrived. Danny Seymour, a young filmmaker and photographer from Minnesota, was living there when Frank came at the end of 1968. Seymour had the money and the abandon to do pretty much whatever he wanted to, and the neighborhood fed his interests. In an autobiographical photo book he published in 1971, *A Loud Song*, Seymour included a photograph of Frank in his building. Below the picture he wrote, "Robert and I work together any way we can, helping each other with projects. I have learned from our friendship as much as from our working relationship— Thank you Robert, Salut!"

Frank also wrote about his friend: "I liked Danny right away. Danny is 26 and I am 47. We live in the same building—look out on the same street, the Bowery in New York City. Danny has a lot of Dope and a lot of despair. He also has friends who share it with him. But Danny is an artist and if he'll survive—we all will be happy and richer to see what he has done."[3]

Danny Lyon remembers when he first met Seymour. "I walked into the apartment one day [on 86th Street] and there was a handsome guy wearing narrow pants and a leather jacket. Robert said 'This is Danny Seymour, he's the best cameraman in New York.' It was interesting. He was younger than me and good looking, and

I thought, 'He's a better camera-man than I am?' And that's how I met Danny."[4]

The older man was casually giving Seymour a photographic tutorial, as much by example as from anything that was said, and serving as assistant cameraman for several of Seymour's films. The Bowery address became a hang for a swinging bunch of studs that included Ralph Gibson, Danny Lyon, Larry Clark, and Frank. They pushed off of each other and careened into the next while organizing around the mass of Frank's mastery and Seymour's money.

The Minnesotan didn't much talk about his fortune, and some who knew him well had no idea he was worth millions. His family story often received an abbreviated telling from Seymour. It might have been a desire to be considered on his terms; it might have been because the story challenged plausibility. Maurice Seymour, Danny's father, was a Russian Jewish immigrant who came to America in 1920, making a living in Chicago by taking photographs of burlesque performers and nightclub celebrities. Maurice married Isabella Stewart Gardner, a red-headed black sheep who was the goddaughter of the Brahmin that Boston's Gardner Museum is named for. By the time Danny was five Isabella and Maurice had separated, and in 1951 Gardner was in love with Robert Hall McCormick III, a member of the Chicago family that had invented the McCormick reaper and now ran the International Harvester Corporation.

Gardner became an editor at *Poetry* magazine. She published her own fine work and received much praise for an innovative autobiographical style ("Mrs. Rich Bitch poet," she called herself[5]). Seven or eight years after marrying McCormick, Gardner wedded the poet and essayist Allen Tate and moved to Minneapolis, Minnesota, where Tate taught. "He was a brilliant man, a poet and a man of letters—a true southern gentleman," said Seymour. Tate's feelings for his stepson were spelled out in a letter Danny placed in *A Loud Song*. Feeling burdened by his stepson's behavior and financial draw, Tate suggested the best thing that could happen to Seymour would be a penniless life on the streets. "I would take the risk of your going to the dogs and/or destroying yourself. This

would be *your* responsibility," he declared.[6] Eventually Tate fell in love with a nun taking one of his classes and abandoned Gardner.

Seymour began study at the University of Minnesota. He explained to a college acquaintance, "I'm from the Gardner family, I'm going to inherit four million, I'm going to use every cent to make myself great." He and friend Robert Bergman set up a darkroom and took pictures around town. "He predicted that he would be like Rimbaud, he'd disappear somewhere," is how Bergman put it. "I remember reciting to Danny from Rimbaud: 'My soul eternal, redeem thy promise in spite of the night alone and the day on fire.' Danny said he would burn like a meteorite and disappear."[7]

By 1968 his circle of friends included a Spaniard named Paco Grande and a student from a Minnesota lumber town, Jessica Lange (she would go on to star in films, television, and on the stage).[8] That February the three left college for Spain, where they stayed with Seymour's half-sister Rosa Van Kirk, who was living with a group of Romani musicians. In May they traveled to Paris, witnessing students battling police in the streets. Eventually they landed in Manhattan. Late in 1968 Seymour used family money to buy three lofts at 184 Bowery. He got one, Lange and Grande another, and Seymour gave the third space to his new friend Frank, who had just been kicked out of his house on the Upper West Side.

"I don't know what they had in common. Maybe it was the Bowery," said filmmaker Steve Gebhardt, who knew both Frank and Seymour. "They were this team, Frick and Frack or whatever. They were this team that somehow came together. I never asked, and I don't think I'd know who to ask who could give an answer I could trust."[9]

When he seized on photography Seymour wrote, "it was as a drowning man reaches out for a life raft." He looked up to Frank. In Nashville Frank helped make a film featuring Seymour's girlfriend, the singer Tracy Nelson. He assisted Seymour on *Flamenco-logia* (1971), which included footage shot in Andalusia, and the following year's *Home Is Where the Heart Is*, a fictional work featuring Jessica Lange's first acting performance.

Gebhardt was behind the camera when Yoko Ono and John Lennon made a notorious underground film, *Fly*, in Seymour's loft. *Fly* traces the path of a bug crawling across the naked body of a very still woman. While the film was shot, Lennon sent Seymour out to score heroin for him, recalled Gebhardt. Ono used gas to stun flies in a Styrofoam cup, and Lennon played "I Don't Want to Be a Soldier" on a guitar. Seymour was calculating and unformed; he had ideas for what he wanted to get into—maybe music, or film, or something underground. He was self-absorbed and annoying and frequently made his friends want to scream, but then he would restore their affection with a big-hearted gesture or by throwing a party that he was palpably enjoying as much as anyone.[10]

"He wasn't much on name dropping. He was a self-effacing, down-to-earth guy," said Tracy Nelson, who dated him in 1969. "Danny never told me how wealthy he was. It never came up, and he didn't act like it. Our relationship was brief, and we mostly talked about the things new lovers talk about, common interests, each other. I do remember thinking back that we were both fascinated by gypsies." Nelson recalls a time when she and Seymour drove from Boston to New Hampshire to visit friends. They left after a gig and immediately hit a wall of snow and sleet. The car spun all the way across the road and was facing into oncoming traffic. With the help of another motorist, Seymour got the vehicle turned around. Shivering as he climbed back into the car, he bemoaned that he was wearing his New York boho clothes rather than Minnesota winter gear.

It was then, Nelson thinks, that Seymour pulled out a turquoise ring set in gold, one that he had bought at an antique store, and proposed. She put him off. "I didn't take him seriously, although he seemed to want me to. I told him that his addiction was a huge obstacle to my thinking of a future with him."[11]

To Ralph Gibson it seemed like Seymour was on a hellfire mission to incinerate all of his money in two years. Around him were drugs, famous people, disreputable people, and Lyon, Clark, Gibson, and Frank.

A young man raised by a series of fathers who were hostile or rarely around became friends with a man who hadn't always bothered with fatherhood and who now, maybe, saw a small second chance. "There's a funny compassion in Robert," said Allen Ginsberg. "Maybe not for himself but for other people, for not exactly *clochards* [vagrants], but for people whose condition on earth is not what it looks like in a good Swiss burger family, for the outcasts, and the outcasts that are exactly real, somebody really stuck in the world, brought out of his control."[12]

One project that came out of the moment was Gibson's Lustrum Press, a pioneering photo book publishing company. Lustrum released Gibson's *The Somnambulist* (1970) and Seymour's *A Loud Song* (1972). Most startling was *Tulsa* (1971) by an amphetamaniacal young photographer from Oklahoma, Larry Clark. While living— and sleeping and shooting up—among teenagers in his hometown, Clark casually pulled out a camera and started photographing a scene he knew intimately, bridging the distance between himself and his subjects in reverse: pulling back, taking pictures of drugs and guns and zoned-out hookups, slowly turning into a photographer instead of a peer. Clark showed the prototype of his book to Frank, who went to Seymour, instructing—telling, not asking—him to give Clark the money he needed to publish. *Tulsa* became a legend that slowly burned through the 1970s. The images call into question the relationship between artist and subject in ways that still trouble some photographers, and it offered a glimpse of a nation of young nihilists reaching out to Tulsa, the Bowery, and empty spaces in between.[13]

The Lustrum Press artists were among the earliest photographers to move the photo book in a personal, informal direction. "These chronicles differed radically from the traditional photoessay, for they were statements by the photographers themselves telling about and photographing their own lives," wrote Jonathan Green.

Frank was a barky observer of this scene, quite comfortable passing judgment. He began speaking to (he didn't like the word

"teaching") film and photography classes, and his method could be harrowing: at the Rhode Island School of Design, for instance, he tore up a student's photograph in front of the class and rearranged the pieces. He would tell his students that he was not a teacher and could not explain how a photograph worked, especially if it was one of his own.[14]

The editor of British magazine *Creative Camera*, Bill Jay, invited him to write a monthly "Letter from New York" in 1969. It must have been inspiring to young photographers as Frank spoke candidly and casually about art and what was going on in America. It was also a bracing read, with Frank hurling his words like wedding china against the wall. He raged against painter Helen Frankenthaler: "What makes a show like Frankenthaler's possible is Power and Money; and that, especially the latter, is the mark of success upon which the system insists—Art or business or anything. That's the way it is in America . . . true but sad."[15] He spoke his mind about Nathan Lyons: super-smart but also a "terribly boring guy to listen to."[16] He vented about his own life: "In the shower I was thinking about how slow it was and how long it took me to give up photography (it will take less time to give up my wife, I speculate). A wife can stop loving you; photography?"[17] He was like some guy with his shirt untucked in a John Cassavetes movie, compelling and lethal, forcing everyone around him to calibrate how close was too close.

LYON DIDN'T KNOW what "too close" was. He liked the guy, and Frank had been nice enough to let him stay with him on 86th Street for months on end. Frank hired him to work sound on several commercial film jobs he landed, and he had brought Lyon on for his own new film. The two had filmed a music combo playing in the New York rain for it, and they shot a choir in a Texas prison. One day Lyon was wandering around Tompkins Square Park on the Lower East Side, recording a group making music by banging on garbage cans, when a kid came up to him. With an offer.

"You wanna buy a Mastercard?"

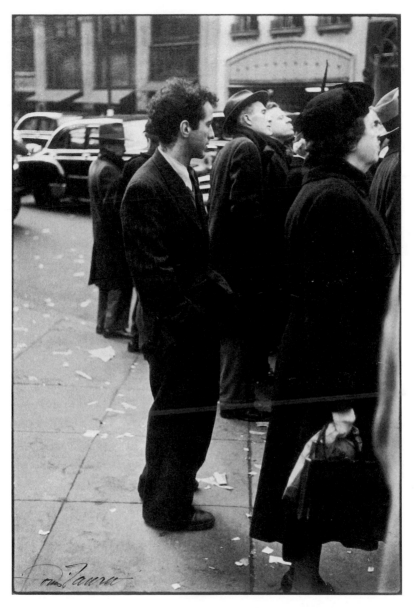

On the edge of the crowd: Louis Faurer, *Robert Frank in Pinstripe Suit*, 1947. Photo by Louis Faurer. Courtesy of Greenberg Gallery and Estate of Louis Faurer.

Switzerland: Werner Bischof,
Winterforest, 1940. © Werner Bischof/
Magnum Photos.

Depiction of a medieval oath-taking
in the Heimat und Volk display at
Landi '39. Photoglob AG (Zürich).

Zurich: Rene Burri, 1955. © Rene
Burri/Magnum Photos.

Bell tower at Landi '39. Jean Gaberell.
© ETH-Bibliothek Zürich, Bildarchiv.

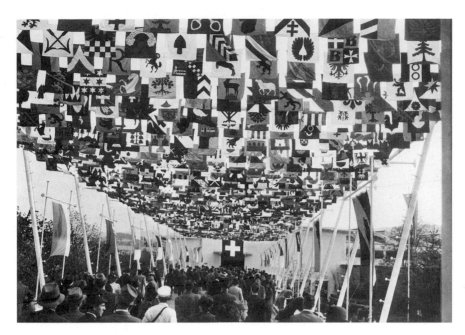

The exposition of 1939: Flags from all parts of Switzerland mark the walkway. Photoglob AG (Zürich).

Hunting hall. Jean Gaberell. © ETH-Bibliothek Zürich, Bildarchiv.

Photographer and curator Edward Steichen arranging the Family of Man, 1955. © Wayne Miller/Magnum Photos.

The Family of Man exhibition, Museum of Modern Art, 1955. © Wayne Miller/Magnum Photos.

Walker Evans. © Bettmann/ Getty Images.

Walker Evans, *Houses and Billboards in Atlanta*, 1936. From *American Photographs*. © Bettmann/Getty Images.

Louis Faurer's portrait of Robert and Mary Frank. This is the picture that led Frank to sue *Saturday Review*. Courtesy of Greenberg Gallery and Louis Faurer Estate.

The 1949 Ford Business Coupe.
© Ford Images.

Robert Delpire, the French publisher of *Les Américains*, 1960. © Henri Cartier-Bresson/Magnum Photos.

Jack Kerouac, tuned to higher frequencies.
© John Cohen/Getty Images.

From left: Allen Ginsberg, Gregory
Corso, and Grove Press's Barney
Rosset, Washington Square Park,
1957. Photo by Burt Glinn/
Magnum Photos.

The cast of *Pull My Daisy* in Alfred Leslie's loft. © John Cohen/Getty Images.

Alfred Leslie and Robert Frank, shooting *Pull My Daisy*. © John Cohen/Getty Images.

Allen Ginsberg getting into character with Gregory Corso on the set of *Pull My Daisy*. © John Cohen/Getty Images.

From left: Larry Rivers, Jack Kerouac, David Amram, and Allen Ginsberg, taken during the filming of *Pull My Daisy*. © John Cohen/Getty Images.

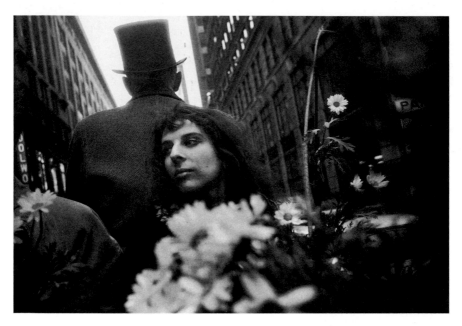

Mary Frank on a horse-drawn carriage on the way to *Pull My Daisy*'s premiere.
© John Cohen/Getty Images.

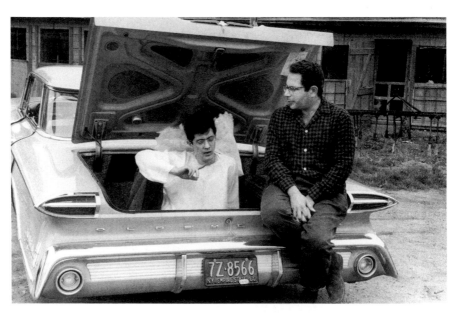

Richard Bellamy and sculptor George Segal on the set of *The Sin of Jesus*, New
Brunswick, New Jersey, 1961. © John Cohen/Getty Images.

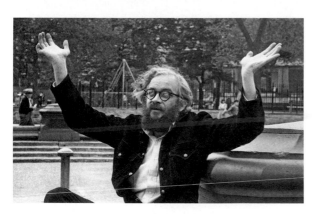

The Sin of Jesus, 1961.
© John Cohen/Getty
Images.

Harry Smith explaining
it all in Greenwich
Village, September
1965. © The Estate
of David Gahr/Getty
Images.

Honorary Hog
Farmer: Frank
and Wavy Gravy.
© Danny Lyon/
Magnum Photos.

Jonas Mekas, May 1965.
© Fred W. McDarrah/
Getty Images.

Jack Smith, Barbara Rubin, and Jonas
Mekas preparing a mixed-media event at
the Filmmakers' Cinematheque, February
1967. © Fred W. McDarrah/Getty Images.

Danny Seymour with singer
Francisco Molina on location in Andalusia
for Seymour's 1971 film, *Flamencologia*.
Photo by unidentified photographer.

David Amram jams at the Five Spot Café on the Bowery, 1957. © Burt Glinn/
Magnum Photos.

A moment in time on the Bowery, where Frank lived in the 1970s. © Richard
Kalvar/Magnum Photos.

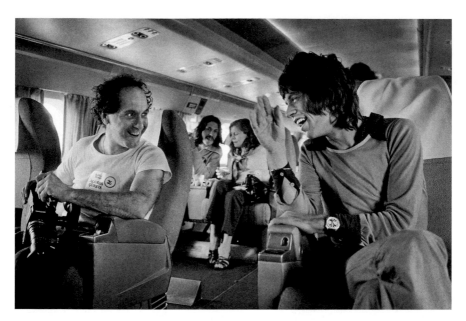

Frank and Mick Jagger on the Rolling Stones' jet; Danny Seymour sits behind Frank. © Jim Marshall Photography LLC.

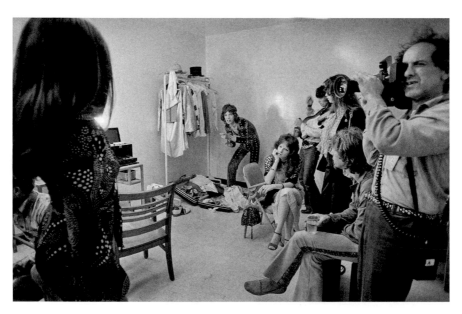

Finding the action on tour with the Rolling Stones. © Jim Marshall Photography LLC.

Torn and frayed: Frank and Rolling Stones' drummer Charlie Watts.
© Jim Marshall Photography LLC.

Rudy Wurlitzer, 1987.
Photo by Lynn Davis.

Frank and artist June Leaf bought this isolated house on Cape Breton Island, Nova Scotia, in 1970. It looks out over rocky waters. © Norbert Bunge.

In Beirut, port district police station, 1991. © Raymond Depardon/Magnum Photos.

With June Leaf, New York University gallery opening question-and-answer session, January 2016. © Taylor Hill/Getty Images.

"No," Lyon said.

"How about for $10?" The kid kept after Lyon, who got him down to five bucks for the plastic. This was when card companies freely mailed them out to prospective customers—"Congratulations, here's your new Mastercard!"—and it was easy to pry open an apartment building mailbox and fish out the goods. The name on the card was "Sweeney."

Lyon told Frank, and the next morning they went out to see if the card worked. "I was the dark side; he liked it when I suggested we try things like this," he said. They drove around in Frank's station wagon, stopping at a random drugstore. When the guy at the counter asked Lyon for identification and he said, "I left it at home," the counterman was not unsympathetic. The guy let him know that if a purchase was under $50, he wouldn't need to show identification. Armed with that information, they went on a binge. They bought film and toys for the kids. "We spent the rest of the day running up $800 in fifty-dollar increments," Lyon said, winding up the day with a big lobster dinner. The next day "I wanted to buy airplane tickets to Albuquerque," he said. "But Robert was a father figure—and at that point he said no and made me cut it up."

The two had discussed formalizing their work partnership. Sid Rapoport, a well-known fine arts printer, was a patient of Lyon's father, who was an ophthalmologist. In lieu of paying his ophthalmological bill, Rapoport offered to print stationery for the son's new production company. There, on the top of the page he designed, the letterhead read, SWEENEY PRODUCTIONS. "We named it after the great crime spree," laughed Lyon.[18]

They finished *About Me: A Musical*, in 1971. Having received a grant from the American Film Institute to shoot a film with music as its subject, Frank wanted to make sure people knew that he didn't. He greets viewers at the beginning of *About Me* by saying, "My project was to make a film about music in America. . . . Well, fuck the music. I just decided to make a film about myself." There is autobiographical footage, including a visit to his father's house in Zurich, where Hermann looks through his stereo camera. But throughout Frank plays with the idea of documentary truth and

the ambiguities of self-revelation. He wants our attention, but he doesn't make it easy to know him; he warns us that we will surely get it wrong whenever we think we do.

Actors portray scenes of his private life, and the fakery is as much the subject as whatever is being "revealed." "This here is the young lady playing me," he tells the viewer. "Her name is Lynn Reyner, and she is a very good actress." A performer on the 1970s New York glam performance scene, Reyner was featured with the Playhouse of the Ridiculous, an important off-off Broadway outpost that elevated camp and artifice. The early 1970s, when she was a celebrity at Max's Kansas City and appeared in films by Warhol, comprise Reyner's heyday. "When I see [*About Me*] today I get sad because I was so beautiful and I didn't even know it," Reyner says.[19] She has carrot-red hair and dramatic bangs. In making the movie Frank didn't explain his methods or intentions. "'Here's your dialog—you're playing me,' that's all he really said. I'm not sure, but I must have given him what he wanted because he didn't complain." She pauses, staring at the wall of her tiny, cluttered apartment in Greenwich Village. "But he's kind of a serious guy, and he doesn't say a lot. I like gruff men. I've always been attracted to grouchy men. It's a challenge."

It wasn't until years later that Reyner even saw *About Me,* and when she did it was a shock to see that version of herself. "It's a terrible thing to say, but I was pretty drugged out for a while. Years after we filmed I was in recovery, and somebody tells me, 'You know you are in this Robert Frank film playing at Anthology Film Archives.' So I went to see it, and it made me . . . I was so full of emotion, I actually went to the ladies' room and I threw up. I felt, 'What have I done?' I was this innocent young girl, and I destroyed my life, seeing it made me realize. I didn't regret doing this film; I regretted everything else. I suddenly realized what I had done to my life.

"I don't know what he saw in me to play him. I'm a woman, I'm a lot younger than him, he just saw something in me. I'm flattered because I always admired his work."

ON A NOVEMBER NIGHT on the Bowery a pair of Japanese men appeared at Frank's front door. Neither spoke English, so they had brought a translator. They also brought a gift, a secondhand tape recorder, and told Frank how much they admired his photography. They wanted to publish a new book of his work and asked for his involvement.[20]

That they wanted to publish his work pleased him, but it set him on edge too, as attention often did. He wanted to show photographs that people hadn't seen before. And he wanted to present them in some new way, not just in another photo book: What was the point of repeating himself? One thing he was not interested in was a backward-looking tribute to a master embalmed in time. The visitors' quirky, sincere demeanor reassured him that they weren't thinking about making money, and that they too wanted to do something different. All these things would have appealed to him while he pondered what kind of book he might put together.

Other projects moved forward more rapidly. The Rolling Stones were finishing a new album, and a personal assistant for the band had mentioned Frank as a candidate to photograph the album's cover. The band liked the idea and summoned him to Los Angeles.[21]

The Stones had just gone through exhausting recording sessions at Villa Nellcôte, a Belle Epoque mansion in the South of France, and now were in Los Angeles finishing the album in early 1972. A meeting with the album's art director was set up, and he brought the photographer he wanted for the cover. With the whole band sitting around a dining room table in a Bel Air villa, a door popped open, and Frank walked through, filming the scene with a Super 8 camera. Marshall Chess, the band's manager and president of Rolling Stones Records, passed around a photograph by Frank titled *Tattoo Parlor*—a wall of photos of carnival performers and sideshow freaks—and Mick Jagger made it clear *this* was the artist he wanted.[22]

The Stones took a liking to Frank, and the feeling was surprisingly mutual. He got so high with them one night in LA that he

couldn't load his camera. Frank wanted to film them in a downtown Los Angeles flophouse. Everyone arrived in a flotilla of Cadillacs, but at the front desk Frank was too broke to rent a $15 room for his shoot. Jagger strolled up and asked how many rooms were available and then said, "Rent them all." Ultimately they shot on Main Street in Los Angeles and later, in New York, on the Bowery.[23]

The Stones' album, titled *Exile on Main St.*, was released in May 1972. Although it looks like a collage, Frank's cover is a photograph of a group of photographs, an array of unseemly pictures that emits a tawdry and exploitive funk. There's a black man with his mouth distorted from the number of billiard balls stuffed in it—a grotesque stage routine dating back to the minstrel circuit. There are marginal white showbizzers and exotic dancers. A lurid cloud hangs over the whole thing: just the mood the Stones were going for. The back cover and inside gatefold feature Frank's Super 8 stills of the band alongside several images from *The Americans,* blended together in a nonstop tongue-out sideshow. By inserting himself in the array Frank was entering the circus tent with the Rolling Stones and the contortionists, and saying something about the role of artists in America. He wrenched *The Americans* out of the sanctified place it had settling into, mocking his own fame while reclaiming ownership of work that his fans felt belonged to them.

The cover was a sleight-of-hand performance as well. The image has been called *Tattoo Parlor* or *Tattoo Parlor, 8th Avenue* and been dated 1958 or 1951. Almost certainly, though, it came from Times Square and not from a tattoo parlor but an attraction called Hubert's Museum, a place that a 42nd Street denizen like Frank surely knew. Hubert's was savored by his friend Diane Arbus, who photographed many of its performers—how we know this photograph is probably Hubert's is because one of the pictures on the *Exile* cover is Arbus's portrait of Hezekiah Trambles, aka "Congo the Jungle Creep," who was a featured act at Hubert's. It was surrounded on the wall by an assortment of eight-by-ten glossy photos that advertised the museum's other talent. Frank is making

assertions that, strictly speaking, are not true: the date is murky, Hubert's is not a tattoo parlor, and this is not a sideshow any more than Lynn Reyner is Robert Frank. The camera lies; nothing is clear.[24]

There are also pictures of writing scattered among the *Exile* photos, a striking juxtaposition. All of this—the self-references, the mixture of words and pictures and movie frames, the game playing—slipped by unnoticed on a rock-and-roll album. But all of these were early indications of a change in Frank's thinking, and they would point the way to important work ahead.

The cover made an impression, and Jagger invited Frank to come along and film the band's upcoming US and Canadian tour. They would pay him and give him access to pretty much whatever he wanted to shoot. Frank responded with stipulations: they buy him the camera he wanted to use, and hire Danny Seymour as his assistant. They agreed, and the tour started on June 3 in Vancouver.

CHAPTER THIRTEEN

A LUCITE SPACESHIP

JUNE LEAF HAD A DREAM, her life unfolding in reverse. She was watching herself as a little girl and watching time flow backward, 1936, 1934, 1932, 1930, back until 1929. That, she explained to her dream companion, was the year she was born. And then she disappeared.

It was the mid-1970s, and Leaf had been with Frank for about eight years. In her sketchbook, where she had written down this dream, she drew knots and people peering at the world through the eye of a needle. It was a period of isolation and looking at whole eras of her life. She had a lot of time to think about things.[1]

Leaf has an unnerving, feral beauty and a disarming directness. "There's a childlike spontaneity there and a naivete in a beautiful way," says the filmmaker Sarah Driver. "I remember the bums stopping her on Bowery and going, 'Are you Native American?' And she'd say, 'No, I'm Jewish!'"[2]

Before Leaf was born her mother's family had left Bialystok, Poland; her father was from a small village outside Kiev. The parents met in Chicago. Her father's father, Max, was the anchor of the family, providing first with a cigar stand, expanding to a liquor store, and then a tavern. Max's son was supposed to take over the business, but Leaf's father was a dreamer and a card player, and he slept all day and socialized at night. It was June's mom who ran the tavern, working so much that June hardly ever saw her.

From the age of six June knew she was supposed to draw, just knew it, and would make art on brown paper brought home from

the bar. Even as a kid she had a marvelous and scary intensity to her; she would sit and make fifty drawings of a head, thrumming and full of color, all at one time. Her grandfather was a Talmudic scholar, and one day June asked him if there was a God. No, was his answer. What? So why do you do this then? Why read the Bible? she asked. He shrugged and said you had to pass the time somehow. There was silence, and then he added that everything she needed was inside her.[3] *That* made her heart beat quicker.

At seventeen she was a model, a dancer, and a new student at the School of Design, founded in Chicago by László Moholy-Nagy, making body-referential, expressionistic art while surrounded by men making geometry. She then headed to Europe because, Leaf figured, that's where her kind of artists lived.[4] Restless after four months, she returned to Chicago. She would walk, eyes down, studying the sidewalks. "I saw that all the art in the world that I wanted to see was on the sidewalks, in the cracks," she said—a Paul Klee here, a Mark Tobey there in the concrete. "That was my path. I just had my head down all the time, looking."[5]

When the painter Leon Golub, a major artist on the Chicago scene, saw her work in a group exhibition, he was impressed enough to seek her out and inquire, "Is there anything I can do for you?" "Yes," Leaf said, "there *is* something. You can come with me to my mother's and tell her that I am a good artist." They rode the bus across town and Golub met her mother. He said to her, "Mrs. Leaf, I came to tell you that your daughter is a great artist."[6]

Leaf would affiliate with the group of mostly painters called the Monster Roster and worked at the Frumkin Gallery, the heart of a Chicago scene that was flecked with funk and savagery and was endlessly not New York. She continued to go her own way, heading to New York, marrying a saxophone player, remaining non-Pop and expressionistic in 1960s New York City.

She met Frank at a party at the painter and writer Sidney Tillim's home; Mary had invited her. Leaf didn't think all that much of him at first. "I looked at him and I thought, 'Oh, there he is. He's more raggedy than I thought he would be; he's more arrogant than I thought he would be. He's married, and I am so happy

that he's married because that is a very difficult man.' That's exactly what I thought.

"I just walked away from him. He tried to talk to me. I just didn't like the way he approached me as a woman. This is kind of private. It's nice, it's true and it's life."[7] She and Mary Frank became good friends, however, until they suddenly were not.

June and Robert lived together for about a year on the Bowery, and then one day Frank turned to her and explained he was sending her to Nova Scotia to find them a summer house. She liked New York and didn't want to go, but she went. Leaf knocked on doors of the village of Mabou on Cape Breton Island, Nova Scotia. It was nothing like New York, and she went house to house, asking strangers in the Scottish Gaelic enclave (read: outsiders don't bother knocking) if they knew of a place she and Frank could live. The idea was to rent and then find a place to buy. At that time several artists the couple knew were buying property on the remote island, turning Cape Breton into a distant outpost of downtown Manhattan—it was way above 14th Street and way below too. Composer Philip Glass, the theater director Joanne Akalaitis, and writer Rudy Wurlitzer all owned land, and soon sculptor Richard Serra, video artist Joan Jonas, painters Hermine Ford and Robert Moskowitz, and writer Steve Katz all arrived on the island. Leaf found a place, Frank came up, and that made it even harder to find something permanent because he would walk into peoples' homes barefoot, like a hippie artist from New York, putting them off. Right before they returned to New York at the end of the summer of 1969 they discovered a place to buy: seventy acres a few miles outside of Mabou in a fishing village with a ramshackle wood house looking out over rocky waters.[8] When the couple saw the house for the first time Frank fell against the wooden structure, and Leaf thought the wind had blown him back. He was swooning.[9] For herself, Leaf liked New York, but in Nova Scotia she made up her mind to never be like a Hamptons artist, vacationing in the summer, and so she resolved to stay there as much as possible, even if Robert wasn't around. That first winter was brutal.

Their plot was stark. The coast below didn't have much in the way of a sandy beach; mostly it was rocks where dead fish washed up. Eagles circled above the cove, looking for a meal. Some evenings on Cape Breton you could see the Northern Lights, and the sky remained bright past ten. When Glass began staying there, he observed the old local practice of those who logged birch trees in the woods: they would leave the trunks out flat at night under a full moon, the moon's pull bringing the sap to the surface so the bark could be easily pulled off.[10]

It was a magical place and a harsh one. The first few years, while Frank was off teaching and making films, Leaf was often by herself. The farmhouse needed a new roof and wouldn't be inhabitable for several years. She felt isolated: "Then came the question of why isn't nature marvelous to me? See, Robert would look out the window and he'd say, 'Oh, it's nature.' And I'd think, 'What nature? I don't like it. I wish I lived by a brook with a big shady chestnut tree. It's too open. It's too vast. The ocean's cold.' I'd watch him looking out the window. He'd be swooning over all this stuff, and I'd think 'I must be the world's most insensitive lover of the land that ever lived.'"[11]

A journalist asking Frank what he did in Mabou was told, "I'm waiting for something to happen."[12] For him Mabou was a place where he could check his head and focus on essential tasks, banishing the distractions and emotional entanglements of New York. "It occupies you to make a fire and make sure that you don't freeze to death, and to get into town." For Leaf Mabou symbolized a fresh beginning. "When I met Robert, it was like we started a new life, and we left New York. I felt like I was finally with the love of my life. I don't know how advanced he was along those lines, but I had enough for both of us. Art was behind me. It was like, 'Now maybe from this you make art.'"[13]

In the first years they were in Mabou Frank wasn't waiting for something to happen because numerous things were happening all around. There was the book the Japanese publisher had proposed and *About Me* needing to be finished in New York. One day Frank called up photographer and musician John Cohen, whom he had

known since the late 1950s. He invited Cohen and his friend, Bob Dylan, to come to the Bowery and see a screening of *About Me*. They drove over in Cohen's Volkswagen.

"Bob can be pretty quiet and shy to be around. So can Robert," said Cohen. Danny Seymour set up the projector, and they projected the film on Frank's wall. When it was over, nobody said anything. Eventually Dylan suggested, "Let's go back now." It was quiet for a long while in the car, and then Dylan muttered, "Your friend Robert, I hear he's hanging out with the Stones."[14]

THE ROLLING STONES were shedding old connections and looking for a chance to revise the narrative in 1972. Their former manager, Allen Klein, had managed them to great personal advantage, and tax problems forced the band to flee Great Britain for France. Eager to end their relationship with Decca Records, whom they owed one more single, Jagger wrote a jam he sensed might speed the divorce along. It was called "Cocksucker Blues," and he sang it for label head Sir Edward Lewis, most certainly including the lyrics about sex with barnyard animals and a late-night encounter with a Leicester Square bobby:

> He fucked me with his truncheon
> and his helmet was way too tight
> Oh where can I get my cock sucked?
> Where can I get my ass fucked?
> I ain't got no money,
> but I know where to put it every time.

That got them out of their contract. Soon they signed with Atlantic Records and recorded *Exile on Main St*. It would be followed by a huge tour of the United States and Canada, an opportunity to show how they had turned the page on the disastrous ending to their 1969 tour when, at a free concert at Altamont Speedway in Livermore, California, a member of the Hells Angels biker gang who had been hired as security stabbed to death an eighteen-year-old

African American man. The Stones had wanted to see how massive the Aquarian good vibes could get at Altamont. They also wanted their songs of moral ambiguity injected into the vast mainstream as a massive art experiment. Together the two were unmanageable—"Sympathy for the Devil" playing as Meredith Hunter was killed.

For this tour "Sympathy" was not on the set list. The 1972 tour would be a really great *show*, ruthlessly controlled: they had their own plane for the first time, there was a doctor on board as well as a makeup artist, and the money was watched like never before. The wildness of the previous tour was now refined and calibrated, conceived as spectacle not revolution.

The leather they were wrapped in was not cop, not biker, and the Stones sheltered themselves from most all incidental contact with fans and strangers. As tour dates approached they began getting death threats from the Hells Angels, who resented the way the band, as they saw it, had evaded responsibility. Two mountainous, gun-toting bodyguards followed the Stones closely, in part to protect them from those who meant them ill and also to shield guitarist Keith Richards, then a heroin addict, from prying eyes in his times of profound intoxication. An unprecedented layer of security was hired in each city, police using tear gas and truncheons to beat those without tickets into the streets and away from the venue.

The new album was a vast success upon release—the music framed them as physically and morally exhausted outlaws, yet ready for the next party. Jagger cultivated a post-hippie image that linked social status to exile, something that wouldn't have been possible just months before. The new identity was massaged into the old Stones myth via the presence of the royals, celebs, and writers Jagger vaguely liked having around and definitely liked telling the world about. Having Robert Frank orbiting you with a camera meant having one of the coolest artists on earth helping you in your project of moving forward. Let the healing begin.

The Stones gave Frank unprecedented access, a view on things fans would never see. Frank didn't particularly like their music, and that definitely appealed to Jagger too. They could do business

together. The singer was interested in photography. Frank gave him a handheld home movie camera, and the two had many conversations about image making. "Everybody knew who he was," said Robert Greenfield, who covered the tour for *Rolling Stone* magazine. "It was interesting—Jagger was under the thrall of Robert. Mick at that point was very much about being validated in America by people like Warhol and Truman Capote. So here comes Robert Frank, one of the iconic artists. But he's never been exposed to anything like this in his life. He was only fifty then but he seemed *old*."[15]

The band launched from Los Angeles International Airport. On the bus to LAX Frank established his bona fides by snatching a joint that was moving up the aisle, holding it before his lens for a few beats, and then passing it on. They set out on an eight-week cross-country tour in a party of thirty. Richards croaked, "We had become a pirate nation, moving on a huge scale under our own flag, with lawyers, clowns, attendants."[16] Frank was outside any of those categories: a nimbus of not-give-a-fuck hung around the guy. That too earned the respect of the Stones.[17]

Vancouver was the first show. The Clark Park youth gang and a Marxist group called the Youngbloods teamed up to trigger a riot; Molotov-cocktail hurling youth put thirty-one police in the hospital, and rioters loaded dumpsters with teenagers and crashed them into the arena's doors.[18] In Los Angeles a police sergeant promised the Stones "ten bikes, 40 men on foot, men in cars, two helicopters if I need 'em and five thousand men to back me up." At the Rubber Bowl in Akron officers in riot gear sprayed mace into the crowd and a buried time bomb exploded out of the dirt beneath fans' feet.[19]

In Warwick, Rhode Island, Frank jumped in. The band had been directed to an airport shed while they waited for their bags when a newspaper photographer snapped a picture of the singer. A bodyguard began hitting him with a leather belt. By the time police arrived, Richards had the belt wrapped around his fist and was punching the guy. But when the cops attempted to put Richards into a squad car, Jagger, manager Marshall Chess, and Frank all "became involved in a struggle with the police," according to

the *New York Post.* "Frank was charged with assault of a uniformed police officer, a felony."[20]

Frank would compare being with the Stones to being around the Mafia: there aren't any bystanders. Later the kind of power you saw might seem amazing or scary. Frank would note, "Everybody is afraid of them. Everybody around them, their friends, everybody. . . . What can they do? They can kill them. It's as simple as that. They can beat you to a pulp and tell you to get up. . . . They can do anything."[21] Frank could fight pretty well himself, and he wasn't in thrall to either the music or the people. He made clear both that he was ready to walk at a moment's notice and that he didn't have his hand out for anything. At the time it only felt exciting.

One more thing that he shared with the Stones: a complicated relationship to the United States of America. Any number of writers followed the band on this tour, including Terry Southern, Stanley Booth, and Truman Capote. But it might have been novelist Richard Elman, whose story *Esquire* never ran (it was later turned into the book *Uptight with the Stones*), who did the best job. He studied how they looked at America and pounced.

Elman quoted the unnamed wife of one of the Stones as she lamented her view of the road: "This is such a violent place. So much brutality. We Europeans are just not used to it." Elman wasn't buying. The Stones, he declared, were aroused by American violence, "in that condescending manner in which some parents of 4-H farm children are aroused by the couplings of their kids' prize livestock. The get-off is to go tisk-tisk for shame, and then copy the style, as if to parody it."[22]

The band communicated "in some pre-verbal manner their own menace: the contempt in which they hold their love of all these American sillies, their love of that contempt, and their contempt for that love."[23] They were fascinated and horrified with American culture and made fun of it while trying on their shit-kickingest southern accents. They were in the place that birthed the music that inspired them and, especially in the South, they longed to shoot out into the countryside after the show was over. Except that *out there* were bikers and hungry fans and George Wallace and

bombs planted underground, and nobody was going to see nothing this tour except through the windows of the Playboy Mansion, the unmarked black vehicle, the chartered plane with the seats ripped out. "It's really crazy," Frank told Elman. "You go to a big effort to get everybody up for you, and then you use all the force you have to keep them away from you. It's like being untouchable. Going through America in a lucite spaceship."[24]

Eventually Frank would play up the Scheherazade of Rolling Stones decadence, declaring, "If I could have shown what really went on, it would have been horrendous—not to be believed."[25] Oh the acts unspeakable. Only, all of it was speakable, and Frank put it in his film: sex with groupies, Mick snorting coke, Keith in full opiate-nod. The film he made, *Cocksucker Blues*, declares that to be with the Stones was to be in a cloud, slickened by an ambient mist of boredom and sleaze. Menace (emotional, physical) adheres to everything, even in scenes of musicians standing around airport hangars. It doesn't feel anything like fun.

He could film what he wanted, but it was also clear enough when filming something would cost him future access. You had to know when to stand your ground and when to fade into the picture. "You're supposed to know when to stop filming—when not to show up with the camera," Frank said.

The spaceship went incredibly fast, and it was impossible to be normal or maintain ties to your identity. "You begin to understand why they're so mean, why they hide, why they don't talk to anyone. People are ruthless, they're beasts when they go after them, can't leave them alone, can't take a piss, can't eat breakfast without having some asshole come up and ask you for money, an interview. . . . I just couldn't take it. They have to hide on tour. They close themselves off. Just appear for the gig and get their release that way when they're on stage and then they go back to the hotel rooms."[26]

Everyone is looking around backstage, listening to conversations they aren't having. Frank complained that he could never get enough "real" stuff to shoot, especially from Jagger.

At the Sheraton Hotel in Nashville it's three-thirty in the morning, and everybody is gathered in an Italian restaurant, draining

the wine cellar of the best parts while ordering "elaborate indi-
gestible meals," as Elman wrote. At the end of a pileup of tables
sat Jagger, guitarist Mick Taylor, and drummer Charlie Watts. An
hour later the food arrived, and they made plans for their next
album. A veloured violinist insinuated himself, the kind who goes
table to table except there is only *one* table possible to play for, the
one where Jumping Jack Flash is gnawing on a breadstick. Jagger
asks him for a country song, a bluegrass number, an American folk
melody—the minstrel won't comply, instead playing a ballad that
surely seemed far more ancient to Jagger than some hillbilly Dust
Bowl number, "Ruby Tuesday," and now Jagger has gone from
telepathically communicating his desire to be alone to something
worse. He looks at the man. For the time it takes someone to choke
on a green olive, he speaks, calling off other compositions, num-
bers by musicians other than the Stones that he wants to hear, and
the fiddler would attempt them in the spirit they were given, but
he could not quite play them, and in his floundering the man offers
his gift of more Stones tunes, as Jagger watches on. Knowing the
band was staying here, he had studied their work and practiced in
anticipation of this very moment. The pitch wobbles, his tempos
lag, and then Jagger holds out an index finger in the violinist's
face, moving it sideways like a metronome, like a judgment, and
slowly the musician backs away, then quickly, Jagger opening his
mouth to sing a few lines from the country standard "Long Black
Veil" with a hickory-sodden wail:

> I spoke not a word
> Though it meant my life
> For I'd been in the arms
> Of my best friend's wife.

Watching from a safe zone near the table, Frank exclaimed, "That's
it! . . . That's the first real moment on this tour."[27]

Everybody was looking for the real. Whether it was the band
on a late-night drive through Louisiana or Frank gauging the hate,
there was the hope that the immense drifting artifice of a rock tour

could be punctured—that will or sensitivity or leather wrapped around your fist could bring you in touch with the reason you chose this road in the first place.

Frank waited for such moments, and with him was Danny Seymour, sometimes carrying a camera and often recording the sounds in rooms, sounds that told their own stories. He was skinny and looked like a Basque anarchist, with his beret and moustache and sad eyes. Seymour held up a microphone and listened to the air, wrote Elman. "In this cruel competition for attention, in which we all got higher and higher, he would spin, like a top, for minutes at a time, hoping to catch any stray sound of significance—a radar scanner, or a divining rod—as if he could Geiger counter all the vibes in the room at once."[28] The radiation flowed through him, and he logged it without judgment.

THE LINES OF MY HAND was published in 1972 in Tokyo by Kazu-hiko Motomura, who had shown up on Frank's Bowery doorstep several years before. It included Frank's first new still photography since he had turned to filmmaking. On the cover was a photocopy of June Leaf's hand facing outward. Motomura would play an important role in Frank's career, a publisher and celebrator of photo books. In Tokyo *Lines* was released in a lush limited edition of one thousand. Several months later Lustrum would put out a slightly different, smaller, and less luxurious version in the United States. The book spans Frank's career, including South America, France, England, Spain, New York, images from the Guggenheim tour that were not in *The Americans*, and only a few that were. There are film stills and written passages from Frank in a swelling, memoiristic voice—he waxes simultaneously grandiose and cryptic. *The Lines of My Hand* was a statement that transcended the images themselves. It presented older work that few had known of and made the case for a constantly evolving creative force that could account for the films and the still photography within an autobiographical framework.

The 1972 editions of *The Lines of My Hand* and then a slightly re-worked version published in 1989 brought Frank before a younger

generation much as *The Americans* had in the 1960s. This was an introduction to Robert Frank not as the force behind *The Americans* but as a protean artist who now seemed undeniable. *Lines* redefined. In their *The Photobook: A History Volume 1*, Martin Parr and Gerry Badger call it "Frank's great confessional," saying it sums up its photographic era and deeming it "the apotheosis of stream-of-consciousness photography."[29]

As Frank finished *About Me* he also began editing *Cocksucker Blues*. From late 1972 through 1973 he worked on a print to show Jagger and the Stones manager, Marshall Chess, in advance of commercial release. In Frank's Bowery building there was a cage where building employees would once check residents in to the flophouse. Now the cage was packed with film cans, its door padlocked. Frank hired a young filmmaker to help him wade through the footage. They looked at it for two weeks, and at the end of that time Frank took his hire, Paul Justman, out to an Italian restaurant. "Do you think there's a film there?" he asked.

"There was Keith shooting up and there was Jagger sniffing coke while he gives Robert a real 'fuck you' look, and . . ." recalls Justman.

"I figured this was some kind of a test. You know, I'm a kid, and this is my first movie, and I'm with my hero, fucking Robert Frank. I mean, the Stones were cool, but. . . . And he's asking me what do *I* think. I thought it was best to just be totally honest with him. I said, 'You know, Robert, if you don't put the messy shit in there it's just a home movie. I said *you* shot it, that's the deal you made, man. It's gonna get through."

"'Well, we'll find out,' he said."[30]

Justman worked with the footage in Frank's loft on the Bowery, and from there the selected film was sent to Susan Steinberg, a producer and director at the beginning of her career: she had been assistant editor on the 1970 rock documentary *Gimme Shelter*. That film (by Albert and David Maysles and Charlotte Zwerin) had followed the Rolling Stones 1969 tour to Altamont and then recorded the band's reaction watching film of Meredith Hunter's murder. Among the first things the editors and Frank had to do

was resolve the issue of material that a second crew had shot: the Stones had hired a more mainstream unit, with ten cameras and a sound truck, to record shows in Texas. The idea was to weave professionally recorded musical performances into Frank's behind-the-scenes "messy shit."

Jagger, Frank, and his editors went to John Lennon's apartment, where an editing machine was available, and watched the performance footage: the cameras were fixed in place, whereas Frank's cameras go everywhere. It looked "professional" alright, radically unlike what Frank was doing.

They watched, and then Jagger said, "Well?" Justman turned evasive, beginning "It's just a matter of space and time, man . . ."

Frank took a more direct route, shaking his head, holding his nose, moaning, "Oh shit, oh shit."

Jagger might have had a smirk on his face when he said, "Yeah, I get it. Okay guys, we'll see you later."

In the end they used bits and pieces of the other team's film. "Robert said he knew nothing about music. He said there was this professional team who shot all the music in 35mm, I believe, and he wanted me to go through all their material," recalls Steinberg. "Frankly the stuff was very boring. And the reason was, I compare it to *Gimme Shelter*, and that footage was very exciting—on *Gimme Shelter* they used all handheld cameras that had a lot more energy, pizazz. This new stuff was all on tripods, and the performances didn't have a great deal of life."[31]

The finished *Cocksucker Blues* would begin with an opening statement that fills the screen: "Except for the musical numbers the events depicted in this film are fictitious." The words could have appeared at the beginning of *About Me: A Musical.* Here they seem comically, intentionally 180 degrees backward because the reality is all outside the music. And from the opening moments on, you know this is a Robert Frank, not a Rolling Stones, film. The subject is not "The Greatest Rock and Roll Band in the World," an overpowering juggernaut of wealth and taste set to roll you over. The uneasy camera movements, the rough sound, the way people go in and out of focus all make the viewer feel like a peeping tom. The

Stones in 1972 were celebrating themselves as a brand—traveling with the ultimate rock-band logo, the lurid lips and tongue, painted on the side of their plane—but the movie was defiantly underground, poisonous to commerce. It put the band at the service of a droning, brooding, helpless vision of celebrity.

Cocksucker Blues is collaged from roughly connected pieces, employing film from Frank's 16mm Eclair along with material from Jagger's camera and other cameras that were passed around from person to person. Bianca Jagger wielded a Super 8, and then there is the performance footage. There was no way to make things look seamless, and Frank delights in jerking the viewer from one moment, one sensation to another, mismatching a radio DJ's banter over a scene of groupie sex. The viewer is being sold something, and denied something, every minute or so of the film. Steinberg does a fascinating job of cutting up disparate performances of "Midnight Rambler" and fanning them like a poker hand—Jagger wearing assorted outfits, the stages clearly not all the same—bracketed by scenes of backstage coke snorting, turning an emotional fulcrum of their performance into something plastic and spectral.

"I remember asking him if there was any decision-making process why some things are black and white and why other things were in color. He didn't directly answer me. I ended up thinking it was completely arbitrary," said Steinberg. "Robert didn't think that the technical part was always important, clearly. The rough and ready quality of it was part of the experience. Robert was capable of shooting it in a more formal way if he had wanted to, but he wanted it to look like home movies."

Another variable was due to one of Frank's 16mm film magazines (he had two or three) having a light leak in it, and every once in a while the editors would see a white quarter-moon along the side of a frame. "It's not exactly how you'd shoot most films," chuckled Steinberg.

In the editing room she introduced a tone to black-and-white footage, an otherworldly blue light, somehow perfect, suffusing many of the scenes. Don DeLillo saw it and sat up. In his novel *Underworld* an underground filmmaker modeled on Frank

is described: "She loved the washed blue light of the film, a kind of crepuscular light, a tunnel light that suggested an unreliable reality—not unreliable at all in fact because you have no trouble believing what you see but a subversive reality maybe, corruptive and ruinous, a beautiful tunnel blue."[32] He had done it in *The Americans* and again with the Rolling Stones: he had created a beautiful and corrupt world out of our world, a different, strange place being seen for the first time.

While he stashed the film on the Bowery Frank protected it exactly as if he were guarding the Rolling Stones' dressing room. He loved Danny Seymour, but the drugs were creating distractions, so Frank asked him to stay away while work was being done. Danny Lyon was off the list, one more friendship Frank mulched for the sake of the ones ahead. He was an artist like Frank; he knew the score and doesn't feel any resentment today. "There are too many intrusions, and one of them is friends," he said. "They can wreck it."

"You get cut—Robert is rough," said Justman. "Ralph [Gibson] could not enter the cutting room—we had strict laws: you could not walk into the loft. Anyone but, like, Dylan walked in, and Robert would say 'pull the plug.' He didn't want electricity running through the machine. Because anybody who walked in would say, 'Oh, can I see something?' Robert would say, 'Well, the machine's not running' and run them out of the place."

Then one morning Dylan wanted to see footage. Frank was working with the writer Rudy Wurlitzer on a fresh project, and Wurlitzer phoned ahead and said the musician requested a screening.

"We were kind of beginning breakfast, and Robert says, 'Yeah, we're making eggs and shit. Come over,'" recalls Justman.

The group arrived, and while everybody else sat down and ate, Dylan remained silently standing. Somebody asked him to take a seat and relax.

"I can't."

"What do you mean you can't? Any chair you want, it's yours."

"I can't."

"What are you . . ."

"I can't."

"Why?"

"I just can't."

They were getting close to an uncomfortable impasse on the issue of Bob Dylan standing when the singer explained, "I just did this movie, *Pat Garrett and Billy the Kid.* I rode horseback, and I didn't listen to the stunt rider and I didn't lift up my ass when he said to, and I am fucking tore up, and he said if I sit down and I start sweating it's gonna hurt like a motherfucker."

When it was time to show the footage Dylan was on his feet.

"He just cocked his head and kind of observed," said Justman. "It wasn't completely together; we just showed him pieces—I think he knew better than to say anything around Robert. I think he was thinking about what the next thing to do would be, if he was going to make another movie. And I think Robert was thinking, 'Well, *I'M* the best guy to make a movie with Dylan.' Guys like this don't ask—it's just "'I'm the movie maker,' 'I'm the star.' It all goes unsaid." It all went unsaid: Dylan and Frank never made a film together.

The Stones deserve a lot of credit: the handheld cameras moving around the band go beyond intimacy to outright invasion, unheard of in movies featuring pop stars. Seymour and Frank deserve credit too for being masterful nonparticipants. "They both had a way of disappearing. They were constantly there, but you didn't notice," Chris O'Dell, who worked for the Stones on the 1972 tour, told *Uncut* magazine.[33]

It's useful to note the artifice of key scenes—and understand that their falseness is part of the point and hardly hidden. There's a scene of group sex on the Stones' plane while Mick and Keith beat out an exotica rhythm on bongos. Frank's camera is in full view of the participants, and his voice audibly directing the sex. Even more staged is a scene where saxophonist Bobby Keys and Keith Richards hurl a TV set off a tenth-floor Denver hotel balcony. (They obligingly did it twice for the camera.) The act has meaning: what was once the ultimate rite of rock-star transgression is now vacant, a fit of violence that doesn't even hold rage anymore—it's just another routine, an abstraction of leisure arcing from the roof

to concrete. The hunt for the real was hard, exhausting, and on a rock tour in 1972—and on the Bowery and beyond—the hunt for a moment of true feeling seemed fated to end like a jumble of smashed vacuum tubes.

The film was scheduled for a November 18, 1972 release, and Jagger was checking in with Frank and Justman every few weeks. He'd stop by the Bowery loft—Jagger was so taken by the flophouse vibe, including the row of urinals in the bathroom, the Coke machine used as a refrigerator, that he offered to buy it from Frank. They regularly met at a Szechuan restaurant on East Broadway where nobody knew who he was. Just "Mister Mick." The conversations were convivial, and Jagger was into the footage he saw—"the Stones, they got it," said Justman. But the singer and Marshall Chess increasingly expressed concern that the footage was pretty rough stuff, and nobody's mind was changing. November 18 came and went.

Work continued, but positions didn't change, nor did they in 1973 or by 1974, when the editing crawled to a stop. Fresh problems arose. Frank hadn't gotten releases signed by people appearing on screen, and attorneys worried about lawsuits. Marshall Chess finally showed it to the band in Munich in February 1974. "They were, like, *stunned*," Chess said. "I thought it was a piece of shit actually," bassist Bill Wyman complained. "It was so amateur and poorly done. I just couldn't relate to it. [Robert Frank] was obviously just looking for anything sensational. That's why me and Charlie are hardly in it, because we weren't sensational. All the good bits, I thought, were cut out. It was just like a poor home movie, shot badly."[34]

The band instead released *Ladies and Gentlemen: The Rolling Stones* in 1974, a film of the live scenes made by the crew that shot in Texas. Frank himself screened *Cocksucker Blues* in California in 1975 and 1976 and several times in Canada, trying to build pressure on the band to release it. Then, in early 1977, Jagger called Steinberg up and asked if she'd come work with him on the film. She called Frank and seemingly got his blessing. "Mick loved it, he said so. He thought it was great. That's how I always remember it,"

said Steinberg. With Frank's okay, she shortened some of the drug scenes and made other small changes. Though *Cocksucker Blues* is most often seen in bootleg versions, the finished 1977 print is said to be the most visually accomplished, viciously and glowingly raw.

Steinberg and Jagger were in a cutting room in February 1977 when she got a phone call that Richards had just been busted in Toronto for possession of cocaine and heroin with intent to traffic. "The next thing I know, Mick says, 'I'm bringing some lawyers in to screen it.'" The legals watched *Cocksucker Blues* and then told her if the film was released, Richards would never be allowed into the United States again. It was evidence, they felt, of crimes committed. "They said it was just too risky" and shut down the production. "We packed up the cutting room."

Fearing Royal Canadian Mounted Police would subpoena Frank's copies of the film to make the case against Richards, the Stones filed a legal claim in Canada declaring copyright owner-ship of *Cocksucker Blues* and demanding retrieval of Frank's copy.[35] Papers were served at his Mabou home. Jagger claimed Frank had made the Stones an object of "scorn and ridicule" and that the film had invaded their privacy. Frank refused to give up what he had and responded with an interview in the *Montreal Star* in which he described in lurid detail the kind of scenes the Stones might be worried about.[36]

In response Jagger told a *Rolling Stone* writer that Frank was "a silly, sick person, and he seems to be trying to ruin Keith's life. I don't know what's the matter with him." The singer denied al-legations that any footage showed Richards on heroin and took another blast at the filmmaker. "Why doesn't he go and make another movie and shut his face? . . . What's he been doing for the last five years that's been so important? Is he so dead, has he no inspiration?" Resenting the depiction of Frank as a film poet being crushed by greedy capitalists, Jagger said Frank was really just a hired hand who did what his employers told him to do. They owned the work: "If I want to go and shred it in the shredder or if I want to put it in the general release, it's up to me, it's not up to him. I'm sorry, that's the way we run this country."[37]

A Port Hood sheriff showed up at Frank's door in Nova Scotia, explaining he was there to collect the film. Frank gave him a seat, fished out some reels of film. "I gave him the wrong can. He didn't know," Frank said later. The real one was beneath the floorboards.[38]

Richards pled guilty to some of the charges and got a wrist slap. The Stones and Frank meanwhile reached an out-of-court settlement in May 1977. Frank could show the film no more than four times a year and had to be present to introduce each screening.

Cocksucker Blues today has a well-deserved reputation for a visual style that has influenced indie films and music videos and a notoriety for its withering depiction of celebrity in a time when celebrity was fertilizing the art world and pop culture. *Cocksucker Blues* makes being famous—not to mention being a Rolling Stone— seem numbingly dull . . . just like real life. Maybe that was what the band had the hardest time forgiving.

The terms of the film's release reveal how perceptive Jagger was. He knew how bad it would look to have the film banned outright. And he knew Frank, he understood how little Frank liked standing up at a seminar and representing his work—and how much less still he would enjoy explaining himself to a room full of Rolling Stones fans. His provisions might keep the film from view and would certainly make Frank squirm every single time it was shown after he introduced it. "There's only one question I like to answer," he said in his sole comment at one screening. "My name is Robert Frank."[39] One of his greatest works, a piece he cared about deeply, would be seen in its proper form by almost nobody. Frank would never, ever reveal how much its withdrawal hurt him.

DANNY SEYMOUR WAS the one person Frank insisted accompany him throughout the filming. The twenty-seven-year-old had just kicked heroin, but for someone trying to stay clean, a Rolling Stones tour was the toughest place to be, and as scenes in *Cocksucker Blues* make clear, Seymour disintegrated. There are scenes of him shooting up while talking to Richards, passing out coke,

and nodding out while the mic hits the floor. At a party for the Stones in Chicago at the Playboy Mansion his friend Paco Grande remembers Seymour as "floor decoration."[40] When it was time to make the handwritten film credits, Frank came up with one for Seymour: "Junky Soundman."

Frank says the Stones had promised to send him to rehab once the tour was over. But the second the tour-ending shows at Madison Square Garden were done, the band was gone, and Seymour was back on the Bowery.

Susan Steinberg has a very distinct mental image. Seymour hadn't seen the film, so she set up a screening for him. "He was pretty young. I remember he came in, he saw it—just him. And he said the saddest thing at the end when the lights went on. He got up and said, 'I don't know how I'm ever going to show this to my parents.' I thought about it a lot. He was like a little boy saying, 'How am I gonna show my mommy?'"

At the end of 1972, some say in an effort to stay off heroin, Seymour sunk $70,000 in a thirty-eight-foot yacht he named *Imamou* after a Haitian deity. He planned an ambitious trip. With his girlfriend Kate Moore, her son, and two friends, Seymour sailed from Miami to Jamaica in October, then headed to Haiti and South America. When they reached Haiti in 1973 the two friends split. On the way to Cartagena, Columbia, the *Imamou* hit a terrible storm, and Seymour and Moore lashed her son to his bunk while staying up around the clock to navigate.

Moore was exhausted when she got to Columbia and decided enough was enough, flying to Miami with the boy. Now Seymour needed to assemble a fresh crew, and he met a young American and two Frenchmen in Cartagena who agreed to help sail *Imamou*. The group posed for a photograph on May 19, the same day they launched for Colon, Panama. It was the last time anyone saw Seymour or the American. Eight months later the boat was spotted by air near Guadeloupe. The two Frenchmen were on board, and when detained, they claimed Seymour had given them the yacht. No bodies were ever recovered, and though foul play was suspected, the French citizens were never prosecuted.[41]

After Seymour had disappeared, Frank didn't want to be in the Bowery building anymore and he would eventually rent a place on Bleecker Street. In a letter to the *Village Voice* the summer of 1974 Frank memorialized his missing friend. Thoughts of Seymour, he said, kept him up at night. "In New York from 1968 on, he gave a lot of his money and his time to his friends. For himself he was determined and destructive."[42] Frank recalled their work on *Cocksucker Blues* and how he hoped the film would see a release. The note finishes with a wish for a miracle, Seymour's return.

The year only became more grievous. Louis Faurer, among Frank's first friends in town, was talking to Andrea Frank on the phone in late December. Though he hadn't stayed in regular touch with Robert, he spoke to his daughter from time to time, and in this conversation she told him how she felt disconnected, uncertain what to do with her life. The feeling of drift came as she was about to go on a trip. A few days later, on December 28, Andrea died in a plane crash in the Guatemalan jungle near the Mayan ruins of Tikal. The twenty-one on board and crew, including a group of tourists from New York City and Robert and Mary's twenty-one-year-old daughter, died when the plane burst into flames and hit the ground a hundred feet from the unpaved runway.[43]

On an early page of *The Lines of My Hand,* beside a picture of his two children sitting at a table, Frank had written a simple dedication. "Above all for Pablo and Andrea who are trying to find a better way to live." It was an acknowledgment of hope, of course, and of parental responsibility. Now it was unbearable. Frank would spend most of his time at home in Nova Scotia, and his thinking and work were at the start of an unsteady, tortured route in which various definitions of meaning came under scrutiny. Later he joked that he put a sign up on his New York door when he left for Mabou: "Back in 15 minutes." It would be longer than that before he returned.

CHAPTER FOURTEEN
SICK OF GOODBY'S

H IS INSTINCTS WERE FIXED: keep working. Flail, howl, shoot at targets—it didn't matter. Work. If you stopped and just laid down, you might not get up again.

He had in mind a film about the losses of the past year, something embracing Andrea and Seymour. He had a lot of Super 8 footage of his daughter when she had stayed in Mabou, and he mailed it to New York, where he planned to work on it. The film disappeared in transit, presumably lost by the post office. "I felt that it was just fate. Nothing could be done, so I gave up," he said.[1]

There were low-impact commercial jobs that kept him occupied. Frank did camera work for the 1973 rock-and-roll concert film *Let the Good Times Roll* and shot parts of *Sunseed*, a blissed-out survey of Eastern mysticism in New Age America. He contributed to *Food*, a casual 1972 documentary on Gordon Matta-Clark's Soho restaurant, and 1974's *No Second Chance*, by animator Leonard Glasser.

In 1975 he and Leaf were driving to a teaching gig in Davis, California, when they stopped and got married in Reno. They were married at the Reno City Hall, the place where a decade before Frank had photographed a young newlywed couple for *The Americans*. Then they went to California.

A young visual artist named Findlay Fryer at UC Davis heard some guy was on campus teaching a class on film. Fryer had made a few films when he was younger, including one about a local farmer who lived with his goats. He stopped Frank one day and asked if he could come to class; registration was full, he was told, but Frank invited Fryer to sit in and show his work to the students.

After Fryer's movie had played, the lights went back on, students distractedly began talking among themselves, and the visitor put the reel into his pocket and walked out. A few blocks away Frank finally caught up with him, grabbing his arm to say that he had liked what he had seen. They hit it off.

"There is this very cryptic, poetic, morose, dark kind of way Robert can think. I didn't know who Robert Frank was. I came from a pretty rural world," said Fryer.

"We had a connection, and I didn't know what it was." Not knowing *who* he was would have been a relief to Frank. "He didn't want that 'he's a master' thing in his life. He never has. It's ironic and a bit of a curse to him on some level that he's gotten as much fame as he has. It's tracked him down."[2]

Leaf had returned east by the time the teaching job was finished, and Frank was looking for someone to drive to New York with him in his pickup truck. "Him and I got along pretty good," says Fryer. "He's a damned good driver! I think he likes being on the road." When they hit Lincoln, Nebraska, Fryer asked if Frank was going to visit the old friends there that he had been talking about. Frank parried for a while, then pulled out a postcard, scraped a dead bug off his windshield, and smeared it across the postcard, writing, "TOO BIG A HURRY TO STOP!" "His sense of humor was pretty right on," said Fryer. "It's allowed him to continue that kind of edge where spirit and spunk and the depth of his work have kept moving forward at a time when a lot of guys just shrivel up. That's why being a professor was so scary—to him it was almost like a failure."

The back of the truck was full of expensive film equipment picked up from *Cocksucker Blues*, and Fryer says he would just throw a dirty tarp over it and pull into the worst part of town and park. "He knew he could be blatant—he had a very different attitude about walking into a bar in the middle of Cleveland. He didn't really worry if it was gonna be ripped off."

Occasionally they talked; many times they did not. "Oh shit, you could barely reach him sometimes," recalled Fryer. "A series of things had happened, and he couldn't make sense of it. He was

trying to make sense of it through the way he was making films, but his work is pretty cryptic—if you want a narrative, you're probably going to the wrong place. He's pretty cryptic."

He got back to New York and then headed to Cape Breton, putting together a film called *Keep Busy*, with Leaf and a few friends and neighbors. The battle with the Stones stuck with him and was not over, but he didn't talk about it. To care deeply about something he had done was a hard admittance, but much easier and maybe much deeper was the need to do work, the act of functioning.

The novelist and screenwriter Rudy Wurlitzer lived twenty miles from Mabou. The two were friends who shared a love of music and a taste for the highway. Wurlitzer's screenplay for the road movie *Two-Lane Blacktop* was a phenomenon in 1971; *Esquire* put the film on its cover and published the entire script. In 1972 *Rolling Stone* excerpted Wurlitzer's novel *Quake*. He wasn't just an experimental writer with a handle on "great American themes"; Wurlitzer was, in the 1970s, as cool as Pelé.

He wrote *Keep Busy* the day before they shot it on an island off the coast of Cape Breton. It was unlike anything else Frank had done: woozily allegorical, it has the feeling of a bunch of friends getting together and making a movie paced to the rhythm of the waves that seem always lapping just outside the frame. There was an old, abandoned lighthouse on the island that became integral to the film. While prepping for a shoot Wurlitzer started tidying up inside the wrecked structure, and Frank got angry—about as angry as Wurlitzer ever saw. "Stop," he yelled at his friend in disbelief. "It's taken ten years for this room to get this way and now you want to fuck it up!"[3]

Quietly, and only for himself, Frank began taking photographs again in Mabou. The move was in no way a bridge to the past, and was done off-handedly in ways that announced its unseriousness; it was cast in the context of kidding and personal ritual and not as the making of art. All the same, something had started. It began at the end of the American edition of 1972's *The Lines of My Hand*, where the roughly assembled composite panorama of the Mabou landscape was accompanied by words that now sound

like an announcement: "Yes, it is later now. . . . The ice is breaking up."

So he started there, and then he reached further back for another starting point. Frank bought a Lure, a cheap plastic camera weighing an ounce and a half. The Lure so resembled a toy that the ads for it declared, "This is not a toy." No settings, you needed sunlight to take a picture. The Lure was simple. When you finished with the twelve color exposures that came loaded into the camera, you mailed the camera back to a post office box address, and the company sent back your developed pictures along with a new, freshly loaded Lure. It was ground-zero time: Frank taught photography at the local adult education program near Mabou.

He has said that he was using a split-frame camera in 1972, a jaunty offshoot of the 35mm camera that divided the size of each frame in two, giving the photographer twice as many exposures.[4] The Lure led him to pick up the Polaroid Land 196 camera in 1974, using black-and-white film to make collages with multiple negatives. It was fun, which he couldn't remember his earlier pictures being. As he spent time in Mabou, repairing structures and working on the house, he thought about how photography might become interesting again. In a year or so he was making collages in color.[5]

He was connecting with still photography in a manner that felt authentic, but there was no straight line of intention. "I would like to have nothing to do with the photographs anymore, forget about them," he also said in 1972. "I'd like to go on, but somehow it always comes back." *It* wasn't just other people bringing up the old work; he was bringing it up and beating it down, looking for a way forward.

Friends came up to Mabou, a bit of a ritual where visitors arrived and met him on his grounds, at his pace. Not a huge amount being said. An old Swiss pal arrived with an expensive and complicated panorama camera, Frank watching him for days as he fussed with the thing to make a good picture looking out on the rocky beach below. The visitor made adjustments, and more adjustments, and finally with disgust and saying something like "this

is how you do it," Frank whipped out his handheld camera, shot, turned, shot, turned, shot—he had taken the pictures, and soon he would tape them together roughly, his way to render the horizon.

He made a number of assembled landscapes. One could view it as a creative act; he saw it as a process of destruction. "It was a deliberate attempt to show that for me the picture itself had ceased to exist," he said. He added that he liked the sutured landscape "because it really expresses the way that I felt about photography—that if I did it now it would be spliced together."[6] Protesting, destroying, using cameras that few self-respecting photographers would employ. "I don't really think very much about the pictures. Actually, I don't look at photography that much any more. It looks back at me. I think I have rather *FELT* something about them and that means about photography. I've felt something about it, and I couldn't explain what I felt."[7]

In the months following the plane crash Frank performed a set of quasi-meditative tasks, making markers of uncertain designation. An arrangement of rocks, a piece of driftwood piled atop another and a plank placed above that. He set them around the perimeter of his property in a way suggesting a symbolic defense or the most basic orientation with the earth. This work was not art, these monuments that had meaning only to him. Man-made natural formations, a giant cedar laying in a full moon. The magic jumbles memorialized the act of doing something, marking in time and space.

Thinking about these works today it's possible to see them as the first step of a new creative drive, the first initiative coming after the ground has been cleared. But they stand alone, in their time, apart from art and audience. Morton Feldman stated, "The question continually on my mind all these years is: to what degree does one give up control, and still keep that last vestige where one can call the work one's own?"[8] Sometimes, after he had assembled one of these totems, Frank brought out a Polaroid and made a picture. That was the true first step toward art.

One rock after another.

The Man Who Walked Away had come to Wellesley College in Massachusetts. In 1975 he participated in Photography in

the Humanities, a series of public symposia also featuring photographers W. Eugene Smith, Irving Penn, filmmaker Frederick
Wiseman, John Szarkowski, writer Susan Sontag, and others. His
method wasn't to hold forth with a prepared lecture—he did not
have a script—but he was ready to take questions. The very first
question at Wellesley inevitably was why had he given up photography. Frank answers joking that usually it's considered polite to
talk first about the weather.

Then he moves to a story from his life in Mabou. His truck
was stuck in a field, he says, and June was behind it pushing as a
neighbor came by and stared intently at him, saying, "Calm down,
Robert. Calm down." Was he telling himself to calm down now?
He went on to note the benefit of the video camera that he had recently started using, then moved on to explain that he doesn't like
talking about photography as much as films because photography
was in the past. Finally, slowly, in a very quiet room, he repeats
the student's question, as if he was wondering if he had possibly
misheard it.[9]

It was a long day full of questions, and later another attendee
circled back. An exhibition of the work of the visiting photographers accompanied the event. This attendee was confused—we
know you had stopped taking pictures, he asks, but in the gallery there was a landscape of Mabou. Are you taking photographs
again?

Frank is startled. He tries out a few sentences that each fall apart
before he says it was just by chance that he found the negatives in
a drawer and had decided to print them. He sounds like he doesn't
know how they came to be in that drawer. He sounds like this
new, wonderful photograph was something that just happened to
him. Which maybe it did.

The Wellesley session is a remarkable record of his state of
mind. There are times when he is dark and bitchy: Harry Callahan
he loathes; Aaron Siskin is just dull. "What about Minor White?"
a student asks. Hold on, Frank says, he's not done dissing Siskin.
And why does Cartier-Bresson still live, he asks?

But the zingers are delivered in a fully engaged way: he's extending to the public the respect of not ever talking down to them. What he objects to in photography is the cult of the beautiful picture and, beyond that, aesthetics. In all that stuff, he says, he does not believe.

"Well, I do," a young woman replies. Her voice full of disbelief, she asks, "What don't you believe in?"

"Beauty," Frank explodes. He could find it, he knew well how to bring it to images, he just stopped wanting to see it.

The work he turned to in the 1970s, for himself, then slowly for others, often involved groups of pictures pushed together—taped, collaged, photographed after they had been taped and collaged. Embracing the Lure, then the Polaroid, was a way of reengaging with still photography while not needing to connect with a whole set of issues that dominated photography in the 1960s and 1970s—it was a reconnection that remained disconnected from the world *The Americans* had helped create. The Polaroid camera felt like a toy, its ability to make an accurate record of the world challenging—it spoke to Frank's desire to short circuit self-consciousness and was a knife that cut away at the doubt and intellect that stood in the way of making something new.

After Andrea's death Frank had said his photography "shifted from being about what I saw to what I felt. I was really destroying the picture. I didn't believe in the beauty of a photograph anymore."[10] That impulse to destroy beauty in order to say something true emerges in an amazing photograph he made in 1978, *Sick of Goodby's*. Two photographs are stacked vertically—in the top half, looking through a window streaked with paint, we see a disembodied hand holding a toy skeleton over the Nova Scotia landscape, the figure hanging between sky and sea. The bottom frame shows a paint-spattered mirror, a picture frame leaning against it.

The words of the title are scrawled across both halves, as if written by a finger on a wet mirror maybe or in blood dripping down a wall. It is embarrassingly open; it shrieks in the stairwell. In a work of exhaustion his mirror does not reveal, and some of the

writing is incoherent. And yet everything is known here—Frank's regret, rage, where he is in this world.

Writing about photography after the September 11 attacks, specifically the flood of pictures of people holding pictures of those gone missing, the poet Eileen Myles has written, "In our time, the 'picture of the picture' has become the international symbol of loss."[11] The representation of an ever-lessening, never-ending connection makes *Sick of Goodby's* exceptional. Pictures within pictures, frames within mirrors, broken containers, Frank's work of the late 1970s hemorrhages loss.

Central to his healing and reemergence was the influence of his wife, June Leaf. Friends of hers have noted her impact on Frank's work of this time. In 1973 she was attaching Polaroid photographs to her paintings and drawings—around the time Frank was developing an interest in manipulating Polaroids. In a work like 1973's *Robert Sewn* Leaf roughly arranges photographs of fragments of Frank's body, transformed with paint, to render a relaxed, composite portrait. Within the next few years Frank was making composite works of multiple photographs that were painted and written on. His use of words in his photo work of this era is in part traceable as well to Leaf. She encouraged him to try the new approach, while her own art brought writing and drawing together on an autobiographical plane.

The film work, if anything, was even more autobiographical than his still photography. Their assembly seemed like metaphors for Frank's elliptical, uncentered way of viewing the world. There are moments of beauty and illumination, yet overall they are sideways moving; they do not build into larger structures. One can watch and walk away with a strong feeling for Frank's thinking and methods but remain remote from the work itself. The films are not built to last. They do not ascend to a resolution; instead, they engage with an everywhere-all-the-time passion for looking, embracing the moment at the expense of much else. Being in the moment arouses his strongest feeling. Then the moment expires—it becomes a photograph and, more generally, memory. "If there were a term that could aesthetically outline Frank's work, it would

be 'fleeting,'" the Austrian film critic Stefan Grissemann has writ-
ten. "His films refuse what one calls 'cinema.' Anyway, Frank is
not interested in being at the height of any type of art. . . . These
films are not interested in leaving behind tracks, they remain pale,
ungraspable, are more 'atmospheric' than 'pictorial.'"[12]

Photography made Frank legendary; film made him disappear.
He liked it like that. And as time went on, Frank cared less about
people being able to see his film work. It held meaning to him,
and what followed from that, from his point of view, was more or
less out of his hands.

Something else that interested the artist: failure. With *The Amer-
icans* Frank knew what he had done even before it was published.
Film he was not as sure about, and that feeling opened up a world
of other feelings he found increasingly worth exploring. He worked
from a space in which it could not be known what came next be-
cause not-knowing seemed an essential part of being alive. Talking
to audiences, Frank described filmmaking as a way of finding his
limits. He compared it to climbing mountains in Switzerland as a
young man, where the satisfaction was in finding your boundaries,
ascending until you could go no further.

There was possibly a personal element in this pursuit as well.
His friend Walter Gutman, who invested in *Pull My Daisy* and *The
Sin of Jesus*, once gave an interview where he explained how, to
his mind, Frank felt "embarrassed" about his mastery—that mak-
ing great photographs came so easy to him that it contradicted
something he felt about himself. Feelings of guilt, Gutman thought,
shaped decisions he would make in the years ahead. Another
friend, Gunther Moses, used the same word in describing how
Frank recoiled from admiration. "He hates the limelight. He hates
it. He wants to be left alone. He does not enjoy all this adulation
and stuff that people throw at him. He doesn't enjoy that at all. In
fact he feels embarrassed."[13]

Frank spoke a good deal about failure at Wellesley, and it made
some who were present nervous. "Are you satisfied with your fail-
ure in films?" one person asks. Well, he responds, "I'm satisfied
that I've done them. I guess I would have been happier if they had

been successful, but I believe very strongly, the main thing is to do it."[14] From the 1970s on, Frank candidly embraces a view of his films as records of imperfection. Making them was hard, and the process was valuable to him. But dwelling on them was harder, and he had little use for that.

Still, he was absorbed in each one as he made it; they mattered intensely to him. Rudy Wurlitzer believed that making films was Frank's strategy for living in the present. When the past—memories, family, *The Americans*—became oppressive, work was a way to dig himself out. Frank acknowledged this when he told Canadian writer Dennis Wheeler, "You know you build yourself a big trap and you fall in—that's how I feel looking at these films often. But they were just essential to my life."[15]

Failure moves in more directions than success. For Frank it summoned the Swiss values he had gleefully failed at, the belief that you made money and found your niche and kept at it with precision and stability for all your days. That failure had been easy, but others drew more blood. He was fifty now and could see, perhaps, how, for all his revolt against the Sammies, ambition had nonetheless steered him. Ambition had shaped his family and cost him a sum that felt heavier now than it did at thirty. He hated beauty—unless you paid him for it, went his little joke—but there was something better than beauty, better than a permanent record or a painting. What most mattered was a line that meandered from moment to moment. Getting lost and not caring. As the composer Henry Threadgill has said, "Everybody wants to be a success, and they want it right now. But you don't learn from success. You learn from what doesn't work. That's how you go forward."[16] If it worked, that was great. If it didn't work, well, that was fine too—you kept moving forward.

AROUND 1976 Frank's friend Ed Grazda got an envelope in the mail postmarked Nova Scotia. In it was a messed-up Polaroid that had been left outside for a few years and a note from Frank that said in total, "Dear Ed: I'm famous, now what?"[17]

Fame was one great subject of *Cocksucker Blues*, and some of the world's most famous people kept nonfamous people from ever being able to see it. Fame was the coin of the art world—certainly the Warhol precincts, where celebrity had become a medium like clay. Frank was a celebrity too and something much rarer than that: a myth. His name stood for a set of values that defined how people on the Bowery, in galleries, in college workshops lived their lives. A decade ago the photographs in *The Americans* made people want to pick up a camera; they made people want to pick up a guitar, too, and a megaphone. But now it was an absence of pictures before the public that inspired people. A narrative had been established of a guy who would rather risk commercial and critical failure than repeat himself. Someone who the Rolling Stones had tried to crush. He favored the hard path to the certain one.

There was an empty spot where the art should be and an empty spot where the man was as he made remote Mabou his preferred address. Frank said that when he stopped taking still photographs he figured people would stop talking about his work, but he discovered that the opposite was true: people's words about him filled the void he'd left in New York. He was an inspiration to those who had not even seen *The Americans*.

Teaching art was paying bills, but it was distressingly close to talking about art, and that lead to talking about one's own work—which, Frank made clear, was the lowest. It made him uncomfortable, not to mention being about the least cool thing one could do. He hated a list of prepared questions.

To make his point he started his talk at a workshop in Rochester, New York, at full blare. He had been yelling at a Brazilian film crew. They were interviewing him in New York for a documentary about the United States. He had forgotten the appointment, he tells the students, so when the Brazilians came to his door he sent them away—he had double-booked an appointment uptown. But uptown sucks, and he's in a bad mood when he lets them into his place two hours later to do the interview. They brought lights to his apartment and asked him to sit in a chair before the lights. He exploded, "I don't want to sit on that fucking chair. I'm gonna

stand up, and why can't you move your camera?"[18] It is good to be angry—that is the message he wanted to impart to these students. It sharpens the mind, and by the way, he asks, is there anybody in the room now who is angry? Can I see some hands? That is how a Robert Frank classroom dialog started. Soon he was lamenting that so few young people seem mad these days.

There was a myth of Robert Frank, and starting in the 1970s, in seminars and workshops and interviews, he acted it out for audiences. "I can never like the middle, to be in the middle," he explained in Rochester. "I guess that's why I moved away from Switzerland to come to New York—which certainly isn't the middle—and then I moved away from New York to go to Canada, to live in a place that's absolutely the opposite of New York. So I see very clearly that I always prefer the extreme."[19]

To meet him was to get pushback. Soon to be one of his best friends, the scholar and curator Philip Brookman encountered Frank for the first time in 1978. As Brookman approached, Frank held up a mirror to this stranger, and asked him, "Do you like what you see?"[20] Accusatory, wounded, proud of his exile—there was a new name for people like this. Robert Frank was a punk rocker.

However much he lived in Canada, he kept finding his way down to the Bowery. In 1977 the photographer Godlis was hanging out in the Bowery club CBGB, shooting the Ramones, Patti Smith, Blondie, the Dead Boys. Godlis was schmoozing with the woman at the door when an older guy brushed past him, pulling up near the bar. "My God, that's Robert Frank," he said. But the people he was talking to didn't know who that was, so Godlis name-dropped *The Americans,* which got no response, then tried *Cocksucker Blues,* which also drew no recognition, so he mentioned *Exile on Main St.,* which finally got a meaningful nod from his friends. The young photographer went up to Frank and started a conversation. Looking around at the sea of people half his age in black leather jackets and high-top sneakers, Frank said in his Swiss accent, "It looks like the way people dress here is really important!"[21]

It's too bad Frank never did a "screen test" at the Warhol Factory: it's hard to imagine him packaging or revealing himself for

four minutes before Warhol's unblinking camera eye—and for that reason a screen test would have been all the more revelatory. But in 1975 the photographer Richard Avedon went to Mabou to make a portrait of Frank, and it is far from bad. The two had given each other extra room since the late 1940s, when they both occupied the world of magazine photography. There was plenty of respect and much resentment too.

Avedon discounted Frank's persona. He called him "One of the great theatrical outsiders. In a room full of people, he becomes the sad corner." Frank's was the kind of sadness that people found sexy, Avedon said. "His silence is very loud."[22] When the two collided in 1975 for the portrait, it was bound to be loud. Each felt judged by the other, which they were. Avedon's picture of Frank is a pretty amazing act, and as Janet Malcolm has written, it is the rare portrait where Avedon's subject fights back enough to render themselves by their design. Frank is seven days of unshaven, concentric circles around his eyes, hair snarling, and he's wearing a sweatshirt and has brought along his dog for backup. It is a performance, one Avedon responds to with his typical containment, putting white space and frame around Frank's self-definition. And then you see his eyes looking past Avedon—*I see you, you have nothing of mine*—to take us in. He's in hostile territory and is not your friend. He doesn't care if you like him (and anyway, he's got a dog). As a voice from CBGB could have put it, "Look here, junior, don't you be so happy. And for Heaven's sake, don't you be so sad."

IN THE 1970s photography was up for grabs. Academia was moving in: on the West Coast John Baldessari and Robert Heinecken, innovators whose own work called into question the nature of photography, were teaching at CalArts and UCLA. Walker Evans was dean of Yale's School of Art, while Nathan Lyons ran the influential Visual Studies Workshop in Rochester, New York. At the Rhode Island School of Design Harry Callahan and Aaron Siskin had established a beachhead. Minor White roosted at MIT.

Meanwhile the definition of what a photograph could look like and what it could say was in midrevolution. And to see that, the sidewalk right outside Frank's Bowery address was as good a place as any to stand. In 1973, while Mick Jagger was upstairs discussing edits, on the street one might have run into another German-speaking photographer, the thirty-two-year-old Sigmar Polke, taking photographs of the homeless men living on the Bowery. The work Polke produced, an astonishing and debauched series, hardly registered at the time but now seems overpowering. The developing chemicals are splashed in a purposefully, randomly revealing way—burning and blurring and smearing the images of the homeless. The pictures look dirty, unwell, and somehow in the act of obscuring people who go unseen in daily life, invisibilities come into view. Meanwhile Polke's work is so abstracted and suggests so many possible methods that it's hard to tell if one is looking at a photograph, collage, or print.[23]

New York photographer Duane Michals was staging scenes to create dramatic photographs that challenged the idea that a photographer discovered truth rather than shaped it. Michals had started his career just as *The Americans* appeared, and he found support and guidance from Lou Silverstein at the *New York Times,* as had Frank. His work, controversial in the early 1970s, would soon be seen as an important influence on Cindy Sherman, Jeff Wall, and others.

But all that was still the future. In the early 1970s critics debated the question of whether photography is art. There were art galleries selling photography and several photo galleries—Witkin and Light, most importantly. But the market value of a photograph was still a fraction of what a desirable modern painting was worth. And as long as collectors didn't feel comfortable paying higher sums for photographs, it didn't matter *how* critics answered the question—the market declared that photographs weren't, in essential ways, art's equal. Still, the possibilities were becoming obvious to those in the business, and a group of unorthodox entrepreneurs began looking at an older generation of photographers, seeking to apply market forces to a canon that would, over time, net a substantial price.

Harry Lunn was a man who liked to collect and share parables. He even had a parable about a stamp collector who possessed a pair of rare stamps worth $1 million each. The man proceeded to destroy one of them, and boom, the price of the other went up to $3 million. He told that one repeatedly. Lunn's gift was to apply a scarcity economics model to an art form based on multiple prints. He would see that, if it was past time to treat photography as art, it was also past time to handle a photograph the way galleries handled paintings or sculpture.[24]

Lunn had opened a gallery in Washington, DC, in 1968, selling late nineteenth- and twentieth-century prints. He told the curious that he had been a young diplomat in Paris before retiring from government service. He sensed a rising interest in photography among his clients and through his extensive connections in the art world. In 1971 he exhibited a portfolio of Ansel Adams's photographs, including *Moonrise, Hernandez, New Mexico*. By selling Adams's prints for $150, Lunn made some $10,000. That was good money for a photographer and for an art dealer in 1971.[25]

Having made a believer of Adams, Lunn convinced him to cap the number of prints he made of a single image—certainly including *Moonrise,* which was en route to making Adams almost a pop star. A proliferation of prints would drive down the market price of a photograph, and to keep that from happening, Lunn put the word out that after Adams released a final run of a desirable work, he would feed his negatives into a Wells Fargo Bank check-cashing machine.[26]

A small circle of dealers and collectors, who in the early days cooperated as much as they competed, shaped the rise of the photographic market. Sam Wagstaff is deservedly the best known today, and a key difference between Wagstaff and Lunn was that Wagstaff wanted to nurture careers and reputations and to teach a growing public how to look at a photograph. Lunn, who possessed a fine eye and loved photography, had narrower interests. He was in the game: "We have become specialists in the creation of rarity," he boasted, and that was where his attention would always be.[27]

While speaking to a *Washington Post* writer he produced a stack of Robert Frank photographs, "dealing them out like gin rummy

cards." The polished persuader explained that he was in control of 2,500 Frank pictures. He had set a limit of selling 250 a year, and 83 were already gone on the day they talked, he explained with a snap of his fingers. He was in the second year of a ten-year deal with Frank. When the *Post* reporter asked if he created demand, the dealer demurred. "I prefer to say that I *organize* the market." The Franks he was pushing would sell for "about $700 to $1200. But," he added, "by the time I get through with a few years of merchandising, they'll be more."[28]

A couple of New Yorkers had introduced Frank to Lunn. "These people bought my photographs," he explained to William Johnson. "One was a very high-powered lawyer from New York and the other one was a guy who was very astute about photography. The two got together and they said, 'There's this guy who sits up in Nova Scotia. We can get his photographs—he needs money.'"[29] Frank was in need because Pablo had developed Hodgkin's disease and was also exhibiting mental illness that demanded extensive medical attention.

Frank's "high-powered lawyer" was Arthur Penn, a New Jersey attorney whose wife was an aspiring photographer. Penn suggested to her that they learn about photography by building a collection. According to Philip Gefter's masterful biography of Sam Wagstaff, the Penns went on a buying spree and, by the mid-seventies, had accumulated some forty thousand prints. They claimed they had never paid more than a dollar for a photograph.[30]

Paul Katz, the photography curator at the Marlborough Gallery, told Penn at the end of 1977 that Frank wanted to sell his work in a bundle and that a deal with the Light Gallery had recently collapsed. Penn and Katz purchased rights to thirty-one hundred of Frank's images, including original prints of *The Americans.* Frank signed each one and Penn paid him $300,000.[31]

Katz and Penn established a partnership and approached Lunn about buying Frank's work. They set up a long-term megadeal that made the Washington, DC, gallery owner the exclusive dealer of Frank's photography spanning from the beginning of his career until 1966. Lunn would market a limited number of signed

complete editions of all eighty-three photographs in *The Americans*. He had already bought the entire Walker Evans collection and would soon have exclusive representation deals with Diane Arbus, Berenice Abbott, and others. "His fingerprints," Gefter writes, "are now visible all over the history of photography."[32]

Lunn's lack of subtlety and his aggressive tactics had created a growing number of detractors. Lee Witkin, the dealer who began exhibiting photography in 1969, once bemoaned, "Harry Lunn represents to me all that is wrong with the art world. He's in it for money; he's really a businessman. He wants to tie everything up."[33] To which Lunn would respond by noting he treated his photographers differently from how other galleries treated them: he treated them as major artists, plain and simple, paying them what major painters were getting.

The partnership sold Lunn tranches of 150 photographs a year, $40,000 the first year, $50,000 the next. In a letter written to Frank in March 1978 Lunn notes, "To a great extent, we all are breaking new ground" in crafting a structure that would remunerate the artist while also feeding growing demand. "I feel very good about the system that has developed," he wrote.[34] Frank agreed: "For me, at that time in 1977, to get $30,000 a year for ten years meant a lot."[35]

Around the time Frank made his sale, Helen Silverstein ran into him at an exhibition opening in Manhattan. The onetime producer of *Me and My Brother* hadn't seen him in a few years. "He was very animated, really excited, when he saw me. He rushed up to me," she recalled.[36]

"I've got something to tell you," Frank said. "I sold all the pictures in *The Americans*."

"'Oh no, you didn't!'—that's what I had to say to him."

"I got four hundred and fifty thousand," she remembers him saying.

"The negatives?"

"Yes, the negatives."

"What a fool," Silverstein said, looking back. "But, it was a lot of money at the time."

CHAPTER FIFTEEN
BOBBY HOT DOG

A T THE G. RAY HAWKINS GALLERY in Los Angeles early in 1980 a print of Ansel Adams's *Moonrise, Hernandez, New Mexico* went for $71,500, breaking the record for the sale of a photograph. (The producer of TV game show *Celebrity Sweepstakes* bought it.[1]) Lunn's fingerprints were on that, too. He was reshaping the art market, braiding connoisseurship and hype into a new form. He appalled, he shook things up, and he left many wondering where he came from. The dealer was expansive and friendly and controlling and unknowable, and if you were lucky enough to sit around a table with Lunn—at a French restaurant in London, say, or at his New York apartment, surrounded by his antiques, the portrait of Lunn taken by his friend Robert Mapplethorpe, and all his fine stuff—you might have realized what a vibrant self-creation he was. He might even point it out to you: if humblebrag had been around in the Ford era, Lunn would have taken credit for inventing it, too.

"He was a dear friend, and I miss him," said the photographer William Eggleston. "He felt at home anywhere in the world, with anyone. He was a very unusual individual."[2] Lunn was born in Detroit, Michigan, during the Depression; his father was a civil engineer for the electric company and had an obsessive streak—Harry grew up in a replica of a Cotswald Mansion that his dad had built in their upper-class neighborhood. Harry collected bottle caps as a boy and was making jewelry by the time he was twelve. While thumbing through a copy of *Holiday* magazine one day he spotted a light fiction written and illustrated by Ludwig Bemelmans. It was the story of a woman sitting alone, in a fine Parisian restaurant,

eating simply the best peach dessert anyone ever had. Right then, that was it for Lunn: he knew he wanted out of Detroit. He was headed to Paris to taste the best peach dessert.[3]

While getting an economics degree at the University of Michigan, Lunn edited the student newspaper and wrote editorials, including one defending a faculty member charged with being a communist. A student who worked on the paper's staff with Lunn recalls him as "manipulative and overtly ambitious."[4]

He was head of the campus branch of the National Student Association, an international organization composed of representatives from student governments all around the country, and soon Lunn became active in the national organization as well. It was while at the University of Michigan that he started working for the Central Intelligence Agency—his recruiter was a member of the administration, says Roma Connable, a fellow journalist at the University newspaper. The National Student Association's international wing, active in student organizations in Europe in the late 1940s and throughout the 1950s, was a front for the CIA, as has been detailed in Karen M. Paget's 2015 book, *Patriotic Betrayal*.[5] Plenty of liberals in the 1950s who disapproved of red baiting at home eagerly joined the fight against totalitarianism overseas. Lunn was already a canny card player, holding out for a CIA position in Paris upon his graduation. It was a gutsy demand for a new recruit. He got it, too. While stationed overseas Lunn threw himself into art collecting.

There was more than a bit of Harry Lime in Harry Lunn. He was a presence in diverse parts of Europe in the 1950s, establishing contact with local youth groups and recruiting mobs of rowdies to break up demonstrations by Soviet-backed mobs at youth festivals and congresses. As a station manager and paymaster, Lunn funneled Company money to organizations on the continent. He recruited agents into government work, including a Smith College graduate named Gloria Steinem (a fact not included in Steinem's 2015 autobiography, though Paget goes into detail[6]).

"He wasn't an easy guy to get along with," said Paget. "From an early age there was a kind of arrogance. You can call it

self-confidence, but it easily spills over to arrogance. People re-acted very strongly to his personality."[7]

By the mid-1960s he was stationed at the Pentagon, and while working for the government he launched his gallery business from twin townhouses off Dupont Circle. Lunn almost certainly would have continued on this path if not for the publication of an article by *Ramparts* magazine in February 1967. The story disclosed in great detail his and the National Student Association's relationship with the CIA. Now exposed, with his market value greatly dimin-ished, Lunn left the shadow world for the world of art. In later years he would downplay the work he had once done as a spy, flashing a smile and telling journalists, "It's not like anybody ever asked me to kill Noriega."[8]

When Lunn died in 1998, Paget notes, his passing triggered a re-markable flurry of CIA activity. He was believed to have collected a wealth of documents, covering his earlier career, which were stored in the basement of his New York home. Immediately after the announcement of his death, people who had known him back in the 1950s got calls from the CIA, inquiring about those papers. The records have never turned up. "Just think about that—we were generations removed from the history involved. I was amazed that they were Johnny on the spot about his papers," says Paget. "It says to me that all these decades later, almost fifty years, they were interested."

In 2001, Paget says, the CIA reclassified a file on Lunn, putting it out of researchers' reach. "One speculation is that there is sen-sitivity because they are running these kind of operations again."[9]

IN THE YEARS after Frank's agreement with Lunn kicked in, his fi-nancial burdens significantly lifted. All the same, their relationship quickly soured. There was the pressure to sign—and sign a certain way—photographs as they moved past him. And there were prob-lems if Frank tried to sell an image on his own. Most of all there was the shock of realizing he had lost essential control of his art and put it in the hands of someone whose interests were not his

own. Frank had always been scrupulous about controlling how his work was shown and had strong feelings about not showing prints that did not meet his standards. Now his work was licensed to a person Frank barely knew. Christophe Lunn, Harry's son, tells the story of his dad publishing one of *The Americans'* most famous images, *U.S. 91, Leaving Blackfoot, Idaho*, in Christophe's high school yearbook. He used Frank's image of two hitchhikers in a car to illustrate the concept of leaving home. It's safe to say Frank would not have been pleased.[10]

Many were glad to have met Lunn. William Eggleston is grateful. Louis Faurer had long put aside his own work to make a living as a fashion photographer until Lunn bought his work. "Harry Lunn's purchase opened up the world of galleries to me," Faurer wrote in 1981. It was by working with Lunn that Faurer was able to do his own photography once again and be introduced to an audience that made his life easier. "Once again I found myself attracted to drawing and, as if by magic, the photographer became an artist!"[11]

A photo market had barely existed before Lunn and a small circle of influential collectors, curators, and dealers, including Howard Gilman, Pierre Apraxine, George Rinhart, and Sam Wagstaff, came along. Frank was unhappy with what prints were selling for in the early 1970s—prices hadn't advanced much beyond what Helen Gee was selling them for in her Limelight Gallery in the 1950s. Lunn helped rectify that, but it was a shock for Frank to suddenly be part of the marketplace and not in control. Lunn's salesman-like patter would have surely offended Frank, had he much listened to it. "I have the Robert Frank archive and make the market in his prints," Lunn told the *Art/Antiques Investment Report* in 1983. "His prices range anywhere from $1,200 to $4,000. Everyone wants the trolley car or the tuba.

"It's a bit frustrating because Robert Frank's personality was obsessed with not creating a 'Moonrise' syndrome for his own work," said Lunn. "And so when he created the archive of 2,500 prints, which constitutes the body of his work available up to the period of the mid-1960s when he turned to film, he refused to make more

than 30 prints of any one image. Consequently 30 tuba players don't go very far, and that's how you get a situation where one will soar at auction to $6,500 which, in a way, is a ridiculous price, given past market history. But there it was; it happened last spring." There it was: Lunn was selling tubas and trolleys, taking them out of *The Americans'* context and marketing them as works on their own.[12]

The impact of these efforts included more prominence for Frank and an understanding of his work that was other than the one he intended. He balked. In a letter to Katz and Penn written in 1985 Frank mockingly notes that when he had given them a photo some time back, he had neglected to inscribe it for them. Here he belatedly offered his inscription: *you are greedy and soulless and immoral.* There was a PS too, all in capital letters, quoting that line in the Bible in which Jesus asks, "For what shall it profit a man if he shall gain the whole world and lose his own soul?"[13]

The experience, Katz said, left him feeling regretful. "I went to Mabou in the middle of winter. I'm an ex-yeshiva boy from New York City, and I think he thought I was a certain type of person. He was comfortable with me, and I was able to make him comfortable to make this deal. But I was always conflicted—he's a very sweet guy, but at the same time there's an anger running through him. There were lots of forces pulling him in different directions. He probably shouldn't have done a deal with anybody and would have been unhappy with anybody, probably. Look, at the time we did this deal nobody knew that pictures would go for hundreds of thousands of dollars in a few years."[14]

In 1979 Frank released *Life Dances On,* which he has called his most personal film and is dedicated to Andrea Frank and Danny Seymour. It also very much involves Frank's relationship with Pablo. *Life Dances On* is a challenging work—scriptless and improvisational yet perceptively focusing on facts of his life and relationships with loved ones, even to some degree consciously revealing the nature of these relationships. "It was always me who forced these people to talk, who made them talk about themselves or expose themselves in a way, I didn't hide that interference and that

brutality that pushes a filmmaker to get something out of people," he has said.[15]

A narrative threading through the film shows Frank trying to communicate with Pablo, who is sinking into something like a psychotic state. Pablo offers a stream of odd observations and non sequiturs, which together seem to have a specific intention: to express his rejection of the father's control. Robert asks Pablo questions: "Why can't you . . . ?" "Why won't you . . . ?"

"Why do you have to carry the whole world on your shoulders?" he pleads. His son answers, "Because I don't like earth's gravity. I want to see what the gravity's like on other planets. I want to investigate Mars." His behavior was becoming more worrisome, and Pablo did not get along with those who tried to help him. "He made a very difficult life for himself," Frank later said to a British documentary maker. "I did try to help and wherever he lived I went there, and it fell apart little by little. There were the hospitals and psychiatrists and the institutions."[16]

Marty Greenbaum had known Frank since the early 1960s and had a central role in *Life Dances On*. He noticed a decline. "Pablo came over to my place a few times; Robert was trying to do things with him and knew I loved sports, and so I was trying to get him to play softball," Greenbaum said. "But Pablo couldn't sustain it. Pablo was real . . . exhausting. He was difficult to communicate with. And Robert was trying to get involved with his life by playing games, but Pablo was living in his own little world."[17]

Around the time *Life Dances On* came out, Frank visited Rudy Wurlitzer in Playa Del Rey, California. Wurlitzer had been reading about renegade scientist Robert Golka, who drew on the studies of the inventor and engineer Nikola Tesla to form luminous balls of plasma (man-made lightning), which Golka rolled across the desert floor. They piled into a car and drove out to Golka's laboratory in an abandoned Army Air Corps hangar in Utah and made a chaotic short film, *Energy and How to Get It*. *Energy* featured William Burroughs, Robert Downey, and Dr. John. It's a shaggy-dog celebration of the eccentric visionary impulse.

Golka remains a shaggy dog himself today: he complains that the film made him look like a violent mad scientist, though it's not clear which part of the equation bothers him. After repeated conversations, Frank and Wurlitzer paid him to not contribute to the script, he says. He notes that *Energy* was made with a grant from the Corporation for Public Broadcasting, and then Golka declares that he doesn't approve of television: "When they took the *Three Stooges* off, that's when I quit TV," he rants. "It's bad enough you have got to pay to watch commercials." Asked what it was like to act with William Burroughs, Golka answers, "I hate to say this, but this country, we're headed for disaster. Can't say if it's this year, next year, five years from now, but it's coming. I think the reason the Chinese haven't put the squeeze on us yet is . . ." and then he got quiet. When he started talking again, it was on an unrelated topic.[18]

His mind runs hot, but for Frank and Wurlitzer, Golka has nothing but love. "I got good feelings about those guys, even though they were on the racy side."

AFTER DANNY SEYMOUR disappeared, Frank found it impossible to live in the building on Bowery that he had shared with his friend. That coincided with his and Leaf's move to Nova Scotia. But by 1980 the couple was interested in establishing a New York presence once more. They moved a few blocks away, into a building on Bleecker Street just off of Bowery. The building was a former mannequin factory, and mannequins filled a hallway and looked out of the first-floor window. Frank and Leaf lived on the third floor, and a woman named Nancy Drew moved into the second floor.

After Nancy Drew moved out, Frank was interested in buying her old loft. The only problem was the owner wasn't interested in selling to him. So whenever the space was going to be shown off to interested buyers, Frank would get there first and pee in the doorway in hopes of discouraging buyers. "He was the original punk," said his friend and neighbor Sarah Driver.[19]

Frank remained busy in the first half of the 1980s, informally recording a Beat reunion in Naropa, Colorado (1982's *This Song for Jack*) and the loopy *Energy*. In 1985 he released *Home Improvements*, an achingly personal video that was shot with a half-inch JVC video portapak camcorder, an instrument that had only come onto the market in 1983. Leaf bought one for Frank. The video camera gave him an ease of movement he took to for a period, and the technology shapes the almost invasive intimacy of *Home Improvements*.

The video touches on the death of his parents, then shows Leaf struggling through a cancer operation. Frank points the camera at a mirror and begins speaking, maybe more to himself than the viewer: "—Wait—Win—Lose—Survive—OK—Listen Again." He's telling what he is, what he must be. "Now I'm on my own. My father has gone somewhere else. My mother has gone somewhere else. So you become your own man, you're trying to make peace, you're trying to grow old gracefully, and you're trying to keep on working. It's not complicated. You go on spinning these basic ideas that you've always had, and you keep trying to express it in photographs, films, tapes, whatever."

He takes the video camera with him when he visits his son at the Bronx Psychiatric Treatment Center, aggressively pushing questions at Pablo as if fishing for a reaction for the camera, but without getting much back. Around this time, in a workshop with students in Rochester in 1988 after *Home Improvements* had been shown, a professor described Frank's harsh manner with his son as upsetting to viewers. Frank turned the comment aside, asking who should feel more upset than the father? A student responded, "The son?" There was then an awkward pause. Frank revisited the question hanging in the air. "So, well, you know, it's a legitimate question that I'm asked, but that's the way it is. That's the soup I cook." With a humor meant to lighten the mood, he added, "I have no message, no moral, and no conscience."[20]

The scenes of Robert and Pablo may not even be the most disturbing part of *Home Improvements*. In another passage Frank watches his friend and electrician, Gunther Moses, drilling holes in

a stack of Frank's photographs. Moses checks his progress by pull-
ing images out of the pile, showing to the camera some of Frank's
most famous work from *The Americans* chewed through with a drill
bit. "Then you start again, huh?" Frank tells him. Later the camera
follows Frank putting the work into a garbage bag. "It's a big mo-
ment," he says in a strangely comic line.

The scene is painful to watch, as Frank no doubt intended. "I re-
ally felt pretty bad," Moses later told an interviewer. "At the same
time, I like to destroy things too. So I took an electric drill and I
drilled holes in the pictures."[21]

It happens matter-of-factly on video and is meant as a gesture
of rage at art turned into commodity. Frank drives down the road
and leaves the trash at a drop-off spot, but he might as well have
mailed it directly to Harry Lunn. It was a petulant, abrasive ges-
ture—with he and his dealer at odds over the distribution of his
work in the world, Frank suggests that power tools would settle
the point.

Allen Ginsberg once introduced Frank to the photographer Ber-
enice Abbott—the single time the two ever met. In the middle of
their conversation Lunn entered the room. According to Ginsberg,
Frank stopped talking and walked out, never seeing her again.[22]

Death to the killer image. Ginsberg studied the words Frank
scratched into the surface of his pictures, the intentional ugliness
he imparted, and viewed it as an act of self-vandalizing. Liberation
through cutting and scraping. "The first time I saw him scratching
words on the negative, I was horrified! He was wrecking the nega-
tive, he was making it irrevocable, why didn't he just do it on the
print?" Ginsberg wondered. "But in some way he was desecrating
the artistic preciousness" of the work. "I thought . . . it was a way
of rejecting the commodity uniqueness of the negative that could
be exploited commercially by not even neat writing but scratchy-
scratchy stuff."[23]

In August of 1984, in a small Canadian magazine, Frank pub-
lished a statement alongside a selection of Polaroids. He likened
himself to a sixty-year-old boxer with tears in his eyes, taking
shouts from the crowd, bad advice from his fat manager, all while

sweating like he never had in his life. "Today I Look in the Mir-
ror," he titled the statement, and for Frank the mirror was a place
of judgment. He ended with a question: "You step in the ring I
look in the mirror am I too old to be a rebel?"[24]

GOOD AT SLOUGHING OFF old friendships, Frank had never bro-
ken with Allen Ginsberg, and in the early 1980s the poet reentered
his life. Frank had had an operation, and Ginsberg invited him to
recuperate in Boulder at a reunion of the Beats. Ginsberg, who was
interested in learning photography, took the opportunity to ask for
lessons. Frank critiqued Ginsberg's work, discussed cropping with
him, and made suggestions—move in closer to your subject, try
to get the person's hands in the frame. Frank took him to a cam-
era store and helped him buy a 35mm camera. They discussed
Frank's interest in writing on photographs, and Frank encouraged
Ginsberg to find ideas in the work of Duane Michals and in photo
books like Jim Goldberg's *Rich and Poor* and Elsa Dorfman's *Elsa's
Housebook: A Woman's Photojournal.* Ginsberg's photo work would
incorporate long caption-like passages.[25] Photography refired
their friendship, and Frank photographed portraits for several of
Ginsberg's books and records. And when the writer came over to
Frank's Bleecker Street home, bent on reading his latest work out
loud, it was Leaf who would finally throw up her arms and shout
out with the glee of a dear friend, "We don't want to *hear* your
poem, Allen! No poem!"

Ginsberg and Frank went to Tel Aviv, where Frank taught a
photographic workshop. In 1984 the two, along with jazz drum-
mer Elvin Jones, taught a three-week workshop in Florida. Later
the poet would consider what brought them together. "We had
our Jewishness in common . . . not in the religious sense . . . but
the European intellectual *delicatesses,*" he said. "We were rootless
cosmopolitans together."[26]

Ginsberg was teaching a poetry class in 1984, perhaps at the Na-
ropa Institute in Boulder. Frank was sitting in. In honor of Frank's
visit, Ginsberg read Kerouac's account of his 1958 Florida road trip

with Frank. He bore down on one of Kerouac's lines. "Night, and Florida, the lonely road night of snow white road signs at a wilderness crossing showing for endless unreadable nowhere directions, and the oncoming ghost cars." Kerouac and Frank came upon clay pelicans in front of a row of gift shops. To describe this image in words struck Kerouac as "a simple enough deal but not when photographed at night against the oncoming atom-ball headlights of a northbound car." Ginsberg repeats the phrase—*the oncoming atom-ball headlights of a northbound car*—and he will invoke it numerous times more in the next half-hour. He incants the words and interjects terse riddles that bounce around the room like pinballs. He all but wills the image into vision: the headlights coming toward us holding a horrific sight; an eye reflecting a mushroom cloud; a projector showing a movie of the end of the world.[27]

"He noticed what he thought," Ginsberg declares, then "he noticed what he noticed," rubbing his own words for meaning, showing how Kerouac's exquisite instincts seized on details that other observers would have missed. This was *not* reporting. "This is making a photograph of your own mind," Ginsberg exhorts. He's *excited.* "The question, writing poetry, is what do you notice?" Frank jumps in with another question: "Is noticing connected to thinking?" Ginsberg doesn't meet him head on. "The oncoming atom-ball headlights of a northbound car," he repeats. "Let's dig that."

Two guys, prying open young eyes. Frank shares memories of that trip and then opens up about his own work, explaining the difference between recording images and recording feeling, saying how "in my later work I put in words, I sort of destroy the picture, in order to show more of myself but at the same time still show what I am looking at, what I'm faced with." Just a couple of old friends shooting it. Let's dig that.

RUDY WURLITZER HAD his own complicated relationship with the road. Genetically linked to the Wurlitzer organ and jukebox dynasty, he was born in Cincinnati, the family seat, and raised

in New York. He was nineteen when *On the Road* was published, the perfect age, and Wurlitzer clearly felt Kerouac's long shadow over his own work: *Two Lane Black Top* was a Zen arrow shot at the whole genre, the latest last attempt to finish off the American trip. In the early 1960s Wurlitzer traveled to Paris, where he engaged in some existential fanboy stalking. He read Beckett; he worshipped Beckett. He knew the café Beckett liked and the time of day when he would be there. The café became a haunt for the young writer, and he would watch a primal routine. After Beckett was seated, sculptor Alberto Giacometti would come around, nodding at his friend and sitting down. Drinking in proximity—all without saying a single syllable to each other. Two men, no words.

"And then they'd get up, shake hands, and go on their way. I was so impressed by that. What an amazing communication they must have," Wurlitzer told a writer for *Vice*.[28] It all but made the young man shake.

Perhaps there was something in Wurlitzer's friendship with Frank that mined this decades-old memory, because Frank could be a man of few words, with a way of solemnly policing the space around him. They got along well, and there was talk of projects ahead. If not Beckett and Giacometti, perhaps the two were at least an ironic Waylon and Willie, high on myth and the right spare word, with masculine silence falling like a cold Carolina rain.

After *Keep Busy* Wurlitzer was looking for a new project with Frank, and the one he had in mind connected to some of his earlier themes. You get a little older, and you learn to distance yourself from the romantic clichés that used to excite you. But you could still say something with the structure of the highway journey, and something about that journey still defined the country. And so Wurlitzer kicked around another road narrative with his Nova Scotia neighbor. Frank, meanwhile, had been weighing a story about moving from the big city to the edge of society. It would be "a short simple film," he explained. "But then it developed."[29] Wurlitzer picked up the thought and wrote something. A Swiss producer of independent films, Ruth Waldburger, had asked Wurlitzer what he was up to, and he said, actually, he was working

on something right then with a Swiss guy. As it was coming to-gether the Mabou outlaws met with Waldburger in Zurich.

Now a joint French, Swiss, and Canadian production, the project kept growing, and when it was set, it featured Frank and Wurlitzer as both the writers and directors. They planned a $1.3 million budget, a multinational crew, and a cast of professional actors and musicians. The performer Tom Waits wanted a role. The movie, called *Candy Mountain*, followed a hungry young road tripper from Manhattan to Cape Breton in order to meet a famous and reclu-sive guitar maker.

The budget meant that the feature-length *Candy Mountain* would look more cooked and less accidental than Frank's movies ever had before. Wurlitzer and Frank worked hard to find an actor who could carry the weight of their seeker. Kevin O'Connor was twenty-two and had just come off working with Francis Ford Coppola on *Peggy Sue Got Married.* "My agent was pushing [*Candy Mountain*] at the time. She showed me *The Americans*, and she said, 'You won't make any money, but this project should be very interesting. Rob-ert is a great photographer.'" O'Connor met with the two and had what he called "the most relaxed, strangest audition" he'd ever been on, so low key he wasn't sure if it *was* an audition. He and Frank got along instantly.[30]

"It was a lot of hanging out—maybe Robert had something up his sleeve, I didn't know. Maybe he wanted me to get more com-fortable, to get into that vibe of 'this is how I do things . . .' And I loved it. I learned who he was, to be honest, by people stopping over at the Bleecker Street address. I would see people waiting outside, young photographers, young artists, and they couldn't *wait* to have a second of Robert's time. I realized how fortunate I was to be sitting there drinking coffee for five-hour stretches. Then I met some of the Beat guys—Ginsberg, Herbert Huncke, Gregory Corso, the musicians, Jim Jarmusch. The people that would stop over and talk about Robert and who idolized him." O'Connor soon went to the library and looked up Frank's work, and that's when he became intimidated.

"Going up to Nova Scotia, it was really about Robert wanting me to be involved in the project in ways beyond being an actor," said O'Connor. He began to realize that this was the biggest project Frank had worked on. "It was as close to being an actual movie as he had ever made.

"It makes me laugh to this day, thinking about how frustrated he would get on the set because the movie was so big and everything was getting so out of control. But the budget was less than most movies, and to think of this as some titanic spectacle! But it *was*, compared to the projects he had done before."

Candy Mountain starts with young musician Julius Book (O'Connor), who has been promised a payday if he can track down a famous guitar maker, Elmore Silk (Harris Yulin). Various people want to find Silk because the market value of his work has shot up to $20,000 a guitar. So Book hits the road from New York City up to Silk's home in off-the-grid Canada. He meets a lot of interesting and duplicitous characters, and it takes most of the movie to find the craftsman. When he does, Book's big encounter ends up being both revealing and anticlimactic, and the young man goes on his way—wiser but still the same.

Silk is a clear stand-in for Frank. His last line in the movie, "Freedom don't have much to do with the road, one way or another," seems meant by Frank and Wurlitzer as a stake in the heart of their genre. Along with crafting a road myth, every generation feels driven to craft a myth of the death of the road epic. *Candy Mountain* was a good one.

One way producers envisioned recouping their investment was by filling the soundtrack with original music and releasing an album featuring people in the film, including Waits, the great Canadian singer-songwriter Mary Margaret O'Hara, David Johansen, Leon Redbone, Joe Strummer and Dr. John, New York improv scene players like Marc Ribot, Arto Lindsay, Ralph Carney, and Joey Baron as well as the Cape Breton singer Rita MacNeil.

It was not a smooth shoot. There were performers with drug habits jonesing because it was hard to score heroin on an island

off Nova Scotia. There were musicians who wanted nothing to do with other musicians. Various producers butted heads. And all around them was a rising tension between the two directors. "It was the weirdest shit ever," said the musician Mark Bingham, who wrote songs and performed in the film.

"As far as I remember, they [Frank and Wurlitzer] weren't speaking. The producers brought their lovers along that they assumed their husbands and wives didn't know about. The whole thing was just like international high school bullshit. Robert wanted to have nothing to do with any of them and just started hanging out with the musicians. We called him Bobby Hot Dog."[31]

Upon release *Candy Mountain* received good reviews, and even those who had followed and supported Frank's more bracing stuff were receptive to what was his most commercial effort. But the film came and went quickly, and Frank's unhappiness with it is clear. Today it is almost as hard to view as *Cocksucker Blues.*

There was an opportunity with *Candy Mountain,* a chance to introduce his sensibility to a receptive film audience at a time when indie films were gaining cache. (He had inspired Jim Jarmusch, and Jarmusch was set to release his own road movie, *Mystery Train,* in 1989). As usual, it is hard to say what this work meant to Frank or why he judged it a failure. Even in press interviews to publicize *Candy Mountain* Frank underscored the difficulty of working with a codirector. Film may often be a collaborative art, and it certainly is on the scale the producers envisioned, but Frank by nature is hardly a collaborative soul, and working with Wurlitzer may have been especially complicated. *Candy Mountain* killed their friendship. Collaborating was "like making a baby," Frank told a film writer. "Two people making a baby. You can imagine," he snorted. "You know, the film is made and it's lying there, and you say, 'hey, it's got red hair, or it's fat, or whatever.' But you're happy it's there. It's alive, it talks, you know, it's got color, so co-directing was a little bit like, you know, you make the baby together. And that doesn't really work that well."[32]

"Ultimately, the only way we could direct together was for me to let Robert do it his way. So I fell back and just tried to sur-

vive," Wurlitzer has said. "Our relationship suffered and, sadly, was never the same."[33]

In the film Silk has entered into a business arrangement with a shadowy Japanese dealer who pays him well but also insists that he never make another guitar—she's driving up the price, à la Harry Lunn. Ultimately Silk destroys his work rather than meet the investors' demands. It is not the road that makes you free.

Destroying art was much on his mind. That and giving it away. At a torturous 1983 photography workshop in Israel Frank silently jingled coins in his pocket when he didn't like the questions he was asked. He finished his lesson by dropping folded pieces of paper in a box, then drawing three out—he was raffling off three signed photographs to lucky students. "I thought I wanted to get rid of some of the photographs and when I stood there I thought, this was how I was going to do it," Frank explained.[34]

He continued destroying prints of his work even after the drill scene in *Home Improvements*. (Besides a protest, this destruction was required by his agreement with Lunn.) Jim Jarmusch recalls stopping by the home on Bleecker Street and finding Frank and Gunther Moses drilling holes into a stack of prints in the basement. Perhaps these were the mangled photographs that Frank bound with wire and nailed to a slab of plywood; on top of them he placed a photograph of a wounded bull, a matador's sword penetrating his back. This untitled assemblage, dated 1989, would eventually itself be put on exhibit: a monument to his own defiance—and a composting of the past, all but necessary to make something new.

The bull outlived the matador. Frank's business arrangement with Lunn, Penn, and Katz was negated in the early 1980s, and he regained control of his copyright and ownership of his work. The bitterness he felt had egged him on to make new work; he wanted to push away the past with what defined him now. With Peter MacGill now as his dealer, Frank had an important, supportive gallery to show his work as he intended.[35]

In 1980s Manhattan, photography was largely defining the post-modernism that dominated art world discourse and pushed painting and sculpture to the curb. Photographers like Cindy Sherman

and Richard Prince made work that was conceptual, sometimes political, that transcended older arguments about the photograph as document. This was not Frank's work. His photographs and collages were viewed with interest but were of their own moment—not the art world's. In an introduction to a portable collection of his photographs that Robert Delpire published in 1984, Frank wrote a statement that modestly and movingly declared his current aims.

"In the slow times left to me between films or film projects I photograph. In black or white or color. Sometimes I put several images together to make one picture. I express my hopes, my lack of hope, my joys. When I can I add a bit of humor. I destroy what is descriptive in the photos to show how I am. When the negatives aren't quite fixed I scratch in words: soup, strength, blind faith. I try to be honest. Sometimes it is too sad. Now it's Monday in the world. The beginning of the afternoon. June is building a forge. You must always keep an iron in the fire, my brother."[36]

CHAPTER SIXTEEN
DETECTIVE WORK

HARRY LUNN HAD given Frank a gift. He had made him *mad*, and that anger glowed long after their deal was dead and the spy disappeared in his rearview mirror. As always, resentment gave him energy. When Lunn had a claim on Frank's past work, Frank was inclined to sever his connection with his past and make new work. There's a scene in *Home Improvements* where he composes a letter to John Szarkowski, offering to give the Museum of Modern Art his archive. Then comes Gunther with his power drill—a much quicker way to lighten his load.

In 1990 Frank did find an institutional home for his archive, giving a large volume of his past to the National Gallery of Art in Washington, DC, including exhibition prints, more than one thousand work prints, all pre-1970 negatives and contact sheets, and one of only four copies of *Black White and Things*. "We were just sitting around one day, talking of my photographs," was the way Frank explained his actions in the *Washington Post*. "I was tired of looking at them. I didn't take very good care of them, and I was tired of thinking about the past all the time."[1]

If the goal was to make it easier to work in the present, he would seem to have succeeded. For the next few years Frank was unusually active. Birmingham, Alabama, was marking an anniversary, and people with money commissioned famous photographers—Gordon Parks, Duane Michals, Bruce Davidson, William Christenberry, Philip Trager, and Frank—to photograph the city. "It paid. It was also a matter of ambitiousness on my part," Frank told William Johnson.[2] He checked into a nice hotel, set out to find stuff to shoot, and promptly fell into a funk as he sensed he

was repeating himself. Doing the Robert Frank. So he pulled up stakes and checked into a dodgy hotel near the bus station. Better, maybe, as he found some soldiers around the depot to photograph. Still, "it seemed to me it was quite ridiculous what I was doing." So he moved out again and found "the worst hotel I could find in Birmingham. I mean, it was pretty grim." And he started shooting signs and slogans announcing the Christmas season. "Out of desperation" he hit the streets, finding a prostitute and paying her to be photographed. "I did it simply because I felt, 'What am I doing here in Birmingham? What do I do here?'" Frank brought her to the hotel room and shot her in front of the TV, with a pitiful little Christmas tree, and if the image wasn't among his very best, at least it had given him a sense of purpose, a feeling that he was doing something that felt like life. And ultimately Frank *did* come up with "kind of a story, I sort of liked the pictures at the end." Even better, perhaps, nothing he made could be mistaken for an advertisement for Birmingham.[3]

In 1990 he made *C'est Vrai!/One Hour.* The work was a part of a series funded by French TV in which filmmakers used a video camera to make an hour-long video in a single take. Kevin O'Connor and Frank jump into a van and rumble around the Bowery from 3:45 to 4:45 on Thursday, July 26. There are encounters, some staged and some accidental, the viewer never knowing which are which, and at one point a deranged Peter Orlovsky jumps into the car for a crazy ride.

"Robert would point at someone and say, 'Why don't you talk to her?'" said O'Connor. "There were plants, I believe, but then there were other people that Robert would point to and say, 'Why don't you have some sort of interaction?' And anything might happen."[4]

In the fall of 1991 Frank was invited to Beirut, Lebanon, to take part in an international photographic project. Along with Gabriele Basilico (Italy), Josef Koudelka (Czechoslovakia), René Burri (Switzerland), Raymond Depardon (France), and Fouad Elkoury (Lebanon), Frank went to the center of Beirut and photographed a district about to disappear.

"I had written, [a] few weeks before, a letter to Robert Frank, asking him if he would be willing to come," said Dominique Eddé, a French novelist and editor who organized the project. "Friends thought I was crazy. The woman in charge of photography at the Ministry of Culture in Paris told me 'you are dreaming' and my friend Robert Delpire told me more or less the same: *impossible.* A letter arrived [a] few days later. It was written by Robert. 'If it is feasible I'll come.' He didn't even ask a question about money.

"He came. I picked him up at the airport of Beirut." Frank worked in Lebanon's historic city center where fifteen years of the grueling civil war had ended just months before. Portions of the city were still mined, and empty cartridges were scattered everywhere. The quarter would be flattened and rebuilt in the next few years. For security he was assigned a special driver who got around in a large Lincoln and carried a revolver on his side. Frank would tell him to pull over to the curb when he wanted to pop the trunk and develop his Polaroids in the plastic containers he brought with him. "The driver had been told that Frank was one of the most famous photographers of all time and here he was acting like a poor handyman," said Eddé in a lengthy email.

"With him, the conversation was always dense, close to the essence and to the absurdity of all things. He was curious, available, aware of the fact that he wouldn't catch, in a week or two, the very complicated past of such a long war. He concentrated on the present. With him, there were no useless words."[5]

A number of his Beirut images appeared in the 1992 book *Beirut City Centre*, documenting the project.[6] They are head-on photographs of architecture impaled by iron bars, folding into brick piles. Frank also returned with a notebook full of Polaroids crudely affixed with Scotch tape, duct tape, surgical tape to the book's gridded pages. They are pictures of bullet-riddled buildings cut up and repasted together in lunar panoramas, crime scenes where history was committed.

A few years later the publisher Gerhard Steidl saw the notebook and told Frank he wanted to put it out exactly like that: something immediate composed on the stripped streets of Beirut. Steidl

couldn't have been more honest or exacting in his presentation, for his ink and shellac lifts off the page, fooling the eye to thinking these really are Polaroids jammed into a sketchbook, the grit and texture of the original page amazingly recreated through a wealth of print technology.[7]

As Frank got older he was more willing to express his personal feelings about the Middle East and, most of all, Israel. After terrorists hijacked the cruise ship the *Achille Lauro,* murdering a Jewish passenger identified by his name and throwing him into the ocean, Frank was photographed wearing a T-shirt he'd made for the occasion: "Jewish sounding name," it read. In the late 1990s stories in the world press about Switzerland's complicity in protecting German gold during World War II filled Frank with resentment over the country's complicity with Nazis.

"In terms of politics, Robert reacts emotionally," says Eddé.

"Once, in New York, around 1999 or 2000, I had a very disturbing experience. I was with June and Robert in a restaurant, close to their place, on Bleecker Street. Frank knew that I had worked in Palestinian camps when I was young and that I was very close to the American Palestinian professor, Edward Said. He told me all of a sudden 'Whoever is not a Jew is an antisemite.' I thought that he was joking. He wasn't. I got angry. June gave me her support. Robert didn't change his mind on the spot. The cold between us slowly disappeared but I can hardly forget that eerie moment.

"What I am sure of is that he was not proud of his parents' behaviour during the second world war. And probably felt the need to be more 'zionist' than ever while aging. A way of repairing the past = his 'late style.' Robert is not political, he is much too sensitive, solitary, provocative, authentic, unfair and fair in the same time, to fit into a compartment."[8]

Frank would again look to his own story for subject matter in an unusually direct way in 1991. *Last Supper* was a fifty-two-minute film as linear as *Candy Mountain,* yet it was casual and unforced. It is a quirky story about a famous writer who has scheduled a book party in an unlikely—and somehow very Robert Frank—space, a trash-strewn lot in Harlem. The great author is a no-show, which

just underscores his gravity—remind you of anybody? The movie feels like a small breakthrough, a moment when the artist took on his biography and legend not as dead weight but as something to talk back to, to make fun of. "The guy that produces this book [in the film], this artist or whatever," Frank explained, "they wait for him, they think it's worthwhile shaking his hand and telling him how great the book is. But I don't quite believe in people who rush to congratulate me."[9] While waiting for the guest of honor, the invited guests dish, his wife kvetches about his ego and frequent absences. The son voices recriminations of a father whose presence sucked the air out of the house and protests being used for his father's art. *Last Supper*'s gritty whimsy reaches all the way back to *Pull My Daisy* (and features two inspired deadpans, Taylor Mead and Bill Rice).

This was the alternative to *Candy Mountain*—a small-scale effort and Frank surrounding himself with friends old and new, making something in his New York City. "The mood was just really special," said Mike McGonigal, a friend of Frank's who had a small part in the film. "You just got an immediate sense this was a celebration—it was him giving back to his community of artists and friends. And the film itself is a party. A boring, weird one where you're waiting for someone, but that's what it is."[10]

Soon after *Last Supper* was completed, Frank had a heart attack. It brought out the buzzard—he turned down a recommended bypass on the grounds that it wasn't necessary and the doctors were overcharging. "I think one of the most difficult things is to grow old gracefully, because you simply cannot keep up with younger people physically. That puts a distance between them and you," Frank told Liz Jobey. "You have to be somehow noble about it, have some largesse, some understanding. It's very difficult for me personally to do it right, because it doesn't come easy."[11]

In *Last Supper* actors and nonactors alike are cast in roles. You see Harlem citizens walking among the performers or stopping suddenly when they see that a camera is filming. Frank is a master at massaging diverse levels of truth into his work, making you notice the disparities without bringing everything to a halt. He's

raised that good old question, *What is Truth?* many times, and by the time he made *Last Supper* he could summon it with a nod of the head. It was playful, but he was never more serious about anything. He finds dishonesty in clichés and received thinking, in conventional storytelling and in acting. And then he questions whether what you are left with after carting all those other things off is any more honest: Was it ever possible to tell? He was driven to search for something he thought might not exist. There was a word for this kind of job he had made for himself, a word with some old Hebrew roots: *shamus.* Or, as Patti Smith writes in *M Train*: "Yesterday's poets are today's detectives. They spend a life sniffing out the hundredth line, wrapping up a case and limping exhausted into the sunset."[12]

Making *The Americans,* he would say, set him on a hunt for what he would find inside more than what he saw outside. His film and video work took this further, turning toward a full-on examination of what "the truth" means. For him it has always been about the personal, the autobiographical, and he has woven into the stories he tells an abundant amount of fiction to throw people off the trail, fiction that is also sometimes meant to be more honest than truth. It is what distinguishes him as an artist.

At the end of *Home Improvements* he films himself in the mirror. "I'm always doing the same images," he says. "I'm always looking outside, trying to look inside. Trying to tell something that's true. But maybe nothing is really true—except what's out there, and what's out there is always different." It's heartfelt and withholding and a good statement of much to be found in his later work, which interjects into the harsh Mabou winter and into the Bowery dust, qualities like loneliness, a New Yorker's candor, self-pity. It's far harder than it looks, and it doesn't look easy.

HE WOULD SCOOP up hotel stationery from wherever he was staying and use it somewhere else later. In March 1994, on old stationery from the Hotel Rothus in Zurich, he wrote a letter to Allen Ginsberg.

The letter, which Frank has forbidden to be quoted, describes an erotic dream in which he is searching for Ginsberg. Frank has keys he wishes to present. He is in a bedroom, and in a bed there is a woman and a man, with room between them. The man is not Ginsberg's partner, Peter Orlovsky. Ginsberg arrives, removing his clothes, and begins coupling with the woman, and after reaching orgasm, Frank hands him the keys. Orlovsky remains outside.[13]

Later that year Frank was surrounded by friends at the National Gallery in Washington, DC, which was presenting "Moving Out," an imaginative overview of Frank's career laced with rarely seen photographs. The exhibition was weighted heavily with work done since the 1970s, and it argued that his whole career wasn't to be found in *The Americans* but that the ideas and themes of *The Americans* could be found outside it too in his work from Zurich, New York, South America, and Europe, and in his recent return to still photography.

Ginsberg was at the opening, as was Peter MacGill and a sizeable contingent from Zurich. A lot was going on. "It was difficult to get in," remembers Guido Magnaguagno, who came from Zurich for the event. Pablo Frank had come from a personal care facility for young people with mental illness in Pennsylvania and brought a group of friends from the clinic. A cluster of Frank's friends were hanging out with the artist, who was sans tie, wearing a green shirt and messy trousers and had fraught hair. "But he had the European look to him with the clothes that he did wear," recalled Marty Greenbaum. "I don't think he wore socks."

Many in Frank's party were smoking, and when the time came, someone nudged him to be at the front of the line. At the door, however, museum guards barred Frank. "I said, 'People, this is the *artist*,'" remembers Magnaguagno. "They said, 'That can't be.'" Magnaguagno sought out exhibition curator Sarah Greenough, and eventually a small group was let in early so Frank could meet with the Swiss ambassador and other dignitaries.[14] (Greenough said that Frank's party arrived before the doors were supposed to open and that Frank's appearance was no issue.[15])

Magnaguagno says that while he waited outside the exhibition with Pablo and his friends, he was struck by the son's frailty. "Pablo, he was very shy. Really kind of sick. He looked small and twenty years older than he was."

A few months before the opening an old friend who had gone to grade school with Pablo ran into Robert at a restaurant on Bleecker Street. "I saw him sitting there; I hadn't seen him for years," recalled Paul Handelman. "I went over to say hello. I didn't introduce myself at first because Robert wouldn't have remembered me. But I wanted to acknowledge how, as a kid, I didn't know what he was about—I was just a kid. I said, 'I just want to say thank you for your incredible body of work, and I just love your work—I am a big fan.' And he said, 'Good—keep the light going.' But then I looked to see who he was sitting with. It was a large man opposite him.

"It was Pablo. I didn't recognize him at first. He was missing teeth and had a long beard. He was pretty conversant, 'Yeah, I've been okay, you know.' We didn't get into any details. I didn't have much to say to him."[16]

Handelman hadn't heard about the suicide attempts, about Pablo eating glass—that he learned about later. He hadn't heard anything about his former schoolmate in a while. Pablo made astonishing collages crammed with images and words that documented both his creativity and his tumultuous mental state. Marty Greenbaum said, "He was doing crazy things. And it was profoundly sad." Pablo killed himself on November 12, in Allentown, Pennsylvania, not long after the National Gallery reception. He was forty-three.[17]

After his death Frank kept working. "Work kept him alive," said Greenbaum. "Work and chopping wood. You could see it in his body—he got stronger from all that working in Canada." For a 2005 British television documentary director Gerry Fox got unusual access to Frank, and the artist spoke more than he ever had in public about Pablo's long struggle with mental illness. "He manifested this strange behavior, and he couldn't really get along with people who helped him, and I saw he made a very difficult life for himself," Frank says in *Leaving Home, Coming Home: A Portrait*

of Robert Frank. "I did try to help and wherever he lived I went there, and it fell apart little by little. There were the hospitals and psychiatrists and the institutions.

"It was a hard road to be on, it got increasingly harder all the time, more desperate and more lonely for him and beyond help, in a way."

As he says this before the camera Frank is standing on a New York street with traffic driving by. At one point he puts his head down on a parking meter, almost as if he were weeping. He says, "A person like that depends on love from his parents, which he didn't get enough of. And the worse his situation got with his mind, the more he needed them and the more difficult it was to give it to him. So this was an extremely difficult period in my life. And June was very helpful. So that's how it ended."

After the documentary was screened at the Tribeca Film Festival in 2006 Frank had second thoughts about having cooperated with Fox, possibly because of the candid discussion of his children. Pressure was put on the director to withdraw the film, and in the end Frank worked out an agreement that echoed the one the Rolling Stones had demanded: Fox could only show the film three times a year. It is rarely seen today.[18]

WHEN *MOVING OUT* TRAVELED to Zurich it ushered in a new prominence for Frank in the country of his birth. The retrospective helped establish him, Magnaguagno said, as a Swiss national treasure. In a place where *The Americans* resonated quite differently from how it did in America, Frank's later work got a less-freighted evaluation, one that the artist appreciated. The homecoming may have signaled the beginning of a reconnection with the country.

Even today, Magnaguagno said, people in Switzerland talk about the exhibition's opening at the Kunsthaus Zurich. Frank wasn't there—not even for the press conference with the artist. He was spotted outside the museum, talking to a dog. After the press conference a small group took Frank out to dinner at a famous restaurant where Henri Cartier-Bresson and Andy Warhol

had been feted on the nights of their openings at the Kunsthaus. Again Frank was a no-show; Magnaguagno said he was seen on the street, eating bratwurst. And then, later in the same evening, there was a speech from Magnaguagno, and Frank showing up to say some things, giving a striking talk in which he explained why he had to leave Switzerland to become an artist. Finally, at the end of the night, Frank took a photograph on the tram No. 2 of an old man, perhaps a banker, sitting with a bouquet of flowers. "It was a wonderful picture," said Magnaguagno. "I never saw it again."[19]

INTERNATIONAL TRIBUTES PILED UP. The Hasselblad Center in Göteborg, Sweden, presented him with their international award for photographic achievement in 1996. An exhibition and book marked the occasion, including an unforgettable image by Frank, *Mabou* from 1991. The photograph is as immersed in particulate matter as any roadside he might have shot decades before. Here the grit has exploded. At the picture's bottom a light burns through the dust, shining toward us. It could be the oncoming atom-ball headlight of a northbound car.[20]

The artist Mike Kelley once described a strategy for the making of art: "Start with the Hallmark version of beauty, then move on to the Burkean sublime."[21] *Mabou* depicts only a little toy flamingo in a bottle, cast in a vague black-and-white landscape that seems remote and yet hums with feeling. It presents itself as a snow globe would, *kitsch,* as Frank's father would have put it, a terrarium for misplaced emotion. The plastic flamingo is a throwaway knick-knack that might perch on a windowsill or be tied to a keychain, but here, with scale obscured and color forbidden (Frank long made black-and-white seem like emotional essentials; here they seem like what is left in a world that's leaking detail), the subject seems immense.

Jed Perl talks of "homemade esotericism," of a New York junk-shop aesthetic that touched artists across many decades.[22] It imbues Frank's presence as well as his work: the Times Square wall hanging of *The Last Supper* that appears in several films and hangs

in his home, the knickknacks he gives to friends, the toys and dead skin of culture pushed out of the way, sitting on the window-sill or dashboard on their way to dust. Perhaps this is what's left of the American scene Walker Evans yearned to protect through pictures: a feeling of fondness receding forever. "I am making sou-venirs," said Frank. "I am making memory because that is what I know, that is what I learned to know about, that is hopefully an expression of my true feeling.

"To tell my story.

"How I know the weakness of these concepts."[23]

In April of 1997 Allen Ginsberg checked himself out of a New York hospital. "There's nothing for me to look at here," he said. "I want to go home."[24] Doctors had missed his liver cancer on previous examinations, and now he was being released with the understanding that he had months to live.

He had days. At his apartment Ginsberg leaned on his wheel-chair and made a tour of his place—his books, records, art—taking a complete mental survey. Then he got into bed and did not get out again. Frank came by after dinner the night he went home, and Ginsberg took a photograph of Frank and Peter Orlovsky to-gether. It was the last picture Ginsberg took.

The loft would fill up over the next day or so: Gregory Corso and Larry Rivers, Patti Smith, Philip Glass, Robert and June. Jonas Mekas was there filming *Scenes from Allen's Last Three Days on Earth as a Spirit.* So many folks, in fact, that Ginsberg's Buddhist teacher Gelek Rinpoche roped off the space around his bed to keep the crowd away.[25]

Allen Ginsberg's ashes were divided among Gelek's Buddhist retreat in Ann Arbor, a place in Colorado, and the family plot in Elizabeth, New Jersey.

"I don't want anymore to taste the good life," Frank had once said. "I don't have the wish to participate in any festivities, or answer any questions, or make polite conversation. . . . I've done what I've done. I don't want to revel in it, or jump back into it. My main work now is to try to come up with something that I would believe in, that's worthwhile doing, at my age."[26]

There was chopping wood. There was work. There was the never-finished labor of rooting down to essences in hopes of uncovering slivers of truth. There was nothing more mysterious than a fact, Frank's disciple Garry Winogrand has said. In the days ahead Frank would be a fact gatherer, looking for a way to put them together in an order that made sense.

CHAPTER SEVENTEEN
THE AMERICAN

ONCE IT WAS "I'm famous: now what?" A fine line and smart pose. His mocking shrug as he turned his back on things that don't matter.

He messed with those who wielded cameras and notebooks. He took a British film crew to Coney Island, where they stumbled on a sideshow with contortionists and fakirs. A miracle man spread out on a bed of razor-sharp nails when the barker called out for audience participation. Who will stand on this brave man's chest? Frank and Leaf hooted as the Brits were selected and, against their wishes, forced to take the stage. It must have seemed rich to Frank, the people who made him feel like a freak now forced to join the show.[1]

Life had moved into the Post–Now What era, and he was handling it with humor, anger, and, of course, a pint of bile. When he won the Edward MacDowell Medal in 2002 for his contribution to American arts and culture, he turned all the deep talk at the award ceremony inside out and joked, "I don't think that much. I think about myself a lot."[2]

Meanwhile there were fanboys massing on Bleecker Street, staring at his fire escape. Punk poets with a pile of zines featuring interviews with John Giorno and Lydia Lunch cranked out at their temp job stopping him on the street, giving him a copy of the new issue, and craving a word of approval. Young film editors knowing he was famous for his scrawled collage postcards, sliding their own postcards into his mail slot, hoping he'd mail one back. Sometimes he did.

Frank and Leaf have lived in their Bleecker Street building on and off for over three decades, the neighborhood markedly changing in that time. The building next door used to house the Yippies but now features a trendy boxing gym on the ground floor and pricey rehabbed lofts above. Frank's building is painted an earthy green, and inside, friends say, a messy informality pushes into the farthest corners. "It's just a beautiful space, and there'll be stuff just laying around and you realize, 'Oh that's a Robert Frank negative or that's a June Leaf toy,' and it's all covered in dirt. It's just an art hovel," said their friend Mike McGonigal. "For years it seemed like he slept or rested on that little bed downstairs that you can see from the street—you'd walk past and think, that's where the magicians live. Something amazing is happening there, and you don't need to bother them."[3]

In his basement, with a chintzy *Last Supper* rendering, a pink yard flamingo, American flags, and scrawls on the walls, Frank rests. It's not as easy as it used to be for friends to see him. A knee replacement makes it painful to walk, and he gets around now on a cane. The glumness that's always been there grew after Pablo's death. So when Paulo Nozolino, a photographer from Portugal, came to New York and reached out to see Frank, he knew a visit might not happen. He'd called his friend most every afternoon for a week, and they would talk before Frank would eventually suggest another day might be better for dropping by. One afternoon, though, Leaf picked up the phone and invited him over. Nozolino was ushered down to the basement, where "Robert looked kind of gloomy." Leaf put chairs out in front of the building, another photographer came by, and they all discreetly decided to see if he could be cheered up.[4]

Frank's eye caught the battered Leica M6 hanging off Nozolino's shoulder. Asking to see it, Frank ran his fingers across the surface, once covered in black paint but worn away to raw aluminum. He held it close for a long time as he quietly looked down at the pavement. Frank's face began to change, Nozolino saw. Handing it back he gently said, "Nice, nice camera." Frank stood up and disappeared into the basement. When he returned he had a red

Polaroid camera, a pile of film packs, and a big smile across his face. "Let's shoot some pictures!" he said.

Then a scramble: Frank arranging his wife and friends in different poses, Polaroids hitting the sidewalk, and plenty of laughter. The red camera was passed around the circle, and everyone shot, and the two visitors grabbed their own cameras, "for the moment seemed so pure and privileged. Robert was happy, we were happy, the black cloud had gone away," said Nozolino. In the end Robert passed the Polaroids around, yet when it was time to go, they all remained before him. His own souvenirs of the afternoon.

IF THE NEIGHBORHOOD was changing, America was changing too. *The Americans* had been met with scorn when it was published in 1959. But fifty years later, when a small publisher sought to present an expensive, for-the-ages bound edition of the Declaration of Independence, they chose to illustrate it with a single summary image: a rotogravure of *Fourth of July–Jay, New York.* One of *The Americans'* images dominated by the flag, Frank's photograph was printed on the Declaration's frontispiece.[5]

The onetime "sad poem by a very sick person" is now celebrated in American culture, and *Fourth of July–Jay, New York* is seen as a window that lets us view the fragile, violent project that began the day the Declaration was signed. "It takes a long time to come from another culture, from Europe, and come here and get used to America," Frank once said. "It took a long time, like to learn how baseball works. It took a long time. Very quickly I read Thomas Wolfe, Sherwood Anderson. The first record I bought was Johnny Cash."[6]

He had become an American. Perhaps in 1963, when he was naturalized and commemorated it by joking, "ich bin ein Amerikaner." Or in 1955, when the white teens in Mississippi told him to go photograph "the niggers." Or when he jumped a Rhode Island cop in 1972. Or the first time he set eyes on Times Square. Now America had joined him, too.

Sometimes when he was asked if he was an American, he would say that really he was a New Yorker. But that feeling also was shifting. By the end of the century Frank was saying he didn't recognize his New York. That what he most recognized was the struggle he'd always enjoyed in New York but was consuming more of his energy than ever. Being a New Yorker was hard. "Sometimes I think that I'm an asshole to stay here," he told Jim Jarmusch, "and run around looking for detours and distractions and destruction and decomposition, decay."[7]

He had even toyed with moving back to Switzerland. In the oughts Frank and Leaf had tried living in a modern high rise on Chrystie Street and Houston for a few years, a place with fabulous views of the Empire State and Chrysler Building, white walls, ultramodern, but they just weren't comfortable. The idea was that it was easier on Frank's knees, but in the end they hauled back to Bleecker. Back to the funk of the familiar. "You would think, 'This is where Robert Frank lives? Like a pauper? It's shocking.' But they do not care," a friend says. "We're not couch people," Leaf has explained. Struggle was better than a white box.

They still go to Mabou in the summer months; Frank visits the discount store. "Robert loves a bargain," says a friend. "For him he's not a millionaire; he's a guy in the Dollar Store. He's not gonna buy his socks at Macy's."

Only he *is* a millionaire. The deal with Lunn greatly improved his finances. Leaving Lunn for the representation of Peter Mac-Gill—along with the long-term growth of the market for photography and his recognized prominence—has made Frank a wealthy man. One photograph of his can sell for $600,000 today.[8] He and Leaf have their spa they like to visit in Switzerland when they make their regular trip.

In other ways the guy who once castigated MacGill for having a phone in his car was showing he wasn't averse to aspects of the good life. There was a lucrative portrait of actress Isabelle Huppert, part of a vanity project for which she hired famous photographers Nan Goldin, Herb Ritts, and others. Frank has photographed luxury clothing catalogs for Italian shirt maker Alberto

Aspesi. Pricey coats hanging on a line in Mabou, echoing, even parodying, his gallery work.

Then there is the ultimate Frank luxury item, *Robert Frank: 81 Contact Sheets,* a limited-edition box set produced in 2009 by Kazuhiko Motomura, the Japanese publisher who had produced *The Lines of My Hand.* It cost $1,500 and was only available to people who had bought from Motomura in the past or would now purchase all $7,500 worth of his photo books. What you got for your money was a numbered black wood box, one of only three hundred. Inside was another wood box with Frank's signature burned into it. Inside that container was a silver folder embossed with Frank's initials, and within that was a handmade Japanese paper vessel with a booklet containing new comments by the artist on his work and an interview, and, finally, enlarged prints of all eighty-one contact sheets for the photographs in *The Americans.* It was years since Frank declared himself opposed to "a certain preciousness. I don't mind if a gallery sells some of my prints, and they go somewhere, and I get some money. But to make a business of it—to print fifty portfolios and sell them for two thousand dollars, and they're all in a box with tissue between them—I don't want to do it. It's deadly."[9]

What had changed? The clothes catalog he said he did because Aspesi was a friend. Perhaps this was what being rebellious *was* in 2000—to turn on those who expected him to be a certain way. Perhaps doing a shirt catalog or a limited-edition pine box was a way to thumb his nose at the church of bohemia. Once more, he did not give a fuck. Or maybe, now that he was into his eighties, he was more inclined to go with the flow. When somebody he trusted or somebody interesting put a proposition before him, he could be convinced to do it. Why not? Frank had nothing left to prove.

"He says yes to people who flatter him or blindside him or are underdogs," says a longstanding friend. "I have been there when this heavy woman in a weird dress who claimed to be Japanese royalty came with her assistant in tow and was getting Robert to sign a huge stack of pictures, one after the other. She had just given June this thousand-dollar rare teapot. Flatter them, and you can

get in." In recent years Frank has been close to François-Marie Banier, a celebrity French photographer with a legendary talent for befriending wealthy women.

In 2014 the Aperture Foundation staged a fundraiser framed as a celebration of Frank's ninetieth birthday. The theme, The Open Road, obviously connected to his work, but its realization was antithetical to its essence. Tickets were $150, and there were prop gas pumps and highway signs and vintage cars parked before roadside backdrops, giving the assembled socialites a chance to pose for their very own *On the Road* portraits. The rock band the Kills played during dessert—a Gehry-esque version of a s'more—and a print of Frank's *Hoboken, New Jersey* went for $95,000 in an auction. The guest of honor smiled gamely and waved when his name was called.

IN 2007 FRANK ALLOWED a friend of his, *New York Times* reporter Charlie LeDuff, to write a profile of him for *Vanity Fair* magazine. LeDuff traveled to China with Leaf and Frank. He had never let a reporter follow him around like this before and, in some regards, had never been so open about his life. There was vivid reporting— Frank passing out and almost dying in a soup shop—and it was the first time for many in the public to experience the man himself. LeDuff described Frank wearing the same pair of pants for many days in a row and the guilt he struggled with in the wake of the death of his children. He captured Frank's sharply alive sense of humor and his brutal candor: he was the kind of person who, when asked, "Do you want to see a picture of my kid?" answered with, "Why should I want to see that?" "People in the photographic community were blown away by the piece," said a photographer who knows him, "because it was so honest. They felt like they finally had a sense of Robert. Before it was just the pictures."[10]

After the article came out, LeDuff and Frank had an onstage conversation on a fall 2008 night. The event was at Lincoln Center, and it instantly became controversial among the keepers of the myth. In the audience was publisher Gerhard Steidl, senior curator

and head of the photography department at the National Gallery of Art Sarah Greenough, and assorted members of the protectorate. LeDuff's strategy seems to have been to hijack Frank's informality in order to see what was beneath the legend. The writer bopped out, popped open a beer, raided what he thought were stage props (they were actually instruments set up for a band). He beat on a bongo before tossing a tambourine at Frank, whom he promptly asked, "So Bob, how's your asshole?"[11]

"The room thickened palpably," wrote poet Eileen Myles. LeDuff fired a high hard one at the master's head, saying that without Kerouac's introduction he wouldn't even be sitting there before an audience. It must have amused Frank, who responded, "Probably not," before adding, "but why are you banging on his drum?" At some point in the evening LeDuff attempted to pull Frank's pants down. At another point somebody asked Frank about the number of African Americans who appear in *The Americans*, and Frank explained it was because they are better looking than white people. Word came from the inner circle that the event had been a disaster and was spectacularly disrespectful to the artist.

Which amused LeDuff, who said virtually every word of it had been plotted out ahead of time. "He knows what he is doing," explained the journalist, who notes that ahead of their conversation LeDuff had stopped by Frank's Bleecker Street loft. Frank seemed more depressed than usual, and LeDuff asked what was bugging him. In his Swiss German accent Frank answered, "I was just watching some Asian pornography, and I found it to be highly unsatisfactory." He invited the writer up. Then they proceeded to "workshop" the whole event, said LeDuff, going over everything that would happen.

Frank was hardly offended—they even hung out after the event, said the writer. "We smoked some weed together, drank rice liquor. It's cool."[12]

If the Lincoln Center appearance unofficially announced a reappraisal of Frank's career, a more formal effort commenced in 2009. The National Gallery of Art in Washington presented "Looking In: Robert Frank's *The Americans*," a major undertaking that

symbolically pulled apart the pages of the book and spread them across many museum walls, showing work prints, contact sheets, photographs from the road trips that went unused, historical data and images from throughout Frank's career to give the public the fullest understanding of what he had done. In the final room "Looking In" presented the stack of power-drilled photographs. It was a show about seeing and working in the world.

The exhibition's opening itself was an extraordinary celebration of the artist: on hand were photographers including William Christenberry, Jim Goldberg, Danny Lyon, Lee Friedlander, and Paolo Roversi. Something was set formally at rest. He had forced this work down, kept it at arm's length for most of his life, arguing that it couldn't be shown or only in some alternate context. Now he was surrendering to his vision. In the *Wall Street Journal* Richard Woodward wrote, "This exhibition both burnishes the myth of the book and destroys it."[13] He meant that the work laid bare more of his process, which included randomness and turning away from many promising avenues. Woodward even suggested that other possible arrangements of *The Americans*, reorderings and photographs never used, could have been brilliant too. Maybe better.

The exhibition showed the artist weighing creative options. In his life, of course, he chose a single option after *The Americans* and pursued it with dedication. Frank faked his own death, an only-the-good-die-young kind of all-American undoing. He was Sandy Koufax pulling out at the peak moment, and he was David Chapelle, measuring the possibilities success promised against the limitations it guaranteed and staging his own car wreck. Robert Frank emerged from *The Americans* a free man, and isn't that what America is supposed to be about? Making a life-changing work gave him a gift, and he didn't squander it. Hiding out, he stayed alive—remaining true to himself and his values and making amazing work that nobody agrees on the way they agree on *The Americans*. Robert Frank never wasted success by living it out. His life—as much as his work—matters.

AN INNOVATIVE TRAVELING exhibition of Frank's work began in
Halifax, Nova Scotia, in 2014, before heading to New York, Los
Angeles, Switzerland, Japan, and Turkey in 2016—more than fifty
stops in all.[14] "Robert Frank: Books and Films: 1947–2016" reflected
an inspired design format: it featured images from throughout his
career, reproduced on newsprint and nailed to gallery walls. The
art felt like broadsides slapped up fast. And when it was done in a
given town, everything was ripped down, torn up, and the exhibi-
tion's next stop was pulled out of a few packing tubes.

The heavy lifting in recent years has been done by Gerhard
Steidl, the German publisher who was now one of the most im-
portant people in Frank's life. At Scalo, Frank's former publisher,
Steidl first worked with him in the early 1990s before starting his
own photo book division. He clearly loves Frank's work and has
been publishing most every scrap of it, and publishing an expen-
sive replica of Leaf's notebook, and work from Frank's father the
amateur photographer, and even photographs from the Japanese
woman who showed up on Frank's doorstep one day and became
his assistant. Steidl has repackaged new and obscure Frank pho-
tographs with familiar images, setting the work in fresh contexts.
These personal projects, with a handmade look and often tied to-
gether with writing from Frank, come across like visual mixtapes:
a friend keeping you posted on the current state of his mind.

Steidl is an intensely focused businessman whose photo books
are printed with state of the art equipment in his enclosed com-
pound in Göttingen. He can seem humorless and aggressive with-
out losing his politesse; Günter Grass once called him a "Manches-
ter capitalist, to whom someone taught manners."[15] The publisher
makes an annual trip to Mabou to go over projects with Frank,
of whom he has been fiercely supportive. Today he is the chief
supporter of Frank's work. "The first thing to say is that with an
incredible energy he has given photo books a place in the pub-
lishing world that didn't exist before," said Swiss photographic
historian Martin Gasser. "He allows a lot of individuality in his
photo books—he tries hard to listen to artists and designers so the
results will be individual works. The problem has become maybe

he has made too much. The sheer mass of books he produces is just overwhelming. But I've worked with him, and he's absolutely fanatic. It's crazy the way he works, the way he deals with artists and is standing there at five in the morning talking with the guy who provides the paper."[16]

Steidl's exhibition came to New York University in January 2016, and for its opening Frank agreed to a brief question-and-answer session with the publisher. It was a rare public appearance, and it brought an overflowing crowd of students and fans to a room on the Lower East Side. The Swiss consulate general gave a little talk, as did a German journalist, vamping until Frank, leaning on a simple wood cane, ambled into the room. He wore a green camouflage jacket, his wispy white hair tossed this way and that.

The conversation started out slowly, Steidl confusing Frank by asking why, growing up in Switzerland, he hadn't gone into his father's bicycle business. (His father sold radios.) Frank talked about why he came to America, saying to the Swiss consulate general and everyone else in the world, "What America brought to me is what I am now. Without coming here I would be a comfortable citizen of Switzerland. I am very happy to have come to this country and was able to leave a mark here."

The publisher got a dig in, noting how the exhibition was an inexpensive way to bring Frank's work to a new generation of young viewers. "Don't you think your gallerists will hate you because this is an exhibition you cannot make any money out of by selling prints?"

"I don't think so," Frank said placidly. "They understand one moves forward."

The exhibition, Frank pointed out, completed a personal circle. As a young man he had started when getting one's photograph in a Zurich newspaper was a primary way to show it to the world, and now he was once again on newsprint, in a display with the pulp feel of the street. With a searching look on his face, he almost painfully put one word in front of the next. A show like this, he explained, can't help but inspire long thoughts about one's

life—thoughts that maybe aren't helpful but also generate good feelings when he sees how his work has been appreciated.

"You are a young man," Steidl ventured. "What are your next plans?" Frank said he wanted to go to bed. "I don't know what else to say. I married a nice woman who is an American woman. I'm proud of her. Her name is June Leaf. She is an artist.

"I've made many friends here, good friends, and I've had a very good life here in New York, and we travel. Every year we go somewhere else. I mean we travel around in America and go to Tucson where it's warmer and uh . . . well, it was a good step to come to America, I assure you." He was rubbing his temple, eyes darting to the side as if looking for the door.

He looked toward Steidl and fished for something else to say. "And so I'm here to say thank you and"—a smile—"come again!" There was applause, and he'd carved out his escape—but then, almost surprisingly, Frank invited questions from the audience. "I can give you the right answer or, I can also make up an answer too," he said. Everybody laughed.

Observers say that he can be quiet and drift for a while but that he chooses his moments, and when he wants to be present, he is. "Losing your memory is kind of funny," he told a Canadian writer. "So maybe you try to make sure some things you don't forget and some things you do."[17] But when somebody at NYU asked him what it was like working with the Rolling Stones, Frank simply went with "they were very good to me, and I thought they were a good bunch of people."

A fine bunch of fellows! He invited one last question from the crowd. There were a lot of photography students present in the room, and a young man asked: What advice would he give them? "I have advice," he said and snorted the littlest bit. "Keep your eyes open!" It wasn't the first time he had said this to a young person. Nor would it be the last. Then the side door opened and he pushed his way out onto the streets of Greenwich Village.

AFTERWORD

"WHEN YOU'RE AT THE END OF THE ROAD AND YOU HAVE
TO MAKE UP YOUR MIND ABOUT WHAT YOU WANT TO DO,
TO NOT BECOME A HERO CAN BE HARD. BUT I WAS SURE
THAT THE OLD MAN WOULD NOT END UP TO BE A HERO."

–ROBERT FRANK[1]

On a cold, winter morning I'm sliding a letter into his mailbox. I did not know then, as Jim Jarmusch would later tell me, that he had painted the mail slot red, for it is a red-hot incinerator of all that is put inside.

Peering up from the sidewalk, I could see a figure in the second-floor window, watching the street. It was Robert, looking. I waved at him; he waved at me. When he was driving across the country making *The Americans* Frank rarely talked to people he photographed, preferring to keep them at a distance that made the work possible. He was a set of eyes floating above the scene. Today he sits in the window, our own Uata, Watcher of the Bowery. "At the end of your days, you need to have a view—not a clear view, but a view," he has said.[2]

Six hours later, walking past the house again, I see Frank still in the window, wearing a hat now. Had he moved at all? "At my age, the pills keep the old man going, so he can still walk and take pictures," he has said. "But, most of all, he has time to think. It becomes, very carefully and slowly, a reminiscence." That's one mental image I will carry forward.

I prefer another, shared by Jim Jarmusch and Sara Driver, one also tied to his Bleecker Street home. Robert and June and

Jarmusch and Driver were walking there one evening after dinner in the late nineties. New York was in the middle of one of its periodic tabloid frenzies, this one over an organization calling itself the Church of Realized Fantasies. This church had a hotline to salvation, but if you called up its number, you could also place an order for grade-A marijuana, and a disciple would tell you how much cash to have on hand and which corner to stand on in an hour. The Church's address was right on Frank's block. That night there were a battery of video cameras lined up on the sidewalk.

All of a sudden the artist waved his arms and began shouting to the journalists. "The Church of Realized Fantasies is *here!*" he yelled from down the street. "Over here! Right here!" And he dashed down some stairs and threw open a door. Workers had dug out Frank's basement in order to enlarge his little room, so the space itself was like a pit. Frank jumped in, all while continuing to shout at the reporters and camera luggers: the Church is HERE! Cackling and flapping until they turned the lights out and walked away. It was a spectacle, both mocking and encompassing.

ACKNOWLEDGMENTS

I must thank a long list of institutions that made this book possible and showed an independent scholar an untold number of kindnesses. There's no better place to grapple with Frank's life and work than in the Robert Frank Collection at the National Gallery of Art in Washington, DC. Many thanks to Sarah Greenough, Philip Brookman, Andrea Hackman, Maryanna Ramirez, and others there who helped me on my visits. Anyone looking to see examples of Frank's work, including a great deal of what is discussed in these pages, need only go to the NGA website and search for the Robert Frank Collection. In Zurich Yvonne Domhardt, scholar and librarian at Israelitischen Cultusgemeinde Zürich, helped me understand the Enge and the history of Jewish Switzerland. The staffs at the city's Zentral Bibliotek and at the reference library at the Centre for Photography in Winterthur made available works on Frank that would be difficult to find elsewhere. The Metropolitan Museum of Art's Walker Evans Archive features a wealth of correspondence between the artists as well as drafts and other material relating to Frank's Guggenheim Fellowship proposal. Laura Reiner, research and instruction librarian at the Wellesley College Archives, found the original recordings for a 1975 public symposium Frank participated in that, along with the publication based on them, *Photography Within the Humanities*, was essential to this work. In Palo Alto the Allen Ginsberg Papers at Stanford University Libraries' Department of Special Collections is a sprawling, complex organism, and I am grateful to Larry Scott and Tim Noakes, among others, for helping me navigate it. I am indebted to those at the Getty Research Institute and also the Margaret Herrick Library, both in Los Angeles, and to those in charge of the Jack Kerouac Papers at the New York Public Library's Henry W. and Albert A. Berg Collection of English and American Literature.

Jonas Mekas and Robert Haller at the Anthology Film Archives made available a treasury of film publications and scholarship. Marisa Bourgoin was extremely helpful at Smithsonian's Archives of American Art in Washington, DC, as was Brandon Eng in their New York office. Finally, thanks to those at Columbia University's Rare Book and Manuscript Library.

Charles Lewinsky took me on a guided tour of Frank's Zurich neighborhood and introduced me to a number of people who enriched my understanding of Frank's early years. He is good company. Pauline von Moos, my dear friend once of Echo Park, brought things into focus. I owe a major debt to Leslie Squyres, senior archivist at the Center for Creative Photography and head of the Volkerding Study Center at the University of Arizona in Tucson. It was in Tucson that I read and learned much from a collection of transcripts of interviews conducted with many who knew Robert Frank. Among the interviewees: Emile De Antonio, Elliot Erwitt, Lou Faurer, Miles Forst, Ralph Gibson, Allen Ginsberg, Brian Graham, Ed Grazda, Walter Gutman, Sid Kaplan, June Leaf, Cynthia MacAdams, Grace Mayer, Jonas Mekas, Duane Michaels, Gunther Moses, Lou Silverstein, John Szarkowski, and Rudy Wurlitzer.

Everyone involved with the public library system for the state of Ohio deserves their own shout out at a time when libraries and other public institutions are under attack. From my seat at the great public library of Cincinnati and Hamilton County I had access to resources, material, and ideas from one end of the state to the other.

Others whose help and support have been essential: Jay Stowe, my onetime editor-in-chief at *Cincinnati* magazine, loves the language and the difference it can make; may he continue fighting good fights on every front in this age of "content." His encouragement and assistance helped make this book possible. Peter Herdrich and Karen Trott are friends for life, life savers, and patrons of the arts; I am lucky to know them. Harold and Sally Burman have made me wish every visit to Washington had been longer. Their conversation, support, and warmth have kept me in the

game. At the *New York Times* Jeff Roth, the overseer of the newspaper's morgue, was a well of information on Frank's history with the paper and more esoteric subjects. Laura Larson is a voice of sanity who read parts of this book and made it better. I am grateful for the help of Isabella Howard at the Howard Greenberg Gallery and David Ferber, Esq., representing the estate of Louis Faurer, for their help in obtaining images to use. Lauren Panzo and Katherine Dever at Pace/MacGill Gallery were expeditious.

This book would not have been possible without the voices and thoughts of so many people who knew Frank and his work, some in the 1940s, some last week. I thank them for their insight: David Amram, Yvonne Andersen, Gert Berliner, Mark Bingham, Massimo Biondi, Stewart Brand, Claude Brunschwig, John Cohen, Melanie Colosimo, Roma Connable, Jerry de Wilde, Sara Driver, Dominique Eddé, Sam Edwards, William Eggleston, Harold Feinstein, Raymond Foye, Findlay Fryer, Martin Gasser, Steve Gebhardt, Steve Gibbs, Ralph Gibson, Godlis, Robert Golka, Marty Greenbaum, Robert Greenfield, Paul Handelman, J. Hoberman, Laura Israel, Jim Jarmusch, Paul Justman, Paul Katz, Charlie LeDuff, Alfred Leslie, Charles Lewinsky, Christophe Lunn, Danny Lyon, Cynthia MacAdams, Guido Magnaguagno, Hudson Marquez, Mike McGonigal, Jonas Mekas, Tracy Nelson, Paulo Nozolino, Kevin O'Connor, P. J. O'Connor, Hank O'Neal, Karen Paget, René Perret, Charles Plymell, Leon Prochnik, Lynn Ratener, Ruby Lynn Reyner, Alexander Rooks, Helen Silverstein, Rani Singh, Emily Socolov, Judith E. Stein, Susan Steinberg, Wavy Gravy (Hugh Romney), and Terence Williams. Equal gratitude goes to those who opted not to have their name attached here.

American Witness could hardly have a better editor than Ben Schafer, a friend of some of those named in these pages, a believer in the work discussed, and in my work as well. Julie A. Ford at George Brothers Kincaid & Horton gave the work a scrutiny that a writer appreciates. Thanks also to Justin Lovell and everyone involved at Da Capo Press and the Hachette Book Group.

Paul Bresnick believes in ideas and good books. He's a fine agent, an effective nudger, and a superlative sounding board. He

is plugged into the Network of Human Mayonnaise. He has been to the Bells of Hell. He knows stuff.

Finally, Jenny Burman has heard me talk about Robert Frank long before I got a chance to write about him. We've been from New York to Los Angeles and to the banks of the O-Hi-O. She sees stuff I don't see, and her support means more to me than just about anything. And to Madeleine Echo, I say: keep your eyes open.

NOTES

INTRODUCTION

1. The National Gallery of Art, through the web pages of the Robert Frank Collection, makes available a great assortment of Frank's work. Numerous images discussed in this book can be viewed there. As of April 2017 *San Francisco* was among the work on display. "*San Francisco, 1956*," Selected prints from The Americans, 1955–1957, National Gallery of Art, www.nga.gov/content/ngaweb/features/slideshows/frank-the-americans-.html#slide_5.

2. Nora M. Alter, *Chris Marker* (Urbana: University of Illinois Press, 2006), 10; Ed Ruscha, "Six Reflections on the Photography of Robert Frank," *Tate Etc.* 2 (2004): 49.

3. Will Perry, "Rock and Read," in *Springsteen on Springsteen: Interviews, Speeches, and Encounters,* ed. Jeff Burger (Chicago: Chicago Review Press, 2013), 248.

4. Manohla Dargis, "On the Roads He Traveled: Viewing Robert Frank," *New York Times,* November 6, 2008, C3.

5. Miles Forst transcript, Robert Frank Miscellaneous Acquisitions, Center for Creative Photography, University of Arizona, Tucson.

6. Sarah Greenough, quoted from *Among Friends: Allen Ginsberg, Robert Delpire, Jonas Mekas, and Ed Grazda,* Part 4, National Gallery of Art audio recording, SoundCloud.

7. Brigitta Burger-Utzer, Stefan Grissemann, eds., *Frank Films: The Film and Video Work of Robert Frank* (Zurich: Scalo, 2004), 12.

8. Charlie LeDuff, interview with author.

9. Ralph Gibson, interview with author.

10. Danny Lyon, interview with author.

11. John Cohen, interview with author.

12. He has also not allowed reproduction of his photographs here. They are, however, easily viewable online at the web page for the National Gallery's Robert Frank Archives or via a simple Google search.

13. Jonas Mekas, interview with author.

14. Laura Israel, interview with author.

15. Jerry de Wilde, interview with author.

16. From author's brief conversation with Kasovitz.

CHAPTER 1: "BRUSH"

1. Massimo Biondi, interview with author.

2. Throughout I have relied on the invaluable "Robert Frank Map and Chronology," created by Sarah Gordon and Paul Roth for the National Gallery of Art, for basic dates and facts. It can be found on the National Gallery's website, www.nga.gov/content/dam/ngaweb/press/exh/2855/robertfrank-chronology.pdf. The timeline itself draws on Stuart Alexander's essential *Robert Frank: A Bibliography, Filmography, and Exhibition Chronology 1946–1985* (Tucson: Center for Creative Photography, University of Arizona, 1986).

3. Robert Frank and Francois-Marie Banier, eds., *Henry Frank: Father Photographer 1890–1976* (Göttingen: Steidl, 2009), n.p.

4. Martin Gasser, "Zurich to New York: 'Robert Frank, Swiss, unobtrusive, nice . . .,'" in *Robert Frank: Moving Out*, ed. Sarah Greenough and Philip Brookman (Washington, DC: National Gallery of Art, 1994). 40–53. Gasser's essay here and his work in general offers the most information available in English regarding Frank's early years in Switzerland.

5. Claude Brunschwig, interview with author.

6. Robert Enright and Meeka Walsh, "Possibly, Everything: An Interview with Robert Frank," *Border Crossings* 125 (March 2013).

7. Frank, "Statement," *Father Photographer*.

8. Enright and Walsh, "Possibly Everything."

9. Frank in *Don't Blink—Robert Frank*, 2015 documentary by Laura Israel.

10. Brunschwig, interview.

11. Rafaël Newman, ed., *Contemporary Jewish Writing in Switzerland: An Anthology* (Lincoln: University of Nebraska Press, 2003), 25.

12. Charles Lewinsky, interview with author. His novel, *Melnitz*, trans. Shaun Whiteside (London: Atlantic Books 2015), tracks a Swiss Jewish family from 1871 to the 1930s.

13. Regarding Jews and Swiss history, see Tamar Lewinsky and Sandrine Mayoraz, ed., *East European Jews in Switzerland* (Berlin: De Gruyter, 2013); Jonathan Steinberg, "The Swiss and the Jews: Two Special Cases?" *Leo Baeck Institute Yearbook* 52 (2007); Oliver Zimmer, "Switzerland," in *What Is a Nation? Europe 1789–1914*, ed. Timothy Baycroft and Mark Hewitson (New York: Oxford University Press, 2006), 100–119.

14. William S. Johnson ed., *The Pictures Are a Necessity: Robert Frank in Rochester, NY November 1988* (Rochester, NY: University Educational Services, International Museum of Photography at George Eastman House, 1989), 160.

15. Johnson, *The Pictures Are a Necessity*, 26.

16. For discussion of Swiss Jews and the Holocaust, see Ruth Rhoduner, "Paul Grueninger," and Jacques Picard, "Switzerland and the Jews" and "Holocaust Money and Swiss Banks," in *Switzerland Unwrapped: Exposing the Myths*, ed. Mitya New (London: I. B. Tauris, 1997); Independent Commission of Experts, *Switzerland, National Socialism and the Second World War: Final Report* (Zurich: Pendo Verlag, 2002); Frieda Johles Forman, *Jewish Refugees in Switzerland During the Holocaust* (London: Vallentine Mitchell, 2009); Georg Kreis, ed., *Switzerland and the Second World War* (Portland: Frank Cass, 2000); Bernhard C. Schär and Vera Sperisen, "Switzerland and the Holocaust: Teaching Contested History," *Journal of Curriculum Studies* 5 (2010); Alan Morris Schom, "A Survey of Nazi and Pro-Nazi Groups in Switzerland: 1930–1945," and "The Unwanted Guests: Swiss Forced Labor Camps, 1940–1944," reports commissioned by the Simon Wiesenthal Center available on the center's website (1998); Simon Erlanger, "Is There a Future for Jews in Switzerland?," *Changing Jewish Communities* 18 (March 15, 2007), Jerusalem Center for Public Affairs, http://jcpa.org/article/is-there-a-future-for-jews-in-switzerland; Simon Erlanger, "Real, Imaginary, and Symbolic Roles of Jews in Swiss Society," *Jewish Political Studies Review* 22, nos. 1–2 (April 27, 2010), Jerusalem Center for Public Affairs, http://jcpa.org/article/real-imaginary-and-symbolic-roles-of-jews-in-swiss-society; Jacques Picard, "On the Ambivalence of Being Neutral: Switzerland and Swiss Jewry Facing the Rise and Fall of the Nazi State," lecture presented at the US Holocaust Memorial Museum, September 23, 1997, www.ushmm.org/m/pdfs/20050726-picard.pdf.

17. Erlanger, "Jews in Swiss Society."

18. Independent Commission of Experts, *Final Report*, 71–72.

19. Marilyn Reizbaum, *James Joyce's Judaic Other* (Palo Alto, CA: Stanford University Press, 1999), 26; Gabe Friedman, "That Time James Joyce Was Mistaken for his Jewish Character," Assimilator blog, *Forward*, October 22, 2014, http://forward.com/schmooze/207769/that-time-james-joyce-was-mistaken-for-his-jewish.

20. Schom, "The Unwanted Guests."

21. Lewinsky, interview.

22. Henry Friedlander, *The Origins of Nazi Genocide* (Chapel Hill: University of North Carolina Press, 1995), 288.

23. Gasser, "Zurich to New York," 41.

24. Martin Gasser, interview with author; Brunschwig, interview.

25. Johnson, *The Pictures Are a Necessity*, 26–27.

26. Kristine McKenna, "A Frank Assessment," *Los Angeles Times*, March 10, 1996.

27. Brunschwig, interview; Gasser, "Zurich to New York," 46.

28. Gasser, interview.

29. Enright and Walsh, "Possibly, Everything."

30. Guido Magnaguagno, interview with author.

31. Guy P. Marchal, "Medievalism, the Politics of Memory and Swiss National Identity," in *The Uses of the Middle Ages in Modern European States: History, Nationhood and the Search for Origins*, ed. R. J. W. Evans and Guy P. Marchal (London: Palgrave Macmillan, 2011), 210–211; Regula Ludi, "What Is So Special About Switzerland? Wartime Memory as a National Ideology in the Cold War Era," in *The Politics of Memory in Postwar Europe*, ed. Richard Ned Lebow et al. (Chapel Hill: Duke University Press, 2006), 215–216.

32. Regarding *Geistige Landesverteidigung* and the 1939 National Exhibition, see André Lasserre, "Political and Humanitarian Resistance in Switzerland, 1939–45," and Josef Mooser, "'Spiritual National Defence' in the 1930s: Swiss Political Culture Between the Wars," in *Switzerland and the Second World War*; Judith Schueler, *Materialising Identity: The Co-Construction of the Gotthard Railway and Swiss National Identity* (Amsterdam: Asksant, 2008), 118–122; Martin Gasser, "From National Defence to Human Expression, Swiss Photography 1939–49," *History of Photography* vol. 22, no. 3 (Autumn 1998): 229–235; Martin Gasser, *Jakob Tuggener* (Zurich: Scalo, 2000); Guido Magnaguagno, Lewinsky, Gasser, author interviews.

33. Kries, *Switzerland*, 214.

34. Gasser, interview.

35. Ibid.

36. Lewinsky, interview.

CHAPTER 2: FLAGS AND MIRRORS

1. Frank and Francois-Marie Banier, *Henry Frank*.

2. Gasser, "Zurich to New York," 46.

3. Anne Bertrand, *Le Présent de Robert Frank, Photographie et Films* (Paris: La Rochelle, 2009), 13.

4. Stéphane Bussard, "Robert Frank: Le photographe, ce détective," *Le Temps* [Geneva], April 28, 2012.

5. Frank mentions the murder in Le Temps; see also Jacques Chessex's novel *A Jew Must Die* (London: Bitter Lemon Press, 2010), which fictionalized the event.

6. Martin Gayford, "Beat Poet of the Lens," *Daily Telegraph*, October 2, 2004.

7. Gasser, "Zurich to New York," 51.

8. Alex Rühle, "The Man Who Travels Faster than Jetlag," *Süddeutsche Zeitung*, August 22, 2009.

9. Stephanie Barron, ed., *New Objectivity: Modern German Art in the Weimar Republic 1919–1933* (New York: Prestel, 2015); Jeffrey Head, *Herbert Matter: Modernist Photography and Graphic Design* (Palo Alto, CA: Stanford University Libraries, 2005); Schweizerische Stiftung für die Photographie, *Herbert Matter Foto-Grafiker: Sehformen der Zeit* (Baden: Lars Müller, 1995); Lisa Jaye Young, "All Consuming: The Tiller-Effect and the Aesthetics of Americanization in Weimer Photography 1923–1933" (PhD dissertation, City University of New York, 2008).

10. René Perret, interview with author, email correspondence.

11. Johnson, *Pictures Are a Necessity*, 28.

12. Ibid., 27.

13. "Bestätigung," letter of recommendation from Zürcher Filmkollektiv, July 18, 1942; Ann Sass, "Robert Frank and the Filmic Photograph," *History of Photography* 20, no. 3 (Autumn 1998): 247–253.

14. Gasser, *Jakob Tuggener*.

15. Michel Guerrin, "Robert Frank raconte sa passion pour Tuggener et le miracle Suisse," *Le Monde*, February 2, 2000.

16. Jakob Tuggener, *Fabrik* (Göttingen: Steidl/Kunstmuseum Olten, 2010); Peter Pfrunder, Martin Gasser, and Sabine Münzenmaier, eds., *Swiss Photobooks from 1927 to the Present: A Different History of Photography* (Baden: Lars Müller Publishers, 2011); Walter Binder, Hugo Loetscher, and Rosellina Burri-Bischoff, *Swiss Photography from 1840 Until Today* (Zurich: A. Niggli, 1977); Sophie Ber, "Montpellier: Rediscover Jakob Tuggener's Factory," *L'Oeil*, September 9, 2015, www.loeildelaphotographie.com/en/2015/09/09/article/159869824/montpellier-rediscover-jakob-tuggener-s-factory; Hans Rudolf Reust, "Jakob Tuggener," *Frieze* 53 (June–August 2000, blog); Magnaguagno, interview.

17. Martin Bieri, "'Peaceful,' sagt Robert Frank," *Der Bund*, April 22, 2012; Brunschwig, interview.

18. Ute Eskildsen ed., *Hold Still—Keep Going* (Zurich: Scalo, 2001), 146.

19. Gasser, interview.

20. McKenna, "Frank Assessment."

21. Johnson, *Pictures Are a Necessity*, 28.

22. In 2009 the German publisher Steidl produced a modern edition of the book titled *Portfolio*.

23. "Zeugnis," February 10, 1944, quoted in Gasser, "Zurich to New York," 44–45.

24. Bertrand, *Le Présent,* 13.

25. Enright and Walsh, "Possibly, Everything."

26. Bertrand, *Le Présent,* 13.

27. Letter, February 19, 1947, quoted in Gasser, "Zurich to New York," 47.

28. Bertrand, *Le Présent,* 14.

CHAPTER 3: A STEP AWAY FROM THEM

1. Robert Frank and Jim Jarmusch conversation transcript, *Switch* (Japanese magazine), September 1992.

2. McKenna, "Frank Assessment."

3. Ibid.

4. Ute Eskildsen, "That Was the Idea of Paris—In Conversation with Robert Frank," in *Robert Frank, Paris,* ed. Ute Eskildsen (Göttingen: Steidl, 2008), unpaginated.

5. Sam Roberts, "New York 1945," *New York Times,* July 30, 1995, 10.

6. E. B. White, *Here Is New York* (New York: Little Book Room, 1999), 52; Eskildsen, *Robert Frank.*

7. Anatole Broyard, *Kafka Was the Rage: A Greenwich Village Memoir* (New York: Vintage, 1997), 80.

8. Frank and Jarmusch conversation transcript, *Switch.*

9. Eskildsen, "That Was the Idea of Paris."

10. Penelope Rowlands, *A Dash of Daring: Carmel Snow and Her Life in Fashion, Art, and Letters* (New York: Atria, 2005), 177–218; Alexey Brodovitch, *Alexey Brodovitch* (Paris: Assouline, 1998); Jane Livingston, "The Art of Richard Avedon" in *Evidence: 1944–1994,* ed. Mary Shanahan (New York: Random House, 1994), 33–36; Owen Edwards, "Zen and the Art of Alexey Brodovitch," *American Photographer,* June 1979, 50–61; George R. Bunker ed., *Alexey Brodovitch and His Influence* (Philadelphia, PA: Philadelphia College of Art, 1972); Martin Harrison, *Outside Fashion: Style and Subversion* (New York: Howard Greenberg Gallery, 1994).

11. Alexey Brodovitch, *Ballet* (New York: Errata Editions, 2011).

12. Kerry Williams Purcell, "Alexey Brodovitch," in *The Education of a Photographer,* ed. Charles H. Traub et al. (New York: Allworth Press, 2006), 100–105.

13. Jane Livingston, *The New York School Photographs, 1936–1963* (New York: Harry N. Abrams, 1996), 290.

14. Peter Galassi, *Robert Frank in America* (Göttingen: Steidl, 2014), 13–15; Sarah Greenough, *Looking In: Robert Frank's* The Americans (Washington, DC: National Gallery of Art, 2009), 17–23.

15. Kalton C. Lahue and Joseph A. Bailey, *Glass, Brass and Chrome: The American 35mm Miniature Camera* (Norman: University of Oklahoma Press, 2002); Alessandro Pasi, *Leica: Witness to a Century* (New York: W. W. Norton, 2002); Galassi, *In America*, 11–14; Anthony Lane, "Candid Camera: The Cult of Leica," *New Yorker*, September 24, 2007, www.newyorker.com/magazine/2007/09/24/candid-camera.

16. Livingston, *New York School*, 293.

17. Geoff Dyer, *The Ongoing Moment* (New York: Pantheon, 2005), 27–28.

18. Wilson Hicks, *Words and Pictures: An Introduction to Photojournalism* (New York: Harper & Brothers, 1952), 6; Galassi, *In America*, 15–17.

19. Jack Crager, "Lillian Bassman's Abstract, Re-imagined Fashion Photography," *American Photo*, May 11, 2016, www.americanphotomag.com/new-exhibit-classic-lillian-bassman#page-6.

20. Rowlands, *A Dash of Daring*, 371, 254.

21. Ibid., 333.

22. Ronit Shani, "Bli Flash," *Monitin* 57 (May 1983).

23. "Art Directors Club Award, 1947," Technical Material, Robert Frank Collection, National Gallery of Art, Washington, DC.

24. Johnson, *Pictures Are a Necessity*, 30.

25. Colin Westerbeck and Joel Meyerowitz, *Bystander: A History of Street Photography* (Boston: Bulfinch, 1994).

26. William Burroughs and Allen Ginsberg, *The Yage Letters Redux* (San Francisco: City Lights, 2006), 57.

27. Westerbeck and Meyerowitz, *Bystander*, 352.

28. Johnson, *Pictures Are a Necessity*, 30.

29. Robert Frank, *Valencia 1952*, ed. Vicente Todolí (Göttingen: Steidl, 2012).

30. Enright and Walsh, "Possibly, Everything."

31. Times Square: Marshall Berman, *On the Town: One Hundred Years of Spectacle in Times Square* (New York: Random House, 2006); Mark Caldwell, *New York Night: The Mystique and Its History* (New York: Scribner, 2005); Tama Starr and Edward Hayman, *Signs and Wonders: The Spectacular Marketing of America* (New York: Doubleday Business, 1998); William R. Taylor, ed., *Inventing Times Square: Commerce and Culture at the Crossroads of the World* (New York: Russell Sage Foundation, 1991), 280–284; Darcy Tell, *Times Square Spectacular: Lighting Up Broadway* (New York: Smithsonian Books: Collins, 2007); James Traub, *The Devil's Playground: A Century of Pleasure and Profit in Times Square* (New York: Random House, 2004).

32. Alfred Eisenstaedt, *Eisenstaedt on Eisenstaedt: A Self-Portrait* (New York: Abbeville Press, 1985), 74.

33. Westerbeck and Meyerowitz, *Bystander*, 71.

34. Louis Faurer, "Narrative of My Life," prepared for a 1981 exhibition at the Art Gallery of University of Maryland, in *Louis Faurer: Photographs from Philadelphia and New York, 1937–1973*, ed. Edith A. Tonelli and John Gossage (College Park: University of Maryland Art Gallery, 1981), 9.

35. Viva, *Superstar: A Novel* (New York: G. P. Putnam's Sons, 1970), 81.

36. Anne Wilkes Tucker, *Louis Faurer* (London: Merrell, 2002), 20. See also Andy Grundberg, "Two Masters Return to the Limelight," *New York Times*, September 20, 1981.

37. Johnson, *Pictures Are a Necessity*, 29.

38. Frank O'Hara, "A Step Away from Them," *Lunch Poems: 50th Anniversary Edition* (San Francisco: City Lights, 2014), 12.

39. Johnson, *Pictures Are a Necessity*, 117.

40. Lisa Hostetler, *Street Scene: The Psychological Gesture in American Photography, 1940–1959* (New York: Prestel, 2010), 83.

41. Sid Kaplan interview transcript, Robert Frank Miscellaneous Acquisitions, Center for Creative Photography, Tucson, Arizona.

42. Faurer, "Narrative of My Life"

43. Charles Baudelaire, *Paris Spleen*, trans. Louise Varese (New York: New Directions, 1970), 20.

44. In Houston's Museum of Fine Arts in Houston there's a print of this photograph donated by Frank. Faurer signed it and gave it to his subject: "To Robert Frank, the best of my New York friends." He signed it "Sammy."

CHAPTER 4: ROAD TRIPS AND MIND TRIPS

1. Washington Square, 1950, Technical Material, Robert Frank Collection.

2. Milton Klonsky, "Down in the Village: A Discourse on the Hip," in *A Discourse on the Hip* (Detroit, MI: Wayne State University Press, 1990), 136.

3. Oral history interview with Mary Frank, January 10–February 3, 2010, Archives of American Art, Smithsonian Institution website, www.aaa.si.edu/collections/interviews/oral-history-interview-mary-frank-15766.

4. Eleanore Lockspeiser papers, Archive of American Art, Smithsonian Institution.

5. Her grandfather, Gregory Weinstein, is described in Tony Michels, *A Fire in Their Hearts: Yiddish Socialists in New York* (Cambridge, MA: Harvard University Press, 2009), 52, 57, 225.

6. Mary Frank: Eleanor Munro, *Originals: American Women Artists* (New York: Simon and Schuster, 1979), 289–308; Hayden Herrera, *Mary Frank* (New York: Harry A. Abrams, 1990), 16; John Yau, "In Conversation with Mary Frank," *Brooklyn Rail* blog, June 3, 2011; Sam Stephenson, "Notes from

a Biographer: Mary Frank," *Paris Review*, May 26, 2011, www.theparisreview
.org/blog/2011/05/26/mary-frank.

7. Herrera, *Mary Frank*, 19.

8. C. P. Trussell, "Senate Body Approves Draft," *New York Times*, May 12, 1948; Associated Press, "Truman Proclamation on Draft Registration," *New York Times*, July 21, 1948.

9. Oral history, Archives of American Art.

10. Liz Jobey, "The UnAmerican," *Independent Sunday Review*, March 29, 1992, 8–10.

11. Oral history, Archives of American Art.

12. Jacki Lyden, "Artist Mary Frank Mingles the Real with the Mythical," National Public Radio, December 29, 2007.

13. Greenough, *Looking In*, 66–71.

14. Mary Frank oral history, Archives of American Art.

15. Letter, June 21, 1950, quoted in Stuart Alexander, "Robert Frank and Edward Steichen," Greenough, *Looking In*, 47.

16. Carl Sandburg, *Steichen the Photographer* (New York: Museum of Modern Art, 1961), 51–55.

17. Robert Frank, "The People You Don't See," *Life*, November 26, 1951. Images and text for "People You Don't See" can be found on the Robert Frank Collection website, National Gallery of Art, www.nga.gov/content/ngaweb/features/slideshows/people-you-don-t-see--1951.html.

18. Robert Frank, Wellesley University public symposium, April 14, 1975, recordings in Wellesley College Archives. These recordings were edited and published in Janis E. Paris and W. MacNeil, eds., *Photography Within the Humanities* (Danbury, NH: Addison House, 1977).

19. Note, n.d., quoted in Alexander, "Robert Frank and Edward Steichen," 47.

20. Herrera, *Mary Frank*, 25.

21. Robert Frank, *Valencia 1952*.

22. "Among Friends: Allen Ginsberg, Robert Delpire, Jonas Mekas, and Ed Grazda on Robert Frank," panel discussion at the National Gallery, October 15, 1994, SoundCloud recording available on the National Gallery of Art's website, www.nga.gov/content/ngaweb/audio-video/audio/ginsberg.html.

23. Michel Frizot, "Robert Frank and Robert Delpire" and "Interview with Robert Delpire," in Greenough, *Looking In*, 190–201.

24. The complete *Black White and Things*, along with contact sheets, can be viewed on the Robert Frank Collection website, the National Gallery of Art, www.nga.gov/content/ngaweb/features/robert-frank/black-white-and-things-1952.html.

25. J. G. Ballard, *Miracles of Life: Shanghai to Shepperton, an Autobiography* (New York: Liveright, 2013), 112.

26. Letter, April 2, 1952, quoted in Alexander, "Robert Frank and Edward Steichen," 49.

27. Letter to Philip Brookman, May 29, 2002, quoted in Philip Brookman, ed., *Robert Frank: London/Wales* (Zurich: Scalo, 2005).

28. Martin Gayford, "Beat Poet of the Lens," *Daily Telegraph*, October 2, 2004.

30. Letter, February 28, 1953, quoted in Gasser, "Zurich to New York," 50.

31. Jacob Deschin, "European Pictures," *New York Times*, May 31, 1953, 237.

32. Brookman, booklet included in London/Wales.

CHAPTER 5: EARLY MORNING IN THE UNIVERSE

1. Versions of this origin tale are multitude. Among those reviewed here: Ann Charters, *Kerouac: A Biography* (San Francisco: Straight Arrow Books, 1973); Hilary Holladay, *Herbert Huncke: The Times Square Hustler Who Inspired Jack Kerouac and the Beat Generation* (Tucson, AZ: Schaffner Press, 2015); "Particularly Little Jack" presents Huncke's version of events, as culled from his archives by Jerry Poynton and Leslie Winer, and can be found at "Particularly Little Jack," June 13, 2013, http://huncketeacompany.com/blog/2013/6/13/particularly-little-jack; Aaron Latham, "The Lives They Lived," *New York Times* magazine, January 4, 1998.

2. Barnett Newman, "The Sublime Is Now," from John P. O'Neill, ed., *Barnett Newman: Selected Writings and Interviews* (New York: Knopf, 1990), 170–173.

3. Helen Gee, *Limelight* (Albuquerque: University of New Mexico Press, 1997), 70.

4. Ibid., 38–40.

5. James R. Mellow, *Walker Evans* (New York: Basic Books, 1999); Belinda Rathbone, *Walker Evans: A Biography* (New York: Houghton Mifflin, 1995); John T. Hill and Heinz Liesbrock, eds., *Walker Evans: Depth of Field* (New York: Prestel, 2015); Leo Rubinfien, "Walker Evans, the Poetry of Plain Seeing," *Art in America*, December 2000; Tod Papageorge, "Walker Evans and Robert Frank: An Essay on Influence," in *Core Curriculum: Essays on Photography* (New York, *Aperture*, 2011).

6. Walker Evans, *American Photographs: Seventy-Fifth Anniversary Edition* (New York: Museum of Modern Art, 2012).

7. David Campany, *Walker Evans: The Magazine Work* (Göttingen: Steidl, 2014); Robert Frank and Walker Evans, "The Congressional," *Fortune*, August 1955, 118–122.

8. "Walker Evans on Robert Frank/Robert Frank on Walker Evans," *Still/3* (New Haven, CT: Yale University Press, 1971), 2.

9. Wellesley symposium.

10. Westerbeck and Meyerowitz, *Bystander*, 282.

11. Gee, *Limelight*, 116–117.

12. Jonathan Goell, "Walker Evans Recalls Beginning," *Boston Sunday Globe*, September 19, 1971.

13. Rudolf Janssens and Gertjan Kalff, "Time Incorporated Stink Club: The Influence of Life on the Founding of Magnum Photos," in *American Photographs in Europe*, ed. David Nye and Mick Gidley (Amsterdam: VU University Press, 1994), 223–242; John G. Morris, *Get the Picture: A Personal History of Photojournalism* (Chicago: University of Chicago Press, 2002), 146.

14. Draft application for Guggenheim Fellowship, 1954, Metropolitan Museum of Art, Walker Evans Archive.

15. Leslie Katz, "Interview with Walker Evans," in *Photography in Print: Writings from 1816 to the Present*, ed. Vicki Goldberg (Albuquerque: University of New Mexico Press, 1981), 361.

16. Draft application for Guggenheim Fellowship.

17. Robert Creeley, "On the Road: Notes on Artists and Poets 1950–1965," in *Poets of the Cities: New York and San Francisco 1950–1965*, ed. Neil A. Chassman (New York: Dutton, 1974), 56, italics original.

18. "Fellowship Application Form," published in Anne Wilkes Tucker and Philip Brookman, eds., *Robert Frank: New York to Nova Scotia* (Houston, TX: Museum of Fine Arts, Houston, 1986), 20.

19. Alexander, "Robert Frank and Edward Steichen," in Greenough, *Looking In*, 50.

20. Edward Steichen, ed., *The Family of Man: 60th Anniversary Edition* (New York: Museum of Modern Art, 2015); Eric J. Sandeen, *Picturing an Exhibition: The Family of Man and 1950s America* (Albuquerque: University of New Mexico Press, 1995); Blake Stimson, *The Pivot of the World: Photography and Its Nation* (Cambridge, MA: MIT Press, 2006), 59–104; Fred Turner, "The Family of Man and the Politics of Attention in Cold War America," *Public Culture* 24, no. 1 (2012): 55–84.

21. Patricia Bosworth, *Diane Arbus: A Biography* (New York: Knopf, 1984), 114.

22. Walker Evans, "The Reappearance of Photography," *Hound & Horn* 5 (October–December 1931): 126–127.

23. Wellesley symposium.

24. Judith Malina, *The Diaries of Judith Malina, 1947–1957* (New York: Grove Press, 1984), 123.

CHAPTER 6: LIKE JUMPING IN THE WATER

1. Robert Lowell, *Life Studies and For the Union Dead* (New York: Farrar, Straus and Giroux, 2007), 11.

2. Raymond Daniell, "What the Europeans Think of Us," *New York Times* Sunday magazine, November 30, 1947, 7.

3. John O'Brian, ed., *Clement Greenberg: The Collected Essays and Criticism*, vol. 3 (Chicago: University of Chicago Press, 1993), 122–152.

4. Steve Gibbs, interview with author.

5. Hudson Marquez, interview with author.

6. Before he was done he would also have by his side a Francis Bacon quotation. It was handed to Frank by the photographer Dorothea Lange, and he posted it in his car: "The contemplation of things as they are, without substitution or imposture, without error or confusion, is in itself a nobler thing than a whole harvest of invention."

7. Frank and Jarmusch conversation transcript, *Switch.*

8. Ute Eskildsen, "In Conversation with Robert Frank," in *Hold Still, Keep Going*, ed. Eskildsen (Zurich: Scalo, 2001), 110.

9. Letter, July 1955, reprinted in Tucker and Brookman, *Robert Frank*, 22.

10. Sean Kernan, "Uneasy Words While Waiting: Robert Frank," *U.S. Camera/Camera* 35 Annual (1972): 139–145.

11. Stuart Alexander, "Robert Frank Discusses *The Americans* at George Eastman House, 17 and 18 August 1967," *Katalog: Journal of Photography and Video* 9, no. 4 (Fall 1997): 34–43.

12. Contact sheet for *Americans 40, Newburgh, New York*, in the expanded edition of Greenough, *Looking In*. The National Gallery of Art web pages for their Robert Frank Collection, as of April 2017, featured *Newburgh, New York's* contact sheet. "*Americans 40—Newburgh, New York XI*," National Gallery of Art, www.nga.gov/content/ngaweb/Collection/art-object-page.88860.html.

13. Forst transcript, Center for Creative Photography.

14. Dan Weiner, *Dan Weiner 1919–1959* (New York: ICP Library of Photographers, 1974), 6.

15. Ibid., 51.

16. Johnson, *Pictures Are a Necessity*, 172.

17. Ronit Shani, "Bli Flash," *Monitin* 57 (May 1983).

18. Frank and Jarmusch conversation transcript, *Switch.*

19. Ibid.

20. Lieutenant Dempsie Coffman, *Arkansas State Troopers: A Breed Apart* (Lt. Coffman, 2005), 99, http://tinyurl.com/y9slr2y7.

21. Ray Carnahan oral history, Pryor Center for Arkansas Oral and Visual History, http://pryorcenter.uark.edu/project.php?projectFolder=Arkansas%20State%20Police&thisProject=8&projectdisplayName=Arkansas%20State%20Police.

22. Letter, November 9, 1955, reprinted in Tucker and Brookman, *Robert Frank*, 25–26.

23. Arrest report, December 19, 1955, ibid., 24.

24. Editors of Time-Life Books, *Documentary Photography* (New York: Time-Life Books, 1972), 167.

25. Wellesley symposium.

26. Johnson, *Pictures Are a Necessity*, 18.

27. Letter, n.d., Greenough, *Looking In*, 155.

28. Herrera, *Mary Frank*, 25.

29. Letter, February 27, 1955, Greenough, *Looking In*, 156.

30. Letter, winter 1955, Tucker and Brookman, *Robert Frank*, 28.

31. Wayne F. Miller, "An Eye on the World: Reviewing a Lifetime in Photography," 2001, Bancroft Library, University of California, Berkeley.

32. Booklet, *Robert Frank: The Americans, 81 Contact Sheets* (Tokyo: Yugensha, 2009).

33. Ed Grazda, "Among Friends," National Gallery recording, www.nga.gov/content/ngaweb/audio-video/audio/ginsberg.html.

34. A great deal has been written about the road trip, the production, and reception of *The Americans*. This is some of the essential work that has shaped my approach. Essays written by Sarah Greenough, including "Resisting Intelligence: Zurich to New York," "Disordering the Senses: Guggenheim Fellowship," "Transforming Destiny into Awareness: *The Americans*," and "Blowing Down Bleecker Street: Destroying *The Americans*," pull together much of the story with impressive detail and critical depth. Her work is profound. They are found in Greenough, *Looking In: Robert Frank's Americans*, a book with many more essays and examinations of those who have shaped *The Americans* (Washington, DC: National Gallery of Art, 2009). Her "Fragments that Make a Whole: Meaning in Photographic Sequences," in *Robert Frank Moving Out*, ed. Sarah Greenough and Philip Brookman (Washington, DC: National Gallery of Art, 1995), looks deep into how Frank made meaning.

Also see Tucker and Brookman, *Robert Frank*; Peter Galassi, *Robert Frank in America* (Göttingen: Steidl, 2014); W. T. Lhamon, *Deliberate Speed: The Origins of a Cultural Style in the American 1950s* (Cambridge, MA: Harvard University Press, 2002); Jonathan Green, "The Americans: Politics and Alienation," in *American Photography: A Critical History, 1945 to the Present* (New

York: Harry N. Abrams, 1984), 80–93; Stuart Alexander, "The Criticism of Robert Frank's *The Americans*" (MA thesis, University of Arizona, 1986); Stuart Alexander, "Robert Frank Discusses *The Americans* at George Eastman House, 17 and 18 August 1967," *Katalog: Journal of Photography and Video* 9, no. 4 (Fall 1997): 34–43; Leo Rubinfien, "One More Trip Through *The Americans*," *Art in America*, May 2009; George Cotkin, "The Photographer in the Beat-Hipster Idiom: Robert Frank's *The Americans*," *American Studies* 26 (Spring 1985): 19–33; Geoff Dyer, "The Road to Nowhere," *Guardian*, October 16, 2004, 16; Jno Cook, "Robert Frank's America," *Afterimage* 9, no. 8 (March 1982): 9–14; Jno Cook, "Robert Frank: Dissecting the American Image," *Exposure* 24, no. 1 (1986): 31–41.

35. Shani, "Bli Flash."

36. Judith E. Stein, *Eye of the Sixties: Richard Bellamy and the Transformation of Modern Art* (New York: Farrar, Straus and Giroux, 2016), 61.

37. Bosworth, *Diane Arbus*, 147.

38. Stein, *Eye of the Sixties*, 62; Forst interview transcript, Center for Creative Photography.

39. Morton Feldman, *Give My Regards to Eighth Street* (Cambridge: Exact Change, 2004), 32.

40. John Cohen, *Visions of Mary Frank*, documentary film, 2014.

41. Grazda, "Among Friends," National Gallery recording.

42. Feldman, "I Met Heine on the Rue Furstemberg," in Feldman, *Give My Regards*, 118.

43. Russell Baker, "Eisenhower Enjoys 3-Hour Parade of Might Featuring Bombs, Bands and Beauties," *New York Times*, January 22, 1957; Jack Gould, "TV at the Inauguration," *New York Times*, January 22, 1957.

44. Klonsky, *Discourse on the Hip*, 139.

45. Konrad Tobler and Michael von Graffenried, "Robert Frank and Robert Walser," *Kunstbulletin*, June 2012, Kunstbulletin, www.artlog.net/de/kunstbulletin-6-2012/robert-frank-und-robert-walser-ferne-nahe.

CHAPTER 7: FIRST THOUGHT, BEST THOUGHT

1. John Cohen, *There Is No Eye* (New York: Powerhouse Books, 2001), 82–83.

2. John Cohen, interview with author.

3. Ibid.

4. Gotthard Schuh, "Robert Frank," *Camera* 36, no. 8 (August 1957), quoted in Martin Gasser, "Photography as Expression," in Gotthard Schuh, Peter Pfrunder, and Gilles Mora, *Gotthard Schuh: A Kind of Infatuation* (Göttingen: Steidl, 2009), 253–254.

5. There are differing versions of how Kerouac came to meet Frank and be involved in *The Americans*. This account draws from the transcript of an interview with de Antonio in the Center for Creative Photography and from Frank's remarks at his 2009 Elson Lecture at the National Gallery of Art, a digital recording of which has been posted on the NGA's website, www.nga .gov/content/ngaweb/audio-video/audio/elson-frank.html.

6. Gilbert Milstein, "Books of the Times," *New York Times,* September 5. 1957.

7. "A Conversation with Allen Ginsberg," in *Frank Films: The Film and Video Work of Robert Frank,* ed. Brigitta Burger-Utzer and Stefan Grissemann (Zurich: Scalo, 2005), 84; Thomas Gladysz, "Photo Metro," in *Allen Ginsberg Spontaneous Mind: Selected Interviews 1958–1996,* ed. David Carter (New York: HarperCollins, 2001), 526.

8. "An Evening with Robert Frank," October 9, 2009, Metropolitan Museum, transcript on museum website, www.metmuseum.org/metmedia/ audio/exhibitions/060-special-exhibition-an-evening-with-robert-frank.

9. Jack Kerouac, interviewed by Ted Berrigan, *The Paris Review Interviews IV* (New York: Picador, 2009), 84.

10. "Introduction," *The Americans,* Robert Frank (Zurich: Scalo, 1993), 5–9. An amazing picture of Kerouac's first draft appears under the headline "Kerouac on 'The Americans'" on the National Public Radio (NPR.org) website, www.npr.org/news/graphics/2009/feb/robertfrankintro.html.

11. The concept is rooted in William Blake, who wrote, "First thought is best in Art, second in other matters." It flowered in Kerouac's 1953 essay "The Essentials of Spontaneous Prose": "If possible," Kerouac said, "write 'without consciousness' in semi-trance . . . allowing subconscious to admit in own uninhibited interesting necessary and so 'modern' language what conscious art would censor, and write excitedly, swiftly, with writing-or-typing-cramps, in accordance (as from center to periphery) with laws of orgasm." Quoted in Kerouac, "Essentials of Spontaneous Prose," in *The Portable Beat Reader,* ed. Ann Charters (New York: Viking, 1992), 57.

12. Kernan, "Uneasy Words."

13. Wheeler, "Robert Frank Interviewed," 4.

14. Tom Maloney, ed., *U.S. Camera Annual 1958* (New York: U.S. Camera, 1957), including Maloney, "Guggenheim Fellows in Photography," 89; Walker Evans, "Robert Frank," 90; Robert Frank, photographs, 91–114, and "A Statement," 115; Maloney, "U.S. Camera 1958," 124.

15. Letter, n.d. (early 1958), quoted in Schuh, Peter, and Mora, *Gotthard Schuh,* 255–256.

16. "A personality thing": Wellesley symposium; "As life goes on": Shani, "Bli Flash."

17. Silverstein: Interview transcript, Center for Creative Photography; Randy Kennedy, "A Lonely Gaze on the Times and Its City," February 17, 2012, *New York Times* Lens, https://lens.blogs.nytimes.com/2012/02/17/a-lonely-gaze-on-the-times-and-its-city/?_r=0; Douglas Martin, "Louis Silverstein," *New York Times,* December 1, 2011. A selection of Frank's work for Silverstein is available in a slideshow accompanying Kennedy's "A Lonely Gaze." Frank's *Zero Mostel Reads a Book* (Göttingen: Steidl, 2008) is a whimsical collection of photographs Frank took of his friend Mostel for a *Times* promotion. Helen Silverstein, the wife of the late Lou Silverstein, interviews with author.

18. Livingston, *New York School,* 307.

19. "On the Road to Florida," *Evergreen Review* 74 (January 1970): 42–47, reprinted in Tucker and Brookman, *Robert Frank,* 38–41. In the New York Public Library's Jack Kerouac Archive you can read the original manuscript, typed out on a length of teletype paper, which a librarian brings you in a six-foot-long folder.

20. "Evening with Robert Frank," Metropolitan Museum, October 9, 2009.

21. Alexander, "Criticism," 68.

22. Johnson, *Pictures Are a Necessity,* 44.

23. Byron Dobell, ed., "Feature Pictures" *U.S. Camera* 17, no. 9 (September 1954): 84.

24. Stein, *Eye of the Sixties,* 91; Richard Bellamy interview transcript, Center for Creative Photography.

25. Stein, *Eye of the Sixties,* 91; Al Hansen, *Incomplete Requiem for W. C. Fields* (New York: Something Else Press, 1966), 5.

26. Yvonne Andersen, interview with the author; "Oral History Interview with Red Grooms, 1974 March 4–18" and "Oral History Interview with Red Grooms, 1967 Sept. 5," Archives of American Art website, www.aaa.si.edu/collections/interviews/oral-history-interview-red-grooms-10671.

27. Robert Dunavon, "The Revolution in Bohemia," *Saturday Review,* September 6, 1958, 13–15, 42.

28. Richard Woodward, "Where Have You Gone, Robert Frank?" *New York Times* magazine, September 4, 1994, 30–37.

CHAPTER 8: THE NETWORK OF HUMAN MAYONNAISE

1. Delpire, "Among Friends," National Gallery of Art; Greenough, *Looking In,* 315.

2. Ginsberg, "Among Friends," National Gallery of Art.

3. Alexis de Tocqueville, *Democracy in America* (New York: Bantam Classics, 2000), 139.

4. Minor White, "Book Reviews: *Les Américains*," *Aperture* 7, no. 3 (1959): 127.

5. Patricia Caulfield, "New Photo Books: *The Americans*," *Modern Photography* 24 (June 1960): 32–33.

6. Quotes from John Durniak, James M. Zanutto, Arthur Goldsmith; other reviews by Les Barry, Bruce Downes, H. M. Kinzer, Charles Reynolds, "An Off-Beat View of the U.S.A.," *Popular Photography* 46 (May 1960): 104–106.

7. "Letters to the Editor," *Popular Photography*, July 1960, 6.

8. Livingston, *New York School*, 305.

9. Gee, *Limelight*, 84.

10. Wellesley symposium.

11. "Far from constituting the collective appraisal of a serious critical community devoted to the art of photography, those mean-spirited blasts demonstrate that such a community did not yet exist," writes Peter Galassi. Yet "The myth that holds up *The Americans* as a once-scorned masterpiece may contain just enough truth to survive": Galassi, *In America*, 36–37.

12. Leo Rubinfien, "One More Trip Through 'The Americans,'" *Art in America* (May 2009): 36–145, 170.

13. Dennis Wheeler, "Robert Frank Interviewed," *Criteria* 3, no. 2 (June 1977): 4–7, 7.

14. Letter, May 23, 1960, posted on photographer/filmmaker Danny Lyon's blog, Bleak Beauty, https://dektol.wordpress.com/picture-essays/hugh-edwards/hugh-edwards-letters.

15. Danny Lyon, "Happy Birthday Robert Frank," November 11, 2012, Bleak Beauty, https://dektol.wordpress.com/2012/11/11/happy-birthday-robert-frank.

16. Paul Katz, interview with author.

17. Cohen, interview.

18. Remarks at screening of John Cohen documentary *Visions of Mary Frank*, Film Forum, New York City, April 22, 2014.

19. Jonas Mekas, interview with author.

20. Matt Trueman, "Jack Kerouac Play to Receive World Premiere," *Guardian*, March 13, 2012.

21. *Pull My Daisy*: Barry Gifford, *Jack's Book: An Oral Biography of Jack Kerouac* (New York: St. Martin's Press, 1978), 260–262; Ellis Amburn, *Subterranean Kerouac: The Hidden Life of Jack Kerouac* (New York: St. Martin's Press, 1998), 229, 302–311; Jack Kerouac and Jerry Tallmer, *Robert Frank: Pull My Daisy* (Göttingen: Steidl, 2008); David Sterritt, *Mad to Be Saved: The Beats, the '50s, and Film* (Carbondale: Southern Illinois University Press, 1998); John Strausbaugh, *The Village: 400 Years of Beats and Bohemians, Radicals and Rogues* (New York: Ecco, 2013), 309–317; Blain Allan, "The Making (And

Unmaking) of 'Pull My Daisy,'" *Film History* 2, no. 3 (September–October 1988): 185–205; Tony Floyd, "*Pull My Daisy*: The Critical Reaction," *Moody Street Irregulars* 22/23 (Winter 1998–1999): 11–14; J. Hoberman, "The Forest and *The Trees*" in *To Free the Cinema: Jonas Mekas and the New York Underground*, ed. David E. James (Princeton, NJ: Princeton University Press, 1992), 100–119; David Amram, *Offbeat: Collaborating with Kerouac* (New York: Thunder's Mouth, 2002), 48–85; J. Hoberman, "*Pull My Daisy/ The Queen of Sheba Meets the Atom Man*," from *The American New Wave 1958–1967*, ed. Melinda Ward and Bruce Jenkins (Buffalo, NY: Walker Art Center/Media Study, 1982), 35–39; George Kouvaros, "'Time and How to Note It Down': The Lessons of *Pull My Daisy*," *Screen* 53, no. 1 (2012): 1–17; "In Conversation: Alfred Leslie with Phong Bui," *Brooklyn Rail*, October 5, 2005, http://brooklynrail.org /2015/10/art/alfred-leslie-with-phong-bui; Jonas Mekas, "*Pull My Daisy* and the Truth of Cinema," in *Movie Journal: The Rise of a New American Cinema, 1959–1971* (New York: Collier Books, 1972); Eileen Myles, "Reunion," *Parkett* 83 (2008): 45–48; Jack Sargeant, *Naked Lens: Beat Cinema* (London: Creation Books, 1997), 17–52; Leon Prochnik, *Jack Kerouac, The Daisy, and Me*, unpublished memoir.

22. Walter Gutman, *The Gutman Letter* (New York: Something Else Press, 1969).

23. Emile de Antonio interview transcript, Center for Creative Photography.

24. David Amram, interview with author.

25. Ibid.

26. J. Hoberman, "Alfred Leslie: Daisy: 10 Years Later," *Village Voice*, November 28, 1968, 54; Sargeant, "An Interview with Alfred Leslie," *Naked Lens*, 27–40; "An Interview with Robert Frank," *Naked Lens*, 41–52.

27. Gert Berliner, interview with author; Allan, "The Making (and Unmaking)," 195; Amram, interview; Tucker and Brookman, *Robert Frank*, 85; Leon Prochnik, interview with author.

28. Alfred Leslie, interview with author.

29. Mekas, interview.

30. "flashy backy": Tucker and Brookman, *Robert Frank*, 71. On the Bus Series: Allan Porter, "Robert Frank: A Bus Ride Through New York," *Camera* 45, no. 1 (January 1966): 32–35; "Portfolio: Robert Frank, 5 Photographs," *Second Coming* magazine 1, no. 6 (January 1965): 15, 28–30; notes for lecture, c. 1988–1989, "Papers, Books, Recordings," National Gallery of Art. The most revealing description of the making of this series is found in the Silverstein interview manuscript, CCP. The *New York Times* art director believed this series began as a potential promotional series showing off the city in a raw, new way.

31. Robert Frank, *Robert Frank* (Millerton, NY: *Aperture* Foundation, 1976).

CHAPTER 9: TOUCHED BY THE HAND OF GOD

1. Shani, "Bli Flash."

2. Prochnik says it was thirty hours; the scholar of the film, Blaine Allan, says it was three.

3. Frank said there were three sections of about ten minutes each recorded, and only one section might have been redone. Sargeant, *Naked Lens,* 63.

4. This account combines many sources and chiefly relies on Prochnik's manuscript and interview, Amram's interview and *Offbeat,* and Sargeant's interviews with Frank and Leslie in *Naked Lens.*

5. Narration transcript in Kerouac and Tallmer, *Pull My Daisy,* 31.

6. Sterritt, *Mad to Be Saved,* 96.

7. Stephen Petrus, "Rumblings of Discontent: American Popular Culture and Its Response to the Beat Generation, 1957–1960," *Studies in Popular Culture* 20, no. 1 (October 1997): 1–17.

8. Allan, "The Making (And Unmaking)," 201–202.

9. Strausbaugh, *The Village,* 313–314; see also Strausbaugh, "The Beats Go to Hollywood," The Chiseler blog, 2012, http://chiseler.org/post/22527019423/the-beats-go-to-hollywood.

10. Paul O'Neil, "Beats, Sad but Noisy Rebels," *Life,* November 30, 1959, 114–130.

11. Quoted in Mekas, *Movie Journal: The Rise of New American Cinema, 1959–1971* (New York: Columbia University Press, 2016), 12.

12. George Kuchar, "The Old Days," in James, *To Free the Cinema,* 49.

13. Ibid., 105.

14. Steven Watson, *Factory Made: Warhol and the Sixties* (New York: Pantheon 2003), 69–71.

15. Sargeant, *Naked Lens,* 128.

16. "Movie Journal," *Village Voice,* September 14, 1961.

17. "Post–*Pull My Daisy*": "Notes on the New American Cinema," in P. Adams Sitney, ed., *Film Culture Reader* (New York: Cooper Square Press, 2000), 94. "comic uniforms": Parker Tyler, *Underground Film: A Critical History* (New York: Da Capo Press, 1995), 48.

18. Mekas, interview.

19. "The First Statement of the New American Cinema Group": *Film Culture* 22–23 (Summer 1961): 131–133, republished in Sitney, *Film Culture Reader,* 79–83.

20. Mekas, interview.

21. Mekas, "From the Diaries," in Ward and Jenkins, *The American New Wave*, 5.

22. Ibid., 6.

23. Eskildsen, *Hold Still*, 111.

24. "On the Pessimism of Robert Frank," *Village Voice*, December 7, 1961, in Mekas, *Movie Journal*, 47–48.

25. "original sin boy": Tom Gunning, "Loved Him, Hated It," in James, *To Free the Cinema*, 72. "didn't turn out very well," Johnson, *Pictures Are a Necessity*, 47.

26. Berliner, interview.

27. De Antonio interview transcript, Center for Creative Photography.

28. Deb Baker, *A Blue Hand: The Tragicomic, Mind-Altering Odyssey of Allen Ginsberg* (New York: Penguin, 2008).

29. Ginsberg, "Back to the Wall," in *Deliberate Prose: Selected Essays 1952–1995*, ed. Bill Morgan (New York: Harper 2000), 8.

30. "Kaddish," in Ginsberg, *Collected Poems 1947–1997* (New York: Harper, 2006), 217–232.

31. Letter from Frank, October 23, 1963, Allen Ginsberg Papers, Correspondence 1960–1969, box 24, folder 31, Stanford University.

32. Filming "Kaddish": "The Conversations Between Allen Ginsberg, Charlie Chaplin, and Robert Frank," in Kane, *We Saw the Light*, 111–145. Letters between Frank and Ginsberg, in the Allen Ginsberg Papers at Stanford University, show how much filming the work meant to both men and the difficulty they experienced; Bill Morgan, *I Celebrate Myself: The Somewhat Private Life of Allen Ginsberg* (New York: Penguin, 2006) produces several colorful details about the effort to make *Kaddish*.

33. Ginsberg interview transcript, Center for Creative Photography.

34. Cohen, interview.

35. Shani, "Bli Flash."

CHAPTER 10: NEW PROJECTS

1. Cohen, *There Is No Eye*, 25.

2. J. Hoberman, "Jack in the Box," *Artforum*, September 2011.

3. Sargeant, *Naked Lens*, 75.

4. Andrew Perchuk and Rani Singh eds., *Harry Smith: The Avant-Garde in the American Vernacular* (Los Angeles: Getty Research Institute, 2010), 50.

5. Paola Igliori, ed., *American Magus Harry Smith: A Modern Alchemist* (New York: Inandout Press, 1996); John Cohen, "Interview in Chelsea Hotel," in

Think of the Self Speaking: Harry Smith, Selected Interviews, ed. Rani Singh (Boulder, CO: Citiful Press, 1998), 66–101; Perchuk and Singh, *Harry Smith;* Mekas, "Movie Journal," *Village Voice,* March 18, 1965.

6. William Grimes, "Lionel Ziprin, 84, Mystic of the Lower East Side, Dies," *New York Times,* March 20, 2009, A19; David Katznelson, "Lionel Ziprin: A Remembrance," *Arthur* magazine, September 17, 2009, https:// arthurmag.com/2009/09/17/lionel-ziprin; John Yau, "The Poet-Magus of the Lower East Side," Hyperallergic, October 20, 2013, https://hyperallergic. com/89359/the-poet-magus-of-the-lower-east-side; Andy Battaglia, "Today Is an Example," *Frieze* (June–August 2014), https://frieze.com/article/today-example.

7. Grimes, "'Lionel Ziprin, 84, Mystic."

8. Lawrence Shainberg, "Notes from the Underground," *Evergreen Review* 11, no. 50 (December 1967): 22–26, 105–112.

9. Liner notes, Kiowa Peyote Meeting, 1973, Smithsonian Folkway Records.

10. Lawrence Shainberg, "Notes from the Underground," *Evergreen Review* 11, no. 50 (December 1967): 22–26, 105–112; Sergeant, "Hallucinations & Homecomings: Notes on Conrad Rooks' Chappaqua," in *Naked Lens,* 147–156; Carl Abrahamsson, "Conrad Rooks: Chappaqua and Beyond," Abrahamsson, June 30, 2012, http://carlabrahamsson.blogspot.com/2012/06/conrad-rooks-chappaqua-and-beyond.html; Vincent Canby, "Who Is Conrad Rooks," *New York Times,* January 15, 1967, D13; Robert McDonald, "The Elusiveness of Conrad Rooks," *Take One* 3, no. 6 (May–June 1971).

11. Alexander Rooks, interview with author.

12. Allen Ginsberg, "Robert Frank to 1985—A Man," in Tucker and Brookman, *Robert Frank,* 85.

13. "Prospectus for 'Kaddish': A 90 minute black and white 35mm film by Robert Frank," in Ginsberg Papers, Stanford University.

14. Greil Marcus, *The Shape of Things to Come: Prophecy and the American Voice* (New York: Faber & Faber, 2001), 267–284; Rolf Potts, "The Last Anti-War Poem," *The Nation,* November 14, 2006; Barry Farrell, "Guru Comes to Kansas," *Life,* May 27, 1966, 78–90; two unpublished short memoirs from Terrence Williams; Charles Plymell, Terrence Williams, P. J. O'Connor, interviews with author.

15. Terence Williams, interview with author.

16. Tucker and Brookman, *Robert Frank,* 74.

17. Robert Frank, Me and My Brother (Göttingen: Steidl, 2007); Luc Sante, "The Films of Robert Frank," *Aperture* 191 (Summer 2008); Morgan, *Celebrate Myself,* 428–429; Ginsberg interview in Sargeant, *Naked Lens,* 151–160; Greil Marcus, "On the Road Again: Robert Frank Driving and Crying," *Artforum*

33 (November 1994): 52–57; Mekas, "Movie Journal," *Village Voice,* February 13, 1969.

18. Rudy Wurlitzer interview transcript, Center for Creative Photography; Frank and Jarmusch conversation transcript, Switch.

19. Wheeler, "Robert Frank Interviewed."

20. Chappaqua press file, Margaret Herrick Library.

21. Ibid.

CHAPTER 11: AN IMPRESSIVE BUNCH OF GUYS

1. Grace Glueck, "Three Artists' Work Destroyed in Fire," *New York Times,* October 20, 1966, 46.

2. Frank blames Leslie: Sargeant, *Naked Lens,* 44; Leslie blames Frank: Sargeant, *Naked Lens,* 38.

3. Grace Mayer interview transcript, Center for Creative Photography.

4. Nathan Lyons, ed., *Contemporary Photographers Toward a Social Landscape* (Rochester, NY: George Eastman House, 1966),

5. Szarkowski, wall text for New Documents, quoted in Lydia Yee, ed., *Street Art, Street Life: From the 1950s to Now* (New York: Bronx Museum of the Arts 2008), 94; see also Sarah Hermanson Meister, "'They Like the Real World': Documentary Practices After *The Americans,*" in *Photography at MoMA, 1960 to Now,* ed. Quentin Bajac, Lucy Gallun, Roxana Marcoci, and Sarah Hermanson Meister (New York: Museum of Modern Art, 2015).

6. Robert Frank, *The Americans,* introduction by Jack Kerouac (New York: Aperture/Museum of Modern Art, 1968), back cover text.

7. Walker Evans, "Photography," in *Quality: Its Image in the Arts,* ed. Louis Kronenberger (New York: Atheneum, 1969), 174.

8. Interview with Sid Rapoport, in Thomas Dugan, *Photography Between the Covers: Interviews with Photo-Bookmakers* (Rochester, NY: Light Impressions, 1979), 215.

9. De Antonio interview manuscript, Center for Creative Photography.

10. Cynthia MacAdams, interview with author.

11. Helen Silverstein, interview with author.

12. "More on Robert Frank and John Chamberlain," *Village Voice,* February 20, 1969, in Mekas, *Movie Journal,* 345.

13. Gibson, interview transcript, Center for Creative Photography.

14. From video interview with Gibson, promoting a December 15, 2016, auction of Frank photographs posted on Sotheby's website, www.sothebys.com/en/news-video/blogs/all-blogs/sotheby-s-at-large/2015/12/ralph-gibson-robert-frank-interview.html.

15. Ralph Gibson, interview with author.

16. Wavy Gravy, interview with author.

17. Stewart Brand, interview with author.

18. Gibson, interview.

19. Gibson interview transcript, Center for Creative Photography.

20. Handelman, interview.

21. Greenbaum, interview.

22. James R. Mellow, "Keeping the Figure Vital," *New York Times*, September 15, 1968, D33.

23. Socolov, interview with author.

24. Silverstein, interview.

25. Gibson video interview, Sotheby's website; interview transcript, Center for Creative Photography.

26. Silverstein, interview.

27. Arthur Lubow, *Diane Arbus: Portrait of a Photographer* (New York: Ecco, 2016), 508.

CHAPTER 12: FINALLY, REALITY

1. Camus, *Notebooks*, quoted in David Reid, *The Brazen Age: New York City and the American Empire* (New York: Pantheon, 2006), 163–164; Janet Flanner and Stanley Edgar Hyman, "The Talk of the Town," *New Yorker* (February 22, 1947).

2. "Letter from New York," *Creative Camera*, August 1969, 272.

3. Daniel Seymour, *A Loud Song* (New York: Lustrum, 1971), 39, 55.

4. Lyon, interview.

5. Marian Janssen, *Not at All What One Is Used To: The Life and Times of Isabella Gardner* (Columbia: University of Missouri Press, 2010), 106.

6. Seymour, *A Loud Song*.

7. "In Conversation: Robert Bergman with John Yau," *Brooklyn Rail*, October 5, 2009, http://brooklynrail.org/2009/10/art/robert-bergman-with-john-yau.

8. Alyssa Ford, "Jessica Lange's Artistic Odyssey," *Artful Living*, Spring 2015, 128–133.

9. Steve Gebhardt, interview with author.

10. Gebhardt, interview.

11. Tracy Nelson, interview with author.

12. Brookman, "A Conversation with Allen Ginsberg," Burger-Utzer and Grissemann, *Frank Films*, 78.

13. Larry Clark, *Tulsa* (New York: Lustrum Press, 1971).

14. Edward Grazda entry on Photo-eye website, 2008, www.photoeye.com/magazine/articles/2008/05_21_qtp_grazda.cfm; Robert Alter, "On the Road to Plymouth Rock: A Recollection of Robert Frank," in *Positive*, ed. Creative Photography Laboratory (Cambridge, MA: MIT Press, 1981), 6–11.

15. "Letter from New York," *Creative Camera*, June 1969.

16. Ibid.

17. Ibid.

18. Lyon interview; Sweeney story recounted in Lyon, *Knave of Hearts* (Santa Fe, NM: Twin Palm Publishers, 1999).

19. Ruby Lynn Reyner, interview with author.

20. Foreword to Japanese edition of *The Lines of My Hand* (Tokyo: Yugensha, 1972), unpaginated.

21. Michael Simmons, "*Exile* on Sunset Boulevard," *LA Weekly* website, May 13, 2010; Mike Goldstein, "The Impact of John Van Hamersveld's Artwork on the Rolling Stones' 'Exile on Main St.,'" *Goldmine*, May 10, 2010, www.goldminemag.com/articles/the-rolling-stones-exile-on-main-street-and-the-artwork-by-john-van-hamersveld. Other accounts suggest it was drummer Charlie Watts who introduced Frank's work to the band.

22. John Van Hamersveld, "Imagining the Stones: John Van Hamersveld," Rock's Back Pages, August 11, 2001, http://rockpopgallery.typepad.com/rockpop_gallery_news/2008/04/cover-story---t.html.

23. David E. James, *Rock 'N' Film: Cinema's Dance with Popular Music* (New York: Oxford University Press, 2016), 300–301.

24. Gregory Gibson, *Hubert's Freaks: The Rare-Book Dealer, the Times Square Talker, and the Lost Photos of Diane Arbus* (New York: Houghton Mifflin Harcourt, 2008), 25, 41; International Center of Photography's Fans in a Flashbulb blog, in an entry by Christopher George dated May 18, 2010 (https://fansinaflashbulb.wordpress.com/2010/05/18/exiles), casts light on aspects of the Arbus portrait of Trambles and the *Exile* album cover.

CHAPTER 13: A LUCITE SPACESHIP

1. June Leaf, *June Leaf: Record 1974/75 Mabou Coal Mines* (Göttingen: Steidl, 2010), 12.

2. Sarah Driver, interview with author.

3. Judith Richards, "Oral History with June Leaf," November 16, 2009, May 17, 2010, Archives of American Art.

4. Paul Richard, "June Leaf's Epiphanies & Other Delights," *Washington Post*, April 14, 1991.

5. Judith Hayes, "June Leaf: The Cape Breton Works, 1970–1990: 'A Place/From Away'—'The Place/From Here'" (MA thesis, Concordia University Montreal, 2006).

6. Jennifer Samet, "Beer with a Painter: June Leaf," Hyperallergic, April 23, 2016, https://hyperallergic.com/293089/beer-with-a-painter-june-leaf. Also regarding Leaf: Philip Brookman, ed., *June Leaf: A Survey of Painting, Sculpture and Works on Paper 1948–1991* (Washington, DC: Washington Project, 1991); Robert Enright, *June Leaf* (Wabern, Germany: Benteli, 2004).

7. Rosemary Feitelberg, "June Leaf Discusses Art, Whitney Show and Living with Photographer Robert Frank," *WWD*, June 17, 2016.

8. Hayes, "June Leaf."

9. Laura Israel, *Don't Blink—Robert Frank*, documentary, 2015.

10. Philip Glass, *Words Without Music: A Memoir* (New York: Liveright, 2015), 264–265.

11. Hayes, "June Leaf," 52.

12. Kernan, "Uneasy Words."

13. Feitelberg, "June Leaf Discusses Art." For the feeling of life on Cape Breton Island, see Guido Magnaguagno, "Meeting R.F.," in *Du: Robert Frank Part Two* (Zurich: Tages Anzeiger, 2002), 74, 79–81; Dee Dee Halleck, "Keeping Busy on Cape Breton Island: Journal of a Production Assistant to Robert Frank," from *Hand-Held Visions* (New York: Fordham University Press, 2001), 30–41.

14. Cohen, interview.

15. Robert Greenfield, interview with author.

16. Keith Richards with James Fox, *Life* (New York: Little, Brown and Company, 2010), 32.

17. Among works consulted on the Stones 1972 tour: Robert Greenfield, *STP: A Journey Through America with the Rolling Stones* (New York: Saturday Review Press, 1974); "The Stones in LA: Main Street Exiles," *Rolling Stone*, April 27, 1972; "The Rolling Stones Go South," *Rolling Stone*, August 3, 1972; Richard M. Elman, *Uptight with The Stones* (New York: Scribner, 1973); Terry Southern, "The Rolling Stones US Tour: Riding the Lapping Tongue," *Saturday Review of the Arts*, August 12, 1972, 23–30; Harver Kubernick, "Marshall Chess Talks Intimately About the Rolling Stones," *Goldmine*, July 6, 2010, www.goldmine mag.com/articles/marshall-chess-talks-very-intimately-about-rolling-stones.

18. Lani Russwurm, "Street Fighting Men," *Past Tense*, November 12, 2009, https://pasttensevancouver.wordpress.com/tag/whistling-smith.

19. Allen Wiggins, "Rock Concert Crowd an Enigma," *Cleveland Plain Dealer*, July 12, 1972.

20. "R.I. Fuzz Gather 2 Rolling Stones," *New York Post*, July 19, 1972.

21. Wellesley symposium.

22. Elman, *Uptight*, 10.

23. Ibid., 7.

24. Ibid., 67.

25. Wellesley symposium.

26. Wheeler, "Robert Frank Interviewed."

27. Elman, *Uptight*, 110.

28. Ibid., 107–110.

29. Martin Parr and Gerry Badger, *The Photobook: A History Volume I* (New York: Phaidon, 2004).

30. Paul Justman, interview with author.

31. Susan Steinberg, interview with author.

32. Don DeLillo, *Underworld: A Novel* (New York: Scribner, 2007), 382–383.

33. John Robinson, "Rolling Stones: Inside the Madness of the Exile Tour," *Uncut*, December 2012. On the making and experience of *Cocksucker Blues*: Richard Brody, "Cocksucker Blues: Robert Frank's Suppressed Rolling Stones Documentary Comes to Film Forum," *New Yorker*, July 20, 2016, www.newyorker.com/culture/richard-brody/cocksucker-blues-robert-franks-suppressed-rolling-stones-documentary-comes-to-film-forum; Stephen Gaunson, "Cocksucker Blues: The Rolling Stones and Some Notes on Robert Frank," *Senses of Cinema* 56, October 2010, http://sensesofcinema.com/2010/feature-articles/cocksucker-blues-the-rolling-stones-and-some-notes-on-robert-frank.

34. "*stunned*": Robinson, "Rolling Stones," 36. "so amateur": Richard Crouse, *The 100 Best Movies You've Never Seen* (Toronto: ECW Press, 2003), 48.

35. Steinberg, interview.

36. "The Trouble with 'Cocksucker Blues,'" *Rolling Stone*, November 3, 1977.

37. Chet Flippo, "Hot Stuff from Mick and Keith," *Rolling Stone*, November 3, 1977.

38. Lois Legge, "Photographer Robert Frank Shares Stories of Light, Loss and Love" (Halifax) *Chronicle Herald*, September 13, 2014.

39. Merrill Shindler, "Rolling Stones' 'Cocksucker Blues' Screens in San Francisco," *Rolling Stone*, December 30, 1976.

40. Ford, "Jessica Lange's Artistic Odyssey," 133.

41. Bruce Rubenstein, *Greed, Rage, and Love Gone Wrong: Murder in Minnesota* (Minneapolis: University of Minnesota Press, 2004), 109–130; Barry Dubner, Appendix, "Review of 'Piratical' Acts," in *The Law of International Sea Piracy* (Dordrecht: Springer, 1980), 154; Lyon, Gibson, Steinberg, interviews.

42. Letter, *Village Voice*, June 6, 1974.

43. Faurer interview transcript, Center for Creative Photography; Associated Press, "21 From U.S. are Killed in Guatemala Plane Crash," *New York Times*, December 30 1974.

CHAPTER 14: SICK OF GOODBY'S

1. Johnson, *Pictures Are a Necessity,* 63.

2. Findlay Fryer, interview with author.

3. Wurlitzer interview transcript, Center for Creative Photography.

4. Kernan, "Uneasy Words."

5. The process for how and when Frank returned to still photography is somewhat vague and accounts vary. I have drawn from various accounts, especially Philip Brookman's "Windows on Another Time: Issues of Autobiography," in Greenough and Brookman, *Robert Frank Moving Out,* 96–125.

6. Johnson, *Pictures Are a Necessity.*

7. Kernan, "Uneasy Words."

8. Feldman, *Give My Regards,* 30.

9. Wellesley symposium.

10. Sean O'Hagan, "Robert Frank at 90," *Guardian,* November 7, 2004.

11. Myles, "Reunion," 47.

12. Grissemann, "Verite Vaudeville. Passage Through Robert Frank's Audiovisual Work," in Burger-Utzer and Grissemann, *Frank Films,* 24.

13. Gutman and Moses interview transcripts, Center for Creative Photography.

14. Wellesley symposium.

15. Wheeler, "Robert Frank Interviewed."

16. Interview with Gene Santoro, Music Aficionado, June 2016, https://web.musicaficionado.com/main.html#!/article/Henry_Threadgill_Article.

17. Grazda, "Among Friends."

18. Johnson, *Pictures Are a Necessity,* 115

19. Ibid., 116.

20. Sarah Boxer, "An Untamable Outsider Who Speaks in Riddles," *New York Times,* August 26, 2002.

21. Godlis, interview.

22. Livingston, *New York School.*

23. Stefan Gronert, "Photographing in a Painterly Way: Polke's Bowery Photographs," in *Sigmar Polke: 1963–2010: Alibis,* ed. Mark Godfrey, Kathy Halbreich, and Magnus Schaefer (New York: Museum of Modern Art, 2014).

24. Ben Lifson, "Collecting Photos for Love or Money," *Village Voice,* October 30, 1978, 109.

25. Alexandra Anderson, "Inside the Photography Marketplace," *Village Voice* special section, December 4, 1978.

26. Dennis Longwell, "Creating Rarity, Dealers and the Photography Market," *American Art and Antiques,* May–June 1979, 84–89.

27. Jacob Deschin, "The Print Prospectors," 35mm magazine, Spring 1976. Also see Philip Gefter, Wagstaff: *Before and After Mapplethorpe* (New York: Liveright, 2014).

28. Henry Allen, "Harry Lunn Jr.: Prints Charming," *Washington Post* magazine, November 19, 1978. Also regarding Lunn and the market: Transcript of August 17, 1976, interview with Landt Dennis, box 181, folder 12, Harry Lunn Papers, J. Paul Getty Trust, Getty Research Institute, Los Angeles.

29. Johnson, *Pictures Are a Necessity,* 164.

30. Gefter, Wagstaff, 294.

31. Ibid.

32. Ibid., 295.

33. Deschin, "Print Prospectors."

34. Harry Lunn to Robert Frank, March 31, 1978, box 22, folder 11, Harry Lunn Papers, J. Paul Getty Trust.

35. Eskildsen, "In Conversation with Robert Frank," 113.

36. Silverstein, interview.

CHAPTER 15: BOBBY HOT DOG

1. Philip Gefter, "Why Photography Has Supersized Itself," *New York Times,* April 18, 2004.

2. William Eggleston, interview with author.

3. English translation of "Harry Lunn: The Man Who Made Mapplethorpe," *Knack Weekend* magazine (April 1, 1997), Harry Lunn Papers; Stephen Rosoff, "The Dealer Who Came in from the Cold," *Michigan Alumus,* July–August 1990.

4. Roma Connable, interview with author.

5. Karen M. Paget, *Patriotic Betrayal: The Inside Story of the CIA's Secret Campaign to Enroll American Students in the Crusade Against Communism* (New Haven, CT: Yale University Press, 2015); Lunn and the NSA: 141–142, 147–155; CIA's funding and influence on the NSA: 5–6, 97–114, 130–143. See also Sol Stern, "A Short Account of International Student Politics and the Cold War with Particular Reference to the NSA, CIA, Etc.," *Ramparts,* March 1967, 29–39.

6. Paget, *Patriotic Betrayal,* 214–216.

7. Karen Paget, interview with author.

8. "Harry Lunn: The Man Who Made Mapplethorpe."

9. Paget, interview.

10. Christophe Lunn, interview with author.

11. Faurer, "Narrative of My Life," in Edith A. Tonelli, ed., *Louis Faurer: Photographs from Philadelphia and New York, 1937–1973* (College Park: University of Maryland Art Gallery, 1981).

12. "Photography: Harry H. Lunn, Jr.," *The Art/Antiques Investment Report*, January 10, 1983.

13. Letter to Penn and Katz, n.d., "Correspondence and Typescripts," in Papers, Books and Records, Robert Frank Collection.

14. Paul Katz, interview with author.

15. Marlaine Glicksman, "Highway 61 Revisited," *Film Comment*, July–August 1987, 32–39.

16. *Leaving Home, Coming Home: A Portrait of Robert Frank*, directed by Gerald Fox, 2005.

17. Marty Greenbaum, interview with author.

18. Robert Golka, interview with author.

19. Driver, interview.

20. Johnson, *Pictures Are a Necessity*, 125.

21. Moses interview transcript, Center for Creative Photography.

22. Ginsberg, "Among Friends."

23. Ibid.

24. "Today I Look in the Mirror," *C*, Fall 1984.

25. Roslyn Bernstein, "The Photography of Allen Ginsberg," *Guernica*, February 4, 2013, www.guernicamag.com/roslyn-bernstein-the-photography -of-allen-ginsberg.

26. Jobey, "The UnAmerican."

27. "Workshop 1984 May 25," cassette box 28, Allen Ginsberg Papers, Courtesy of Department of Special Collections, Stanford University Libraries.

28. Jonathan Dixon, "Writer Rudy Wurlitzer's Underappreciated Masterpieces," *Vice*, February 26, 2015.

29. Glicksman, "Highway 61."

30. Kevin O'Connor, interview with author.

31. Mark Bingham, interview with author.

32. Glicksman, "Highway 61."

33. Lee Hill, "Return of the Frontiersman: Rudy Wurlitzer in Conversation," *Vertigo 18* online, June 2008, www.closeupfilmcentre.com/vertigo _magazine/issue-18-june-2008/return-of-the-frontiersman-rudy-wurlitzer -in-conversation.

34. Shani, "Bli Flash."

35. Greenough, *Looking In*, 321.

36. *Collection Photo Poche No. 10* (Paris: Centre National de la Photographie, 1983), translation in Johnson, *Pictures Are a Necessity*, 70.

CHAPTER 16: DETECTIVE WORK

1. Paul Richard, "The Artist's Gift of a Lifetime," *Washington Post*, September 7, 1990.

2. Johnson, *Pictures Are a Necessity*, 170.

3. Ibid., 170–171.

4. O'Connor, interview; Jonathan Rosenbaum, "Metaphysical," in Burger-Utzer and Grissemann, *Frank Films*, 190–191.

5. Dominique Eddé, email to author.

6. Dominique Eddé, ed., *Beirut City Centre* (Paris: Editions du Sycomore, 1992); Gabriele Basilico, *Beirut* (Paris: La Chambre Clair, 1994).

7. Frank, *Come Again* (Göttingen: Steidl, 2006).

8. Eddé, email.

9. Jobey, "The UnAmerican."

10. Mike McGonigal, interview with author.

11. Richard B. Woodward, "Where Have You Gone, Robert Frank?," *New York Times* magazine, September 4, 1994, 32–37; Jobey, "The UnAmerican."

12. Patti Smith, *M Train* (New York: Knopf, 2015), 32.

13. Letter, March 3, 1994, Correspondence 1990s, Allen Ginsberg Papers.

14. Greenbaum, Magnaguagno, interviews.

15. Greenough, email to author.

16. Handelman, interview.

17. "Memorial sketchbook celebrating the life of Pablo Frank (1951–1994)," Robert Frank Collection.

18. Julia Weiner, "Interview: Gerry Fox," *Jewish Chronicle*, December 2, 2010, www.thejc.com/culture/interviews/interview-gerry-fox-1.19805.

19. Magnaguagno, interview.

20. Robert Frank, *Flamingo* (Göteborg: Hasselblad Center, 1997), 26.

21. David Rimanelli, "More Art Hours than Can Ever Be Repaid," *Frieze*, January 5, 1994, https://frieze.com/article/more-art-hours-can-ever-be-repaid.

22. Perl, *New Art City* (New York: Vintage, 2007), 304.

23. Letter to Ann Tucker, winter 1985, Tucker and Brookman, *Robert Frank*, 72.

24. Raymond Foye, interview with author.

25. Bill Morgan, *I Celebrate Myself: The Somewhat Private Life of Allen Ginsberg* (New York: Viking, 2006), 646–652; Rosebud Feliu-Pettet's account of Ginsberg's last days, Allen Ginsberg Project website, http://ginsbergblog.blog

spot.com/2014/04/allen-ginsbergs-parinirvana.html; Jonas Mekas, *Scenes from Allen's Last Three Days on Earth as a Spirit*, 1997 videotape; Foye, interview.

26. Robert Sklar, "Through a Lens Darkly, Robert Frank Looks Back," *Forward*, November 10, 1995.

CHAPTER 17: THE AMERICAN

1. Gerald Fox, "Leaving Home, Coming Home," ICA newsletter, September 25, 2013.

2. Boxer, "An Untamable Outsider."

3. McGonigal, interview.

4. Paulo Nozolino, written account.

5. *The Declaration of Independence* (New York: Limited Edition Club, 2010).

6. Frank and Jarmusch conversation transcript, *Switch*.

7. Ibid.

8. James Estrin, "Robert Frank, Valuing the Image Over the Object," *Lens* blog, February 5, 2016, https://lens.blogs.nytimes.com/2016/02/05/robert-frank-steidl-books-films-exhibit-nyu/?_r=0.

9. Wellesley symposium.

10. Myles, "Reunion"; Charlie LeDuff, "Robert Frank's Unsentimental Journey," *Vanity Fair*, April 2008, 164–177.

11. Jeff Ladd, "Report from the May 15 Robert Frank Event at Lincoln Center," Photo-Eye blog, August 8, 2008, www.photoeye.com/magazine/articles/2008/05_21_frank_event.cfm.

12. LeDuff, interview.

13. Woodward, "The Americans Revisited," *Wall Street Journal*, November 18, 2009.

14. Estrin, "Robert Frank Valuing the Image."

15. Alex Rühle, "The Man Who Travels Faster than Jet Lag" *Suddeutsche Zeitung*, August 22, 2009.

16. Gasser, interview. See also Liz Jobey, "Q&A with Gerhardt Steidl, Publisher," *Financial Times*, February 27, 2015.

17. Legge, "Frank Shares Stories of Light, Loss and Love."

AFTERWORD

1. Michael Kaplan, "Moving Images," *Spin*, May 1988.

2. Tacita Dean, "You Can't Go Home," *Parkett* 83 (2008): 63.

INDEX